FROM RUSSIA

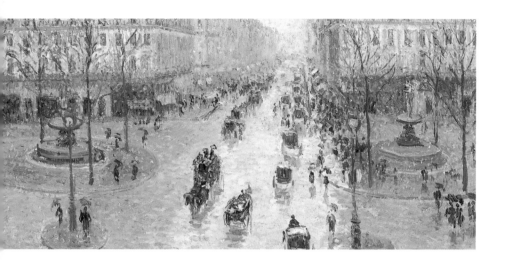

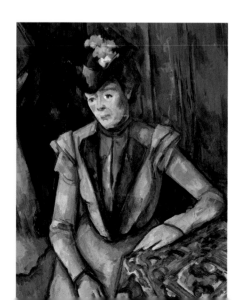

FROM RUSSIA

FRENCH AND RUSSIAN MASTER PAINTINGS 1870–1925 FROM MOSCOW AND ST PETERSBURG

ROYAL ACADEMY OF ARTS

This catalogue was first published on the occasion of the exhibition
"From Russia: French and Russian Master Paintings 1870–1925
from Moscow and St Petersburg"

museum kunst palast, Düsseldorf
15 September 2007 — 6 January 2008

Royal Academy of Arts, London
26 January — 18 April 2008

SPONSORED BY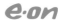

ROYAL ACADEMY OF ARTS

Exhibition curators
Ann Dumas
Sir Norman Rosenthal

Exhibition organisation
Cayetana Castillo
Lucy Hunt

Photographic and
copyright co-ordination
Andreja Brulc
Roberta Stansfield

ACKNOWLEDGEMENTS

The curators of the exhibition and the publishers of this catalogue
would like to extend their particular gratitude to Mikhail Shvydkoi,
Head of the Federal Agency for Culture and Cinematography,
Moscow.

They would also like to thank the following for their invaluable
support and for most generously agreeing to lend works to the
exhibition: Irina Antonova, Director of the Alexander Pushkin
Museum of Fine Arts, Moscow; Vladimir Gusyev, Director of the
State Russian Museum, St Petersburg; Mikhail Piotrovsky, Director
of the State Hermitage, St Petersburg; and Valentin Rodionov,
Director of the Tretyakov Gallery, Moscow.

They would like to thank the following for their advice: Lydia Iovleva,
Deputy Director of the Tretyakov Gallery, Moscow; Yevgenia Petrova,
Deputy Director of the State Russian Museum, St Petersburg;
Tatyana Potapova, Deputy Director of the Alexander Pushkin
Museum of Fine Arts, Moscow; Albert Kostenevich, Chief Curator
of Nineteenth- and Twentieth-Century French Painting, State
Hermitage, St Petersburg; and Joseph Kiblitsky, Publisher and
Artistic Director of the Palace Editions Europe publishing house.

They extend their grateful thanks to all those who have assisted with
the development of the exhibition and its catalogue, chief among
them Christina Lodder and David Jackson. Thanks are also due to
David Breuer, Christa Gerke, Lucy Hunt, Olga Ilmenkova, Sarah Lea,
Irina Lebedeva, John Milner, Caroline McCarthy, Inna Orn, Katia
Pisvin, Christopher Riopelle, Ivan Samarine, Marjorie Shiers, Peter
Sawbridge, Andrew Spira, Nick Tite, Anne Winton, and Janina
Wegner-Kereš.

Palace Editions Europe extend their thanks to the four museums
and their photographers for their collaboration in the creation of this
catalogue. Unless otherwise mentioned, all reproductions belong to
the lending museums, to the essay authors or to the Palace Editions
Europe archives. Palace Editions Europe would also like to thank the
Central State Archives of Cinema, Photo and Audio Documents,
St Petersburg; and Iveta and Tamaz Manasherov, Moscow.

CATALOGUE

Publishers
Palace Editions Europe
Royal Academy of Arts, London

Concept
Joseph Kiblitsky

Design and layout
Kirill Kryukov

Catalogue and biographies
Natalia Ardashnikova (N. A., Tret. Gal.),
Boris Asvarishch (B. A., Herm.),
Lyudmila Bobrovskaya (L. B., Tret. Gal.),
Elena Karpova (E. K., Russ. Mus.),
Valentina Knyazeva (V. Kn., Russ. Mus.),
Albert Kostenevich (A. K., Herm.),
Galina Krechina (G. K., Russ. Mus.),
Vladimir Kruglov (V. K., Russ. Mus.),
Alisa Lyubimova (A. L., Russ. Mus.),
Olga Musakova (O. M., Russ. Mus.),
Alfia Nizamutdinova (A. N., Russ. Mus.),
Alexei Petukhov (A. P., Push. Mus.),
Galina Churak (G. Ch., Tret. Gal.),
Lyubov Shakirova (L. Sh., Russ. Mus.),
Irina Shuvalova (I. Sh., Russ. Mus.)

Translation from the Russian
Peter Bray
Kenneth MacInnes

Editor of the English text
Irina Tokareva
Galina Maximenko

Proofreader of the English text
Galina Maximenko

Photographs
Sergei Petrov (Russ. Mus.),
Photography sector (Herm.),
Alexei Sergeyev (Tret. Gal.),
Alexander Sharoukhov (Tret. Gal.),
Nikolai Alexeyev (Tret. Gal.),
Anatoly Sapronenkov (Tret. Gal.),
Department of visual information (Push. Mus.)

ISBN 978-1-905711-16-1 (softcover)
ISBN 978-1-905711-15-4 (hardback)

Printed in Italy

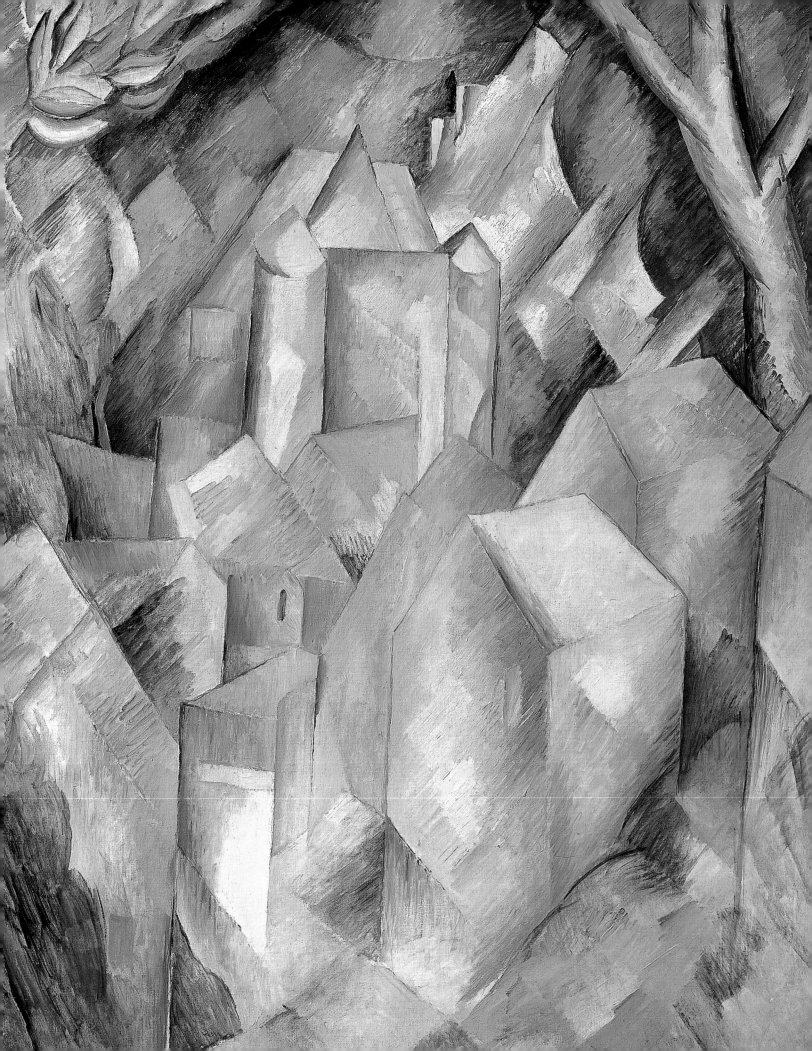

Contents

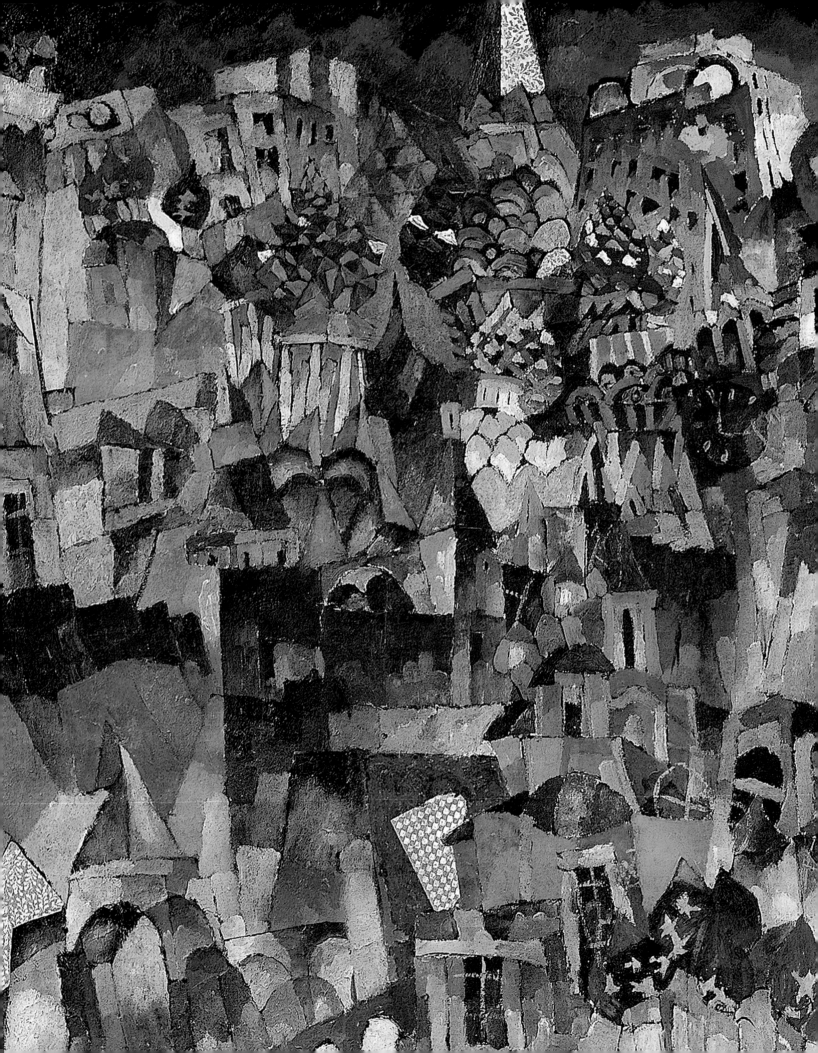

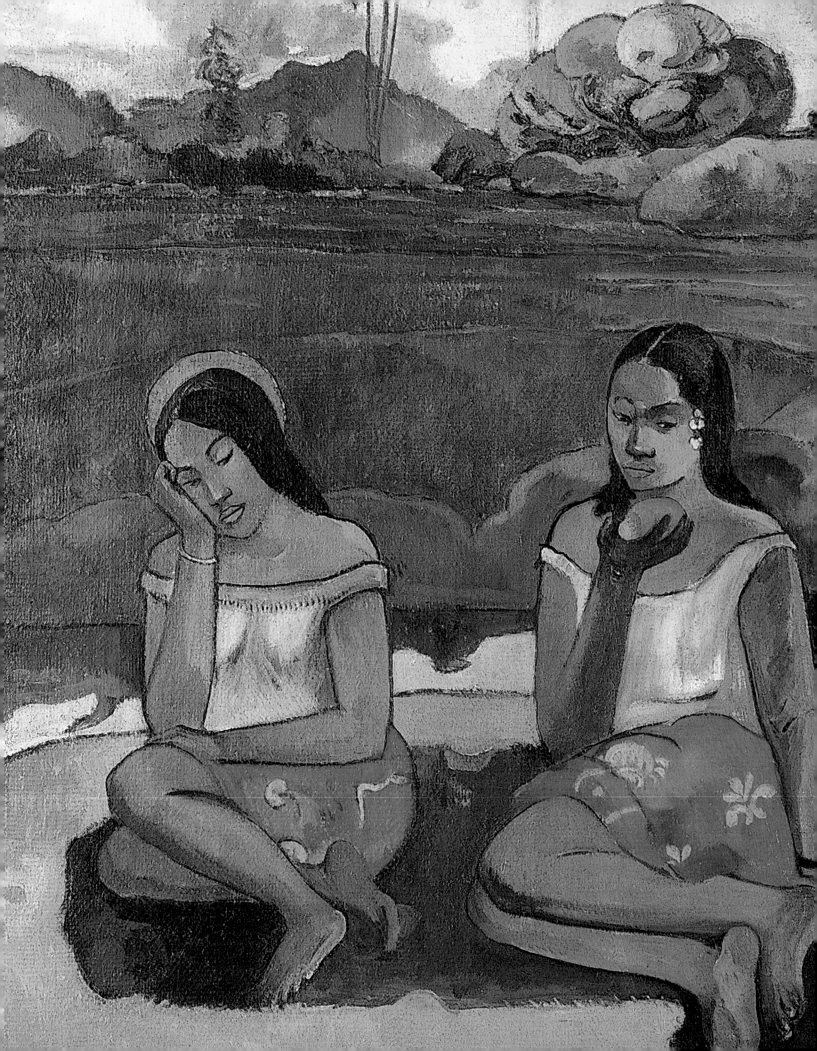

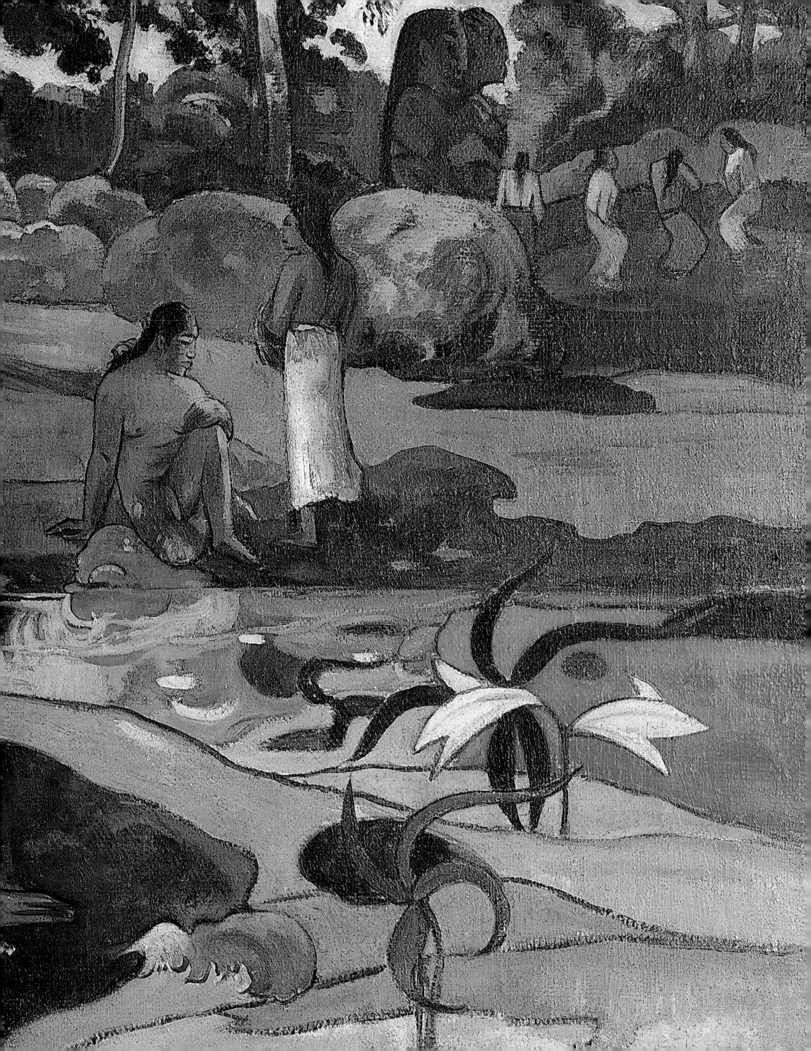

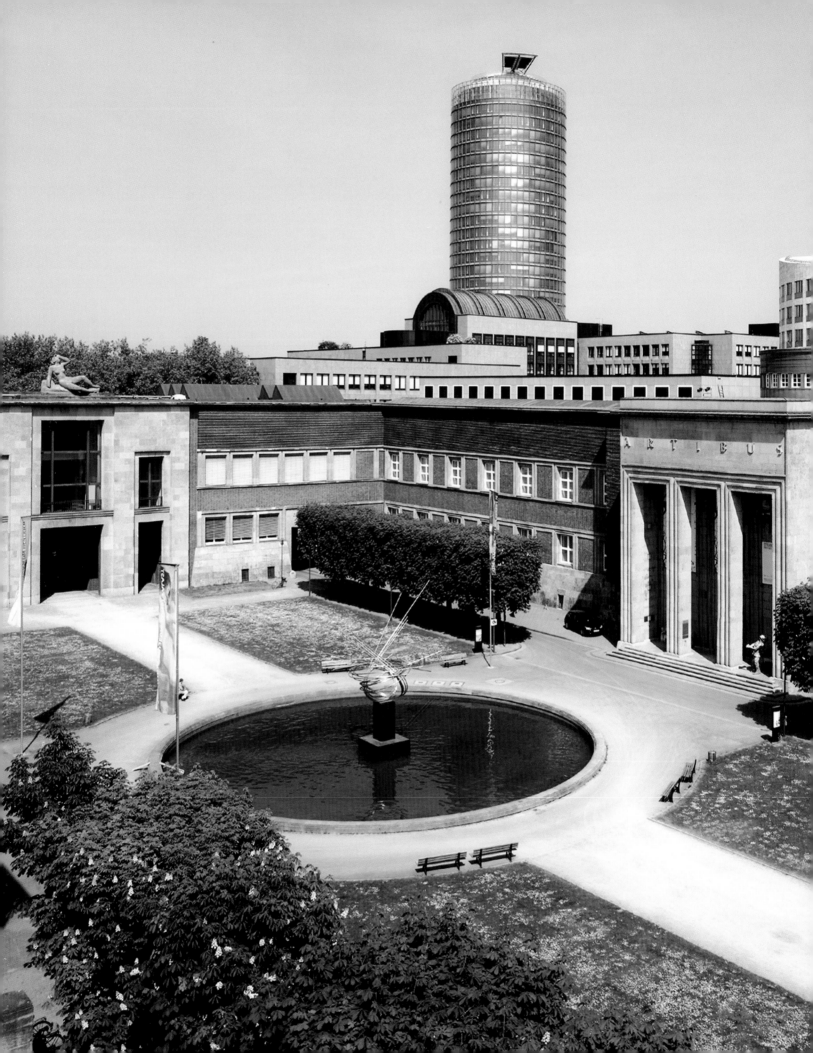

A unique presentation of French and Russian masterpieces from Moscow and St Petersburg, this exhibition is both a salute to a European nation with a great artistic heritage, and a rare encounter between two cultures. In a concerted effort unrivalled for many years, the four premier museums of Moscow and St Petersburg — the Hermitage, the State Russian Museum, the Pushkin Museum and the Tretyakov Gallery — have lent 130 of their finest paintings by Russian and French artists from the beginning of the modern era. Some of these works have never been displayed before.

The exhibition reveals the multi-faceted, tightly interwoven tradition shared by Russia and the West. As it examines the intense mutual cross-fertilisation that took place between artists, the selection highlights influences and interesting parallel developments that took place in Russian and French painting, and furnishes proof of the fascination with Picasso, Cézanne and Matisse that existed among the art-collecting élite in Russia. For many years *The Dance* (1909–10), one of Matisse's major works, adorned the Moscow mansion of the Russian textile merchant and art collector Sergei Shchukin, who had commissioned it. Evidently, a flourishing international art scene is not a phenomenon limited to our own time.

As principal sponsor, and drawing on its long-term relationship with Russia, E.ON has been instrumental in ensuring the delivery of this unique exhibition, which coincides with the delivery of the 500 billionth cubic metre of Russian gas to E.ON Ruhrgas. We are delighted that our long and dependable interaction with Russia in the field of energy supply is now paralleled in the art world.

Following the showing at the museum kunst palast in Düsseldorf, "From Russia" moves to its only other venue, the Royal Academy of Arts in London. We are extremely pleased that E.ON UK is helping to showcase this exhibition in the United Kingdom.

Last, but not least, we hope that "From Russia" will not only create an aesthetic experience for the viewer, but also communicate the importance of cultural interchange between nations.

Wulf H. Bernotat
Chairman of the Board of Management and CEO of E.ON AG

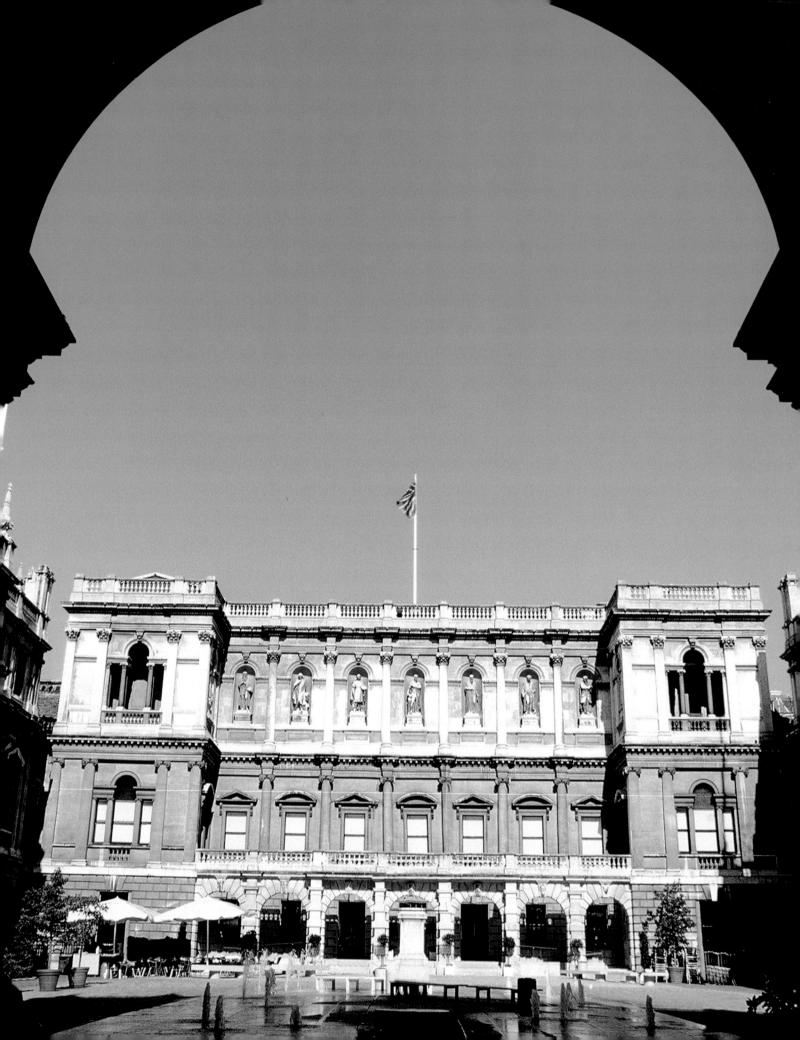

"From Russia" promises to be one of the most remarkable exhibitions to be staged by the Royal Academy in recent years. When Achim Middelschulte visited three years ago and suggested that, with the museum kunst palast in Düsseldorf, the Royal Academy might participate in an exhibition that would consist of masterpieces of Russian and French painting from the State Pushkin Museum and the State Tretyakov Gallery in Moscow and the State Hermitage Museum and the State Russian Museum in St Petersburg, we were all gripped with excitement.

At the heart of "From Russia" are some forty masterpieces acquired at the beginning of the last century by Sergei Shchukin and Ivan Morozov, two legendary and extraordinary collectors by any international standards. These paintings have never been seen in Great Britain before. We felt that the chance of showing Henri Matisse's legendary masterpiece *The Dance* of 1910 at the Royal Academy was an opportunity not to be missed. But there was more — namely a group of great Russian paintings from the late nineteenth century and, above all, some works representing the kaleidoscope of great art produced by Russian artists from the period 1900–25, culminating in Kazimir Malevich's famous *Black Square*, *Black Circle* and *Black Cross*, themselves prescient of so many developments in art later in the twentieth century.

Many individuals in Russia, Germany and Great Britain pulled together to make "From Russia" possible. Sir Norman Rosenthal and Ann Dumas curated the exhibition both in Düsseldorf and in London. MaryAnne Stevens, formerly Acting Secretary of the Royal Academy, and Charles Saumarez Smith, our current Secretary and Chief Executive, have been actively engaged in the negotiations, together with Sir Norman Rosenthal, our Exhibitions Secretary.

In Germany, we are above all indebted to our friends at E.ON, Achim Middelschulte and Dorothee von Posadowsky, as well as their Chairman, Wulf Bernotat. We are also very grateful to E.ON UK and its Chief Executive, Paul Golby, for their support of the project. Whereas E.ON has a long tradition of supporting the arts in Germany, this is E.ON's first entry into the cultural arena in the UK, the company having hitherto been a major supporter of football in this country. We hope that all concerned will find this a positive and stimulating experience.

Beat Wismern and Mattijs Visser, our colleagues at the museum kunst palast, Düsseldorf, have been very supportive throughout. Our grateful thanks go to them as well.

Our deepest debt, however, is to our many colleagues in the Russian museums for their co-operation and sage advice. We have learnt much from them, and would particularly like to thank Mme Irina Antonova and Mme Tatyana Potapova at the State Pushkin Museum; Mikhail Piotrovsky and Albert Kostenevich at the State Hermitage Museum; Valentin Rodinov, Mme Lydia Iovleva and Mme Tatyana Gubanova at the State Tretyakov Gallery; and Vladimir Gusyev and Mme Yevgenia Petrova at the State Russian Museum.

This handsome exhibition catalogue has been organised by Palace Editions Europe and its publisher, Joseph Kiblitsky. We would like to acknowledge the work of the many catalogue authors, whose scholarship has contributed so much to our understanding of this fascinating subject.

Finally, the exhibition stands under the patronage of Vladimir Putin, President of the Russian Federation, and the Rt Hon. Gordon Brown MP, Prime Minister of the United Kingdom of Great Britain and Northern Ireland. Our former Prime Minister, Tony Blair, lent his support at a decisive moment in the negotiations, and for that we are most grateful.

We like to think that "From Russia" will come as a great revelation to the British public and will contribute to further growth in understanding at the deepest level between Russia and the United Kingdom.

Burlington House,
Piccadilly, home of the
Royal Academy of Arts

Sir Nicholas Grimshaw CBE
President, Royal Academy of Arts

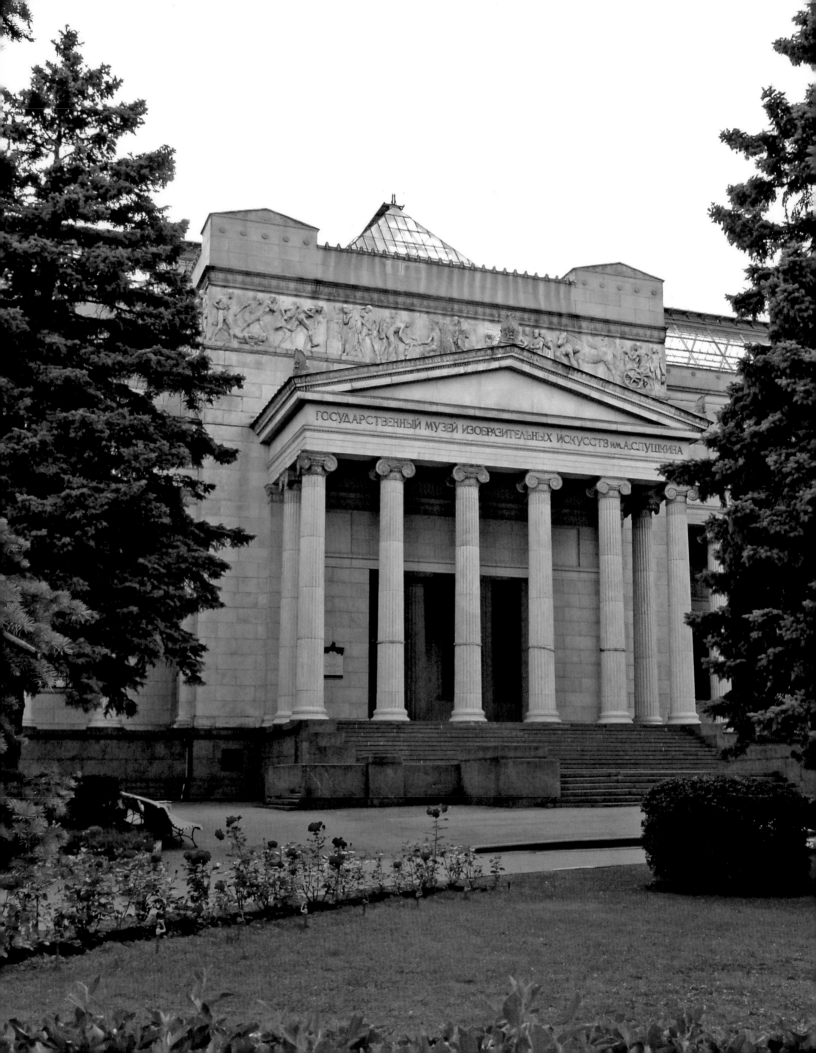

The Pushkin Museum of Fine Arts

The participation of the Pushkin Museum of Fine Arts in an exhibition devoted to the artistic dialogue between Russia and France is logical, inasmuch as the museum contains one of the finest collections in the world of turn of the 20th century French art. It was this that enabled the museum to organise one of the most innovative, substantial and large-scale exhibitions of the 20th century, "Moscow — Paris. 1900–1930".

Moscow's role in the formation of the Russian avant-garde art movement at the beginning of the 20th century was enormous. The city produced the two great collectors Sergei Shchukin and Ivan Morozov, whose efforts resulted in the creation of astoundingly high-quality collections of contemporary French masters, none of whom were considered "museum-worthy" in Russia or even in their native France. How did this happen? There were many reasons. The main one, of course, was the two men's "collector's genius", their ability to attune themselves to the Zeitgeist. Historically, Russia at that period was at the epicentre of a global shift away from aristocratic government. Powerful seismic jolts signalling major changes to come were occurring with ever greater force. In the collecting sphere, this allowed Moscow patrons of the arts to be freer and more independent of Imperial tastes.

The fate of the Shchukin and Morozov collections turned out to be dramatic, like the age which gave birth to them. Documentary evidence bears eloquent witness to this. In 1918, the collections were appropriated by the state under decrees signed by Lenin. Shchukin's collection was singled out as "an exclusive collection of great European masters, mainly French, of the late 19th and early 20th centuries." In 1922, both collections were united into a single Museum of New Western Art.

In March 1948, however, the museum was liquidated by a resolution signed by Stalin, on the grounds of its being a "breeding ground of formalist views and obsequiousness before decadent bourgeois culture." This was one of the totalitarian regime's gravest crimes in the area of artistic policy, for it destroyed the historical context of the museums' creation as institutions of culture.

By will of fate, the A. S. Pushkin Museum of Fine Arts inherited part of the liquidated museum's collection; over the course of the following years, it made a significant contribution to educating viewers about its collections and their scholarly significance. Today, the collection of the former Museum of New Western Art is housed in a separate building, and a catalogue of all its holdings has been issued in both Russian and English.

In our day, Russia is undergoing important changes in all areas of life. Among other things, we are witnessing an impressive restoration of unjustly neglected and damaged architectural monuments along with the rehabilitation of the memories of great artists, writers and composers.

We continue to hope for a restoration of the remarkable Museum of New Western Art in Moscow, which made a unique contribution to the development of world artistic culture and to defining the important place of Russian art therein.

Irina Antonova
Director of the Pushkin Museum of Fine Arts

The Tretyakov Gallery

The Tretyakov Gallery in Moscow and the Russian Museum in St Petersburg are the two major museums of Russian national art in Russia. Founded in 1856 by Moscow merchant and industrialist Pavel Tretyakov, the Tretyakov Gallery soon became one of Russia's most popular museums. It remains so today, a century and a half later. It would be no exaggeration to say that every inhabitant of Russia, and many a foreigner as well, is in one way or another familiar with the name "Tretyakov Gallery"; the one and a half million visitors who come to the museum every year bear witness to this fact.

Pavel Tretyakov (1832–1898) was an outstanding collector and a great patriot. The veritable life's credo of this man, one of the richest entrepreneurs of the late 19th century, is now widely known: "My desire from my very youngest years was to grow rich in order to give what I had taken from society back to society (the people) in the form of some sort of useful institution; that thought never left me over the whole course of my life."

For more than forty years, beginning in 1856, Tretyakov bought all (or nearly all) the best things which appeared in Russian art in their time. Though he clearly favoured Russian Realism and the Wanderers, he did not neglect Russian artworks of previous epochs — from the 18th and first half of the 19th centuries. Finally, at the end of the collector's life, artefacts of medieval Russia in the form of several dozen icons made their appearance in the Tretyakov Gallery, along with works by young Impressionist painters, Symbolists and others — those, in other words, who based their artistic conception on the denial of the realistic principles of the Wanderers. In this way, we see how Tretyakov conceived of and formed the gallery's collection to reflect the dynamic and forward-moving historical development of Russian national art.

In 1892, Pavel Tretyakov bequeathed his gallery, including the building on Lavrushinsky Lane specially constructed just for displaying pictures, to the City of Moscow, a gesture which was met in Russia with enormous enthusiasm. After this, many Moscow collectors, including Sergei Shchukin and Ivan Morozov, set out to follow in the footsteps of Pavel Mikhailovich Tretyakov, whom they deeply respected.

Today, the collections of the Tretyakov Gallery are tens to hundreds of times bigger than those of Tretyakov and his successors. A huge collection of 20th-century (and now 21st-century) Russian painting, graphic arts and sculpture has appeared in the gallery. New, spacious exhibition halls and storage facilities, and all those things no modern museum can do without — exhibition spaces, lecture halls, a children's education centre, and so on — have also made their appearance. The gallery carries out enormous exhibition, research, publishing and educational work. One can say with complete confidence that today not a single major showing of Russian art in Russia or abroad takes place without the participation of the Tretyakov Gallery, including the current Düsseldorf–London exhibition which we have the honour of introducing and welcoming.

Valentin Rodionov
General Director of the State Tretyakov Gallery

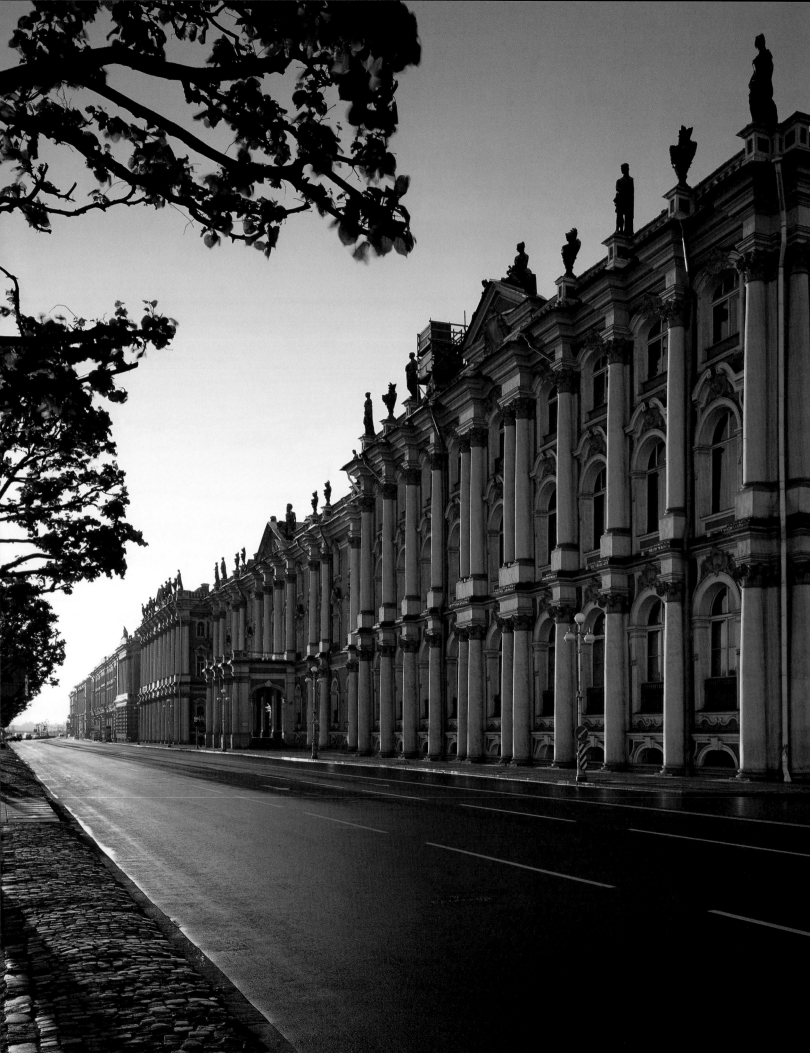

The Hermitage

Moscow collectors acquired their first French Impressionist pictures at the end of the 19th century. The Shchukin and Morozov brothers, not only successful entrepreneurs but men of refined artistic knowledge and taste, were able in just a few years to put together collections which became true museums of contemporary art.

After the revolution, their collections were nationalised and transferred to state museums. At the end of the 1920s, when the Soviet Union began to solve the problem of redistribution of art objects in a new way, the Hermitage transferred a large number of Old Master paintings to Moscow. In exchange, Moscow offered the Hermitage around 80 canvases of French painters from the former collections of Shchukin and Morozov. In 1948, the Museum of New Western Art in Moscow (GMNZI) was closed, its collections divided between the Hermitage and the Pushkin Museum in Moscow. Since the GMNZI was closed under the pretext of the ideological battle against formalism, the Hermitage was unable at first to display the works of Matisse, Picasso and other masters it had just received.

Only in the middle of the 1950s did the museum begin gradually to exhibit some of the pictures — first the Impressionists and Cézanne, then Gauguin, Van Gogh and onward, so that by the beginning of the 1960s everything which had been transferred from Moscow to the Hermitage was on proper display in the exhibition halls of the Winter Palace. While Shchukin's approximately 250 paintings were hung edge to edge and covered the walls of his medium-sized mansion from floor to ceiling, the late 19th and early 20th-century display at the Hermitage was organised according to modern museum principles. Thus *The Dance* and *Music* which Matisse created for Shchukin were displayed in his house, where it was impossible to stand back sufficiently to view them properly; in the spacious halls of the Hermitage, however, they became, along with the works of Leonardo and Rembrandt, among the museum's most celebrated masterpieces.

In recent years, the Hermitage has been carrying out work on a major project for a museum of the 19th through 21st centuries in the nearby General Staff Building, where a Shchukin and Morozov gallery will occupy a central place. In this new exhibition space, the problems of exhibiting and preserving the unique works will be solved using the most advanced contemporary methods.

Mikhail Piotrovsky
Director of the Hermitage

Art museums might be compared with gigantic theatres and their halls with stages on which grandiose dramas unfold, whose acts are measured in centuries. Every age, every epoch has its favourite motifs, its own melodies and characteristic movements, and its own understanding of space. Learning to distinguish and understand them means discovering for oneself and gaining access to the enormous spiritual riches amassed by the peoples and countries of the world. This is precisely what brings people to museums: the possibility of overcoming the invisible barrier of time, of making a pilgrimage to the sources of one's own unique and inimitable life, of coming face to face with one's personal and common past, and of feeling a sense of participation in the history of one's country and world civilisation as a whole.

Our museum is a museum of Russian art. Artists who worked and lived in Russia from the 10th century until the present day are exclusively exhibited within its walls. It contains the largest collection in the world of Russian artworks, in which practically all art forms, genres, styles, schools and tendencies are represented — around 400,000 exhibits in all. There is no other collection in the world like it. So comprehensive is this collection that one feels as if one is turning over the pages of Russian history as one wanders through the halls of the museum.

At this exhibition, we have offered you several such pages from one of the brightest and at the same time possibly most tragic and catastrophic periods of that history: the end of the 19th and beginning of the 20th centuries. This was a time when the former idyllic calm, balance and stasis of Russia's society, artistic life and artworks were lost — maybe forever?

However, art became neither worse nor better as a result. It simply changed, reflecting the changes in the way that people viewed the world. It became what it necessarily had to be. There is nothing new in this. Art has always developed and moved within the eternal dichotomy of two extremes — the creation of strict laws and their complete destruction. From the icon to the *Black Square* by Malevich, the artist who became the leader of a new movement in art known as the Russian avant-garde.

This movement united artists who defined themselves as destroyers, who renounced everything created before them: all accustomed rules, aesthetic laws, familiar forms and concepts. This short but extremely vivid and dramatic period in the history of the development of the Russian visual arts lasted for the first third of the 20th century.

The world's largest collection of Russian avant-garde works is the pride of the Russian Museum. Its uniqueness lies in the fact that its main part consists of hundreds of works selected in Petrograd in 1921 by the avant-garde artists themselves in an attempt to create a completely new Museum of Artistic Culture in the midst of the revolutionary transformations taking place then. The collection they put together was transferred to the Russian Museum in 1926. In effect, this was an unprecedented attempt at self-identification on the part of a large group of artists united by common ideological and aesthetic principles; they significantly influenced the further course of development of not only Russian art, but European and world art, too.

Vladimir Gusyev
Director of the State Russian Museum

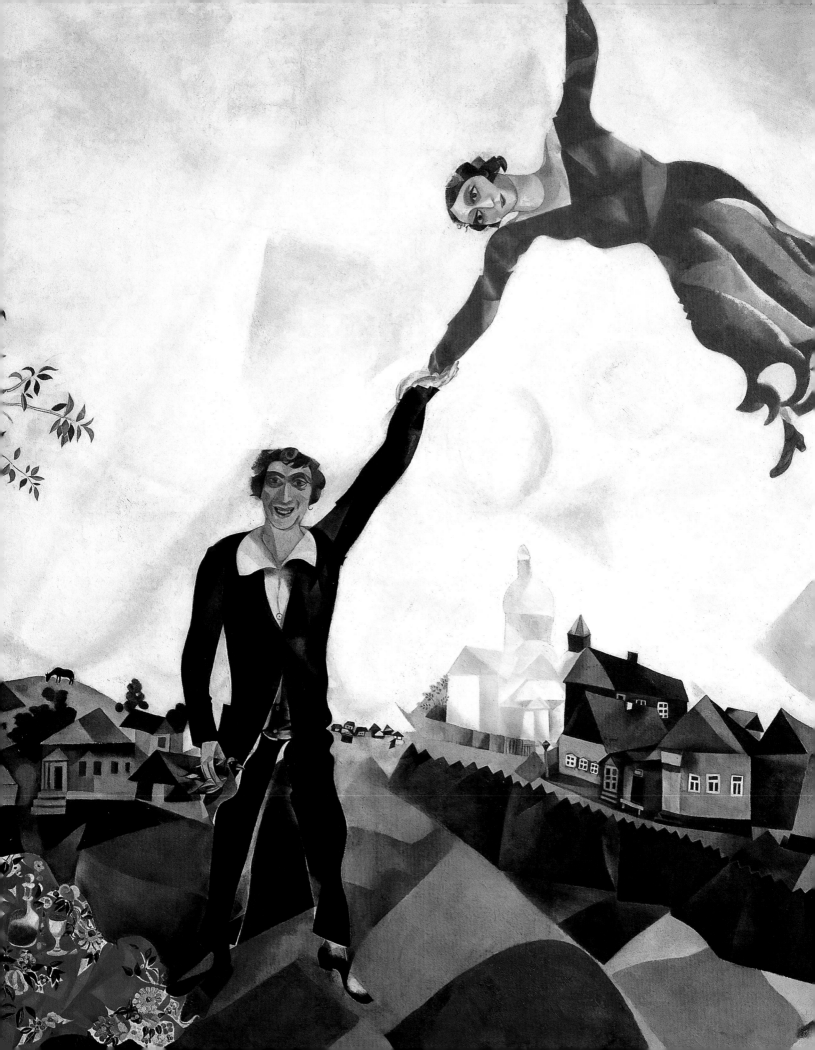

Curators' Preface

This exhibition presents 120 paintings by Russian and French artists active at the end of the 19th century and the beginning of the 20th who have emerged as the greatest pioneers of the main directions of modern art. All the paintings have been lent by the four principal Russian museums: the State Pushkin Museum and the State Tretyakov Gallery in Moscow and the State Hermitage Museum and the State Russian Museum in St Petersburg. For the first time, works from these museums have been gathered for a single exhibition. The aim of the exhibition is to demonstrate the remarkable story in the history of modern art, the intersecting paths from Impressionism and Realism to Abstract painting, told by these masterpieces from Russia and France.

These four great museums are a testimony to the glorious history of Russian collecting. The State Russian Museum was established in St Petersburg in 1895 by Tsar Nicholas II to commemorate his father, Alexander III. Its comprehensive collections encompass the history of Russian art from medieval icons to the avant-garde. In Moscow, Pavel Tretyakov, a wealthy merchant and textile-mill owner, assembled an extensive collection of Russian art, with a particular emphasis on nineteenth-century Realists connected with the "Wanderers" movement and on portraits of eminent Russians in the world of culture and art. His collection, together with that of his brother Sergei, was donated to the city in 1892. The holdings of both the State Russian Museum and the State Tretyakov Gallery were expanded by the addition of works from private collections that were nationalised after the 1917 revolution. The incomparably rich collections of the State Hermitage Museum in St Petersburg are the legacy of Catherine the Great who, in the mid-eighteenth century, purchased hundreds of works of art from all over Europe, many of them masterpieces. The State Pushkin Museum, which opened in Moscow in 1912, was originally the creation of Ivan Tsvetaev, a professor of the theory and history of art at Moscow University. The collections of both the State Hermitage Museum and the State Pushkin Museum were immeasurably enriched with outstanding Impressionist paintings by Degas, Monet and Renoir, and splendid works by Gauguin, Cézanne, Van Gogh, Matisse and Picasso, from the collections of the progressive merchant patrons Sergei Shchukin and Ivan Morozov.

Russia has always been a country of explosive contradictions. On the one hand always fiercely independent, she has been open to the culture of the West since the time of Peter the Great. France was a key influence; indeed at the court of Catherine the Great French was the language of the elite. Although European neoclassicism had dominated the Russian visual arts throughout the eighteenth and early nineteenth centuries, as the nineteenth century advanced this admiration for Western culture began to be replaced by a growing and powerful sense of national identity — of Russianness. Russian musicians, writers and artists turned increasingly to their own long cultural tradition for inspiration, although many were still responsive to the lure of the West. This dichotomy is apparent throughout all the arts in Russia in the nineteenth century. In the world of music, The Mighty Five — Cui, Mussorgsky, Rimsky-Korsakov, Balakirev and Borodin — rejected foreign influences as they sought to compose music inspired by Russian religious and folk music; and yet Tchaikovsky, who is known for the distinctively Russian character of his music, was especially open to the influence of the West. In the great nineteenth-century flowering of Russian literature, Turgenev, the friend of Flaubert, resisted the ideas of the slavophiles in favour of the influence of Western literature, while Tolstoy was intent on capturing the rich textures of Russian life with the greatest possible realism. These concerns were paralleled in painting by developments that led to the establishment of a truly Russian school. The group known as the Wanderers, initially dissidents who had bro-

ken away from the St Petersburg Academy and its emphasis on Western art, came to attract the leading artists of the day, among them Ilya Repin, Ivan Kramskoy, Isaac Levitan, Valentin Serov and Mikhail Nesterov. Their aim was to paint the Russian landscape and traditional peasant life, as well as scenes from Russian history, in a naturalistic style. Nevertheless, despite an assertively nationalist stance, several Russian realists, including even Repin himself, looked to the French tradition of naturalism exemplified by Jules Bastien-Lepage as well as to Barbizon painting and occasionally the Impressionists. The Russian Realists will be presented in the first section of the exhibition where their work will be explored in the context of relevant works by French artists.

French Impressionism and Post-Impressionism were profound influences upon the next generation of Russian artists. The two collections assembled by Morozov and Shchukin made an astonishing impact. Without doubt the most brilliant and daring Russian collectors of their day, these two Moscow textile merchants scoured Paris for paintings by the Impressionists, Monet, Renoir, Cézanne, Gauguin, Van Gogh, Matisse and Picasso with a passion matched only by a handful of collectors in the United States, Germany and France. Morozov was perhaps the more conservative of the two, but Shchukin acquired around a hundred works by Picasso, including key pieces from the Blue, Rose and Cubist periods. He became Matisse's great patron at a time when the artist was enjoying little commercial success, and commissioned the celebrated *Dance* as part of an astonishingly bold scheme to decorate the grand staircase of his Moscow mansion. *The Dance* will form the centrepiece of the second section of the exhibition which will present a remarkable selection of works that were once in Shchukin's and Morozov's collections.

Cross-currents between Russian and French art were particularly fertile in the early twentieth century. The third section of the exhibition will be devoted to the famous theatrical impresario and exhibition-maker Sergei Diaghilev, who was at the forefront of the World of Art movement, played a vital role not only in presenting modern French art in Russia but also in taking Russian art to the West, and especially to Paris where he caused a sensation with his revolutionary Ballets Russes.

Out of all this, something remarkable happened. From around 1910, the bold innovations of Mikhail Larionov and Natalia Goncharova opened the way to an extraordinary unfolding of developments in the visual arts that gathered momentum at an astonishing rate. This step forwards was certainly unprecedented in Russia and in its way resembles other great innovative periods in the history of European art, among them the Florentine Renaissance and the French Impressionist and Post-Impressionist movements. At first, Larionov and Goncharova fused the simplicity and decorative energy of Russian folk art with the influence of Cézanne and Post-Impressionism in the uniquely vigorous Neo-Impressionist style. Wassily Kandinsky, meanwhile, took the imagery of Russian fairy tales and combined it with Fauvist colour as a starting point for his daring steps towards abstraction, and Marc Chagall adapted elements of French Cubism to his highly individual and poetic distillation of Russian-Jewish folklore.

The final section of the exhibition will encompass this exhilarating kaleidoscope of rapidly succeeding innovations. Bold reinterpretations of Cubism, as well as Italian Futurism, resulted in the brilliant Cubo-Futurist works by Larionov, Goncharova, Ivan (Jean) Puni, Pavel Filonov and a remarkable group of experimental women artists including Olga Rozanova, Lyubov Popova and Alexandra Exter. Vladimir Tatlin's unique three-dimensional constructions heralded the advent of Constructivism. Suprematism, the radical, purely abstract style pioneered by Kazimir Malevich, is the culmination of these experiments. Malevich's celebrated *Black Square* seemed to reject all forms of pictorial tradition: the stark, blank canvas

was, on the face of it, an expression of aesthetic purity, and yet by hanging it across the corner of a room, as he did at the "0.10" exhibition in St Petersburg in 1915, Malevich referred to the domestic display of icons, thus evoking a religious and spiritual dimension that is uniquely Russian.

This exhibition enables the visitor to explore the fascinating interplay that existed between French and Russian art during fifty-five crucial years, 1870 to 1925, many of them witnesses to upheaval and revolution. Although modern French art was undoubtedly a touchstone throughout the period, the variety of ways in which so many Russian artists, both men and women, succeeded in fusing it with the extraordinary wealth of their own cultural heritage resulted in a wonderful flowering that changed the course of modern art.

Ann Dumas and Sir Norman Rosenthal

FRANCE

RUSSIA–FRANCE
A Meeting at the Crossroads

In August 1834, *The Last Day of Pompeii* arrived at last in St Petersburg. Rumours of the painting had already reached the capital, and now it was to be exhibited at the Hermitage. [1] The picture created a joyous furor: Who else among Russian painters could boast such sweep and dazzling effects? The work's author, Karl Briullov, a son of French immigrants born and educated in St Petersburg, had laboured over his colossus for several years in Rome. Art lovers flocked to his studio, and Walter Scott himself had declared *Pompeii* "not a painting, but an epic". The painting's loud reputation impelled the artist to show his "epic" at the annual Paris Salon before its appearance in Petersburg.

For centuries, European artworks had moved in a West-East direction — most intensively during the age of Catherine the Great, when the pro-French orientation of Russian cultural, fashion and society life reached its peak. In reversing this movement, Russia was offering the West the first proof of what she had achieved. Paris awarded the painting a big gold medal, though the success here was more modest than in Italy, and all the more so in Russia. French critics reacted more restrainedly to Briullov's sensational effects, finding in them signs of a "theatrical manner" [2] whose novelty for them had long since worn off.

Briullov's picture would continue to be regarded for a long time as a milestone in Russian painting. In 1899, the hundredth anniversary of Briullov's birth, Ilya Repin and Vladimir Makovsky praised the work. They were speaking not only in the name of the Academy of Fine Arts, but as members of the Society of Travelling Exhibitions, which, in one of fate's ironies, had arisen as a protest against academic art. Thus, idealism and Realism, so recently enemies, now enjoyed a harmonious co-existence. This should not surprise us, however. In Russia, as in Western Europe, realism was in decline, its leaders failing to keep up with the accelerating pace of artistic development.

Four decades earlier, Ivan Turgenev had written to critic Pavel Annenkov from Rome: "…I got into a terrible row with our artists here. Can you imagine, it's as if all of them (practically without exception — excluding Ivanov, of course) are hung by their tongues; they keep mindlessly babbling one name over and over: Briullov, and they're calling all other painters from Raphael onwards idiots… Finally I declared to them that our art will begin the day Briullov is buried, just as Marlinsky was." [3]

Echoes of the battle between academic and realistic art which had begun earlier in France, were being heard in Russia too, but in each country the grounds for the antagonisms were different. Perspicacious Annenkov, a friend of Gogol to whom the latter had dictated the first volume of *Dead Souls*, a man who had travelled much in Europe, noted the characteristic features of the "new French school" in his overview of the 1847 Paris Salon: "Many of its leaders either didn't send their pictures or were ignominiously dismissed by the jury, which as we know consisted of academicians. Decamps, Rousseau and Cabat weren't given the honour of exhibiting their works, but from those who were allowed, like Delacroix, Couture, Corot and Díaz, we can see well the direction this school is taking and its recent burgeoning development. They were showered with accusations by those who consider such phenomena to be the latest sign of the fall of art and congratulated fervently by others who on the contrary see in it the dawn of something new and art's true path of development." [4]

Russian Realism had not come into its strength yet, still lacked immunity to the formulae of the academicians, but Annenkov had already found an example of movement in the right direction in contemporary French painting. "It's the only art in Europe which speaks with its own voice, without prompting from one or another school or approval by an academy or some important person. Only it is sincere, only it is working in the strictest sense of the word — that is, seeking out the basis on which the artist can be a truly

[1] In 1835 the picture was transferred to the Academy of Fine Arts, from where it returned to the Hermitage in 1851. Toward the end of the century, it was transferred to the newly-created Russian Museum and became its most famous exhibit.

[2] Apparently they did not know, or were not interested in the fact, that Briullov conceived his painting under the impression of Giovanni Pacini's opera *The Last Day of Pompeii*.

[3] Late 1857. P. V. Annenkov. *Literaturnye vospominaniya*. Moscow, 1960, p. 416. He is referring to the withering criticism to which Vissarion Belinsky subjected Alexander Bestuzhev-Marlinsky for his stilted romanticism.

[4] P. V. Annenkov. *Parizhskie pis'ma*. Moscow, 1983, p. 117.

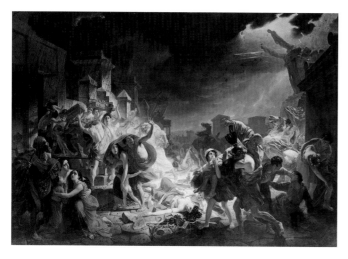

Karl Briullov. The Last Day of Pompeii. 1833. Russ. Mus.

5 Ibid. p. 126.
6 P. M. Tretyakov's letter of bequest. 17 (29) May 1860. State Tretyakov Gallery. *Ocherki istorii. 1856–1917*. Leningrad, 1981, p. 301.

36

useful and necessary part of society's development. You have already noticed contemporary French art's rejection of all the hidebound ideas and musty explanations traditionally foisted upon artists, its restless pursuit of the varied phenomena of nature and the spirit, and its irrepressible curiosity. It is the child of its age, both in the daring of its undertakings and the depth of its failures."[5]

Sharing much with Annenkov in matters of artistic taste was his younger contemporary Count Nikolai Alexandrovich Kushelev-Bezborodko (1834–1862), the major Russian collector of the mid-19th century. He had inherited an enormous fortune as a very young man, along with part of a collection of Old Master paintings acquired by his father, Chancellor of Ekaterinburg Alexander Andreyevich Bezborodko. Now he was aiming to expand the collection with works of contemporary art. Destined to live only a short life, he nonetheless managed in little more than five years to put together a true museum in which works of French masters set the tone. Many salon-academic canvases entered his Petersburg collection — by Delaroche, Gérôme, Bouguereau and Meissonier — however, it is not these, but the pictures of the Romantics and Realists which comprise the main virtue of the collection, which would later enter the Hermitage. Relying only on his own taste and knowledge, Kushelev-Bezborodko brought into the country works by Delacroix, Decan, Courbet, Millet, Theodore Rousseau, Dupré, Daubigny, Díaz and Corot — this at a time when their art was not universally recognised and often subject to fierce attacks by critics. Kushelev's gallery, which the count bequeathed to the Petersburg Academy of Fine Arts, remained for several decades the main place where viewers could acquaint themselves with the new French painting. Though over the course of time the novelty of their work naturally wore off, Delacroix, Corot, Millet and the Barbizon School remained a starting point for the establishment of many a young Russian artist over the last third of the 19th century.

After Kushelev-Bezborodko's death, no other collectors of his stature would appear in Petersburg. Leadership passed to Moscow, where a handful of real patrons of the arts from the merchant-industrialist class was coming to the fore. It is impossible to overestimate the significance of the gallery created by the Tretyakov brothers. At the very beginning of his collecting career, Pavel Mikhailovich Tretyakov made a will bestowing the majority of his fortune for the "creation of an art museum or public picture gallery in Moscow".[6] During his life, he dedicated all his energies to Russian art, while his younger brother Sergei focused on European art.

Though born the same year as Kushelev-Bezborodko, Sergei Tretyakov (1834–1892) began his collecting career significantly later. The difference between the two was that the former considered himself an active player in the art world, while the latter remained merely a collector. From its creation, Kushelev's gallery became a catalyst for artistic development, but two decades later pictures in this style were not being received with the former enthusiasm. A superb eye made Tretyakov the owner of many splendid canvases, from Géricault and Delacroix to Corot. Works of the Barbizon School, a step ahead of the rest of Europe in their realistic mastering of landscape, were favourites of both the Moscow collector and his Petersburg counterpart. This was the situation at mid-century, when Kushelev was still alive. With the arrival of the Impressionists, however, everything changed; now they replaced the Barbizons as the latest word in art. Sergei Tretyakov knew about the Impressionists, of course, but he could only muster the courage to buy works of their most moderate imitators such as Heilbuth, Loir and Bastien-Lepage. So it was not a work of Manet, but Jean-Paul Laurens' *Last Moments of Emperor Maximilian*, with its scrupulous finish and theatrical *mise en scéne*, which now graced the Tretyakov Gallery. [7]

The gallery was created at the turn of the 1860s, an extremely important decade in Russian history, and the starting point for this exhibition. Defeat in the Crimean War capping the age of Nicholas I, the enthronement of Alexander II, the abolition of serfdom in 1861 and simultaneous appearance of the "Land and Will" revolutionary organisation — everything indicated that deep shifts in the consciousness of the people were taking place. This was a time of radical reforms: of land ownership, schools and the judicial system. For the first time, the government deemed it necessary to inform the populace about the national budget. These were years of peace, in short, years which seemed to promise prosperity. The empire waged no wars, if we do not count its gradual expansion into Central Asia.

In France things were much different. Forty years after the Russian army's entrance into Paris, the country was tasting the sweetness of *revanche* resulting from victory in the Crimean War. The Second Empire's authority was on the rise on the Continent, and a relative calm reigned in its domestic politics. A series of cataclysms was soon to strike, however: the failure of Napoleon III's policies, the humiliating invasion of Prussian troops, the siege of Paris, the Commune, the loss of Lorraine, and the proclamation of the Third Republic.

Large but dissimilar shifts were occurring in the cultural lives of both countries. A deep and long-awaited investigation into fundamental problems of society and the individual leads in the beginning of the 1860s to a mighty upsurge in Russian literature. Turgenev published *On the Eve* and *Fathers and Sons*; Dostoyevsky, *The House of the Dead* and *The Insulted and the Injured*; Leskov, the anti-nihilist novel *Nowhere*; Nekrasov, *Who Is Happy in Russia*; and Leo Tolstoy begins *War and Peace*. No country in history had ever known such an amazing breakthrough in literature, occurring in such a short time. Seminal events were taking place in music: the society of composers known as the "Mighty Handful" (Balakirev, Borodin, Mussorgsky, Rimsky-Korsakov and Cui) was formed, and Anton Rubinstein founded the first conservatory in St Petersburg. Victories on the painting front were much more modest, however. Ivan Kramskoi recalled that in the beginning of the 1860s "there was an extraordinary number of young upshoots… but they all seem to have wilted after sprouting." [8]

Though France had fewer musical and literary accomplishments, the opposite was true for painting. In 1860, Ingres and Delacroix were still active, and the future Impressionists, those who were destined to bring about a revolution changing the course of world art, had already made their appearance. That year

[7] The pictures by Heilbuth and Laurens are now in the Hermitage; those by Loir and Bastien-Lepage are in the Pushkin Museum in Moscow.

[8] *Kramskoi ob iskusstve*. Moscow, 1960, p. 150.

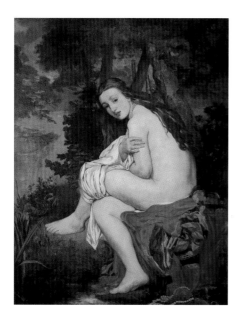

Edouard Manet. Nymph Caught Unawares
National Museum of the Visual Arts
in Buenos Aires

[9] Now in the National Museum of the Visual Arts in Buenos Aires. At the Petersburg exhibition the picture figured under the name *Nymph and Satyr*. It did not tempt anyone, though it hardly could have cost much. We know the price of the exhibition's most expensive exhibit: 1500 roubles for Jacobi's *Prisoners' Rest*.

[10] F. M. Dostoyevsky. *Vystavka v Akademii khudozhestv za 1860–1861 god. Polnoe sobranie sochineniy*. Leningrad, 1979, Vol. 19, p. 157. The article was published with no signature and attributed to Dostoyevsky only many years after his death.

Manet took the lead as the most promising embodiment of the new trend by painting his first masterpiece, *The Guitar Player*. Degas was at work on *The Bellelli Family*, the best group portrait of the century. Twelve year-old Renoir decided to become a real artist and requested permission to work in the Louvre as a copyist. Claude Monet, still unaware that he was to become the greatest landscapist of the epoch, was mastering the fundamentals of the human figure.

Over the course of the decade, a series of masterpieces would emerge from the easels of Manet and Degas, signalling a new understanding of colour and form. Monet, in *Women in the Garden* and *Luncheon on the Grass*, achieved the height of realism in painting, taking it to the boundaries of Impressionism. Alongside him, in his *Grenouillère* series, Renoir was mastering the techniques of light, colour and motion no less successfully. Cézanne, in his portraits and *Girl at the Piano*, began working out the principles of composition and control of colour which would impact the development of all European art three to four decades later.

In painting, the Russian and the French realms were remote from each other not only geographically but ideologically, too; they were independent worlds. The leading lights of French art paid only rare visits to Russia. In 1876, Carolus-Duran arrived in St Petersburg — to the dismay and envy of local painters — to paint for a very high fee the portrait of Nadezhda Polovtsova, foster daughter of Baron Stieglitz, one of Russia's richest men. On the other hand, more Russians were travelling to Paris, and they were travelling more often.

In the reform era it became significantly easier for residents of the Russian Empire to cross the border than it had been under Nicholas I; the results of this new situation began to make themselves felt by the 1870s and 1880s. It is worth noting that the Academy of Fine Arts' most successful graduates were now drawn to France, rather than Italy as they had been before. This was undoubtedly the result of changes taking place in art in general, of the supplanting of Romanticism by Realism. In 1862, the Art Academy sent Perov to Paris on a stipend, although he did return earlier than planned. Two years later Vereshchagin went there to work with Gérôme. In the 1870s, Polenov, Repin, Savitsky and Vasnetsov were all in Paris working on Academy stipends. In later years these numbers would increase further.

Though few French painters were attracted to Russia, their pictures found their way there little by little, beginning in the 1860s. In 1861, the Petersburg Academy held its annual exhibition. Among the works on sale and display were not only Russian but foreign ones, including Manet's *Nymph Caught Unawares*.[9] The mythological justification of nudity did not save the French painter in Petersburg, however, and the picture was subjected to harsh attacks, most notably from Fyodor Dostoyevsky, who had been allowed to settle once again in the capital after his Siberian exile and military duty. "Horrible, horrible, horrible!" exclaimed the writer indignantly, excoriating "Mr. Manet from Paris". "The last picture was shown, of course, with the intent of proving what hideousness the artist's imagination is capable of; he is painted the most vapid thing, and given the nymph the colouration of a five day-old corpse."[10]

It would be a mistake to regard Dostoyevsky's outburst as just a bout of personal annoyance. Other critics were no kinder. The main reason lay in the nude genre itself, long consid-

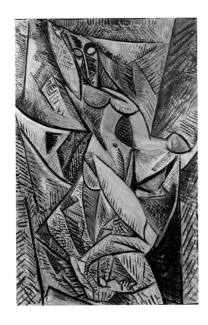

Pablo Picasso
Dance of the Veils. 1907. Herm.

ered suspect in Russia. Fundamentally incompatible with the Orthodox mentality, it remained practically undeveloped until Serov and Kustodiev. Later, though the Soviet regime would attempt to do away with Orthodox Christianity, it nonetheless inherited from it an ingrained distaste for depictions of nakedness, as harmful to the maintenance of high moral standards. In France, of course, no one challenged the genre's right to existence. The harsh criticism levelled at Manet at his Paris exhibitions — which he himself helped to provoke, be it by his *Olympia* or *Le Déjeuner sur l'Herbe* — was aroused not by the fact of any public display of nudity, but by the artist's violation of accepted aesthetic norms. By today's standards these violations were not even very radical, nowhere near the Olympia-Venuses of Larionov, executed in the spirit of amateur art.

Perhaps Manet was simply unaware of the moral climate of an unfamiliar country when he sent his picture to Petersburg, but the most interesting thing is that a shift in Russian tastes and loosening of moral taboos actually did occur. In the mid-19th century, treacly "bathers" by Neff enjoyed a certain demand, but they were painted from Italian models and fully satisfied the impersonal standards of "lovely nudity". Dostoyevsky probably would not have taken these seriously enough to get upset about them, but the Manet painting offended him, since his notions of propriety in depicting the nude female body were drawn from classical art. Before taking Manet to task, he wrote in that same article: "There is nothing more splendid than a splendid body." [11] In other words, like the rest of society, the writer maintained loyalty to an abstract ideal of beauty.

If we move ahead half a century and examine the activities of Sergei Shchukin, who challenged the norms of his native merchant-industrial milieu by his purchases of French pictures, it will be no exaggeration to say that it was the very inflexibility of that milieu which sometimes hinted at ways to overcome long-lived prejudices, that invisible *genius loci*. Up until the latter years of his collecting career, Shchukin, for all his boldness, had avoided pictures of unclothed figures, the sole exception being Gauguin (*Her Name is Vairaumati, Are You Jealous?* and *The King's Wife*). Gauguin was less risky, for this artist was depicting a non-European, or more accurately, anti-European reality in his canvases — a fairy-tale world re-created in a two-dimensional style reminiscent of the old Russian icons dear to Shchukin's heart.

Possessing a true collector's love of risk more than any of his contemporaries, Shchukin nonetheless hesitated before granting Matisse's enormous murals *The Dance* and *Music* admission into his gallery. Doing so was something akin to a leap over the abyss. His doubts were fuelled above all by the pictures' belonging to the nude genre, against which Russian society was ever on its guard. Once he overcame this barrier in social ethics and aesthetics, however, the Moscow collector was able to forge ahead, acquiring the boldest and most expressive nudes by Picasso, *The Dance of the Veils, Woman Seated* and *Dryad* — pictures where the genre itself was subjected to the most merciless dissimilation.

[11] Ibid.

Though Russia was gradually becoming more open in the years of reform, it would take a long time before such rare occurrences as the showing of Manet's *Nymph Caught Unawares* would grow into a tradition of full-scale exhibitions of foreign works. The country was too racked by its own inner socio-political and economic problems to respond with interest to the impulses of foreign art, impulses which reflected not only a different, but alien reality.

The demands of this crisis period in Russian culture were ideally met by the creation of the Society of Travelling Exhibitions, the "Wanderers". The juries of the Paris Salons took a hard-line attitude towards creative innovation but were unprejudiced when it came to nationality. Though the Wanderers Society also seemed open-minded in this regard, all its members were nonetheless Russian artists engrossed, which was understandable, in purely national concerns and the burning Russian issues of the day. It would not have occurred to any of them to invite a foreigner into their club. In France, art was maximally centralised; everything was inevitably oriented around Paris. In Russia, on the other hand, mighty centrifugal forces were in play, and the art of the Wanderers was intended for showing not just in one city, but in both capitals and the provinces as well. The Society's 1870 founding charter declared the following goals: "a) to offer residents of the provinces the possibility of acquainting themselves with Russian art and following its development; b) to inculcate love for art in society; and c) to help artists sell their works." The third item bore witness to the Wanderers' businesslike, guild orientation, and presupposed above all the rights of national painters.

Russian art of the day was marked by extreme topicality and service to "progressive ideals". With great conscientiousness it focused on the life of the poorest segments of the population. If we place the works of the Wanderers produced in the early 1870s alongside those of the Impressionists produced at the same time, the differences are extreme, especially when it comes to choice of subject, a matter to which both the leaders of the Paris Salon and the Wanderers ascribed the utmost importance. However, this was the thing the Impressionists cared about least of all. The disparities are visible in other genres as well. The Wanderers were not drawn to the still life, a genre which "had too little to say", while the Impressionists turned to the genre often, though less often than the landscape. In this area a curious echoing of motives can often be observed.

The most well-known examples of Russian painting from the early 1870s can be found in school textbooks to this day. This is a selection of social and historical subjects, sometimes with a degree of allegorical meaning: Repin's *Barge Haulers on the Volga* (1870–73), Ghe's *Peter the Great Interrogates Tsarevich Alexei at Peterhof* (1871), Vereshchagin's *Apotheosis of War*, Myasoyedov's *The Officials' Lunch Break*, Kramskoi's *Christ in the Wilderness*, Konstantin Makovsky's *Children Running from a Thunderstorm* (1872), Perov's *A Meal in the Monastery* (1865–75), and Savitsky's *Repairing the Railroad* (1874). In these pictures, all painted with an accent on topicality and visual effect, the formal explorations are minimal (they would have been superfluous here), though the sympathy of the artists for their subjects is absolutely sincere.

The Impressionists' very first exhibition catalogue lists mainly landscapes. There are a few portraits. Figure compositions are clearly in the minority: Degas' ballet scenes, Renoir's *Loge*, Berthe Morisot's *The Cradle* and *Hide-and-Seek*, and Monet's *Luncheon*. There is no narration here, with its inner intrigues and characters. The majority of works resemble studies rather than finished works. Among the nearly 300 pictures there is no hint of any social concerns, or civil or patriotic unrest.

It is not easy to find points of contact between the art of the Wanderers and that of the Impressionists. Basically, we are faced with contrasting views on the purpose of art itself. In Russia, for example, no one painted "luncheons on the grass". Not so much because that combination of leisure with taking of nourishment was still not very widespread as because the Russian *intelligentsia's* aching conscience got in the way. The theme seemed petty and trivial. To devote a massive canvas of nearly 30 square metres to that subject, as Claude Monet had done — well, such a thing would have occurred to no one in Russia. For fairness' sake we could mention the only Russian "luncheon on the grass", Perov's *Hunters at Rest* (1871), but this is an example of another genre, where the luncheon situation is just a convenient pretext for a theatricalised anecdote. In other words, literature and story-telling were more important than visual motives, or overshadowed them in any case.

It is logical, therefore, that Russian painting preferred things more serious than Monet's and Renoir's *Grenouillère* bathers, and if a composition with figures and water was required, then what could be more appropriate than barge haulers? Instead of Impressionist haystacks in all the colours of the rainbow, next to which the presence of a human being would seem inappropriate and undesirable, we have the hard day labour of peasants in the field, with a haystack serving at best as an element of the background. Even if the haystack is chosen as the main motif, as with Levitan, it serves merely as a source of inexpressible melancholy. Instead of the holiday-like liveliness of a Paris station with its haze, puffs of steam and play of colours, we have insistently everyday scenes whose dramatic nature is underlined by their setting, say a station. Whether the train carriage is carrying army recruits or prisoners being taken to exile, any subject will do as long as the life of the people is inseparable from the dramatic intonation.

In French art, the cataclysms of the age were reflected indirectly, for the most part; in painting we see an increase in the number of battle and historical compositions, for example. However, there is no question of any sort of radical influence of politics and the public mood on official art, much less on that of the up-and-coming Impressionists. How should we regard such apoliticism? Positively or negatively? To put it simply, French aesthetics arrived earlier at the conclusion that the main thing in art is not direct reflection of socio-political events but something else, something outwardly less noticeable but more important. Russia, with her missionary demands from art, always struggled with this point of view. So where can we find a common denominator with which to approach two such disparate worlds? And how did they look to each other?

Let us imagine that not even at the moment of the Wanderers' and the Impressionists' appearance on the scene, but later, in the 1880s, Russia was to receive those foreign canvases considered at the time to be the last word in European painting. Whether they were academic works or realistic ones (by this time the boundary between the two schools was becoming more and more hazy), the reaction of both the general public and local opinion-makers would have been absolutely predictable. They would have voiced a certain satisfaction to the effect that "we can do that too and even better, because we are closer to life and our themes are more meaningful."

The truly new painting, on the other hand, like that of the Impressionists, would more than likely have been passed over with a shrug. Art historians love to quote the hostile reviews of the first Impressionist exhibition written by leading Parisian critics of the day, but the Russian critics and public were even less prepared for the manifestos of the "independents". What of the fact that the Petersburg journal *Vestnik*

Evropy published, on Turgenev's initiative, Zola's *Parisian Letters*, where the author discussed Impressionism? It might seem that one could hardly desire fresher and more objective information in 1876. However much the *Letters* may have meant to Turgenev, though, or Repin, who had just returned from Paris, they said little to the readers of this respectable liberal journal "without pictures" whose illustrations made using outdated etching technology are unlikely to have made much of an impression.

To cultivate an adequate perception of not only the new painting, but painting *per se*, decades were required, and here the service rendered by the Wanderers' educational activities cannot be overestimated. Their exhibitions not only introduced the public to modern subjects, but inculcated a taste for painting in general. The Russian public, like any other, was in need of "polishing", without which it would be impossible to grasp the logic of the formal methods used by the Impressionists to express the spiritual essence of their pictures.

In the first place, it was necessary to get beyond the ideological axioms of the Wanderers' early period, with their unrelenting empathy for the people's lot and their social illusions — everything that Chekhov referred to in the early 1890s as "alien scraps, like the ideas of the 1860s". [12] This would be difficult to achieve; such ideas, however musty they had become, remained dear to the Russian *intelligentsia*. That *intelligentsia* also had to realise, be it with a significant delay, the fruitlessness of national isolation and to grope its way to something more constructive than endless disputes between Westernisers and Slavophiles about Russia's inscrutable and unique fate. Overcoming both earthbound realism, on the one hand, and sterile literary fantasies, on the other, was especially difficult in a country whose culture was marked by such deep-seated literary tendencies; it was necessary to arrive at an understanding that Critical Realism had reached the end of its resources.

When exhibitions of foreign art began to take place one after another in the 1890s, one of the main factors driving them was accumulated fatigue from "Wanderer-ism". Stasov, the mouthpiece of the Society, understood earlier than anyone else that such showings were fraught with the danger of encouraging the imitation of apolitical foreigners. The Wanderers' exhibitions were geared completely to domestic consumption: in those years it would not have occurred to anyone to publish a Wanderers anthology for export. Attempts to put together a Russian art section at the World's Fairs of 1878, 1889 and 1900 in Paris produced little result.

If today interest in late 19th-century Russian art is growing noticeably, the reason lies less in the soaring demand created by "New Russians", who have forced prices to fabulous heights in just a short time, than in a worldwide tendency towards examining in full all the major world schools, instead of just one, as was the case until recently. At the end of the 19th century the road to success lay through Paris, recognised as the world capital of art. By focusing our attention on the non-French artists who were active there, we can acquire a firm foundation for the examination of the interrelationships of various schools. In this connection it is worth analysing last year's exhibition in Boston and New York entitled "Americans in Paris", where the best American canvases created in a French environment during the Impressionist age were shown. Monet, Degas and Renoir were not mentioned, but it was clear that the greatest achievements of Robinson, or even Sargent or Mary Cassatt, compare unfavourably to the works of the movement's French founders.

Here once again the eternal mechanism of artistic development comes into play. Followers often master the "secrets of the workshop", the techniques and the methods of a style, no worse than the founders,

[12] Letter to A. S. Suvorin of 25 November 1892. A. P. Chekhov. *Polnoe sobranie sochineniy i pisem*. Vol. 15, p. 447.

but the divine spark remains with those who came first. Every succeeding generation brings forth its own leaders, but for leadership mere mastery is not enough. People of a new aesthetic are required, endowed, among other things, with a deep inner strength and intuition. That is why Robinson or, say, Savrasov, who painted several evocative landscapes, were unsuitable for the role of leaders who might have been capable of drawing others along behind them, even within the framework of their national schools. The art of Kandinsky, on the other hand, whether we consider it within the borders of the country from which he came or in a much broader European context, pales before nothing and no one, because the magnitude of his creative individuality always makes itself felt.

As a whole, Russian culture at the beginning of the 1890s appeared to be in decline in comparison with the 1860s and 1870s. In both literature and painting the quest for new forms was leading to a retreat from Realism. Several painters of the younger generation managed to break through the triumphant prosaicism of the Wanderers to a more poetic element, finding it in light, in colour, or in immersion in legend. Serov, one of Repin's students, was already expressing a different creative spirit than his teacher; it is therefore unsurprising that his *Girl in the Sunlight* raised the ire of the Society's founders. Chekhov summed up the general situation in culture with the expressivity which only he possessed: "Do the pictures of Repin or Shishkin really sweep you off your feet? Yes, they are charming and talented. You take delight in them, but without forgetting for a moment that you want to have a smoke. It is science and technology which have achieved greatness in our day. As for us [creators], this is a time of dullness and uncertainty; we ourselves are dull and dispirited, the babies we give birth to are not living but rubber ones, and it is only Stasov who fails to notice this, endowed as he is by nature with a rare talent for receiving intoxication even from slops… We describe life as it is, and that's all. We are unable to go any further…"[13] A merciless verdict, but as bleak as Dr. Chekhov's diagnosis in this private letter might be, he does not rule out a future metamorphosis in Russian culture. More than that, the letter implies such an expectation.

The sparks ignited by the reform era were too powerful for even the damp dreariness of time to put out. As a rule, the art of any large country tends to develop not steadily but in bursts, and a temporary lull after a period of rapid development sooner or later will be followed by a flight to new heights. Indeed, the ensuing period would give birth to truly living literary "babies": Pasternak, Akhmatova, Tsvetaeva, Mandelstam, Mayakovsky, Bulgakov and Zoshchenko. The realm of painting would be less generous with major figures, but nonetheless Chagall, Popova, Lissitzky and Rodchenko would make their appearance.

It was at this time that Russia began her closer acquaintanceship with the contemporary art of France. In 1891, an enormous French art and industrial exhibition was organised at Moscow's Khodynskoe Field,[14] with rarities for every taste. Illuminated fountains served as the main attraction, just like at the 1889 World's Fair, after which the event was modelled (a special panorama was dedicated to it and the Eiffel Tower). Naturally, there was no shortage of artworks.[15] Today, most of the names will not mean anything even to connoisseurs, but it was select material. The tone was set by masters of the Salon whose names are once again emerging from obscurity in our day: Bouguereau, Gérôme, Lefebvre, Laurens, Roll, Bonnat, Jules Breton, Dagnan-Bouveret and Neuville.

In 1896, a French exhibition devoted entirely to art, the largest so far,[16] came to Petersburg and then moved on to Moscow. Once again, the idols of the Salon dominated, but room was found for Monet, Degas, Renoir and Sisley, too. Especially noteworthy among the pictures furnished by Durand-Ruel for the exhibition were Monet's *Cliffs at Étretat* and *Haystack*. Sergei Shchukin remembered the first picture very

13 Ibid.
14 "The structure of the French Exhibition consists of eight covered pavilions interconnected by two rows of galleries so that the whole building forms a closed circle with an inner courtyard in the centre. The courtyard has illuminated fountains, two stages for music and 24 kiosks for the sale of newspapers, beverages, sweets, cigarettes and so forth. There is an outer park surrounding the building with many separate pavilions of the most varied size and architecture." Guidebook to the French Exhibition in Moscow. Moscow, 1891, p. 7.
15 More than 463 pictures and 84 sculptures were shown, along with many works of applied art.
16 Guide to the French Art Exhibition, organised by Imperial Decree with the assistance of the French Ministry of Fine Arts, for the benefit of the Sisters of the Red Cross Aid Committee under the patronage of the Princess of Oldenburg. St Petersburg, 1896. 470 works were shown in Petersburg, a third fewer in Moscow.

vividly, and three years later he would buy it from "Papa Durand". The second picture made a strong impression on the young lawyer Wassily Kandinsky, who later mentioned the two things which had most influenced his creative life: a performance of Wagner's *Lohengrin* at the Bolshoi Theatre and Monet's *Haystack*.

"Impressionism," recalled Alexander Benois, one of the most erudite men of his day, "remained an 'underground' phenomenon known to only a small number of people right up until the 1890s. An even smaller number of people not only knew of the existence of certain artists who called themselves impressionists, but were able to appreciate their art, considering it beautiful and interesting. The masses received only rare snatches of information about such artists as Manet, Degas, Monet and Renoir." [17]

Nonetheless, we cannot say that the Russian public was denied the opportunity to acquaint itself with the Impressionists' works. For a long time it simply remained indifferent to them. In 1899, the Imperial Society for the Encouragement of the Arts organised an exhibition in Petersburg and Moscow of eleven Monet canvases, one of the most important outside France at that moment. Durand-Ruel provided the pictures. Possibly remembering how the public had received Monet at the 1896 exhibition, he changed his tactics and left out the most radical compositions which might have incited protest. The presence of three delicate still lifes and the dominance of the "classic" works of the 1870s is evidence of this. The *marchand* miscalculated, however; his pictures failed to arouse interest, and the exhibition remained unnoticed in the annals of Russian art life.

Having lived in France longer than in his homeland, Turgenev was very attentive to French culture and became interested in Impressionism early on. [18] Other Russian writers, at the rare moments when they happened to encounter the new Western painting, were less indulgent. The greatest misfortune, however, lay in the fact that the leading lights of Russian literature — Alexander Herzen, Ivan Goncharov, Nikolai Nekrasov, Mikhail Saltykov-Shchedrin and Vladimir Korolenko — remained disarmingly insensitive even to Russian, not to mention foreign, painting.

In 1897, Leo Tolstoy's treatise *What is Art?* was published, creating a great resonance. Many of the theses of the writer's aesthetic credo retain their validity to this day, but not his assessments of writers, artists and musicians whose work he regarded as false, counterfeit art. "People in our society today are thrilled by the poetry of Baudelaire, Verlaine, Moréas, Ibsen and Maeterlinck, the paintings of Monet, Manet, Puvis de Chavannes, Burne-Jones, Stuck and Böcklin, the music of Wagner, Liszt and Richard Strauss, and so on and so forth, but they're capable of understanding neither the most sublime nor the simplest art." [19]

Tolstoy bolstered his antipathy to Impressionism by citing a diary of a certain art lover who had been to the 1894 Paris exhibitions. "Went to three exhibitions today: symbolists, impressionists and neo-impressionists. Looked at the paintings intently and conscientiously, but once again felt only bewilderment and finally indignation. The first exhibition, Camille Pissarro, was the most comprehensible, though there's neither outline nor content, and the colours are simply unthinkable. The draughtsmanship is so indefinite that it's sometimes hard to understand which way a head or a hand is turned. The works consist mainly of 'effects': *effet de brouillard*, *effet du soir*, or *soleil couchant*. The colour range is dominated by bright blue and bright green paints. And every painting has a main colour with which it seems to be spattered… In that same 'Durand Ruel' gallery there are other pictures, by Puvis de Chavannes, Manet, Monet, Renoir and Sisley — those are all impressionists. One of them — I could not make out the name,

[17] A. N. Benois. *Moi vospominaniya*. Moscow, 1990, Vol. I, pp. 490–491.

[18] The range of his interests, by the way, was not broad. Claude Monet's contemporary Alexei Kharlamov was much more dear to Turgenev than the leader of the French Impressionists.

[19] L. N. Tolstoy. *Chto takoe iskusstvo. Sochineniya grafa L. N. Tolstogo. Chast' pyatnadtsataya*. Moscow, 1898, p. 196.

Claude Monet. Woman in the Garden. 1866. Herm.

[20] Ibid. pp. 106–107.

[21] He is referring to the famous Caillebotte collection. V. V. Stasov. *Stat'i i zametki, publikovavshiesya v gazetakh i ne voshedshie v knizhnye izdaniya.* Moscow, 1952, Vol. 1, pp. 78–79. First published in the newspaper *Novosti i birzhevaya gazeta* of 23 June 1898.

[22] The museum opened in Moscow in 1895. It was free and open to the public.

[23] S. I. Shchukin's collection became accessible to the general public beginning in 1908, when every Sunday the doors of Shchukin's mansion on Bolshaya Znamenskaya Street would open to all comers.

something like 'Redon' — painted a blue face in profile. The whole face is coloured in that blue tone with white patches…"[20]

How could Russian society not take into account the authority of Leo Tolstoy, all the more so since his approach to art, for all of his inability to understand painting, was motivated by the sincerest Christian imperatives? The writer may have been anathematised by the Church, but his message of virtue and moral usefulness to society commanded unconditional respect. Furthermore, he had a mouthpiece for his views in the person of Stasov, the most forceful music and art critic of the age, who once wrote about some Impressionist canvases on display at the Musée du Luxembourg: "…in terms of colour and paint there were actually many noteworthy studies of the decadents, who are usually so lacking in brains, and whose pictures are so pointless and stupid, that their achievements in terms of colour are not devoid of significance. This is all they are capable of — 'studies'. They have not yet arrived at an understanding of 'subject', and thank God for that!"[21]

From citations like this it is easy to imagine what a mighty resistance was faced by those who were drawn to Impressionism and young painters like Konstantin Korovin; he was giving art lessons at the time to the Morozov boys, the future collectors.

There were very few collectors — the Morozov and Shchukin brothers — and fate had allotted them only a short time for their collecting careers: about five years for Mikhail Morozov, slightly over ten for his younger brother Ivan, and barely fifteen for Sergei Shchukin. First place must go to the Moscow entrepreneur and importer of fabrics Sergei Ivanovich Shchukin (1855–1936). Before their discovery of Monet, Pissarro and Renoir, Shchukin and the Morozovs had already established contact with the young Moscow painters Korovin, Serov, Levitan and Pasternak, who were pushing for greater freedom in painting. The collectors would be able to count on their support, then, in their struggle against the authority of the old Wanderers and the invectives of Tolstoy and Stasov.

The new era in Russian collecting began in 1898 with the appearance of Claude Monet's pictures in Moscow collections. True, at the beginning only the master's *Woman in the Garden*, on exhibit at the Pyotr Ivanovich Shchukin Museum,[22] was available to the general public. The canvases brought from Paris by Sergei Ivanovich, on the other hand, were seen mainly by those artists whom he always joyously received in his home, but a few years later they would be displayed to the public as well.[23]

Not counting his very first steps as a collector, when he bought mainly works of the Wanderers, which he later sold off and never mentioned again, Shchukin's collecting career is customarily divided into three periods. The

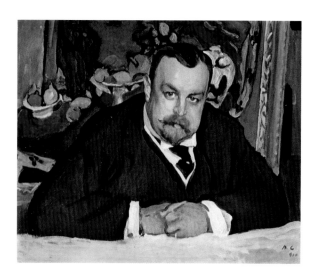

Valentin Serov. Portrait of Ivan Morozov. Tret. Gal.

24 Y. Tugendhold. *Frantsuzskoye sobranie S. I. Shchukina // Apollon.* 1914, No. 1– 2, p. 6.
25 His house, after the collection was nationalised in 1918, was turned into and remains a museum of new Western art now belonging to the Academy of Fine Arts of the Russian Federation.

46

first began with his discovery of Impressionism, a real revelation for him. Later, around 1903–1904, Shchukin's tastes shifted towards Cézanne, Van Gogh and Gauguin. His latter period (1910–1914) is connected with the names Matisse, Derain and Picasso. His collecting work went in bursts; by importing French pictures to Moscow, Shchukin wished them to serve as a sort of bubbling ferment for the development of Russian art. Simultaneously, without waiting for the results to fully take effect, he forged ahead, carried away with ever more radical paintings. It was always important for him to remain a participant in the artistic process.

The Moscow public's dissatisfaction was unable to stop the collector. In 1914, when there were still those alive who could remember the first years of Shchukin's collection, Yakov Tugendhold wrote: "The first Monet landscapes brought by Shchukin into the country aroused the same degree of indignation as Picasso does today: the fact that one Monet picture was crossed out in pencil by a protesting gallery visitor says a great deal." [24] The episode recounted by Tugendhold happened no earlier than 1908. Thus we see that for many viewers hostility to the new art was slow to be overcome indeed.

Mikhail Morozov (1870–1903) jumped just as quickly as Shchukin from Impressionism to Van Gogh, Gauguin, the Nabis and other painters of the next generation. His early death eliminated Schukin's only real competitor from the Russian collecting arena. A rival did appear, however. This was Mikhail's younger brother Ivan Morozov (1871–1921), who continued where his brother had left off. He began purchasing French pictures alongside Russian ones. In this the Morozov brothers differed from Sergei Shchukin, who had once and for all lost interest in Russian painting.

In scrupulously building his collection, Ivan Morozov spared no expense: "He is a Russian who does not bargain," quipped Vollard. In just a short time he got his hands on many unique works, such as Monet's Montgeron canvases, and his *Boulevard des Capucines*. Following in Shchukin's footsteps, Morozov displayed his Monets, Sisleys and Pissarros in the brightest hall of his mansion on Prechistenka Street. [25] Then he set his sights on the next evolutionary stage in the new painting. Both of them, especially Shchukin, desired to participate in the creative process, so their interests inevitably overlapped, from Monet and Degas to Gauguin, Van Gogh and Cézanne and onward — into the 20th century.

Van Gogh, Gauguin and Cézanne took up their places very early on, in the minds of both collectors and authors of "unofficial" Russian art, alongside their "forerunners" the Impressionists, forming a practically religiously revered triad regarded in turn as "liberators" (in the words of Pyotr Konchalovsky) or martyrs. Their creative methods and preferences, and their words and expressions, which were greedily picked up and passed on, found a grateful

following among the first Russian avant-garde artists. However, this borrowing of the methods of Van Gogh and Gauguin was as short-lived as it was intense. Neither the one nor the other was to become an intermediary in the ongoing Russian-French dialogue of the minds — it was Cézanne who was to play this role. At the beginning of the 20th century, Cézanne's pictures [26] could be found alongside those of Larionov and Goncharova in the same exhibitions. The important thing was to dumbfound the Russian viewer with the shocking novelty of new techniques and to show that "our painters" could do just as well as "theirs".

The Cézannes bought by Shchukin and Morozov demonstrate perfectly why the master from Aix en Provence so captured the imaginations of the pioneers of the avant-garde. It would be no exaggeration to say that Russia, no less than France herself, was the country where Cézanne became and remained for a long time an object of the most zealous adoration. His art was seen as a lever capable of overturning a whole world of established conceptions, and Russian artists of the time were not ready to settle for anything less. It is logical that Russian maximalism, both political and ideological, often went hand in hand with artistic maximalism. To paint a picture just for the purpose of decorating someone's existence — that occupation seemed to many Russian painters unworthy of art's high calling.

Cézanne's art would seem to have no direct correlation with Russia's national traditions, and the intense interest which it aroused in Russian artists can be at least partially explained by the serious crisis that those traditions were going through. It was one of those short and rare periods in our national history when a prophet not from our homeland not only called, but was heard. If we are to assess the phenomenon of Cézanne from the point of view of his purely painterly qualities, the beauty of his pictures and the boldness of his artistic methods are insufficient to explain his supreme authority. The main reason, apparently, should be sought in the fact that his art intrigued by its promise of a new artistic system capable of revealing theretofore inaccessible secrets of creativity and encompassing the most profound generalisations. By the beginning of the 20th century, the old scholastic system seemed insipid and superficial. Cézanne's pictures could not have arrived in Moscow at a better time. Young Russian painters were unacquainted with Gauguin's ironic phrase: "Has Cézanne found an exact creative formula which works for everyone?" [27] — but many of them would have been ready to echo these words in perfect earnestness.

The first Cézanne picture, *Still Life with Fruit*, made its appearance in Russia in 1903. Shchukin had spotted that still life in the gallery of Durand-Ruel, who was unable to sell the picture for a long time. The following year he returned there to buy *Flowers in a Blue Vase* and *Pierrot and Harlequin*, earlier belonging to Victor Choquet, the great French collector who was a comrade-in-arms of the Impressionists and close friend of Cézanne. Among the 32 canvases of the master, which he owned, *Pierrot and Harlequin* occupied the place of honour. Shchukin paid 4,450 francs for it, a very high price at the time.

It was at this time that Shchukin began to realise that Impressionism was not the last word in French painting. That is not to say that he fell out of love with Monet, Renoir and Degas — he continued with his former pride to exhibit their paintings to his numerous guests — but he stopped filling out this part of his collection, and began to see his calling in acquainting the Russian public with more current European trends. Later, after discovering Matisse and Picasso and abandoning further purchases of the pictures of Van Gogh and Gauguin, he continued to keep Cézanne "in his sights". The last Cézannes to grace Shchukin's mansion illustrate his deeply personal approach to paintings. His choice fell on the more severe pictures, where the

[26] *Château Noire* (Museum of Modern Art, New York) and *Portrait of the Artist's Wife* (Metropolitan Museum, New York) were both exhibited at the 1908 "Golden Fleece" exhibition.

[27] Letter by Gauguin to Camille Pissarro in July 1881. *Correspondance de Paul Gauguin*. Ed. V. Merlhes. Paris, 1984, p. 21. [*Mr. Cézanne a-t-il trouvé la formule exacte d'une oeuvre admise par tout le monde?*]

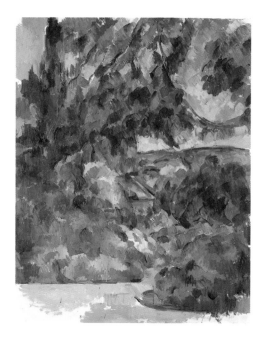

Paul Cézanne. Blue Landscape. 1891. Herm.

[28] E. Teriade. *Matisse Speaks*. Art News Annual, No. 21, 1952. Cited from J. Flam. *Matisse on Art*. Berkeley-Los Angeles, 1995, p. 203.

[29] In the archive of the Pushkin Museum in Moscow there is a catalogue of this exhibition with notes by Ivan Morozov.

[30] The first picture belongs to the Pushkin Museum, the other two to the Hermitage.

[31] S. Makovsky. *Frantsuzskie khudozhniki iz sobraniya I. A. Morozova // Apollon.* 1912, Nos. 3–4, 5–6. The purchase probably took place in May 1911.

[32] *Matisse speaks*. Op. cit.

[33] F. Feneon. *Les grands collectionneurs. Ivan Morosoff // Bulletin de la vie artistique*. 1920, p. 356.

personages depicted (*Man Smoking a Pipe* and *Woman in Blue*) do not merely pose but seem eternally immersed in themselves, transformed into "thinking nature".

Shchukin impressed Matisse with the breadth, one might even say universality, of his views on art, which were as open to the Orient and Antiquity as they were to the West and modernity. "In Paris," recalled the artist, "his favourite pastime was visiting the Gallery of Egyptian Antiquities at the Louvre: he discovered parallels there with Cézanne's peasants." [28]

It is well known what significance the posthumous Cézanne exhibition held at the Autumn Salon in 1907 had on the destiny of both French art and all European art in general. One of its most attentive visitors was Ivan Morozov. [29] At that time he selected some of the master's true masterpieces at Vollard's gallery: *Plain by Mont Saint-Victoire*, *Mont Saint-Victoire* and *Still Life with Curtain*. [30] Though the market (and that meant Vollard, above all) could offer many splendid Cézanne canvases, Morozov collected with great scrupulousness, sometimes spending years hunting down a work which he needed. An excellent example of this is his favourite picture, *Blue Landscape*, which he found at Vollard's in 1912. "I remember during one of my first visits to the gallery," wrote Sergei Makovsky, the author of the first essay about Morozov's gallery, "how I was surprised to see a blank space on the far edge of the wall otherwise completely covered by Cézanne's works. 'That place is intended for a "blue Cézanne"' (that is, for a landscape from the artist's final period), Ivan Morozov explained to me. 'I have had my eye on one for a long time, but just cannot seem to make up my mind'… That spot remained vacant for more than a year, and only recently a splendid new 'blue' landscape, chosen from among dozens of candidates, has taken up its place alongside the earlier elect." [31]

Morozov could take a long time choosing, when works of the greatest masters were under consideration. Though his eye had become extremely well honed, he continued to suffer from a certain lack of confidence. He would require a second opinion from an artist friend — often Serov, while the latter was still alive — or a *marchand* whom he trusted. That does not mean he always followed their advice, but advice was necessary to begin the dialogue with a painting. "When Morozov would go to Ambroise Vollard's," recounted Matisse, "he would say: 'I want to see a very good Cézanne.' As for Shchukin, he would ask to see all the Cézannes which were for sale and chose from among them himself." [32] Each method was good because it fit the personality of each collector. For Cézanne, where a special prudence was required, the first method perhaps produced the best results. In the given case, Morozov could rely on Vollard, and as shrewd as the merchant was, he would never offer the Moscow collector anything less than a superb Cézanne. There is not the slightest doubt that Morozov's ensemble, consisting of eighteen of the master's works, was the best in the world at the beginning of the 20th century, though Auguste Pellerin's Paris collection contained more paintings. Ivan Abramovich was justly proud of his ensemble, and when asked which painter he loved most of all he named Cézanne. [33]

Turn-of-the-century Russian painters looked either to Munich or to Paris for future trends. "Munich at that time was a front-line trench holding back the influence of French painting as it advanced eastward." [34] For the "World of Art" group founded in 1898 in Petersburg, Munich turned out to be the closer of the two cities in spirit. The leaders of this first artistic alliance of the 20th century (Benois, Somov, Bakst, Dobuzhinsky, Ostroumova-Lebedeva and others), were equally opposed both to the academicians and the Wanderers and found inspiration mainly in the German Secession, with its literary and philosophical tendencies and its dry and elegant Europeanism giving preference to line over colour. However, even in this environment French models turned out to be more attractive. Larionov recalled how in the Spring of 1904 he met Diaghilev, one of the founders of the World of Art. "We were standing not far from a mural by Max Klinger, and he asked, I remember: 'Do you like that? I do not.' He fell silent and then added: 'but it is very fashionable…' The only thing I asked him on that occasion was whether he liked Shchukin's collection, which was just getting underway then and numbered some 40 or 50 things by Claude Monet, Cézanne, Gauguin and Van Gogh. Diaghilev replied that he liked it very much, and that he would publish reproductions of these artists in the next issue of the 'World of Art' journal, but different works than the ones in Shchukin's collection." [35]

If the attention of young Moscow painters was attracted first by Monet, Pissarro and Degas, then by Cézanne, Van Gogh and Gauguin, and finally by Matisse and Picasso, none of this could have happened had these canvases remained mere rumours. Fortunately, however, students at the School of Painting, Sculpture and Architecture could see the works with their own eyes: they "covered" painting in Shchukin's gallery. In Petersburg no such galleries existed; there, on the contrary, the Hermitage, Academy of Fine Arts Museum and the newly-opened Russian Museum inculcated a taste for classical, traditional art, and the work of young artists was therefore of a completely different character than in Moscow. As Kuzma Petrov-Vodkin would later write: "While Moscow regarded Petersburg with hatred, the latter simply maintained its patrician mien, pretending not to notice Moscow's heretical enthusiasms." [36]

The heretical enthusiasms of students, former students and even the semi-educated, their irrepressible talent and their high ambitions made a demonstration of their creative boldness an urgent necessity, and the Paris Autumn Salon of 1906 became the first international venue for such a demonstration. Thanks to Diaghilev's efforts, a Russian section was organised there which valiantly attempted to rival that of the luminaries of the French avant-garde. An enormous retrospective at the Grand Palais consisting of 750 works spanned everything from 18th-century portraits to the latest creations of Yavlensky, Larionov and Goncharova. Parrying inevitable reproaches for the conspicuous absence of most of the leading Wanderers, Diaghilev explained in the catalogue's foreword that such names, though once famous, had now lost their former glory, some temporarily and others forever. [37] The Realists, having gone through the sieve of Diaghilev's selection process, were represented in Paris by other pictures than the ones which had made them famous across Russia. It is telling that none of Repin and Ghe's thematic compositions were on display, only portraits.

At the same time, the selection of modernist- and symbolist-influenced paintings looked impressive: around 30 works by Vrubel (including *Pan*, *The Swan Princess* and the enormous murals commissioned by A. V. Morozov), even more works by Somov, 20 or so by Borisov-Musatov, and paintings by Benois, Bakst, Roerich, Dobuzhinsky and Kuznetsov. In its reviews of the exhibition, the French press accentuated Vrubel especially, mentioning such contemporary works as the landscapes of Yavlensky and the still lifes of Larionov as well.

[34] K. Petrov-Vodkin. *Khlynovsk. Prostranstvo Evklida*. Samarkandia. Leningrad, 1970, p. 393.

[35] Larionov's reminiscences of S. P. Diaghilev. *Mikhail Larionov — Natalia Goncharova. Shedevry iz parizhskogo naslediya. Zhivopis'*. Moscow, 1999, pp. 189–190.

[36] K. Petrov-Vodkin. Ibid., p. 357.

[37] *Exposition de l'art russe. Catalogue. Salon d'Automne*. Paris, 1906. Preface by Diaghilev, p. 7. After Paris the exhibition went to Berlin and Venice.

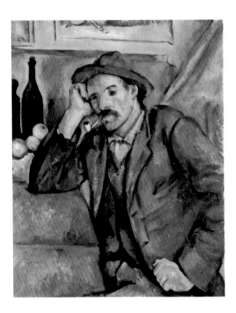

Paul Cézanne. Smoker. 1895–1900. Herm.

Mikhail Larionov returned from Paris elated. Not without irony, Leonid Pasternak repeated in a private letter the leader of the Moscow avant-garde's words to the effect that only he and Grabar had made a worthy impression in Paris. However, the phrase of Larionov's which Pasternak cited literally was even more interesting: "Even Monet was left in the shade." [38] For people who understood each other implicitly, the mention of that name signalled not only the arrival of the already-recognised French avant-garde, but a call to action for the latest generation of "destroyers of the foundations".

The young Moscow artists who exhibited at the Autumn Salon had a dual education. The first was furnished by art school, the second by Shchukin's gallery. Especially influenced by the latter was the "Jack of Diamonds" group, who even elected the gallery owner as their first honorary member. Their paintings really do remind us of Shchukin's Cézannes and Gauguins, but one would not call them imitations. The "Jacks" did not copy their methods, but adapted and sharpened them to their purely Russian ends. Larionov's *Soldier Smoking* (1910–11) copies the pose of Cézanne's smokers exactly, and *Peacocks* (1910) is inspired by motives from Gauguin's *Matamoe*. Goncharova's *Sunflower* variations (1908–09) follow Gauguin's *Sunflowers*, and so forth. However they might have been "prompted" by the great Post-Impressionists, though, the Muscovites had moved forward. Departing from literal representation, they began constructing an intuitive parallel world of more and more autonomous forms and colours. This world did not desire to be a naive reflection of nature and aspired to the element of primitivism as an attempt to break through to the truth, to overcome academic artificiality. Larionov, Kandinsky and Malevich, having acquired from folk-art culture the secret of expressing the inner essence of things, felt themselves to be primitives of the new art.

The same year as when the Russian section opened at the Autumn Salon, a new journal entitled *Golden Fleece* began to circulate in Moscow. At first it was supported by many former artists from the World of Art group. Its publisher, Nikolai Ryabushinsky, attracted Blok, Bely, Briusov and Merezhkovsky to the journal. Benois considered the "arch-luxurious style" of the publication in bad taste, and its general program to be somewhat silly. The attempt to publish *Golden Fleece* in very large format, with golden type and in two languages, betrayed pretentiousness, so a year later they made it Russian-only and shrank the format. Be that as it may, the journal became for a time not only a place to publish Russian verse and pictures, but a mouthpiece for writings of the French avant-garde, from articles by Charles Morice and Maurice Denis to Matisse's "Notes of a Painter". The project for Matisse's *The Dance* and *Music* ensemble was described on the pages of *Golden Fleece* a year before the work actually materialised. [39]

Under the journal's auspices, a "Golden Fleece" salon was opened in Moscow in 1908, exhibiting both Russian and French avant-garde works, with the French section being significantly larger than the Russian one (in paintings, 197 works versus 107). The Russian section fell short of the French in quality, too. The only truly major artists on exhibit were Larionov (20 pictures), Goncharova, Kuznetsov and Saryan. The section's poor makeup was to a large degree a result of the dilettantism of the event's organiser, Ryabushinsky.

[38] From Leonid Pasternak's letter to P. D. Ettinger of 17 October 1906. P. D. Ettinger. *Stat'i. Iz perepiski. Vospominaniya sovremennikov.* Moscow, 1989, p. 102.
[39] A. Mersero. *Henri Matisse i sovremennaya zhivopis'. Zolotoye Runo,* 1909, No. 6, p. II.

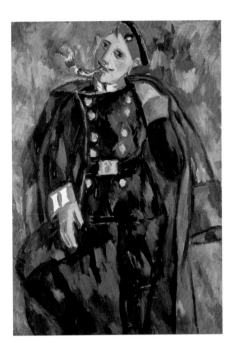 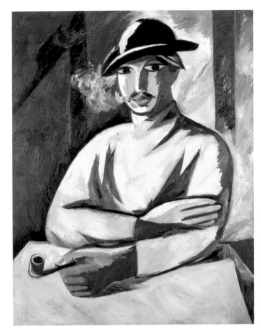

Mikhail Larionov
Soldier Smoking. 1910–1911. Tret. Gal.

Natalia Goncharova
Smoker (Tray Painting Style)
1911. Tret. Gal.

[40] *Vystavka Sto let frantsuzskoi zhivopisi (1812–1912), ustroennaya zhurnalom «Apollon» i Institut Francais de St Petersbourg.* St Petersburg, 1912.

The virtues of the French part are impossible to overestimate, however. Degas, Cézanne, Renoir, Pissarro, Sisley, Van Gogh, Gauguin, Redon — the best masters of the new painting were on display. What is more, they were represented by their best works, true masterpieces, such as Renoir's *Sleeping Woman*, Cézanne's *Portrait of the Artist's Wife* and *Château Noire*, and Van Gogh's *Zouave*, *La Berceuse* and *The Night Café*. Alongside these works by the founders of the avant-garde, the paintings of the next generation of artists held their own, too: Bonnard, Vuillard, Roussel, Denis, Manguin, Puy, Friesz, Van Dongen, Desvalliéres, Le Fauconnier, Glaize and Metzinger. Four splendid landscapes from Derain's London series commissioned by Vollard, views of the Louvre Embankment by Marquet, Fauvist landscapes by Braque, Matisse's San Tropez and Collioure landscapes, along with his *La Coiffure* and *Girls*, and Rouault's *Bathers* — these pictures would adorn any exhibition.

The next "Golden Fleece" exhibition (1909) was half the size of the first. Remaining among the French were Braque, Derain, Van Dongen, Le Fauconnier, Manguin, Marquet, Matisse, Vlaminck and Friesz. There were more Russian pictures, but few significant ones. The third salon, which opened around New Year, 1910, was already completely Russian: it united the "Blue Rose" artists with the "Jacks of Diamonds". Then everything came to an end, both the journal and the exhibitions: Ryabushinsky lost a fortune in cards. Even if he had not, though, the result would probably have been the same. The organiser, for all his wealth, lacked thoroughness, and, in addition, his exhibitions had not satisfied the French participants. Most of the works were brought from France with a view to their possible sale, but such sales were rare.

Of all the foreign exhibitions which took place in Russia in the pre-revolutionary years, the largest was the one entitled "A Hundred Years of French Art" held in Petersburg in 1912.[40] It signalled the complete rout of salon-academic tastes. Baudry, Bouguereau and Carolus-Duran were represented by just a handful of works — the complete opposite of the situation at the 1896 exhibition. Nearly 1,000 exhibits formed an extremely representative panorama. With perfect justification, the organisers named the event "the first beyond the borders of France where the whole development of French painting in the

past century is represented".[41] "Our attention," wrote the organisers Nikolai Wrangel and Sergei Makovsky, "was directed not at the official academic or salon artists, who enjoy a partially undeserved fame in Russia, but at the true leaders, artists who opened up new paths in their day, while at the same time preserving the splendid old traditions of the French school."[42] The artists were selected mainly by Sergei Makovsky, who had once worked at *Golden Fleece* and later founded the journal *Apollon* in Petersburg. The most contemporary avant-garde artists were practically absent at the "Hundred Years" exhibition. Braque, Matisse, Vlaminck and Van Dogen were not invited, and two things by Derain were not enough to change things cardinally. The accent was on the proven classics of the new art, and the accent was placed convincingly.

A half century after his unsuccessful debut, ten of Manet's works were brought to Petersburg, including pictures which are among the master's greatest: *The Old Musician, Argenteuil, Nana, Portrait of Berthe Morisot* and *Bar at the Folies-Bergère*. Today we can only wonder why no one heeded Benois' appeal to purchase *Bar*, one of the prime masterpieces of late 19th-century French art. There were enough people with the money, and some of them were collectors. However, there were really only two who were capable of heeding the call: Shchukin and Morozov. So what got in their way? At the time Shchukin was concentrating on the current avant-garde, buying pictures by Matisse, Picasso and Derain. When Matisse convinced a Paris gallery owner to hold for his patron Gauguin's major painting *Where Do We Come From? What Are We? Where Are We Going?* and sent an urgent message to Moscow, the answer was unexpected, but explainable if we bear in mind Shchukin's strategy: "Gauguin does not interest me any more; the dealer is free to offer the picture to another buyer."[43] Morozov was interested in Manet, but he was looking for one of the master's finest landscapes, one that would reflect his connection with the Impressionists. Serov and Grabar tried to find the right picture, but without success. On the other hand, Russian connoisseurs considered *Bar at the Folies-Bergère* an uncharacteristic picture for Manet. Thus the picture failed to find a home in Russia and returned to the Bernheims in Paris.

The hundred-year period of French art was very thoughtfully represented by the works of the best masters, beginning with David (11 works), Ingres (14), and Delacroix (21). The mid-century period looked no less fundamental, with 22 pictures by Corot and 16 by Theodore Rousseau forming a natural bridge to the Impressionists, represented by nine pictures by Monet, seven by Sisley, four by Pissarro, 24 by Renoir, 19 by Gauguin and 17 by Cézanne. The exhibition was organised through the joint efforts of many people, including collectors from both Petersburg and abroad, but above all by leading Paris gallery owners Durand-Ruel, the Bernheims, Druet, Vollard, Rosenberg and Barbazange.

Ambroise Vollard was especially active. Furnishing Shchukin and Morozov with the creations of the fathers of modernism, he decided that he could now achieve more by entering the Russian market directly and sent 36 canvases of the highest quality to the Hundred Years Exhibition. The *marchand* valued Renoir's *Lovers* highest of all, at 100,000 francs. Though the catalogue contained neither reproductions nor even information about the dimensions of pictures, and the theme of love is not a rare one for Renoir, we can assume this was the *Lovers* now hanging in the National Gallery in Prague. Along with this masterpiece of Impressionism came superb canvases by Cézanne: *Village Road at Auvers, L'Estaque, House Among the Trees, Mountain, Sugar Bowl and Fruit, Harlequin, Self-Portrait* and others. The exceptional group of works by Gauguin barely fell short of the Cézanne group. Vollard tried to interest potential buyers in pictures from the Breton period which Shchukin and Morozov had overlooked completely: *Young*

[41] Ibid. p. 13
[42] Ibid.
[43] Sergei Shchukin's letter to Henri Matisse of 14 May 1913. A. Kostenevich. *La correspondence de Matisse avec les collectionneurs russes.* In: A. Kostenevich, N. Semionova. *Matisse et la Russie.* Paris, 1993, p. 174.

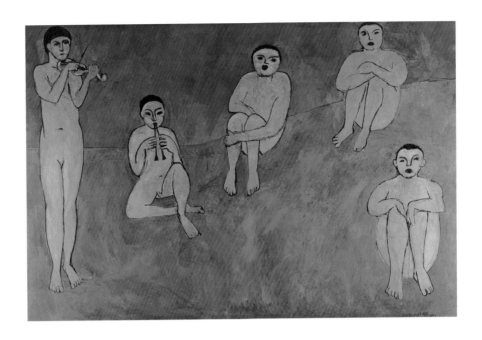

Henri Matisse. Music. 1910. Herm.

[44] The picture, now in London's Tate Gallery, was one of the two major compositions of 1898 belonging to Vollard (the second was in the possession of Georges-Daniel de Monfried). Vollard valued it at 35,000 francs. The Tahitian name is usually translated as "Preparatifs de fête".

Breton Wrestlers, *House in Brittany*, *Loaves* and *Breton Girls*. The group of Tahitian works also contained masterpieces, including *Tahitian Family*, *Bouquet of Red Flowers*, *Mother and Daughter* and *Man in Red*, pictures unlike the ones in Shchukin's and Morozov's collections. Vollard considered the most important composition in the Tahitian group to be "Scène de Tahiti", which he valued two or three times higher than the other canvases. We can identify the picture today. In all probability it was *Faa Iheihe*. [44]

Vollard took the Petersburg exhibition more than seriously, but the public in the Russian capital failed to respond with due enthusiasm. Vollard could not interest the Muscovites, who regarded the Petersburg undertaking with their traditional coolness, in his pictures either. However, they did not even buy those Cézannes sent from Paris specially for sale in Moscow, at the "Golden Fleece" exhibition and elsewhere. Whichever way we look at it, Shchukin and Morozov turned out to be unique; no other Russian collectors of new art even came close to them, neither in Moscow nor all the more so in Petersburg.

Shchukin's collection played an inestimable role in the formation of the new Russian avant-garde. Firstly, because of its accessibility, and secondly, because in his continual quest for ever bolder and bolder experiments in French art the Moscow collector stimulated a sense of risk and exploration in the young generation of artists in his own country. In some fantastic manner Shchukin was able to divine to whom the future belonged; at the very dawn of the 20th century, he became the owner of the largest and highest-quality collection of pictures by Matisse and Picasso, masters who would only later be recognised as figures central to the whole century.

Having met Matisse in 1906, Shchukin soon became his patron. Two years later, Matisse created his picture-cum-manifesto *The Red Room*, shown in the Autumn Salon of 1908 under the title "Decorative Panel for the Dining Room of Mr. Shch." The appearance in Moscow of *The Red Room*, *A Game of Bowls* and *A Satyr and Nymphs* made Shchukin's gallery into the home of the boldest experiments of the European avant-garde. Having no intention of stopping there, however, the collector commissioned Matisse to do *The Dance* and *Music* for the staircase of his mansion. This was the culmination of their collaboration. When the artist's son Pierre was later asked (by that time he had become a major art dealer himself) if his father would have painted such enormous murals if it had not been for Shchukin, he only laconically

replied: "For whom, then?" Thanks to Shchukin, Russia became the first country to begin "importing" works by Matisse, and other Fauvists after him.

The prophetic significance of Picasso's art was revealed to Shchukin early on. Here is what the collector once said, as reported by one of the frequent guests of his gallery: "I did not like that painter [Picasso] and never bought his pictures… Friends urged me to buy at least one of his things to fill out my collection, but I continued to hold back. Finally they somehow convinced me to buy one picture; it was being sold cheap, so I agreed. When I brought it home to Moscow I didn't display it for a long time; I realised there was nothing that could hang next to it — it waged war with all the other pictures and introduced a harsh dissonance into the whole collection. Finally I hung it not far from the front door, in a half-lit corridor where there were no other pictures.

I had to walk down that dark corridor every day on my way to the dining room. As I walked by the picture, I would throw an occasional glance in its direction. Soon this turned into a habit, and unconsciously, without stopping, I began to look at it every day. About a month passed, and I realised that if I had not looked at the picture I would feel uncomfortable at dinner, as if I'd forgotten something. Then I began to look at it longer, and I would have a sensation as if I had put shards of broken glass in my mouth. I began looking at it at other times, not just on my way to dinner.

Finally, one day, I gave a horrified start; I suddenly realised that the picture had an iron backbone, a hardness, a strength, in spite of its lack of subject. I was horrified because suddenly all the other pictures in my gallery seemed to lack that backbone, to be made of cotton wool, and the worst thing was that I did not want to see them any more — they had become somehow uninteresting and pointless. I bought a second Picasso. I felt that I could not live without him. I bought another… He took me over completely, and I started to buy picture after picture and stopped looking at all other artists. In this way, 51 Picassos ended up in my collection, many times more than any other artist." [45]

Shchukin's gallery and his exhibitions in collaboration with the French spurred more and more young artists to do their own experimentation, in which orientation towards Paris was accompanied by the desire to surpass the foreign source. On the eve of World War I, Paris drew many emigrés from the Russian Empire. It was they who would become a large army of the Paris School, an international conglomerate in which the most active role was played by artists of Jewish origin. They came to the French capital from all over, but mostly from Russia. The Jewish milieu was always marked by heightened mobility and mutual aid, and this was especially true at the beginning of the 20th century. In addition, in those years there was the additional element of temporary or permanent emigration, spurred by the existence of the Pale of Settlement in Russia, limitations on the rights of Jews to live in capital cities, and the cheapness of bohemian life in Paris. The words "Paris School" soon became a universally-recognised notion. This notion did not presuppose any stylistic unity; it was more a unity of fate. Bakst, who achieved success early, did not belong to this school, but such emigrés from Russia as Chagall, Soutine, Kremen, Mane-Katz and Żak were its subjects, along with the emigré from Bulgaria Paskin and the Italian Jew Modigliani. All of them were immersed in French art and borrowed its methods, but always preserved their individuality and retained their lyricism.

A bit to the side stood those artists who were more oriented towards exploration within the framework of a common style, be it Fauvism or Cubism, the two main movements of the prewar period. Some of them studied with Matisse, like Marevna and Survage, who went on Shchukin's recommendation, and

[45] N. Preobrazhensky. *V galeree S. I. Shchukina v Moskve. Metsenaty i kollektsionery. Al'manakh Vserossiyskogo obshchestva okhrany pamyatnikov istorii i kul'tury.* Moscow, 1995, p. 49.

54

some took instruction in private schools in Paris, like Sonia Delaunay, the wife of Robert Delaunay and his partner in "simultaneous design". Some purposefully mastered Cubism, like Popova and Udaltsova, who studied with Le Fauconnier and Metzinger, while others adapted the methods of this style for decorative ends, without joining any camp, like Marevna or Annenkov. There were some who jumped from one Parisian movement to another, like Baranoff-Rossiné or Exter. The ambiguity and theatricality of the age was naturally evident in the creations of all these artists excited by endless explorations in formerly unheard-of styles outwardly very formalised but often enigmatic, their formality expressing with surprising vividness the rhythms and spirit of contemporary life.

MOSCOW AS A CENTRE FOR COLLECTING CONTEMPORARY FRENCH PAINTING

from 1870 to 1920

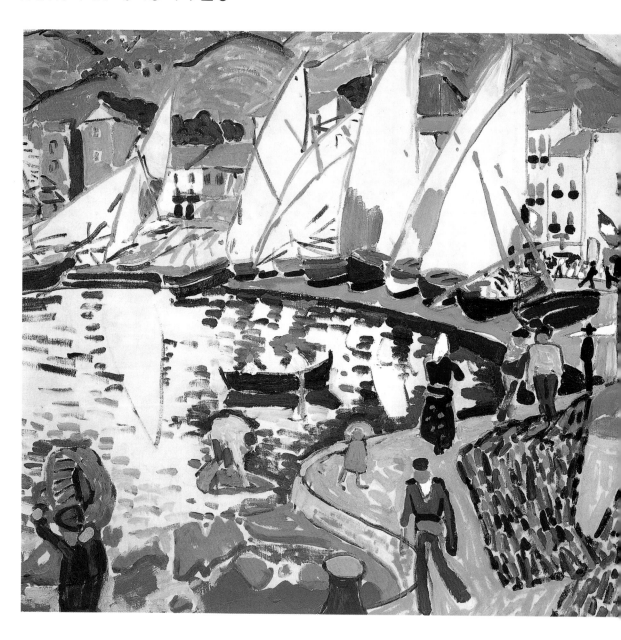

Until the second half of the 19th century, collecting objects of art in Russia had the been the privilege of the Imperial Family and the upper aristocracy. By the end of the 18th century and the beginning of the 19th, the Stroganovs, Golitsyns, Yusupovs, Sheremetevs, Shuvalovs and Orlov-Davydovs had amassed splendid collections.

But then the situation changed dramatically. A whole throng of major industrialists arose who began to initiate and organise large-scale cultural projects. Though lacking specialised education, they possessed excellent artistic taste, which allowed them to put together unique collections of contemporary artworks distinguished by exceptional quality. "A unique role was placed on the shoulders of private amateurs — the correction of those injustices committed against the new art … by the government and the public", the Russian critic Yakov Tugendhold was later to remark.[1] Thanks to the tireless efforts of representatives of the merchant class and even sometimes the peasantry, democratic "Old Dowager Moscow" was transformed by the turn of the 20th century into a major centre of artistic life, leaving aristocratic St Petersburg far behind, constrained as it was by its conservative traditions.

Against a background of social ferment in the country and the rapid development of Russian culture, works by Russian artists were especially popular with Moscow collectors at the time. Moscow was famous for the gallery of Pavel Tretyakov, who had systematically collected and even specially commissioned works by contemporary Russian painters, bequeathing them to his native city. If such collections of native art were natural, though, the collecting of contemporary works by foreign artists was regarded by Muscovites with caution at first. However, a circle of collectors gradually arose who gave preference to Western European art, especially to representatives of the French school. After a long period of neglect, a rebirth of the so-called "low" genres had occurred in France, accompanied by an intense search for new expressive means. Small-format "landscapes of mood", with bucolic views and quaint costumed historical/genre scenes, appealed to the tastes of new collectors considerably more than monumental formal portraits or subjects from ancient mythology. At the same time, the aesthetic value and quality of the French artists' "subjectless" and "empty" canvases (from the Wanderers' point of view) turned out to be significantly higher than that of most of their Russian contemporaries' works.

The Pushkin Museum's collection of French painting received its most valuable contribution from the collection of Sergei Mikhailovich Tretyakov (1834–1892), which took in the period from the 1830s to the 1870s. Following the lead of his brother Pavel Tretyakov, Sergei Mikhailovich bequeathed his collection to the city of Moscow. Until 1925, it made up the Foreign Section of the Tretyakov Gallery, at which point it was transferred to the Pushkin Museum. Though Sergei Tretyakov's first art acquisitions were works from the easels of Russian artists, by the beginning of the 1870s he had immersed himself completely in the artistic life of Paris. The future collector's first mentors were the landscape painter Alexei Bogoliubov, who was living in France at the time, and Ivan Turgenev, who was a passionate art lover with his own collection of Barbizon School paintings. It is no accident that one of the best Barbizon School works in the Pushkin Museum collection, Théodore Rousseau's *In the Forest of Fontainebleau*, was acquired by Turgenev in 1875 at auction at the Hôtel Drouot in Paris and sold to Tretyakov only seven years later. Pictures by the Barbizon School and Camille Corot would later make up the lion's share of Tretyakov's collection of Western European art. Considering that artistic life in Paris during the last third of the 19th century presented an extremely varied picture, it is not surprising that Sergei Mikhailovich was able to recognise and appreciate the trend in French realist painting which resonated with the Russian landscape

[1] Y. Tugendhold. *Pervy muzei novoi zapadnoi zhivopisi.* Moscow, 1923, p. 7.

Mansion of Sergei Shchukin in Moscow

painters he knew so well. Because of Sergei Tretyakov, the Pushkin Museum's collection now contains works of Camille Corot, Jules Dupré, Charles-François Daubigny, Théodore Rousseau, Constant Troyon and Narcisse-Virgile Díaz de la Peña. With Alexei Bogoliubov's help, the collector acquired Gustave Courbet's *The Sea* and expanded his collection independently with the works of Jean-François Millet, Eugène Fromentin, Léon Bonnat, Jules Breton and Pascale Dagnan-Bouveret. The French part of Tretyakov's collection was strikingly crowned by *Rural Love*, from the easel of Jules Bastien-Lepage, an exceptionally well-known artist at the time who was especially popular in Russia. According to contemporary witnesses, Valentin Serov, a great admirer of Lepage's art, came to the Tretyakov Gallery every Sunday to look at the picture.

Sergei Tretyakov's main competitors were the Moscow collectors Pavel Ivanovich and Vera Andreyevna Kharitonenko. The scion of a Ukrainian sugar-refining family with an elegant mansion on the Sofiyskaya Embankment, Pavel Kharitonenko was an active philanthropist (he was one of the first to respond to Professor Ivan Tsvetayev's appeal for funds to build a museum of fine arts) who took a lively interest in Western European art. Like Sergei Tretyakov, the Kharitonenko couple preferred French painting, above all Camille Corot and the Barbizon School. Thanks to their collection, works of Horace Vernet, Eugène Isabey, Léon Lhermitte and Jean-Charles Cazin are now in the possession of the Pushkin Museum.

Works of the Barbizon School and canvases by Camille Corot, Gustave Courbet and Jean-François Millet made up the core of Dmitry Petrovich Botkin's collection of Western European painting. Botkin, from a family of major tea merchants, set aside special halls for these pictures in his home on Maroseika Street, which he opened for visitors. In the 1880s, the Botkin gallery was highlighted in all Moscow guidebooks as one of the city's main tourist attractions.

Finally, it is necessary to mention the works of French artists which made up an important part of Ilya Semyonovich Ostroukhov's collection. Better known as a collector of ancient Russian manuscripts, Ostroukhov also owned works by Degas, Matisse, Manet, Daumier and Renoir. He began collecting in the 1880s, and by the moment of the revolution in 1917 his Western European art collection numbered around forty works. After his collection was nationalised, Ostroukhov managed to obtain permission to open a museum of icons and paintings in his former house, in which he served as curator, guide, guard and ticket taker. The collection was redistributed after Ostroukhov's death in 1929, with the works by Russian artists being added to the Tretyakov Gallery collection, while those of European masters were dispersed throughout the country. The Pushkin Museum received just a few works, including a London landscape by Charles Daubigny and the remarkable *Portrait of Antonin Proust* by Edouard Manet.

Ostroukhov's collecting activities peaked at the turn of the 20th century, when the second generation of Moscow-industrialist art patrons were beginning to form their contemporary French art collections. The main representatives of this generation were the now world-famous Sergei Ivanovich Shchukin and Ivan Abramovich Morozov. Continuing the tradition established by their predecessors, they created two of the most impressive domestic galleries of contemporary art in the world, whose significance went far beyond that of ordinary private collections.

One might say that the spirit of experimentation and innovation inherent in contemporary French art at the time found an echo in the burgeoning growth of Russian mercantile capitalism; the keen ability to understand still-unrecognised art and to appreciate its genuine freshness and worth could be seen as parallel to the acute business sense, sharp intuition and love of risk for which Moscow industrialists were legendary.

The "secrets" of Shchukin and Morozov remain unexplained to this day, and a certain aura of enigma will probably always remain in their biographies. Their contemporaries often regarded these extravagant rich men with distrust and suspicion, since they paid what were significant sums at the time for works of French innovators considered by many to be "unbearable in their impudence" or "intolerably vulgar" (in the words of Sergei Shcherbatov). Later generations, on the other hand, have always been amazed by the faultless "eyes" of these collectors of 100 years ago, upon realising that the "Russian" Monets, Gauguins and Matisses which passed through the fine filter of the two collectors' individual tastes have now become indisputable classics against which works by the same masters in many other museums and private collections throughout the world are measured.

At a time when heated debates were still raging in France about whether to recognise the art of the Impressionists, and about whether Manet's *Olympia* and the Caillebotte collection were fit to be housed in government museums, the Moscow industrialists were actively making the rounds of Paris galleries in search of *le dernier cri*. The textile magnate Sergei Shchukin was one of the first to be seized by the idea of creating a contemporary art collection; soon his gallery would become a unique phenomenon in Russian and world culture.

Sergei Ivanovich belonged to a family famed for its activities in the area of collecting. Three of his brothers dedicated themselves to this activity: Dmitry carefully collected works by the Old Masters, Pyotr was a tireless lover of ancient Russian artefacts (which would later grace the collection of the Historical Museum in Moscow), and Ivan, the most unusual of all, settled in Paris, where he became a part of its bohemian art world and also put together a picture collection. It was Ivan Shchukin who, together with the

Shchukins' relative Fyodor Vladimirovich Botkin, first took his brother Sergei to Durand-Ruel's Paris gallery in 1898.

The energetic, passionate and enthusiastic Sergei Shchukin soon lost his head over the new French art, and his earlier idea of systematic collecting was swept aside by successive emotional obsessions for certain trends and painters. From the very beginning, he possessed a faultless collector's "sixth sense" and a fine "eye" — the majority of the works he bought were masterpieces. With each new passion, Shchukin's mansion on Bolshoi Znamensky Lane in Moscow, now his personal museum, was filled with first-rate artworks. From Shchukin's collection one can follow not only the history of the art of the day, but, as the art historian Boris Nikolayevich Ternovets put it, the collector's own "history of enthusiasms".

Shchukin's nearly seven-year first love for the art of the Impressionists ended in the birth of a unique "gallery", or "salon", dedicated to Monet, where one could follow the long evolution of that master's inimitable style. Along with the art itself, the Moscow collector was possibly attracted to the painter's conviction and fiery temperament, which were so similar to his own. The gallery consisted of 13 of the artist's works, from examples of early Impressionism to his very latest, purchased immediately after their creation (as with *Village of Vétheuil*, for example). One of the last works he bought was *Luncheon on the Grass*, the only surviving completed witness to the painter's early monumental conception.

Shchukin was so carried away with collecting that he saw the personal events of his life through its prism and often sought solace in his passion at tragic moments in his life. After the Impressionists came a stormy period (1906–1907) of collecting the paintings of Paul Gauguin, in whose tropical daydreams the collector would lose himself to assuage the sense of loss he experienced after the deaths of his wife and son. In just a few years, he acquired 16 Gauguin's pictures. Hung close together in several rows in the dark, wood-panelled interior of his dining room, the works created a special, concentrated environment which approached the sacral atmosphere the painter himself strove to achieve. It is no accident that contemporaries compared this wall in Shchukin's house with the iconostasis of a Russian church. The critic and historian Yakov Tugendhold wrote rapturously about the gallery: "Russia and snowy Moscow can be proud that they have given loving shelter to these flowers of eternal summer which their official mother-stepmother, France, failed to pick up."[2]

Towards 1910, Shchukin became a serious buyer and patron for two major 20th-century masters who were just entering their creative maturity: Henri Matisse and Pablo Picasso. Braving the prejudices of conservative public opinion, he decorated his home with their works, practically flaunting them before the public. Matisse's monumental canvases *The Dance* and *Music* were placed in the staircase of his mansion, and Matisse canvases adorned the central "rose room", too. The Russian collector first encountered the art of Matisse in 1908, and Shchukin's Moscow mansion became the first place where the artist was able to realise his dream of using his paintings to transform an interior into one harmonious environment. In just a few years, Matisse not only executed several dozen works for his Russian patron but personally took part in their installation, making a trip to Moscow in 1911 and also advising Shchukin in a lengthy correspondence. A rare mutual understanding arose between Shchukin, a frequent guest at Matisse's Paris studio, and the artist. The collector accepted unconditionally all of the master's ideas, even the most scandalous ones, being religiously convinced, as he wrote in France in December 1910, that "time will become my ally, and I will be victorious in the end."[3]

[2] Ibid., p. 48.
[3] Kostenevich 1993. p. 72.

60

Mansion of Ivan Morozov in Moscow

Led only by his collector's intuition, Shchukin began acquiring Picasso's canvases despite his initial aversion to them. The Moscow factory owner became one of the first connoisseurs and promoters of the avant-garde, infecting his contemporaries with his passion and enthusiasm. Shchukin "discovered" Picasso around 1908, remaining from that moment under the hypnotic spell of the "demonic Spaniard". Coming to an understanding and recognition of Picasso's genius was a painful and protracted process: already-purchased pictures would often languish undisplayed for a long time in his gallery. The mysterious Picasso both attracted and repelled, forcing the collector to overcome his habitual tastes and principles on the path to recognition of his art. However, Shchukin was wise enough to be able to repress his personal biases; relying on the guiding star of Picasso's genius, he amassed the largest and one of the finest collections of his works in the world (numbering more than fifty). Sergei Shchukin generously shared his enthusiasm for the magic of Picasso with visitors to his home, and Russian critics saw in the Spaniard and his works the embodiment of a contemporary "alchemist" of art.

In 1914, when Shchukin's collecting activities were interrupted by the First World War, the Moscow mansion on Bolshoi Znamensky Lane turned into a major private museum of contemporary art. It was opened to the general public, often with the owner himself in the role of museum guide. Shchukin's mansion became a place of pilgrimage for lovers of modern art: thanks to him, the Moscow art world was able to acquaint itself with the latest from Paris, sometimes before the French themselves. This gallery played a defining role in forming the style of the Russian avant-garde, and the fact that principally new and significant artistic events, like those of the "Jack of Diamonds" group, for instance, took place in Moscow was in large part due to Shchukin's efforts. Early on, Sergei Ivanovich began to ponder the fate of his unique collection. Before the revolution of 1917, he made the decision to transfer it to the city of Moscow as a bequest.

If the extrovert, active and impulsive Shchukin felt a constant need for the company of like-minded people and loved to discuss art and argue about it, his Moscow collecting colleague of many years, Ivan Abramovich Morozov, possessed a calmer and more balanced temperament, preferring to immerse himself in contemplative admiration of his art treasures to which, unlike Shchukin, he jealously restricted public access. Also a textile-factory owner (in an ironic twist, his factory town near Tver was dubbed "Paris" by its residents), he made his first Paris purchases of contemporary art in 1903 and, step by step, began turning his mansion on Prechistenka Street into a personal museum. Even today, the Morozov pictures in the Pushkin Museum — balanced, calm, with a decorative accent — are not difficult to distinguish from the "Shchukins" — bold, uncompromising artistic statements. This was the main difference between the two great collectors: Ivan Morozov was as concerned with the harmonious decoration of his house as with the systematic collection of modern artworks.

The first works to enter Morozov's home gallery were modest landscapes on a domestic scale by Alfred Sisley, which formed a "bridge" to the Russian industrialist's understanding of French art. He valued highly the works of Auguste Renoir, and in the majestic, epic rhythms of Cézanne's compositions he might have felt a consonance with his own contemplative and fundamental approach to art. By 1906–1907, Morozov had become one of the world's foremost collectors, organising in his personal gallery a small but systematic selection of works by the representatives of the 20th century's first "ism", *Fauvism* (the Fauves).

If Shchukin entrusted Matisse with the crucial task of creating atmosphere in his house, this function was carried out for Morozov by artists of the movement Les Nabis to which he was especially attracted. The harmonious and conflict-free world of Nabi art resonated with the Russian collector's own calm temperament; soon he became their generous patron and even co-author. Ivan Abramovich's major, one might even say fabulous, commissions were carried out by Maurice Denis, who visited Moscow in 1909, painting a whole series of large decorative murals for the mansion on Prechistenka Street, crowned by the famous *L'Histoire de Psyche* cycle, which created, together with sculptures by Aristide Maillol, a subtly planned visual effect in the main hall's ensemble. Pierre Bonnard took charge of the mansion's main staircase, executing several monumental decorative murals for it.

With Morozov, we see evidence of a thoughtful, art historian's approach to collecting; he acquired many works based not just on personal taste, but through a painstaking process of selection and lengthy consideration, giving preference to quality over quantity. Using this approach, he masterfully "illustrated" the creative evolution of Picasso and Matisse in the 1890–1910 period with just a few carefully selected works ranging from early, practically student examples to such consummate world-class masterpieces as *Girl on a Ball*. An important feature of Morozov's collecting was his parallel interest in the contemporary art of Russia as well as France. In his gallery, pictures by Korovin and Monet, Serov and Matisse complemented each other and enjoyed equal status. The collector often turned to Russian artists for advice; for example, he was often accompanied by the painter Valentin Serov, the author of the famous portrait of Morozov with a Matisse canvas in the background. It was this sense of dialogue between Russian and French art, a unique and not fully appreciated feature of the Morozov collection, which was lost, alas, after the transfer of the "Russian" part of the collection to the Tretyakov Gallery in 1925.

At the moment of the Bolsheviks' coming to power in 1917, the Moscow collections of contemporary European art were unparallelled for their richness. The new regime dealt cruelly with their creators: both Shchukin and Morozov were forced to leave the country, with the latter even committing suicide. Realis-

ing, however, the high value of their legacy, the Soviets disposed of it in a fairly rational manner; specialists came to the abandoned mansions and systematically catalogued the collections. In 1928 the collections of Shchukin and Morozov were united under one roof in the mansion on Prechistenka Street, where the State Museum of New Western Art, the first museum of its kind (and largest at the time), opened its doors to the public. This centre of learning became widely known both in Russia and abroad. In 1948, the museum fell victim to Stalin's campaign against formalism and was liquidated. The artworks purchased by Moscow collectors and industrialists were redistributed between the Pushkin Museum in Moscow and the Hermitage in Leningrad.

FRANCE

Théodore ROUSSEAU
Landscape with a Ploughman

Early 1860s
Paysage au laboureur
Oil on wood panel. 38 x 51.5
Signed bottom right:
Th. Rousseau
Herm.
Provenance: 1930, Gatchina Palace
Museum. Earlier: collection of Tsar
Alexander III at the Gatchina Palace

According to one legend, the composition depicts the view from the window of Rousseau's studio in Barbizon. Without doubt, the picture reflects the master's impressions of Barbizon, but even taking into consideration later changes in the village, there was never such a view from Théodore Rousseau's home on the Grande Rue. In *Landscape with a Ploughman*, the artist merely used motives taken from life. The painting was "composed" indoors in his studio rather than outside amid nature. (A. K.)

Camille COROT

A Gust of Wind

Mid-1860s — early 1870s
Le coup de vent
Oil on canvas. 48 x 66
Push. Mus.
Provenance: 1925. Earlier: until 1892,
collection of S. M. Tretyakov, Moscow;
Tretyakov Gallery

The artist creates an image of nature full of expression and drama imbued with the disquieting atmosphere of an approaching storm. The master's contemporaries already noted the affinity of this and other of his paintings with the 17th-century Dutch landscape tradition; the work may indeed have been inspired by a trip Corot made to Holland in 1854. Along with this, the master turns to a favourite theme of Romantic art, the juxtaposition of man and all-powerful nature, placing a small bent female figure under the wind-swept trees. The picture and its wind gust theme brought Corot success at the 1864 Salon; after this he would execute several similar canvases, among which was the *Gust of Wind* from Sergei Tretyakov's Moscow collection. (A. P.)

Charles DAUBIGNY

Banks of the River Loing

Late 1860s
Les Bords du Loing
Oil on canvas. 25.5 x 41
Signed bottom left: *Ch. Daubigny*
Herm.
Provenance: 1919. Earlier: collection
of O. Ovsyannikova, Petrograd

Researchers disagree about the paint-
ing's date. Daubigny painted pictures
like this one in the 1850s and 1860s
on board a specially-equipped studio
boat on which he travelled along the
rivers of Northern France. The striking
freshness of the colours, presaging
Impressionism, forces us to date this
landscape to the end of the 1860s,
however. Hellebrandt left the picture
undated in his catalogue of Daubigny's
paintings. (A. K.)

68

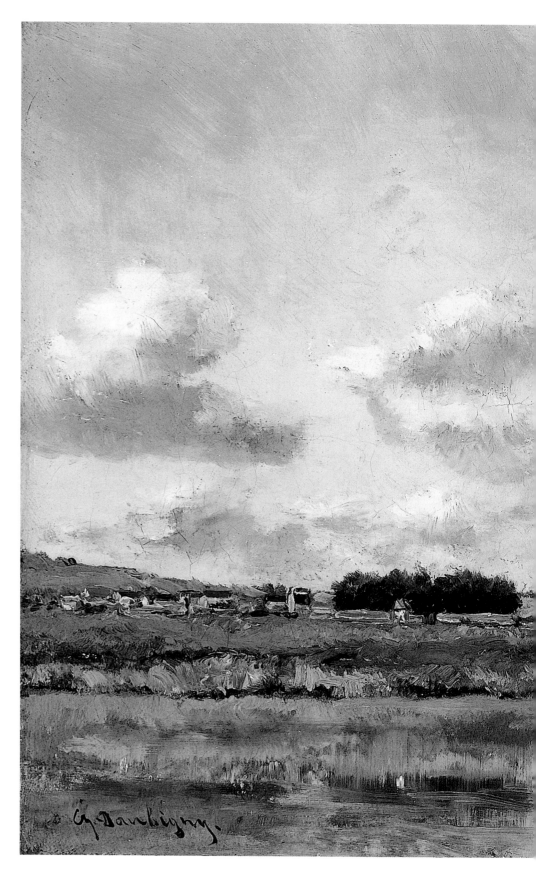

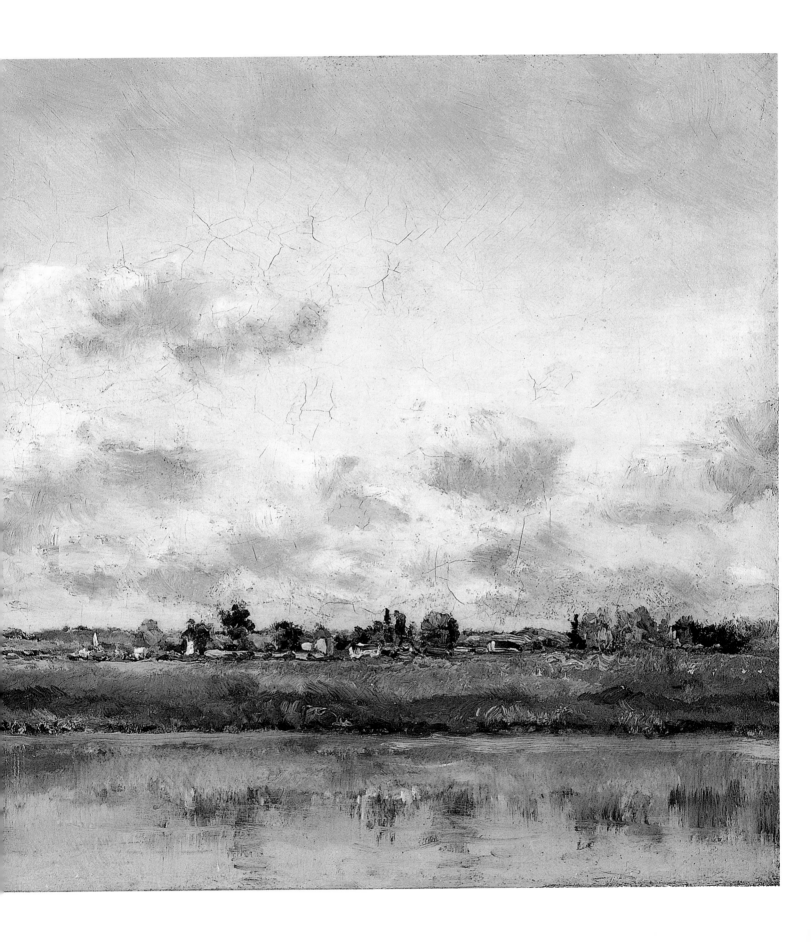

Charles CAROLUS-DURAN
Portrait of Nadezhda
Polovtsova

1876
Portrait de Mme N. M. Polovtsova
Oil on canvas. 206 x 124.5
Partially cut-off signature, inscription
and date at the top left: ...lus Duran
St. Petersbourg Juin 1876
Herm.
Provenance: 1926, Museum of the
Stieglitz Academy (Baron Stieglitz Central
Academy of Technical Drawing). Earlier:
collection of Alexander Polovtsov in
Petersburg (commissioned from Carolus-
Duran for 30,000 francs)

According to family legend, Nadezh-
da Mikhailovna Polovtsova (1838–
1908), née Yureneva, was the illegiti-
mate daughter of Grand Duke Mikhail
Pavlovich and K., a lady-in-waiting of
the Empress. Adopted and raised by
Baron Alexander Stieglitz, a leading
Russian financier and head of the
State Bank, she became one of Rus-
sia's richest brides in the mid 19th
century. The immeasurable wealth
she inherited from Stieglitz was large-
ly squandered by Alexander Polovtsov,
whom she married in 1861. Along
with financial fraud and speculation,
this senator, and later Secretary of
State and member of the State Coun-
cil, displayed a keen interest in art and
was an honorary member of both the
Academy of Fine Arts and Academy of
Sciences. Carolus-Duran came to the
Russian capital at his invitation. (A. K.)

Auguste RENOIR

Portrait of the Actress Jeanne Samary

1878
Portrait de Mlle Jeanne Samary
Oil on canvas. 174 x 101.5
Signed and dated bottom left: *Renoir 78 Herm.*
Provenance: 1948, GMNZI. Earlier: Galerie Durand-Ruel, Paris from 1881; returned to the artist in 1884; Galerie Durand-Ruel, New York from February to November, 1886; purchased by Durand-Ruel from the artist on 29 December 1886 for 1,800 francs; collection of Prince Edmond de Polignac, Paris from 29 December 1886 (purchased for 2,000 francs); again at the Galerie Durand-Ruel from 1897 (purchased for 4,000 francs); La Salle Collection, Paris from 1897; Galerie Bernheim-Jeune from 1898; collection of M. A. Morozov (bought at the Bernheim-Jeune Gallery); collection of M. K. Morozova from 1903; Tretyakov Gallery from 1910 (gift of M. K. Morozova); GMNZI from 1925

A large full-length portrait, the most imposing of the twelve or more oil and pastel portraits of Jeanne Samary executed by Renoir between 1877 and 1880. It was intended, together with the *Portrait of Madame Charpentier with Her Children* (*Portrait de Madame Charpentier et ses filles*) (1878, Metropolitan Museum, New York), for showing at the 1879 Salon. Only *Madame Charpentier with Her Children* enjoyed success at the Salon, however.

Jeanne Samary (1857–1890) came from an artistic family, making her debut at the Comédie Française at age eighteen. By 1877, she already owned nearly all the servant and soubrette roles in Molière's plays. Incidentally, there is nothing in Renoir's portrait to indicate the profession of his model; the artist admitted that he rarely saw her on stage: "I do not like how they act at the French Theatre" (*Je n'aime pas comme on joue au Théâtre Française*) (A. Vollard. *Auguste Renoir*. Paris, 1920, p. 169). Jeanne Samary is depicted here in a ball gown; she might have been dressed this way at Charpentier's, where the artist is believed to have met her. In all of Renoir's portraits, Jeanne Samary looks rather more elegant than in the photographs taken of her at the time. There is no hint of vulgarity, which she seems to have possessed to a degree. (A. K.)

Auguste RENOIR

In the Garden
(Under the Arbour of the
Moulin de la Galette)

1876–1880
Sous la tonnelle au Moulin de la Galette
Oil on canvas. 81 x 65
Push. Mus.
Provenance: 1948. Earlier: collection of
Eugène Murer, Paris; 1896–1897, collec-
tion of J. Villot, Paris; 1907, purchased at
the Villot collection sale at Galerie
Durand-Ruel on behalf of I. A. Morozov;
until 1919, collection of I. A. Morozov,
Moscow; MNZZh-2; from 1923, GMNZI

The canvas depicts the atmosphere of
the garden of an old mill in Mont-
martre, which was made into a well-
known cabaret and dance hall in the
19th century. In 1875, Renoir moved
in right next to the Moulin de la Galette
on the Rue Cortot, turning one of its
barns into a studio. From that moment
on, the artist's friends and the habi-
tués of that picturesque spot in the
very centre of Paris became the in-
variable heroes of his canvases. De-
pictions of dances at the cabaret oc-
cupy a central place in Renoir's mid-
1870s works, the Pushkin Museum
painting being part of an extensive
group of canvases connected with this
theme. According to the inscription on
the back of the canvas, the picture de-
picts the model Nini Lopez (standing
on the left), Claude Monet (in a hat,
seated, in profile), the artist Ch. Cordey
(in a straw hat and light suit, seated at
the table) and the artist F. Lamy (in
dark clothing, standing in back). (A. P.)

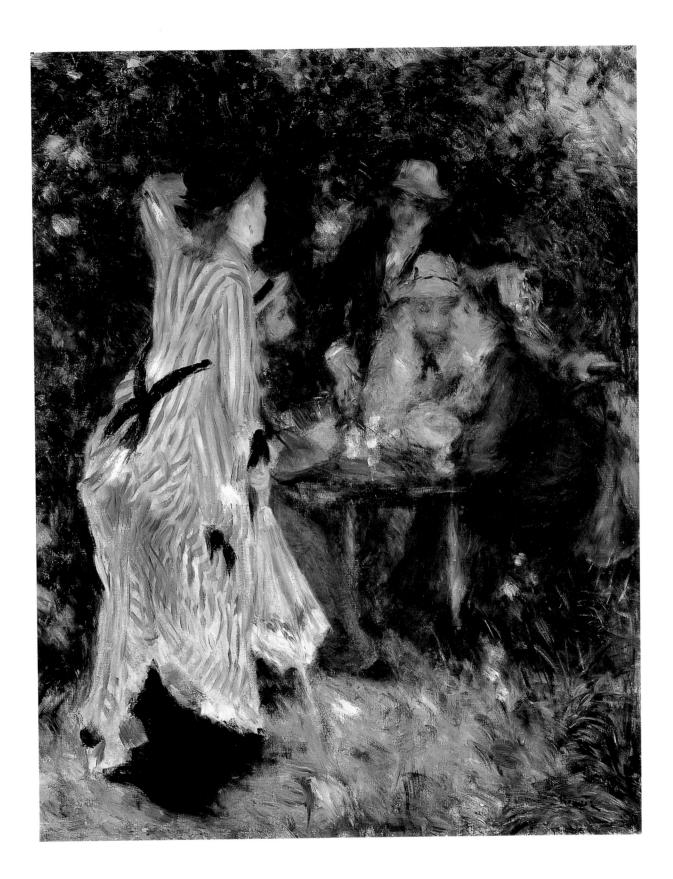

Edouard MANET

In the Bar (Le Bouchon)

1878–1879
Guinguette
Oil on canvas. 72 x 92
Push. Mus.
Provenance: 1948. Earlier: until 1900,
Tavernier collection, Paris; 1900,
purchased from Georges Petit at the
Tavernier sale, Paris, by S. I. Shchukin;
collection of S. I. Shchukin, Moscow;
until 1910, collection of M. A. Morozov,
Moscow; 1910, transferred to Tretyakov
Gallery in accordance with the will of
M. A. Morozov by his widow; until 1925,
Tretyakov Gallery; MNZZh-2; from 1928,
GMNZI

This painting, a work of the artist's mature period, remained in the stage of an unfinished study. This sketch, snatched from the life of a little Paris tavern and transferred to the canvas, was preceded by a series of preliminary drawings. The canvas is painted with a broad, confident brush; the tree trunk, the objects on the tables, and the main figures convey a feeling of depth with stereoscopic accuracy. The personalities and relationship of the picture's nameless heroes are conveyed bitingly and discerningly. Thanks to Manet's typical attention to detail, the bottles and glasses take on the features of an independent still life. Mikhail Morozov, one of the first serious Russian collectors of contemporary art, was attracted to the picture at the end of the 19th century and bought it, making In the Bar one of the first "new" French artworks to appear in Russia. (A. P.)

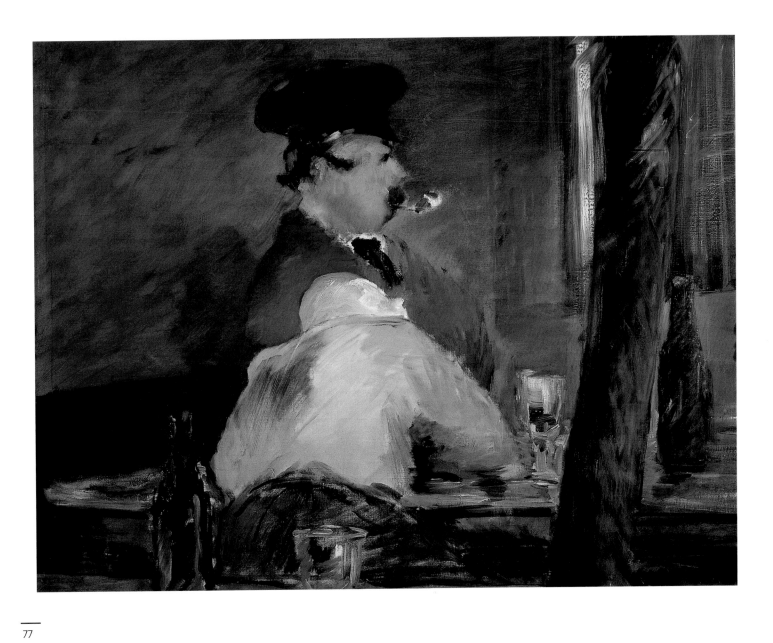

Claude MONET

The Pond at Montgeron

1876
L'étang à Montgeron
Oil on canvas. 174 x 194
Monogram at the bottom right: *Cl. M.t*
Herm.
Provenance: 1931, GMNZI. Earlier:
Hoschedé collection, Montgeron–Paris;
Galerie Vollard; collection of I. A. Morozov
from 1907 (bought for 10,000 francs);
MNZZh-2 from 1918; GMNZI from 1923

The painting was part of a decorative series in the Hoschedé home in Montgeron (a Paris suburb on the Yerres River). Along with *Corner of the Garden in Montgeron* (Hermitage, St Petersburg), the series also contained *Turkeys* (Musée d'Orsay, Paris) and *The Hunt* (Durand-Ruel Collection, Paris). Financier and entrepreneur Ernest Hoschedé and his wife Alice (she would later become Monet's second wife) were among those few who supported the Impressionists when they were still struggling for recognition. Monet spent the autumn of 1876 at the Château de Rottembourg, their estate in Montgeron. Though Monet usually painted outdoors at that time, this picture was done indoors based on a preparatory sketch (private collection). In this decorative work, Monet strove to capture his impression of nature exactly. (A. K.)

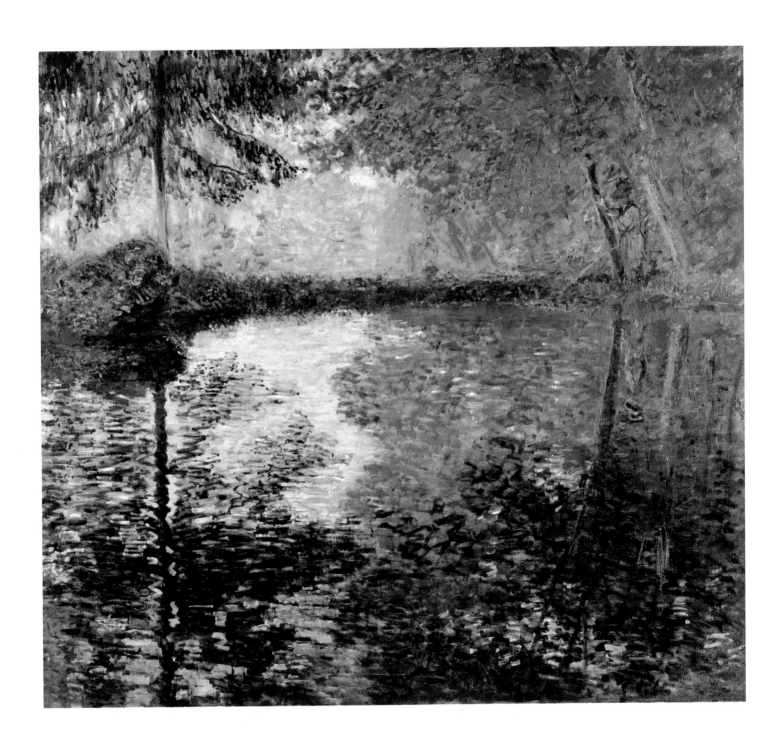

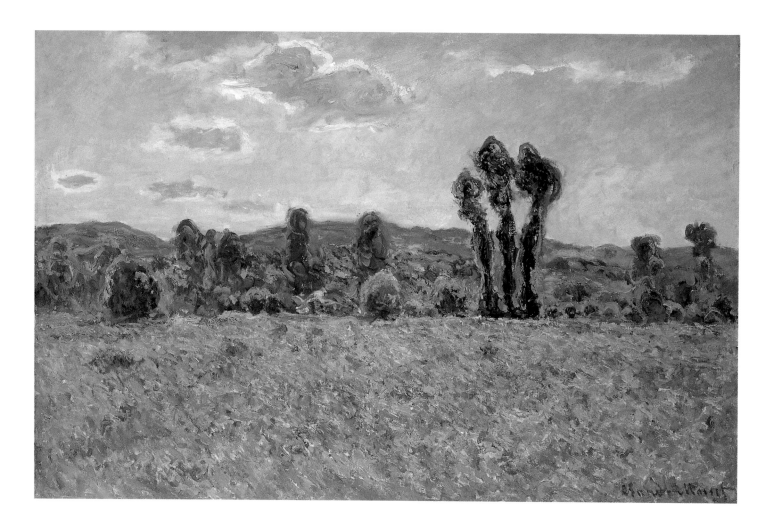

Claude MONET
Poppy Field

1890–1891
Champs de coquelicots
Oil on canvas. 61 x 92
Signed bottom right: *Claude Monet*
Herm.
Provenance: 1948, GMNZI. Earlier: Fey-
deau Collection, Paris; Galerie Bernheim-
Jeune from 1901 (Feydeau auction at the
Hôtel Drouot, 11 February, 1901, No. 74);
collection of M. A. Morozov; collection of
M. K. Morozova from 1903; Tretyakov
Gallery from 1910 (gift of M. K. Morozo-
va); GMNZI from 1925

Monet repeatedly depicted poppy
fields in the 1870s and 1880s, but
the Hermitage painting is distin-
guished from analogous ones by its
lack of detail and highly dynamic
painting manner. It should be dated
either 1890 or 1891. In those years,
Monet executed a series of "Poppy
Fields" similar to the Hermitage pic-
ture both stylistically and in terms of
the view depicted. In all cases we see
the plain of Essarts near Giverny with
the heights of Port-Villez in the back-
ground. Two pictures from this series
were dated by the artist himself: 1890
for the one in the Smith College Art
Museum in Northampton, Massachu-
setts and 1891 for the *Poppy Field* in
the Art Institute of Chicago. (A. K.)

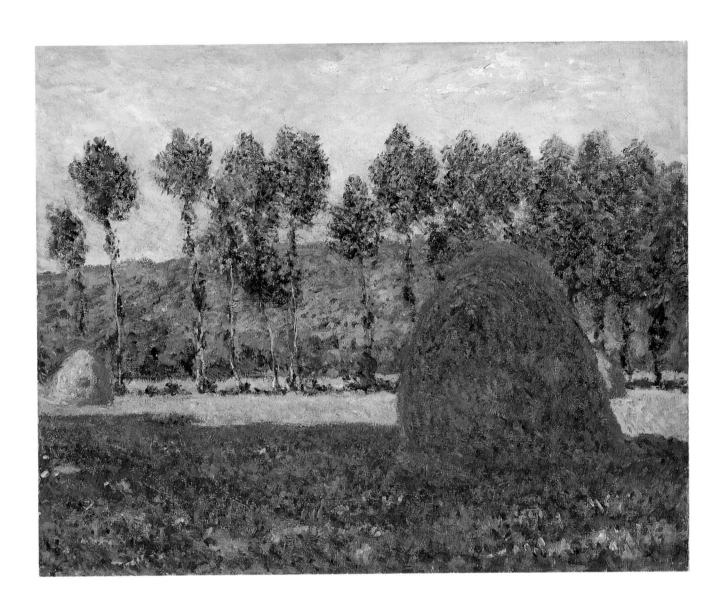

Claude MONET
Haystack at Giverny

1888
Une meule prés de Giverny
Oil on canvas. 64.5 x 87
Push. Mus.
Provenance: 1948. Earlier: 1906,
collection of Jean-Baptiste Faure, Paris;
1907, Durand-Ruel Collection, Paris;
1907, purchased from Durand-Ruel,
Paris, by I. A. Morozov; until 1919, collec-
tion of I. A. Morozov, Moscow; MNZZh-2;
from 1923, GMNZI

Monet's began work on his "Haystack" series of paintings in the mid-1880s, continuing until the early 1890s. Captured at different seasons and times of day, with varying illumination and atmospheric environments, the haystacks and row of poplars on the banks of a tributary of the Epte became a favourite motif for the artist. Most of the works in this series are constructed on a calm and epic rhythm of horizontals — in the Pushkin Museum painting these are formed by the row of poplar crowns, the line of the riverbank and its shadow, and a light diagonal emphasising the impression of three dimensions. The picture's colour scheme is subtly gradated. Around the turn of the century, the work entered the private collection of the singer Jean-Baptiste Faure, a friend and connoisseur of the Impressionists; in 1907 it was acquired by Ivan Morozov, who preferred "contemplative" Impressionist works to the more temperamental ones. (A. P.)

Camille PISSARRO
Avenue de l'Opéra. Snow
Effect. Morning

1898
Avenue de l'Opéra. Paris. Effet de neige
Oil on canvas. 65 x 82
Push. Mus.
Provenance: 1948. Earlier: Durand-Ruel
Collection; until 1918, collection of
S. I. Shchukin, Moscow; MNZZh-1;
from 1923, GMNZI

This work belongs to a romantic and poignant series of paintings executed by the aged artist in January and February of 1898. At the beginning of that year, he moved to the Hôtel du Louvre, which enjoyed a view of the Avenue de l'Opéra. With Impressionist accuracy, the master captures the haze of the damp city, the diffuse light of the low, grey sky and the shininess of the damp pavement, but an emotional accent is also introduced into the atmosphere, one of melancholy and loneliness. This series, the last of Pissarro's suite of Parisian views, is perceived as a farewell to motifs which were dear to the Impressionists from the very beginning. This painting was one of the first works of the new French school to enter a Russian collection, being acquired at the turn of the century by Sergei Shchukin. (A. P.)

Vincent Van GOGH

Portrait of Dr Felix Rey

1889
Portrait du docteur Rey
Oil on canvas. 64 x 53
Push. Mus.
Provenance: 1948. Earlier: 1889–1900,
property of Dr. Rey, Arles; 1900, Galerie
Vollard, Paris; Galerie Kassirer, Berlin;
until 1908, Galerie Druet, Paris; 1908,
purchased from Druet by S. I. Shchukin;
until 1918, collection of S. I. Shchukin,
Moscow; MNZZh-1; from 1923, GMNZI

In January 1889, Van Gogh was finishing his treatment at the hospital in Arles after his first attack of mental illness. During his stay there, the artist struck up a friendship with his doctor, the intern Felix Rey (1865–1932), who showed an interest in his paintings. To thank the doctor and simultaneously interest him in his art, Van Gogh decided to paint his portrait, finishing the work by 17 January. The *Portrait of Dr Rey* is marked by an intentional simplification of painting technique, intended perhaps to make the artist's creative language more accessible and understandable for the provincial doctor and dilettante. The recipient failed to appreciate his gift, however, and later parted with it without regret. In 1908, the picture entered Sergei Shchukin's collection in Moscow. To this day, it is the only Van Gogh portrait in a Russian museum. (A. P.)

Paul GAUGUIN

Matamoe (Death)
Landscape with Peacocks

1892
Paysage aux paons
Oil on canvas. 115 x 86
Push. Mus.
Provenance: 1948. Earlier: 1895,
purchased at the Gauguin picture sale
at the Hôtel Drouot, Paris, by Armand
Séguin; from 1906, Galerie Vollard, Paris;
1907, purchased at Galerie Vollard, Paris,
by I. A. Morozov; until 1919, collection
of I. A. Morozov, Moscow; MNZZh-2;
from 1923, GMNZI

This painting dates from Gauguin's first trip to Tahiti. The young Tahitian with an axe raised over his head is a scene that Gauguin actually saw while walking along the seashore early one morning. The incident is described in his diary, *Noa Noa*: "...on the shore is a man, practically naked, standing next to a high coconut palm... With an elegant and flexible motion, the man raises with both arms a heavy axe leaving a blue gleam on the silver background of the sky above and its mark on the dead tree below..." The Tahitian's pose with the axe repeats that of a figure on the frieze of the Parthenon, a photograph of which Gauguin had brought with him to Tahiti. Gauguin translated the Tahitian word *Matamoe* inscribed in the lower right corner as "death". The explanation for such a strange name given to this marvellous, celebratory landscape can be found in Gauguin's writings, where he wrote that the sight of the Tahitian chopping trees aroused in him the sense of his death as a civilised man and rebirth as a "savage". (A. P.)

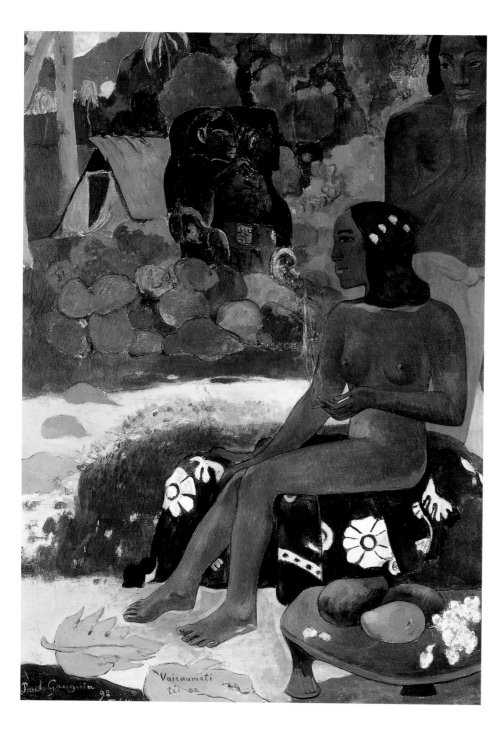

Paul GAUGUIN

Vairaumati Tei Oa
(Her Name is Vairaumati)

1892
Vairaumati tei oa
(Vairaumati elle se nommait)
Oil on canvas. 91 x 68
Push. Mus.
Provenance: 1948. Earlier: 1895, offered
at the Gauguin picture sale at the Hôtel
Drouot, Paris, but remained unsold;
1905–1918, collection of S. I. Shchukin,
Moscow; MNZZh-1; from 1923, GMNZI

Painted during the artist's first trip to
Tahiti, this picture was later included in
the famous Gauguin "iconostasis" on
the dining-room wall of Sergei Shchu-
kin's house. The Tahitian myth of the
god Oro and the beauty Vairaumati is
recounted by Gauguin in his book *Noa
Noa*: "Oro..., the greatest among the
gods, once decided to choose a girl-
friend from among mortal women... Af-
ter many days of vain effort, he was
about to return back to the heavens
when he ... noticed a young girl of un-
usual beauty... Vairaumati was the
girl's name... In the meantime, Vairau-
mati laid her table with fruits for the
guest and spread her couch with the
most luxurious fabrics..." Vairaumati
is depicted in the painting as a con-
temporary Tahitian woman with a cig-
arette in hand. The composition re-
flects the artist's attention to the tra-
ditions of this ancient civilisation.
Hinting at the Tahitian woman's com-
munion with the gods, Gauguin seats
her in the pose of a priestess which re-
calls ancient Egyptian reliefs and wall
paintings. (A. P.)

88

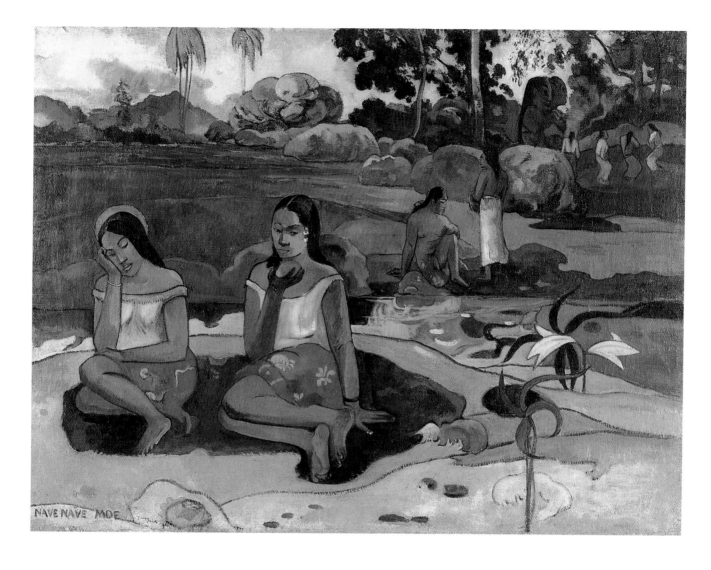

Paul GAUGUIN

Nave Nave Moe. Sacred Spring
(Sweet Reveries)

1894
Nave Nave Moe. Eau délicieuse
(Douces rêveries)
Oil on canvas. 74 x 100
Inscribed, signed and dated bottom left:
NAVE NAVE MOE P. Gauguin 94
Herm.
Provenance: 1931, GMNZI. Earlier: Gauguin exhibition/sale at the Hôtel Drouot, Paris, 18 February 1895, No. 23; collection of Emile Schuffenecker (purchased for 340 francs); Dosbourg sale of 10 November 1897, Paris, No. 16 (160 francs); collection of the Prince de Wagram; Galerie Vollard; collection of I. A. Morozov from 1908 (purchased from Vollard for 8,000 francs); MNZZh-2 from 1918; GMNZI from 1923

The painting's subtitle "Sacred Spring", which it is traditionally known by in Russia, comes from the catalogue of the 1895 Gauguin exhibition/sale, which was probably put together by the artist himself (it is called "Eau delicieuse" there). Incidentally, the Tahitian name written on the picture itself translates differently. Georges Wildenstein interprets it as "The Joy of Leisure" (*Joie de se reposer*). Bouge and Danielsson offered more precise variants: "Sweet Reveries" and "Sweet Dreams". The picture belongs to the period between two of Gauguin's stays in Tahiti. It was painted in Paris at the beginning of 1894 as a memento of Oceania and was constructed of images from the first Tahitian period. Richard Field posited that the double Tahitian deity is the supreme god Taaroa and one of his wives (R. S. Field. *Paul Gauguin: The Paintings of the First Voyage to Tahiti*. New York–London, 1977, p. 95).

The picture which Gauguin relied on most of all when creating his *Sacred Spring* was *Women on the Riverbank* (private collection, Paris). That canvas was executed in a rather Impressionist manner, which the artist later rejected, moving on to the stylised generalisations of synthetic composition imbued with his peculiar religious ideas. The necessity of expressing these ideas led to the inclusion of the double idol (it was not there in *Women on the Riverbank*), as well as the Virgin Mary and Eve with an apple in the foreground, depicted as Tahitian women. (A. K.)

The picture is related to the large composition *Where Do We Come From? What Are We? Where Are We Going?* (Museum of Fine Arts, Boston). In the centre of that mural there is a figure of a man raising his hand to pick a fruit on a tree. He is depicted there just as he is in the preparatory painting for the mural, which the artist entitled "Tahiti. Personages from *Where Do We Come From?...*", practically naked, in just a loin cloth. In the mural this fig-

ure plays an important symbolic role, as an obvious allusion to the tree of knowledge. In *Man Picking Fruit from a Tree*, however, there is no clear philosophical idea; the picture is more like an everyday scene. We can assume, therefore, that it was executed before the Boston mural. Later, the personage from the Hermitage painting will appear in *Faa Ara* ("The Awakening") (1898, Ny Carlsberg Glyptotek, Copenhagen). (A. K.)

Paul GAUGUIN

Man Picking Fruit from
a Tree

1897
Homme cueillant des fruits dans
un paysage jaune
Oil on canvas. 92.5 x 73.3
Signed and dated bottom left:
P. Gauguin 97
Herm.
Provenance: 1948, GMNZI. Earlier: Sent
by Gauguin in Tahiti to Vollard on 9 December 1898; Galerie Vollard; collection
of S. I. Shchukin; MNZZh-1 from 1918;
GMNZI from 1923

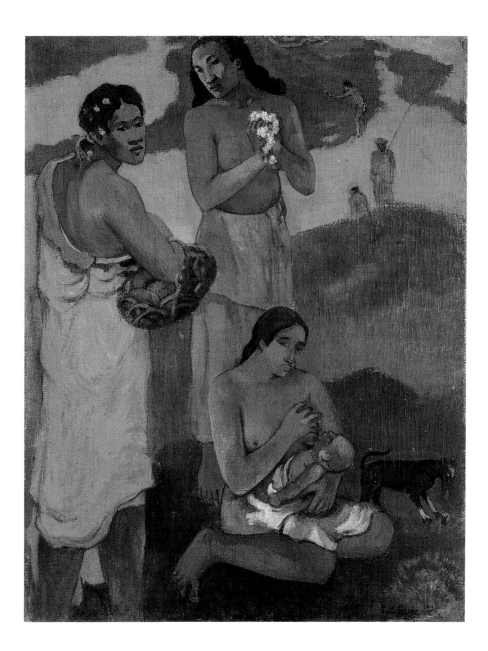

Paul GAUGUIN

Three Women on the Seashore
(Maternity)

1899
Femmes au bord de la mer (Maternité)
Oil on canvas. 95.5 x 73.5
Signed and dated bottom right:
Paul Gauguin 99
Herm.
Provenance: 1948, GMNZI. Earlier:
Galerie Vollard from 1900; collection of
S. I. Shchukin from 1903 or 1904;
MNZZh-1 from 1918; GMNZI from 1923

In March 1899, Pahura gave birth to a son whom Gauguin named Emile (this was the name of his first son from his first wife, Mette; who remained in Copenhagen). Wildenstein, Danielsson and several other critics connected this event with two paintings, which they referred to as "Maternity I" (Hermitage) and "Maternity II" (former collection of David Rockefeller, New York). The second canvas is distinguished by a greater brightness and decorativeness, and also by the absence of the dog and figures in the background.

The Hermitage composition was part of a shipment of 10 canvases sent to Vollard in January 1900 with the following description: "8) Three figures. In the foreground, a seated woman breastfeeds an infant. On the right, a small black dog. On the left, a woman in a red dress standing with a basket. Behind, a woman in a green dress holding flowers. In the background, blue lagoons and orange-red sand" (J. de Rotonchamp. *Paul Gauguin*. Paris, 1925, p. 221). (A. K.)

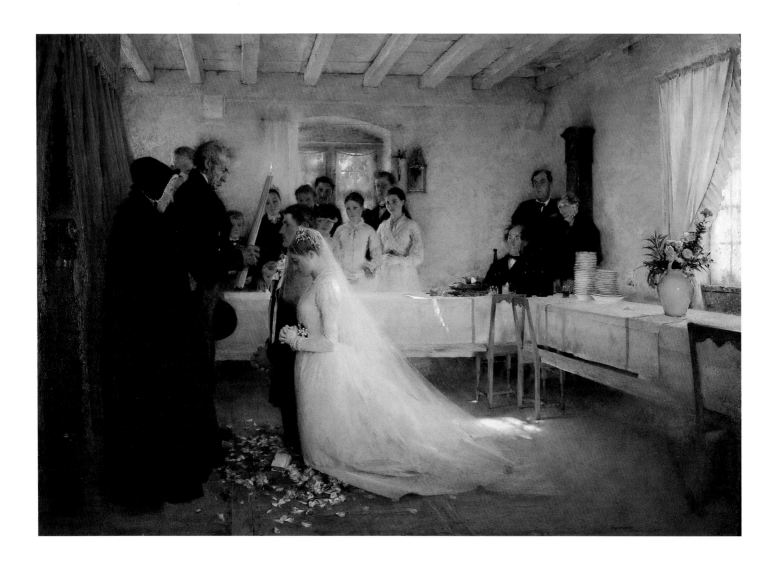

Pascal DAGNAN-BOUVERET

Blessing of the Young Couple
Before Marriage

1880–1881
La bénédiction des jeunes époux
Oil on canvas. 99 x 143
Push. Mus.
Provenance: 1948. Earlier: winter of
1888, purchased at the Dagnan-Bouveret
exhibition, Paris, by S. M. Tretyakov;
until 1892, collection of S. M. Tretyakov,
Moscow; from 1892, Tretyakov Gallery;
from 1925, Pushkin Museum;
from 1930, GMNZI

Depicted is a scene of parents bless-
ing the young couple before leaving
their house for the church, as was the
custom among the people of Franche-
Comte, the ancient province in cen-
tral France where Dagnan-Bouveret
often travelled in search of subjects
for his genre paintings. The painting
brought the artist fame at the 1882
Salon, where the critics declared it
one of his best works. The picture's
success at the Salon, together with its
similarity to certain works of Russia's
"Wanderers", aroused the interest of
Sergei Tretyakov, who bought it for his
Moscow collection. Along with the an-
ecdotal subject, the work possesses
unquestionable painterly virtues, such
as the subtle conveyance of detail and
lighting effects which we can see in
the brilliantly executed still life with a
stack of dishes, bottles and a vase of
flowers on the wedding table. (A. P.)

James TISSOT

Ruins (Inner Voices)

1885
Les Ruines (Les Voix intimes)
Oil on canvas. 214 x 124
Herm.
Provenance: 1922, State Museum Fund.
Earlier: in the artist's collection until
1903; posthumous sale of Tissot's Paris
studio in 1903 (L'Atelier de M. James Tis-
sot, Paris, Hôtel Drouot, Lot 1); Auer col-
lection, Petrograd; State Museum Fund,
Petrograd from 1918 or 1919

The painting was entered in the Her-
mitage catalogue under the name
"Christ Consoling the Wayfarers" (*Le
Christ consolant les pauvres*). Howev-
er, the artist's name for the picture,
which it was known by during his life-
time, was "Ruins", and it was pub-
lished under this name as an engrav-
ing in Clifton Levy's book (C. H. Levy.
James Tissot and His Work. New Out-
look, London, p. 955). At the Paris sale
of Tissot's studio in 1903, the paint-
ing figured under the name "The Vi-
sion" (*L'Apparition*). That is probably
when it came to Russia, since until re-
cently it was considered in the West to
be lost. It was this picture which sig-
nalled Tissot's turn to the Catholic
faith, as a result of which the entire
next period of his life would be dedi-
cated to Christian and Biblical themes.
(A. K.)

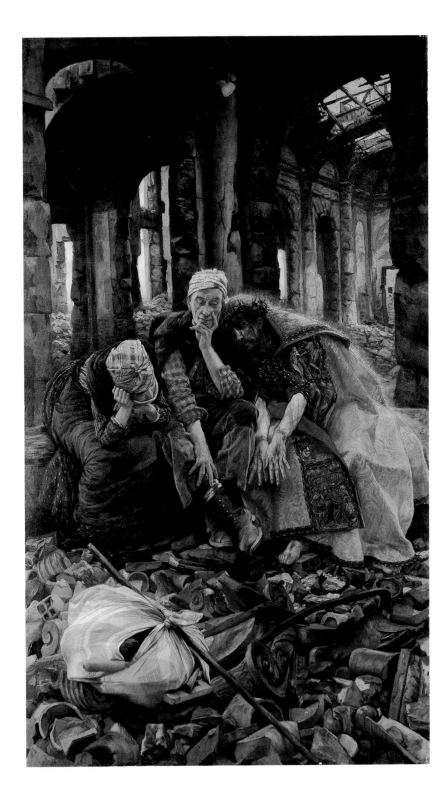

Paul CEZANNE

Girl at the Piano. *Tannhauser* Overture

Circa 1869
Jeune fille au piano. L'ouverture de "Tannhauser"
Oil on canvas. 57.8 x 92.5
Herm.
Provenance: 1948, GMNZI. Earlier: collection of Maxime Conil, Montbriand; Galerie Vollard from 18 December 1899; collection of I. A. Morozov from 1908 (purchased from Vollard for 20,000 francs); MNZZh-2 from 1918; GMNZI from 1923

The picture was painted at Jas de Bouffan. The same wallpaper pattern is visible on the background of the later *Self-Portrait in a Straw Hat* (1878–79, Museum of Modern Art, New York, R. 384), and the armchair is depicted in the earlier *Portrait of Louis-Auguste Cézanne, the Artist's Father, Reading "L'Evénement"* (1866, National Gallery, Washington, R. 101). At the piano are most likely the artist's sisters: the elder, Mary, and the younger, Rosa. By some accounts, two earlier versions of the composition existed, but did not survive. Work on the first was begun in 1866 and the second, in brighter colours, in the summer of 1867. The second version appears to have been influenced by Manet's *Madame Manet at the Piano* (1867, Musée d'Orsay, Paris). In general, the artist is striving in the work for greater simplicity and laconicism. A hypothesis that the earlier versions might be hidden under the Hermitage composition has now been rejected. Apparently, Cézanne was dissatisfied and simply destroyed them.

The picture's subtitle reminds us of the music of Cézanne's beloved Wagner, a standard-bearer of the avant-garde in music at the time. (A. K.)

94

Paul CEZANNE

Bridge over the Marne
at Creteil

1888–1895
Les bords de la Marne
Oil on canvas. 71 x 90
Push. Mus.
Provenance: 1948. Earlier: 1912,
purchased at Galerie Vollard, Paris,
by I. A. Morozov; until 1919, collection
of I. A. Morozov, Moscow; MNZZh-2;
from 1923, GMNZI

Cézanne painted many views of the River Marne. Today, most researchers date this landscape to 1894, when the artist made a trip to Paris and small towns in the Île-de-France. John Rewald discovered the exact topography of Cézanne's landscape, identifying the place as the town of Creteil on the Marne, not far from where the river flows into the Seine. *Bridge over the Marne at Creteil* embodies Cézanne's unique manner and the supreme degree of elaboration and refinement which marks his works from the 1890s. The painting's organisation of space, creating an impression of depth and three-dimensionality, its colour scheme, and its fine textural gradations are impressive in their degree of elaboration and perfection. In 1902, the picture was bought by Moscow collector Ivan Morozov, a discerning connoisseur of Cézanne's art and owner of an extensive collection of his works. (A. P.)

96

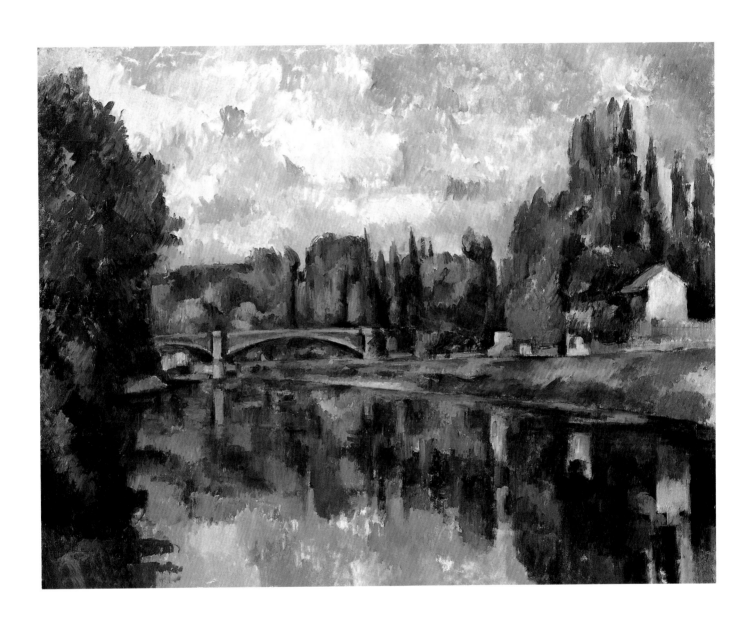

Paul CEZANNE

Woman in Blue

Circa 1900
Dame en bleu
Oil on canvas. 90 x 73.5
Herm.
Provenance: 1948, GMNZI. Earlier:
Galerie Vollard; collection of
S. I. Shchukin; MNZZh-1 from 1918;
GMNZI from 1923

Venturi dated *Woman in Blue* to 1900. The photograph of the painting in Vollard's archive is marked "1899". The Hermitage composition is usually compared to *Woman with a Book* (Phillips Collection, Washington, R. 945), where the model is wearing the same dress and hat. One other detail in the picture, the rug in the lower right, figures in *Still Life with Apples and Oranges* (circa 1899, Musée d'Orsay, Paris, R. 847), and also in *Young Italian Woman at a Table* (private collection, New York, R. 812), which is now usually dated 1900.

The identity of the model remains unknown.

Françoise Cachin interprets the left part of the background as a reproduction of one of Cézanne's pictures, probably *Large Bathers* (1900–1905, Barnes Foundation, Marion, Pennsylvania, R. 856). Indeed, Cézanne resorted to such self-citation more than once. The placing of his model in stark contrast to a whole group of nude women could have been an expression of Cézanne's peculiar sense of humour. (A. K.)

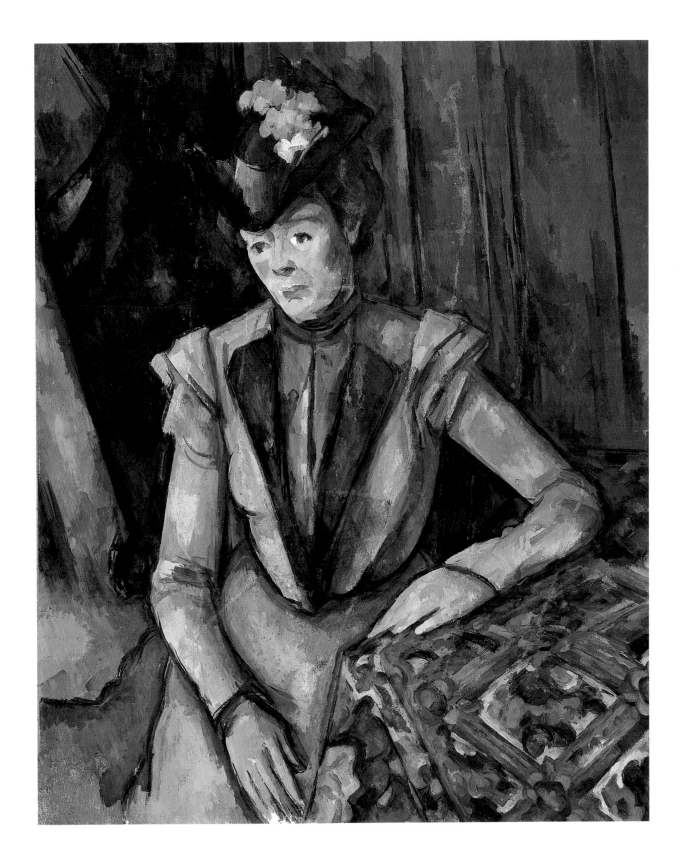

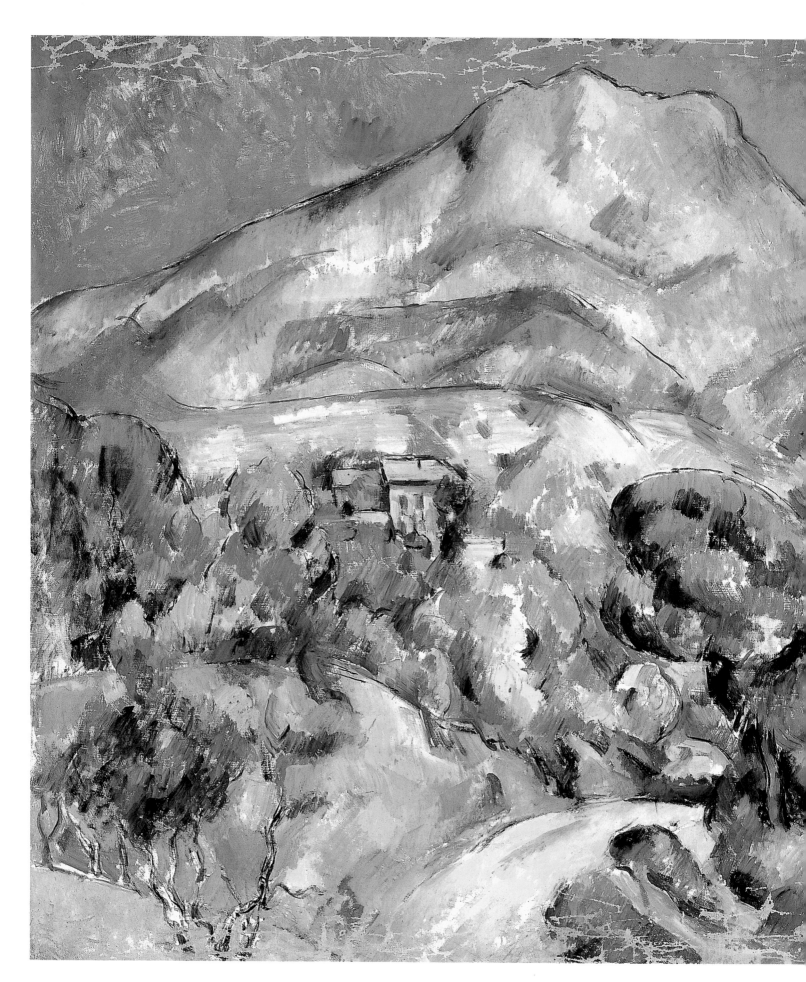

Paul CEZANNE
Mount Sainte-Victoire

Circa 1896-1898
La montagne Sainte-Victoire
Oil on canvas. 78.5 x 98.5
Herm.
Provenance: 1948, GMNZI. Earlier: Galerie
Vollard; collection of I. A. Morozov from 1907
(purchased from Vollard for 20,000 francs);
MNZZh-2 from 1918; GMNZI from 1923

Comparing the picture with a photograph of the subject made by John Rewald in 1935 reveals that Cézanne, while accurately reproducing real details, distorted the perspective significantly, moving the mountain forward a great deal. A unique, "amplified" understanding of perspective, intended to convey all the energy of colour, distinguishes the Hermitage landscape from the artist's other Mount Sainte-Victoire paintings. The landscape's unusual three-dimensionality is especially striking when compared with a later version in the Cleveland Art Museum where the mountain, though viewed from practically the same angle, recedes significantly farther into the distance.

The painting is rather badly damaged at the top and bottom due to being stored rolled-up. Vollard is known to have received many of the master's canvases in that condition.

Rewald dated the picture most convincingly, to 1896–98. He explained that Cézanne, in creating the landscape, looked at the mountain from the road to Tholonet (in his catalogue the painting is called "Le Mont Sainte-Victoire au-dessus de la route du Tholonet"). Château Noire, where the artist rented a room for work, is halfway between Tholonet and Mount Sainte-Victoire. In the picture, the house is hidden behind the trees. (A. K.)

Paul CEZANNE
Mont Sainte-Victoire
Seen from Les Lauves

Circa 1906
Paysage d'Aix (la montagne
Sainte-Victoire)
Oil on canvas. 60 x 73
Push. Mus.
Provenance: 1948. Earlier: 1911,
purchased at Galerie Vollard, Paris,
by S. I. Shchukin; until 1918, collection
of S. I. Shchukin, Moscow; MNZZh-1;
from 1923, GMNZI

This painting is one of Cézanne's last
views of his favourite mountain,
caught from the road to the hills of Les
Lauves, where the artist created a stu-
dio in 1901 to get closer to his favou-
rite subject. The nearly square, crystal-
like fragments of forms on the canvas'
surface arrest us with their richness of
colour and multi-layeredness. The va-
riety of colours and their division into
a patchwork of fields on Mont Sainte-
Victoire's slope is transformed by
Cézanne into an almost abstract play
of brushstrokes, both joining together
and parting in front of the viewer's
gaze. This quality of Cézanne's late
work (and this picture is commonly
dated to 1906, the year of his death)
was highly valued by the Cubists, who
would interpret the hermit of Aix's
unique creative "will and testament"
in their own way. (A. P.)

102

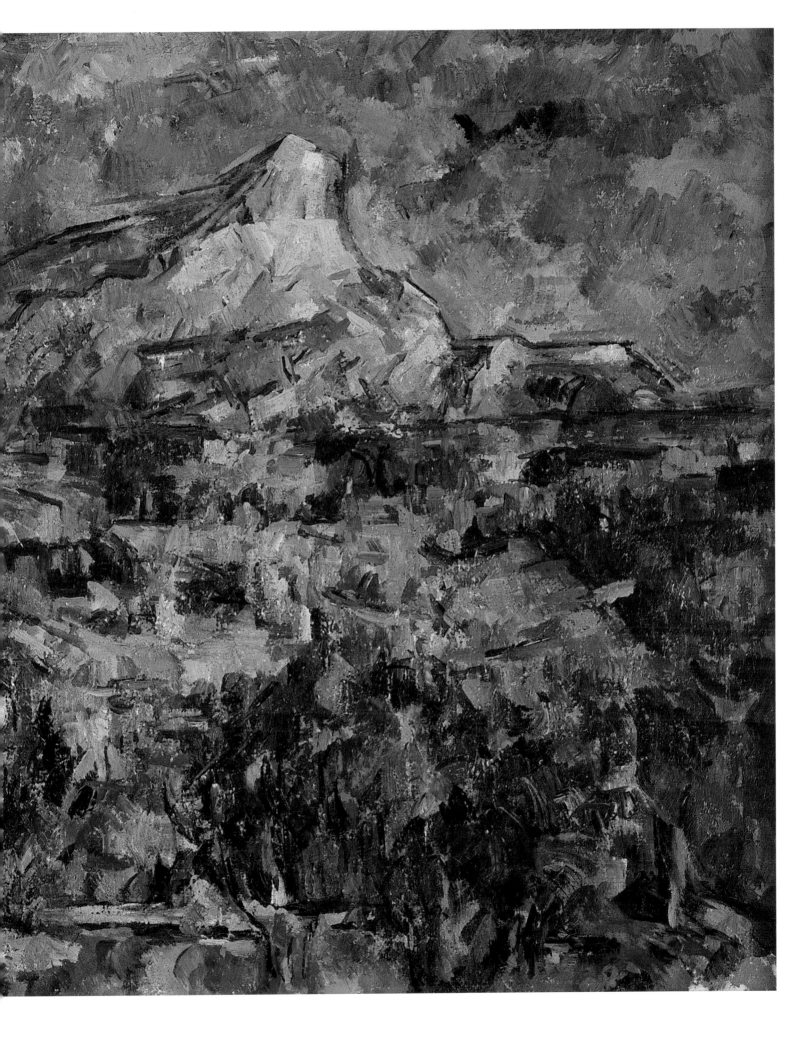

Albert BESNARD
Portrait of the Kharitonenko
Sisters (Princess Elena
Urusova and Countess
Natalia Stenbok)

1903
Les soeurs Charitonenko
Oil on canvas. 80 x 66
Push. Mus.
Provenance: 1948. Earlier: until 1918,
collection of P. I. and V. A. Kharitonenko,
Moscow; State Museum Fund; until 1925,
Pushkin Museum; until 1948, GMNZI

Besnard, a fashionable Parisian salon portraitist, was popular at the turn of the 20th century in high-society circles for his recognisable style, which cleverly combined traditional qualities of the portrait genre — intimacy, and good composition and likeness in a staged indoor portrait — with the innovations of the Impressionists. Their influence can be seen here in the light colouration of the elegant dresses and the airiness of the brushstrokes, lending freshness to the flowers in the bouquet. Inviting a French artist was prestigious and *comme il faut* for the father of the depicted ladies, well-known sugar magnate Pavel Ivanovich Kharitonenko, who owned a significant collection of French paintings and was known in Moscow as a connoisseur of things elegant and refined. In 1905, the just-painted portrait took up its place of honour at the exhibition of Russian portraits held in Petersburg's Tauride Palace. (A. P.)

Charles GUERIN

Two Girls on a Terrace

1903
Jeunes filles sur une terrasse
Oil on canvas. 147 x 131
Push. Mus.
Provenance: 1948. Earlier: until 1918,
collection of S. I. Shchukin, Moscow;
MNZZh-1; from 1923, GMNZI

A touching nostalgia for the past, the "Age of Gallantry" in particular, was typical for this artist, whose favourite subject was ladies in luxurious antique dresses. The languid movements of the personages, seemingly abandoned to reverie, emphasises their unique detachment and isolation in their idyllic world. The work's colour execution combines Impressionistic attention to the light and atmospheric environment with a subtle decorativeness recalling the art of *Les Nabis*.

"The talented Charles Guérin is reminiscent of our Borisov-Musatov in the elegant aristocracy of his female figures and his distant hints of tapestry art", remarked Russian art historian and essayist Pyotr Pertsov in 1922, underlining a sort of intuitive dialogue between Russian and French art which existed at the beginning of the 20th century. (A. P.)

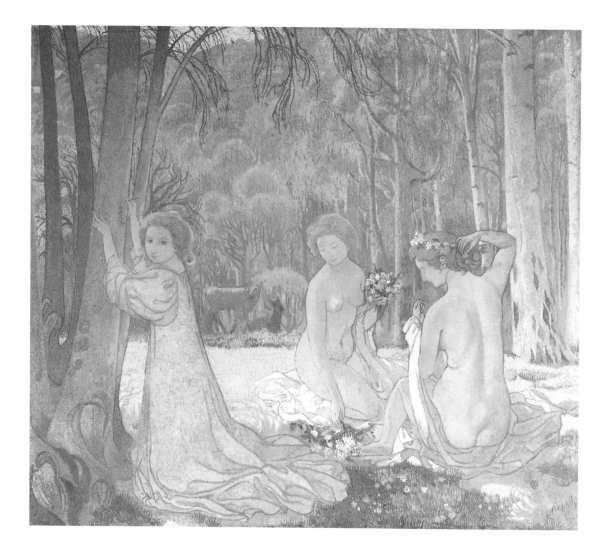

Maurice DENIS

Figures in a Spring Landscape
(Sacred Grove)

1897
Figures dans un paysage de printemps
(Le bois sacré)
Oil on canvas. 156.3 x 178.5
Monogram and date on the trunk of the
tree at the left: *MAUD 97*. Monogram in
a circle at the bottom right: *MAUD*
Herm.
Provenance: 1948, GMNZI. Earlier:
Galerie Vollard from February 1899 (pur-
chased from the artist for 1,000 francs);
collection of P.I. Shchukin from 1899 or
1900; collection of S. I. Shchukin from
1912; MNZZh-1 from 1918; GMNZI
from 1923

The painting probably received the ti-
tle "Sacred Grove" at Galerie Vollard.
The author's title, *Figures dans un
paysage de printemps*, is written on
the back of the canvas. In his diary
(January 1909), Denis refers to the
picture as "Spring in the Forest". The
name "Sacred Grove" shows that the
artist's contemporaries considered
the painting to be a descendant of Pu-
vis de Chavannes' composition by
that name (1884, Musée des Beaux-
Arts, Lyon), which was extremely pop-
ular at the turn of the century. We are
also reminded of Sérusier's picture *In-
cantation or the Sacred Forest* (1891,
Musée des Beaux-Arts, Quimper),
which Maurice Denis was undoubted-
ly familiar with. Similar subjects were

often treated by the academic artists.
The picture was foreshadowed by De-
nis' works of the early 1890s, *Soir Tri-
nitaire* (1891, private collection), *Girls
Who Would Be Called Angels* (1892)
and others. By that time, Denis was al-
ready using the technique of tripling a
single image. We might also mention
Virgin Spring (1894, Le Prieuré Muse-
um, Saint-Germain-en-Laye), where the
images of young women in a grove are
connected with the theme of awaken-
ing nature. Alexander Benois claims
it was on his initiative that Sergei
Shchukin advised his brother Pyotr to
buy the picture at Vollard's (A. Benois.
Moi Vospominaniya. Moscow, 1990,
Book 4, Vol. II, p. 151). (A. K.)

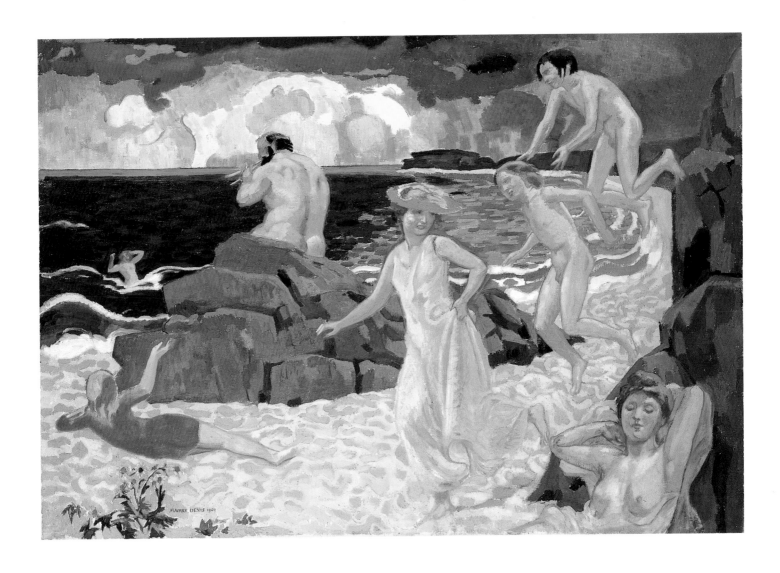

Maurice DENIS

Polyphemus

1907
Polyphème
Oil on canvas. 81 x 116
Push. Mus.
Provenance: 1948. Earlier: early spring
1907, purchased from the artist, Saint-
Germain-en-Laye, by I. A. Morozov; until
1919, collection of I. A. Morozov, Moscow;
MNZZh-2; from 1923, GMNZI

At the beginning of the 1910s, sever-
al former members of *Les Nabis* —
Pierre Bonnard, Ker-Xavier Roussel
and Maurice Denis — fulfilled a com-
mission for a cycle of works to deco-
rate collector Ivan Morozov's mansion
in Moscow. The harmonious and con-
flict-free world of the Nabis paintings
was dear to the Russian collector, who
himself possessed a calm tempera-
ment: he soon became a patron and
even co-creator for the group, as
Shchukin was for Matisse and Picas-
so. Morozov ordered *Polyphemus* as a
pair for the composition *Bacchus and
Ariadne* (Hermitage), his first pur-
chase from the artist. Denis's con-
ception interweaves the mythological
with the real: modern bathers on the
beach share the landscape with the
mythological cyclops Polyphemus. A
key Symbolist idea seems to be ma-
terialised here: the dream of a Golden
Age where an all-embracing poetic
harmony permeates all aspects of life.
(A. P.)

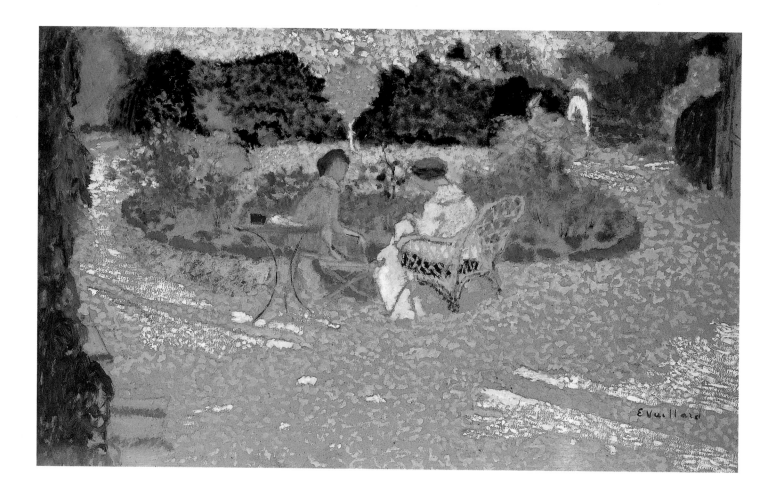

Edouard VUILLARD

In the Garden

Circa 1898
Au jardin
Tempera on pasteboard. 51 x 83
Push. Mus.
Provenance: 1948. Earlier: until 1918,
collection of Prince S. A. Shcherbatov,
Moscow; 1918, transferred by the owner
to the Rumiantsev Museum, Moscow
for safekeeping; from 1924, Pushkin
Museum; from 1925, GMNZI

The scenes in the pictures of *Les Nabis* member Edouard Vuillard, whose manner is often referred to as "intimism", usually take place in melancholy chamber interiors or restful gardens. The master always felt comfortable in this closed, familiar world, regardless of whether he was working on a small picture or a monumental decorative mural. The Pushkin Museum's *In the Garden* is part of a major cycle entitled "Public Gardens" executed in the mid-1890s for the collector Alexandre Natanson, one of the founders of the journal *La Revue Blanche*. Vuillard subtly transforms the unpainted yellowish brown surface of the pasteboard into the ground of a garden path on which he scatters sunbeams in pastel tempera tones. The lines of the work's compositional structure are marked by a gradual, bending rhythm, like the Art Nouveau works which many of the Nabis artists were indebted to. (A. P.)

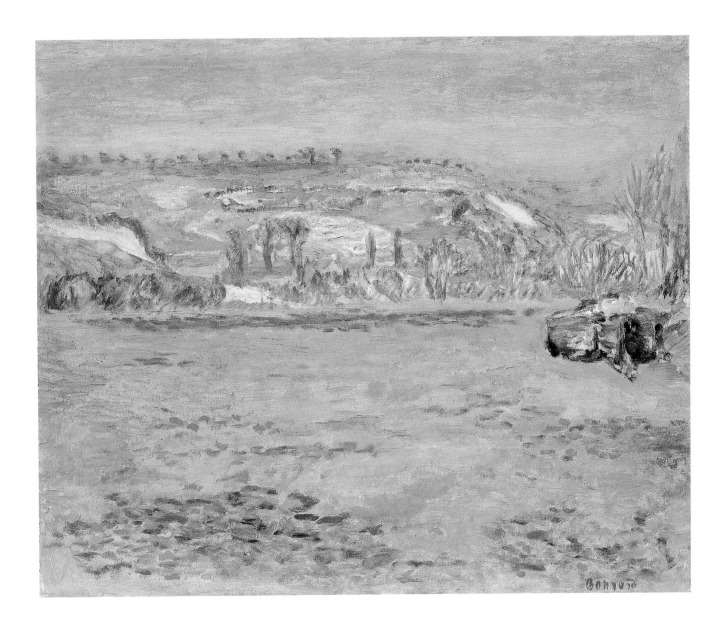

Pierre BONNARD
The Seine at Vernonnet

1911
La Seine à Vernonnet
Oil on canvas. 51 x 60.5
Push. Mus.
Provenance: 1948. Earlier: 1911, purchased from the artist by Galerie Bernheim-Jeune, Paris; 3 Jan. 1913, purchased from Galerie Bernheim-Jeune by I. A. Morozov; until 1919, collection of I. A. Morozov, Moscow; MNZZh-2; from 1923, GMNZI

In 1910, Bonnard began working in the village of Vernonnet on the Seine, near Vernon and Giverny. The artist took trips along the Seine beginning in the early spring; it is likely that *The Seine at Vernonnet* in the Pushkin Museum collection was painted under the impression of such a trip. It is part of a group of landscapes of analogous composition and theme which were executed at that time. The light painting manner and evanescent presentation of nature, along with the unified light and atmospheric environment connecting the water with the sky, invites parallels with Impressionism. Bonnard retains his usual flat, decorative manner, however. (A. P.)

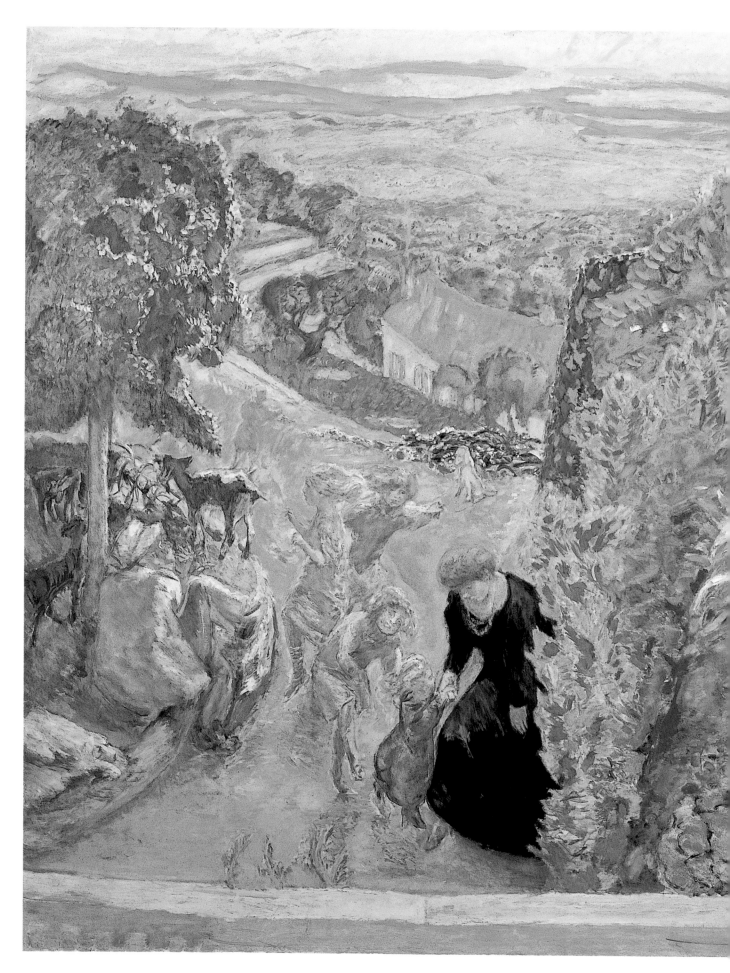

FROM RUSSIA

Pierre BONNARD
Summer. Dance

Circa 1912
L'été. La dance
Oil on canvas. 202 x 254
Push. Mus.
Provenance: 1948. Earlier: 1912,
purchased from the artist by Galerie
Bernheim-Jeune, Paris; early 1913,
bought from Galerie Bernheim-Jeune,
Paris by I. A. Morozov; until 1919,
collection of I. A. Morozov, Moscow;
MNZZh-2; from 1923, GMNZI

In 1911 and 1912, Bonnard worked on a major decorative series commissioned by Moscow collector Ivan Morozov for his mansion on Prechistenka Street. *Summer. Dance*, a part of that project, was created at the Villa Antoinette near Grasse on the French Riviera, where the artist lived at the time. On the terrace of this house, with its marvellous view of the surrounding area, Bonnard created a panoramic composition which seems to resurrect the myth of the Golden Age through its joyful, uplifting mood. The artist expresses harmony and freedom from care through the idyllic theme of the family, the luxurious depiction of nature, and the bright and variegated palette. The motifs included in the composition would become favourite ones for Bonnard, reappearing often in later paintings. (A. P.)

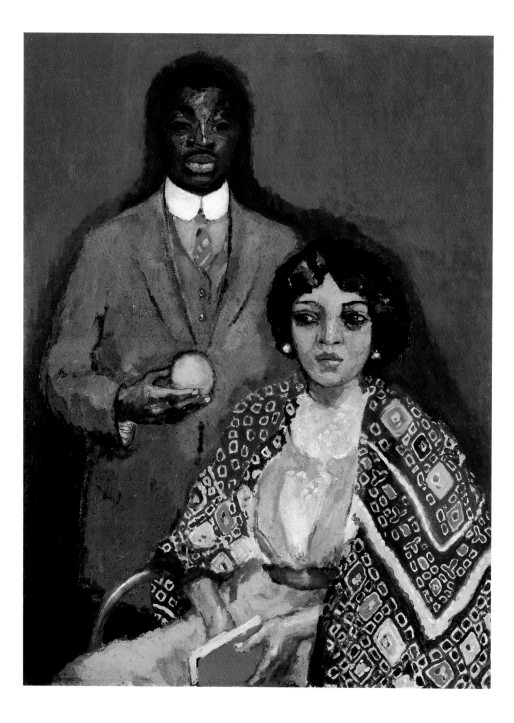

Kees VAN DONGEN
Lucie and Her Partner

1911
Lucie et son danseur
Oil on canvas. 130 x 96.5
Signed bottom left: *Van Dongen*
Herm.
Provenance: 1948, GMNZI. Earlier:
Galerie Bernheim-Jeune; collection of
M. O. Tsetlin, Moscow; Poryvkina collec-
tion, Moscow; GMNZI from 1939
(purchased from Poryvkina)

The picture is also known as "The
Dancer and the Negro". Thematically,
it belongs both to improvisations on
the cabaret theme and to the portrait
genre. We see here a certain ambigui-
ty in regard to the subject: Van Dongen
was a keen and ironic observer, as he
proved in his numerous drawings for
satirical journals, but here he seems
to be accommodating his models' de-
sire to appear more dignified — this
ability explains why he later became
such a successful high-society por-
traitist. The picture was shown in 1911
at an exhibition in the Galerie Bern-
heim-Jeune. A year earlier, Lucie had
posed for Van Dongen for *The Mulat-
to Lucie* and her partner Jinnad Tair,
nicknamed Charlie, for the *Portrait of
Jinnad Tair* (both reproduced in the
book *Van Dongen*. Paris, 1925, Nos.
11, 16). (A. K.)

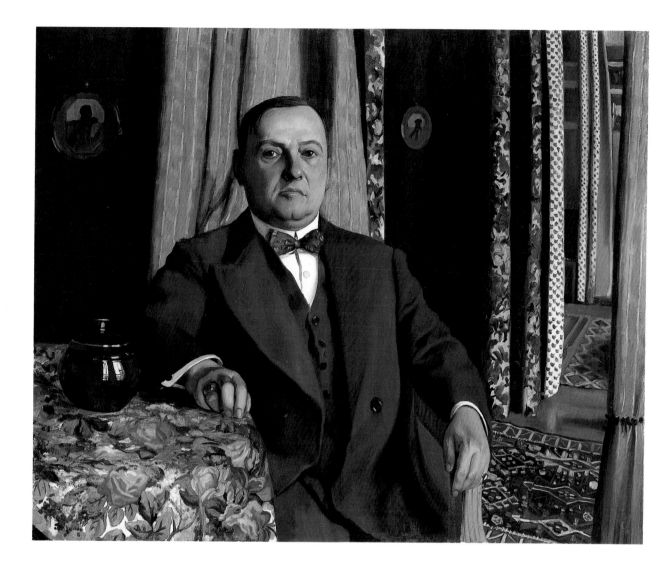

Félix VALLOTTON

Portrait of G. E. Haasen

1913
Portrait de M. Haasen
Oil on canvas. 81.7 x 100.5
Signed and dated top left:
F. Vallotton 1912 + 1
Herm.
Provenance: 1921. Earlier: collection
of G. E. Haasen, St Petersburg (commis-
sioned for 1,500 francs).

Georgy Emmanuilovich Haasen (Geor-
ges Haasen) was a collector of mod-
ern art (mainly French) who bought
and traded pictures by Bonnard, Val-
lotton, Marquet, Manguin and others,
together with his business partner,
Félix Vallotton's brother Paul. He was
also the representative of the Swiss
chocolate company Cailler in St Pe-
tersburg, where he settled in 1906. At
the beginning of March 1913, Vallot-
ton came to Petersburg on Haasen's
invitation and stayed in his home. The
artist wrote then: "The portrait is al-
most done; it came out well and is full
of attractive colourful details, since
nearly all of the rather motley apart-
ment is visible in it." In a letter sent
from Paris on March 29, Vallotton
mentioned the picture once again:
"The portrait of Haasen is good one, a
bit severe as always, but I'm to blame
for that: I can't look at life humorous-
ly." Judging by the date added by the
artist, "1912 + 1", we can assume
that he began work on the painting
(possibly from a photograph) in Paris
in 1912. (A. K.)

André DERAIN

Drying the Sails

1905
Le séchage des voiles
Oil on canvas. 82 x 101
Push. Mus.
Provenance: 1948. Earlier: purchased
in Paris by I. A. Morozov; until 1919,
collection of I. A. Morozov, Moscow;
MNZZh-2; from 1923, GMNZI

This painting was shown at the 1905 Autumn Salon in Paris, where a group of artists — soon to become the Fauvists — exhibited innovative works which they had painted in Collioure, on the shores of the Mediterranean. One of them was *Drying the Sails*, part of a series of around 30 landscape works created in close contact with Henri Matisse. Here Derain employs a new conception of lighting, painting in separate dabs and refraining from the depiction of shadows. Contrasting splotches of colour are boldly scattered over the plane of the canvas, which remains unpainted in many places. The lightness and spontaneity of the momentary impression reminds us of the drawings of children, whose special instinct and intuition the Fauvists valued highly. Reproduced in the journal *Illustration* in November 1905, the picture became a controversial symbol for the new direction in art, and was criticised acidly by Louis Vauxelle. (A. P.)

114

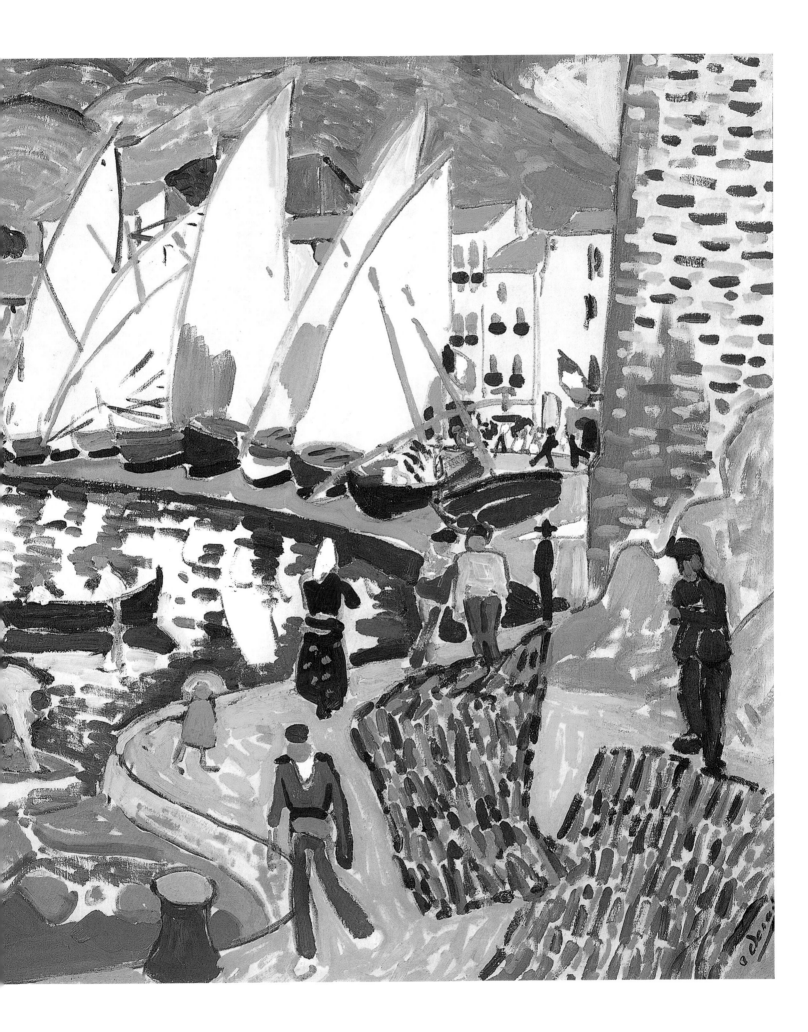

Henri MATISSE

Nude (Black and Gold)

1908
Nu (Noir et or)
Oil on canvas. 100 x 65
Signed bottom right:
Henri-Matisse
Herm.
Provenance: 1948, GMNZI. Earlier:
Galerie Bernheim-Jeune from 15 February
1908 (purchased from the artist); collec-
tion of S. I. Shchukin from 1 May 1908
(purchased for 1,000 francs); MNZZh-1
from 1918; GMNZI from 1923

The picture's model can be recog-
nised in two 1908 sketches, *Nude*
(Musée de Grenoble) and *Seated
Nude* (Metropolitan Museum, New
York). According to the artist's daugh-
ter, these sketches were made in
1908 in Munich. Matisse spent the
summer of 1908 working there in the
studio of his friend and former stu-
dent Hans Purrmann, where a Ger-
man model posed for him. By the way,
the author of the first book about Ma-
tisse, Marcel Sembat, referred to the
picture as "Nude Italian Woman" (M.

Sembat. *Matisse et son œuvre*. Paris,
1920, p. 19). The picture might even
have been painted in Paris, at the
master's studio on the Boulevard des
Invalides. *Black and Gold* was one of
the four canvases chosen by Matisse
to illustrate his "Notes of a Painter"
(published in *La Grande Revue* of 25
December 1908). A date of 1908 for
the picture is also supported by the
fact that Matisse put a date on two re-
lated female nudes, the first of which,
Nude Woman (Hermitage), was a study
for this painting. (A. K.)

116

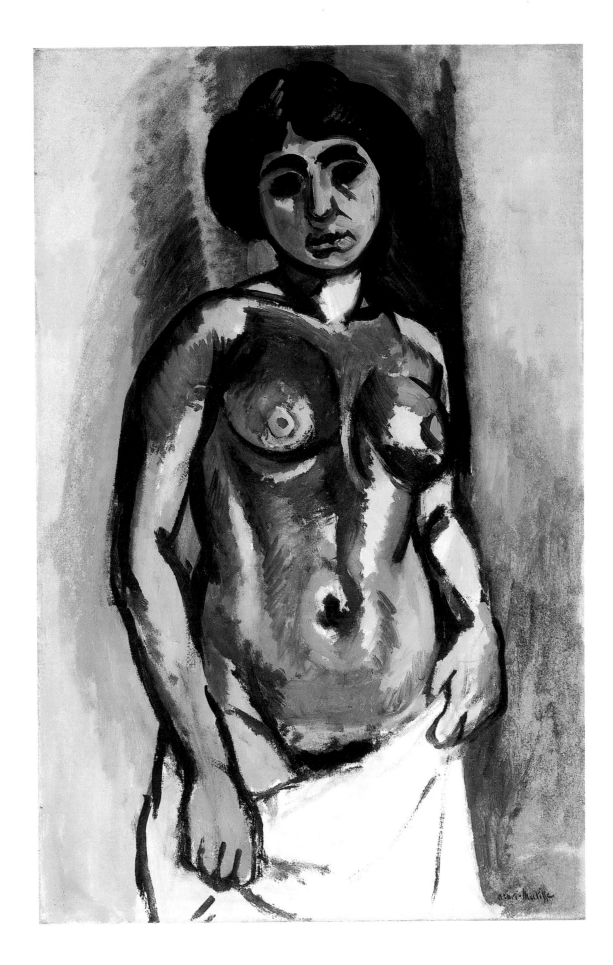

Henri MATISSE

The Red Room
(Harmony in Red)

1908
La chambre rouge (Harmonie rouge)
Oil on canvas. 180 x 220
Signed and dated bottom left:
Henri-Matisse 1908
Herm.
Provenance: 1948, GMNZI. Earlier: collection
of S. I. Shchukin from 1909 (purchased from
the artist for 4,000 francs); MNZZh-1 from
1918; GMNZI from 1923

The painting was commissioned by Sergei Shchukin. Beginning work on it as "Harmony in Blue" in 1908, Matisse took as his starting point the decorative *toile de Jouy* fabric with a light blue pattern which he loved and kept in his studio until the end of his life. A bit earlier, that fabric had been depicted in *Still Life with Vase, Bottle and Fruit*; and would be much later, in *Still Life with Blue Tablecloth* (both in the Hermitage). Matisse resorts to a compositional scheme he had used in the realistic *Breton Servant Girl* (1896, collection of the artist, now Musée Matisse, Cateau-Cambrésis), and then in the Impressionist *Dessert* (1897, Niarchos Collection, Paris), filling the well-tested scheme with new content (if we consider a completely new colour structure to be content). We can judge what *Harmony in Blue* must have looked like from the remaining greenish-blue strips of the former painting at the edges of the canvas and the colour slides of the picture in its original incarnation. On the eve of the 1908 Autumn Salon, for which *Harmony in Blue* was intended, Matisse radically repainted it to take with him to Shchukin's in Moscow. As the artist explained in a letter: "...it seemed insufficiently decorative, and I could not have done otherwise than to begin it anew, and I am now glad I did. For even those who thought it was done well the first time now find it significantly more beautiful. I myself am very pleased with the composition..." The picture is more commonly known in Russia as "The Red Room". (A. K.)

118

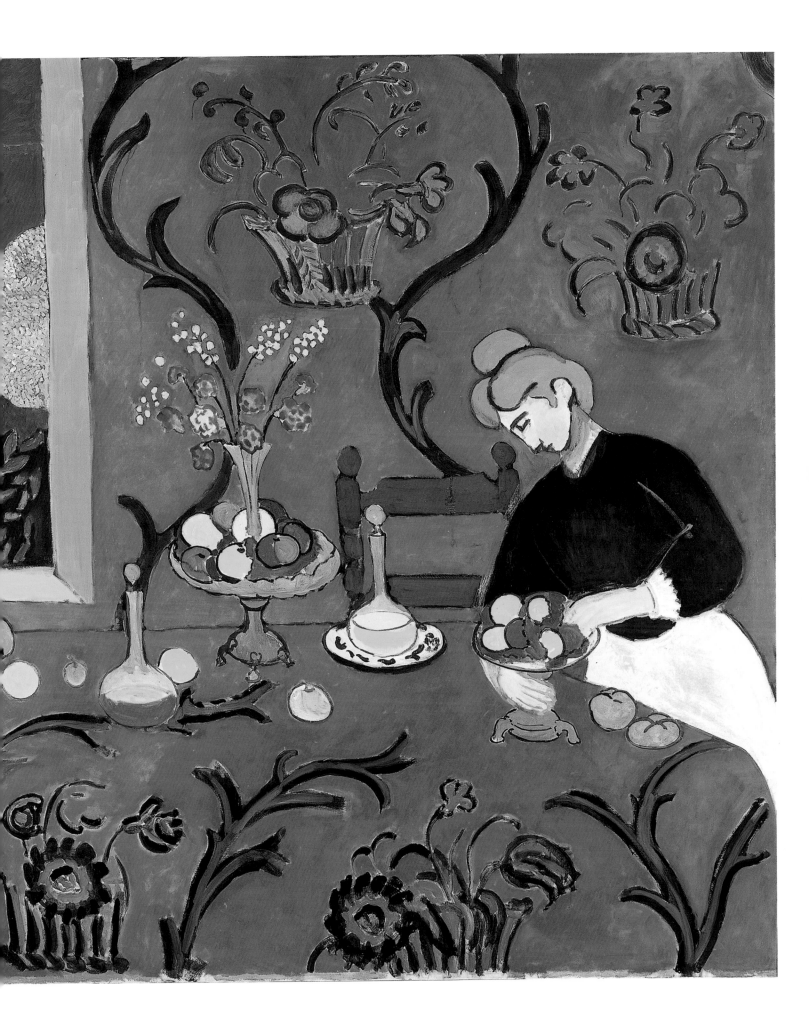

Henri MATISSE

The Dance

1910
La Danse
Oil on canvas. 260 x 391
Signed and dated bottom right:
Henri-Matisse 1910
Herm.
Provenance: 1948, GMNZI. Earlier:
collection of S. I. Shchukin from 1910
(commissioned in 1909 for 15,000
francs); MNZZh-1 from 1918; GMNZI
from 1923

The conception of *The Dance*, like that of the closely-related *Music* (Hermitage), crystallised over the course of five years. Compositionally, the picture descends from *The Joy of Life* (1905–1906, Barnes Foundation, Marion, Pennsylvania), with its circle dance in the background. At the beginning of 1909, when Matisse was working on the first version of *The Dance* (Museum of Modern Art, New York), Sergei Shchukin, who undoubtedly saw the work, ordered another mural of the same size for his Moscow mansion. Compared to the first one, it turned out to be significantly more dynamic. In the middle of March, he wrote Matisse to confirm receipt of the artist's letters with "sketches of the large pictures". He was referring to the watercolour sketches *Composition I* and *Composition II* (GMII). The first is a sketch of *The Dance*. In addition to it, there are two other drawings of the composition, in pencil (Museum of Modern Art, New York) and charcoal (Musée de Grenoble). *Composition II*

depicted bathing girls. This subject did not suit Shchukin, however. Instead, he wanted a mural symbolising the power of music. On 31 March 1909, Shchukin wrote Matisse: "I find such nobility in your panneau *The Dance* that I have decided to ignore bourgeois opinion and put the work with its nude figures in my staircase. I will need a second panneau to go with it, whose subject might be music. I would be most grateful for your answer: Accept my final commission for a panneau *The Dance* for 15,000 francs and a panneau *Music* for 12,000 francs, the price being confidential. I am very grateful to you and hope to receive the sketch of the second panneau soon. We do a lot of music making in my home... *Music* should give some indication of the house's character. I trust you completely and am sure that *Music* will be just as successful as *The Dance*." Thus, hung side-by-side in Shchukin's mansion, *The Dance* and *Music* formed a magnificent logical unity. (A. K.)

120

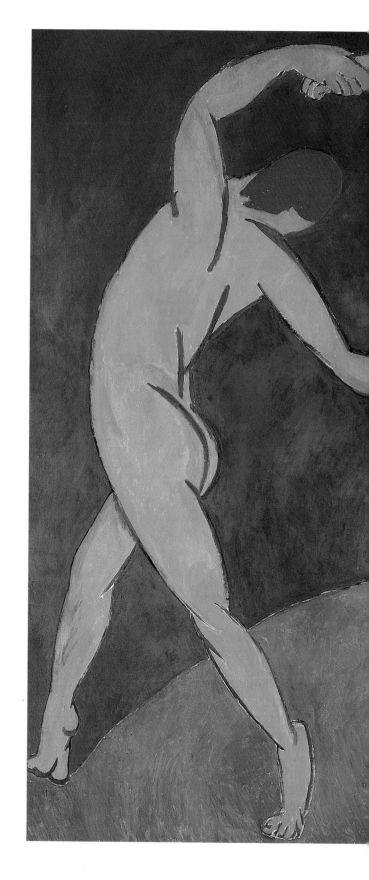

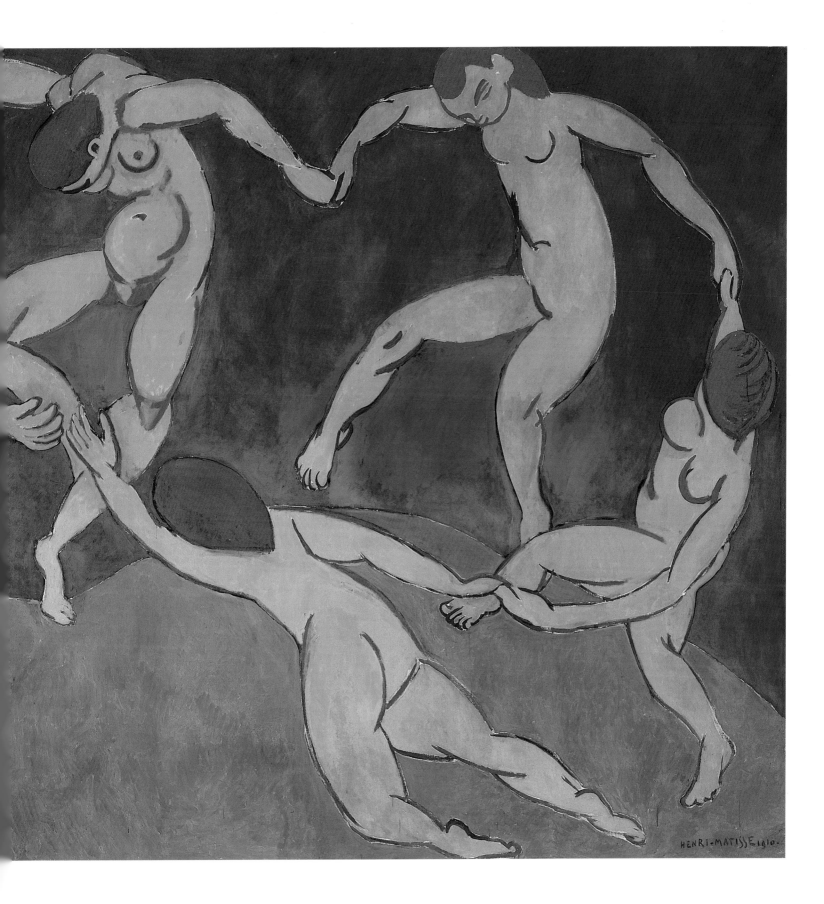

FROM RUSSIA

Henri MATISSE
Zorah Standing

1912
Zorah debout
Oil on canvas. 146.5 x 61.7
Herm.
Provenance: 1968, GMII. Earlier:
collection of S. I. Shchukin from 1913;
MNZZh-1 from 1918; GMNZI from 1923;
GMII from 1948

The nearly hieratic solemnity of *Standing Zorah's* pose has led several researchers of Matisse's œuvre, beginning with Barr, to compare the picture with Hans Holbein's *Christina of Denmark* (National Gallery, London). Persian miniatures could have been an influence, too, especially since Matisse, just before beginning work on *Zorah Standing*, had likely visited the exhibition of Persian miniatures which was in progress then at the Musée des Arts Décoratifs in Paris. In addition to Persian miniatures, we must consider another even more important possible source of powerful artistic impressions: the art of ancient Russia. In the churches of the Kremlin, Rogozhsky Cemetery and Old-Believers' Cemetery in Moscow, Matisse saw many full-length frontal depictions of saints on Deesis tiers. Ancient Russian art captivated the artist by its purity and harmony of colour, and in it he encountered methods such as the use of an abstract red background, as in Novgorod icons, for example.

Among Matisse's "Moroccan personages", *Zorah Standing* was the most successful. One of the reasons for this success, apparently, was that Matisse had painted Zorah before, depicting her more often than his other Moroccan models. The pictures *Zorah in Yellow* (private collection, New York) and *Zorah Seated* (private collection, Paris), as well as a page of pen-and-ink studies of Zorah's head (Isabella Stewart Gardner Museum, Boston), date from Matisse's first Moroccan trip. (A. K.)

Henri MATISSE
"La Danse" with Nasturtiums
Version II

1912
Les capucines à „La dance"
Oil on canvas. 190.5 x 114.5
Push. Mus.
Provenance: 1948. Earlier: late June
1912, purchased from the artist, Issy-les-
Moulineaux, by S. I. Shchukin; until 1918,
collection of S. I. Shchukin, Moscow;
MNZZh-1; from 1923, GMNZI

The artist worked on this painting,
along with the other canvases for
Sergei Shchukin's mansion, in the
spring and early summer of 1912 at
his studio in Issy-les-Moulineaux near
Paris. By incorporating his own paint-
ing *La Danse II* (Museum of Modern
Art, New York) in the composition, Ma-
tisse adds an element of intrigue, cre-
ating a "picture within a picture" ef-
fect. This was one of the master's
favourite methods; it allowed him to
graphically illustrate his ideas and ob-
servations about the organic "merg-
ing" of his works into an interior envi-
ronment. The seemingly accidental
effect of the figures on the canvas
dancing around a "real" vase with
flowers erases the boundary between
the real world and the artist's imagi-
nary one, making *La Danse*'s energy
literally spill out onto the viewer. This
aspect of the picture acquired a uni-
que meaning in Sergei Shchukin's
home, where the famous mural *La
Danse* (Hermitage) was located, and
which became one of the first organ-
ic realisations of Matisse's artistic
conception. (A. P.)

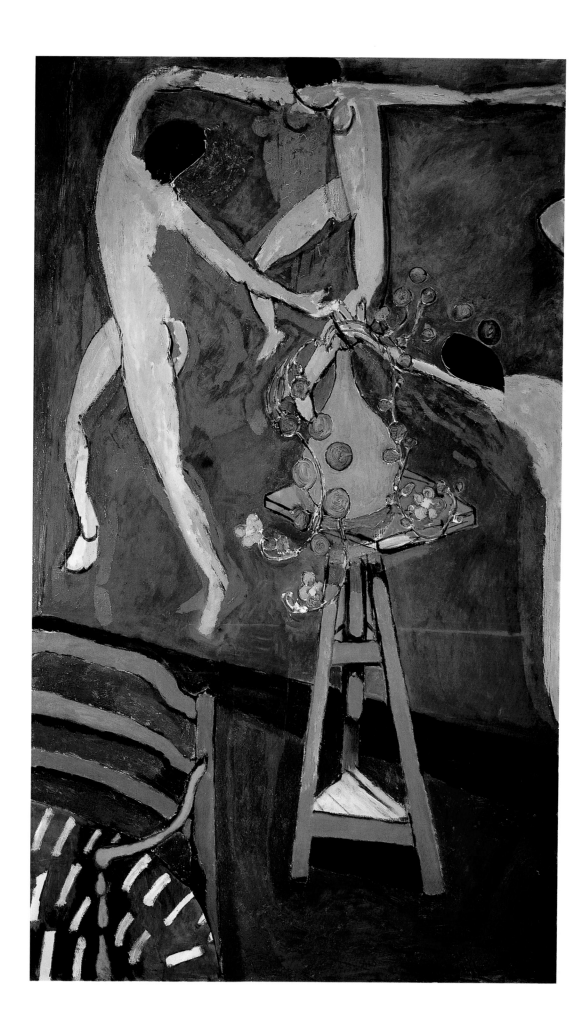

Henri ROUSSEAU
The Muse Inspiring the Poet

1909
La muse inspirant le poète
Oil on canvas. 131 x 97
Push. Mus.
Provenance: 1948. Earlier: 1909, purchased from the artist, Paris, by Vollard; 1910 (?), purchased at Galerie Vollard, Paris, by S. I. Shchukin; until 1918, collection of S. I. Shchukin, Moscow; MNZZh-1; from 1923, GMNZI

On this canvas, Rousseau depicted his friend Guillaume Apollinaire (1880–1918), the outstanding 20th-century poet and art critic, with his partner Marie Laurencin (1885–1956), an artist. Le Douanier ("The Customs Official" [Fr.], Rousseau's nickname — translator) decided to paint them in his trademark "landscape portrait" genre. The individual details in the landscape symbolise the portrait's programme as conceived by the artist: the flowers in the foreground, for example, are an attribute of the poet's immortal soul. Marie Laurencin is given a special role in this programme, as the poet's muse and source of inspiration; therefore, she is robed in a violet-coloured antique peplos. Apollinaire holds a goose quill in his hand, an attribute of his trade. Rousseau entitled the picture "The Muse Inspiring the Poet" before sending it to the 1909 Salon des Indépendants, where it was bought by the well-known art dealer Ambroise Vollard for a mere 300 francs. (Vollard was the only steady buyer of Le Douanier's works.) Sergei Shchukin first noticed Rousseau's works in Vollard's gallery in Paris; soon, on Picasso's advice, he acquired several of the artist's canvases for his Moscow collection. (A. P.)

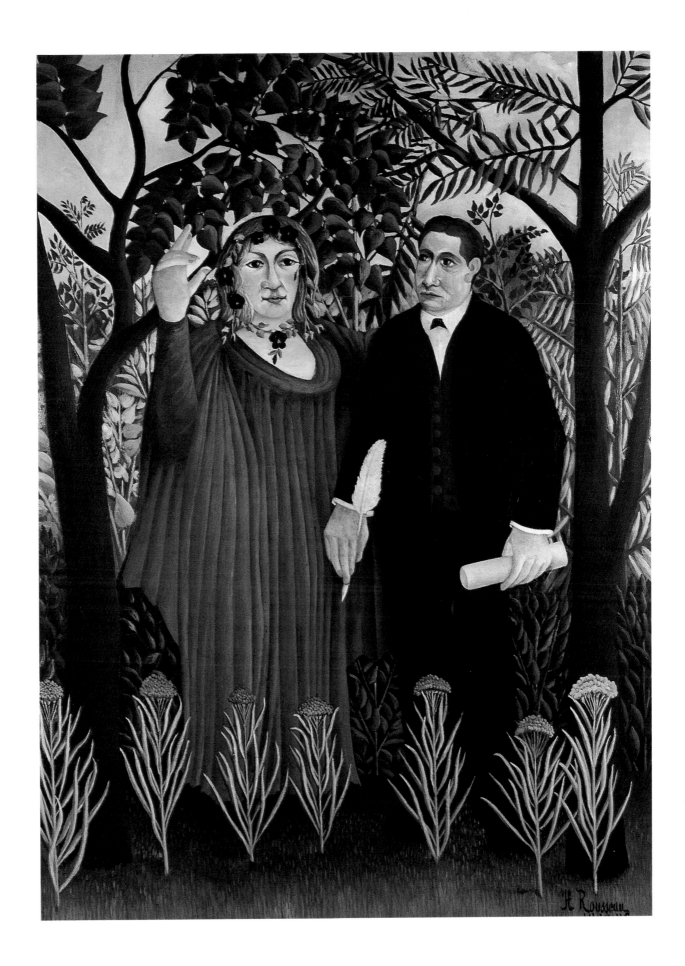

Pablo **PICASSO**

Green Bowl and Black Bottle

1908
Soupière verte et bouteille noire
Oil on canvas. 61 x 51
Signed on the reverse side: *Picasso*
Herm.
Provenance: 1934, GMNZI. Earlier:
collection of Leo and Gertrude Stein,
Paris; collection of Gertrude Stein; Galerie
Kahnweiler; collection of S. I. Shchukin
from 1912 or 1913; MNZZh-1 from 1918;
GMNZI from 1923

Picasso included a limited number of objects with extremely simple outlines in his Paris still lifes of the summer of 1908. Placing them in an overly-dramatised colour environment, the artist juxtaposed contrasting forms and colours with an intentional violence. Excepting *Composition with Skull* (Hermitage), this still life is the most tragic grouping of objects in Picasso's cubist œuvre. In contrast to the funereal *Composition*, the details here give us less reason to suppose that this still life reflected some concrete event. However, the sense of horror which overcame the artist after Wiegels' suicide, which he devoted *Composition with Skull* to, was not quick to pass and can still be felt in the mood of *Green Bowl and Black Bottle*. (A. K.)

Pablo PICASSO

Farm Woman (bust)

1908
La fermière (en buste)
Oil on canvas. 81 x 65
Signed on the reverse side: *Picasso*
Herm.
Provenance: 1930, GMNZI. Earlier:
Galerie Kahnweiler; collection of
S. I. Shchukin; MNZZh-1 from 1918;
GMNZI from 1923

Picasso dedicated two paintings and several drawings to the landlady of the house in La Rue-des-Bois where he stayed in August 1908. A second *Farm Woman*, also in the Hermitage, depicts its subject full-height. The "farm woman", Marie-Louise Putman (1850–1939), was a Flemish woman who would come to France to work. After first working as a cook, she married a shepherd and moved to La Rue-des-Bois. Widowed, she managed her household alone, cultivating the earth and raising seven children. She could neither read nor write and spoke French rather poorly. Stout and very tall, nearly two meters, she became the main feature of the landscape for Picasso, an incarnation of Mother Earth, primordially untouched by culture. Madame Putman never posed for Picasso; he simply observed her, making sketches later from memory. For all their schematic nature, they bear a surprising resemblance to their model, which is evident from surviving photographs of the "farm woman". Madame Putman's external features, a powerful, stocky figure with a thick inflexible neck, are already captured in the preparatory sketch (collection of Marina Picasso, Geneva), but in the painting they are rendered more grotesquely and geometrically. (A. K.)

Pablo PICASSO

Bathing

1908
La baignade
Oil on canvas. 38.5 x 62.5
Signed on the reverse side: *Picasso*
Herm.
Provenance: 1948, GMNZI. Earlier:
Galerie Kahnweiler; collection of
S. I. Shchukin; MNZZh-1 from 1918;
GMNZI from 1923

The picture evokes the spirit of Cézanne's *Bathers* and is part of a series of works depicting female nudes outdoors: *Three Women*, *Bathers in a Forest* and *Friendship* (Hermitage). It is possible that Picasso intended to do a more monumental composition: the picture gives the impression of a study. *Bathing* appears to have preceded the drawing *Bathers* (1908, Musée Picasso, Paris), whose style could be described as more realistic. In February 1908, Picasso kept a small album (Carnet 14, Musée Picasso, Paris) consisting of nine sketches. They are mostly preparatory studies for the figures in *Bathing*. The first page (4R) contains only a date, "8 Fevrero", allowing us to fix exactly the starting point of *Bathing*'s creation. Clearly, Picasso had a large composition in mind, which he first intended to realise in the spirit of *Bathing*, which was left in sketch-like form. The picture made a strong impression on Vladimir Tatlin. (A. K.)

Pablo PICASSO

Dryad

1908
Dryade
Oil on canvas. 185 x 108
Signed on the reverse side: *Picasso*
Herm.
Provenance: 1934, GMNZI. Earlier:
Galerie Kahnweiler; collection
of S. I. Shchukin; MNZZh-1 from 1918;
GMNZI from 1923

Among the large number of Picasso's works of 1907 and 1908 dedicated to bathers and owing their existence to Cézanne, *Dryad* or *Nude in the Forest* stands out strikingly. One might regard the pencil drawing from Carnet 15 (36R), *Woman in an Armchair* (1908, Musée Picasso, Paris) as one of the first impulses which led to the painting's creation. Steinberg cites even earlier sources for *Dryad*: the painting *Embracing Nudes* (1905, Statens Museum for Kunst, Copenhagen), in which the pose of the female figure already contains all the characteristics of the 1908 painting; and the drawing *Female Character* (1908, Musée Picasso, Paris), where the enticing pose and gesture are frankly confirmed by the letters S.V.P., or "s'il vous plait", written by the artist on the same page.

The Dryad, however, cannot be interpreted in the same spirit as that drawing from the Rose Period, with its sarcasm bordering on indecency. This unprecedented parody on the eternal feminine, both inviting and threatening in its gesture, resembles a fearsome image of an idol from some unknown cult. The feeling of horror which the picture evokes is to a large degree connected with its first source, which was recently discovered by Richardson: the Dryad's pose is absolutely identical to that of a corpse hung by its neck in an engraving from the second volume of *On the Fabric of the Human Body*, by famous 16th-century natural scientist Andreas Vesalius (Andreas Vesalius. *De Humani Corporis Fabrica*. 1543. See Richardson 1996, p. 89). It was probably Apollinaire, an avid bibliophile, who acquainted Picasso with this engraving. (A. K.)

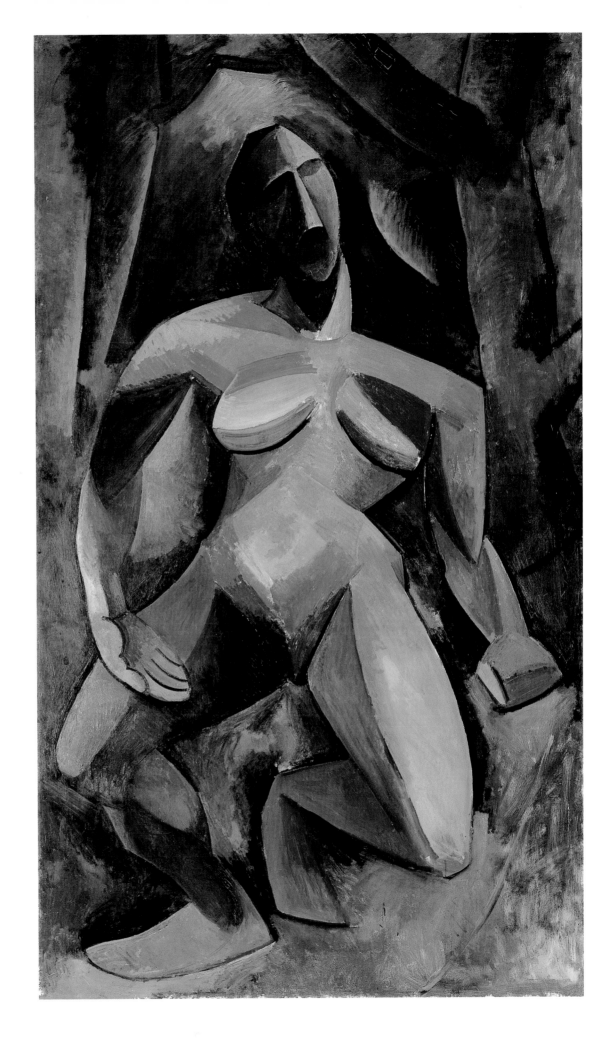

Pablo PICASSO
Violin and Guitar

Circa 1912–1913
Violon et guitare
Oil on canvas. 65 x 54
Signed on the reverse side: *Picasso*
Herm.
Provenance: 1948, GMNZI. Earlier:
Galerie Kahnweiler from 1913; collection
of S. I. Shchukin from 1913; MNZZh-1
from 1918; GMNZI from 1923

Over the course of the year 1912, Picasso created a whole series of paintings and numerous drawings on the "guitar and violin" theme. In December, he executed several vertical compositions of approximately the same dimensions as the Hermitage painting. These compositions usually contain an emphatic central vertical supported by the lines of the strings to a greater or lesser degree; the top is denoted by the violin's scroll, and in the centre the f-holes in the soundboard serve to cement the whole construction. Such are *Composition with Violin* (private collection), *Violin* (Pompidou Centre, Paris) and others. They are mostly executed in collage technique, with the use of pasted-on newspaper fragments. The Hermitage canvas seems to have been painted at that time or at the very beginning of 1913. In the literature it also figures under the name *Violin and Glasses on a Table*. (A. K.)

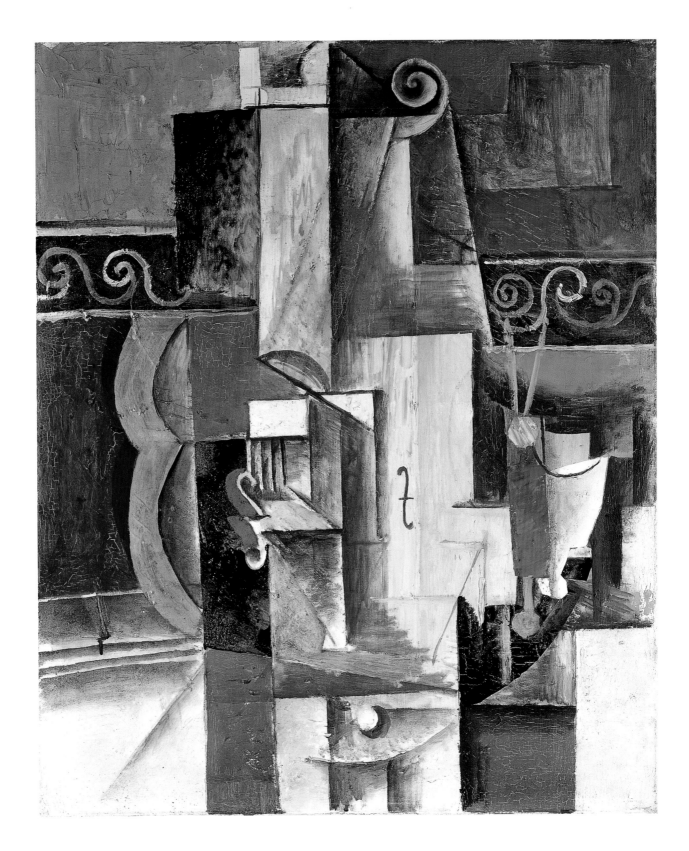

Georges BRAQUE

Castle of La Roche-Guyon

1909
Le château La Roche Guyon
Oil on canvas. 92 x 73
Push. Mus.
Provenance: 1948. Earlier: purchased
from the artist by Galerie Kahnweiler,
Paris; 1910, purchased at Galerie
Kahnweiler, Paris, by S. I. Shchukin;
until 1918, collection of S. I. Shchukin,
Moscow; MNZZh-1; from 1923, GMNZI

In the summer of 1909, Braque worked
in a small town near Mantes on the
banks of the Seine named for the near-
by ancient castle La Roche-Guyon. The
view of this medieval monument of ar-
chitecture looming on the cliff became
a favourite motif for the artist in his ear-
ly Cubist period. This landscape is
painted from the cliff next to the castle;
we can see the crystal-like geometric
forms of its buildings and towers. The
view is framed from above like a stage
set, by a bare tree trunk and branches
with large leaves. In creating his Cubist
suite of views of the castle, Braque var-
ied this favourite motif on canvases of
differing sizes, the one in the Pushkin
Museum being the largest. A year after
its creation, the painting was bought at
Daniel-Henry Kahnweiler's Paris gallery
by Sergei Shchukin. (A. P.)

134

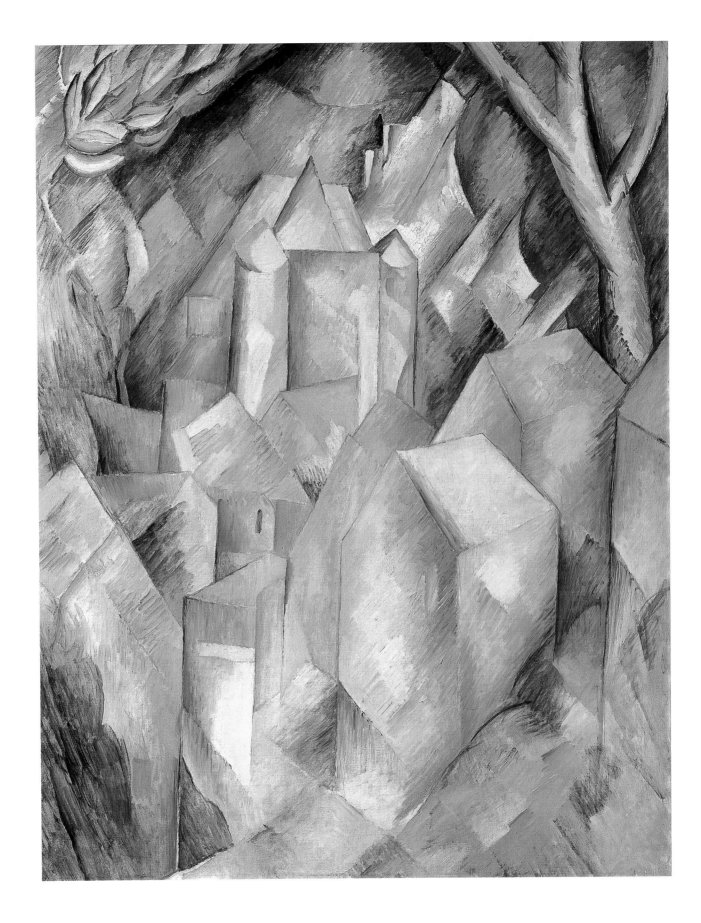

André DERAIN

The Old Town, Cagnes
(Castle)

1910
Le vieux quartier à Cagnes (Château)
Oil on canvas. 66 x 82
Push. Mus.
Provenance: 1948. Earlier: 1914,
purchased at Galerie Kahnweiler, Paris,
by S. I. Shchukin; until 1918, collection
of S. I. Shchukin, Moscow; MNZZh-1;
from 1923, GMNZI

At the end of the first decade of the century, Derain's work takes on a severe and ascetic cast. At that time he was trying to generalise and synthesise the methods of the "old" art with that of his contemporaries, to "gather honey from all flowers, but transform the alien into his own", as Yakov Tugendhold discerningly noted [Tugendhold, 1923, p. 104]. The painting was executed in February 1910 in the picturesque town of Cagnes-sur-Mer, and depicts the upper part of the old quarter, seeming to grow out of the cliffs. An attention to precise compositional structure and the geometry of both architectural and natural forms evidences Derain's respect for the principles of Paul Cézanne. At the same time, the artist attempts to bring out the inner essence of the objects he depicts, parallelling the experiments of the Cubists. In his "analysis", Derain also resorts to the methods of chiaroscuro, colour and composition of medieval and Renaissance masters. (A. P.)

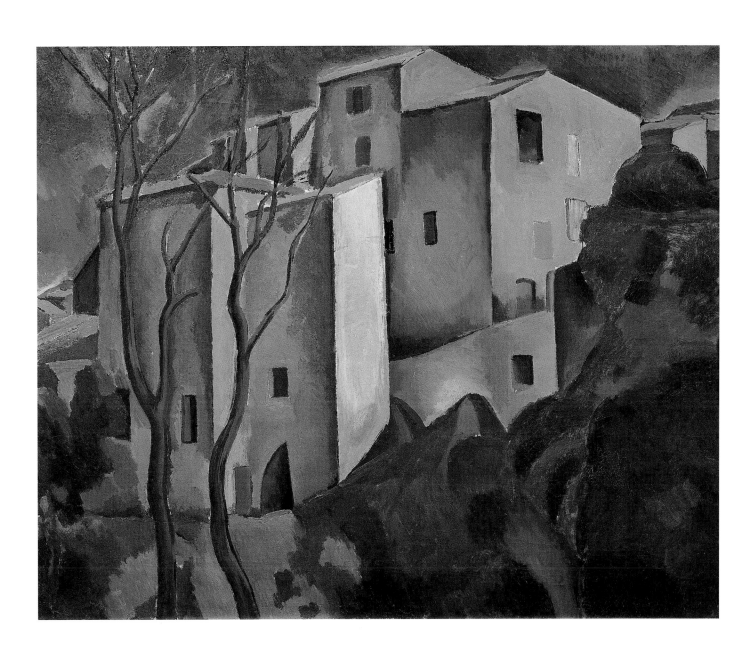

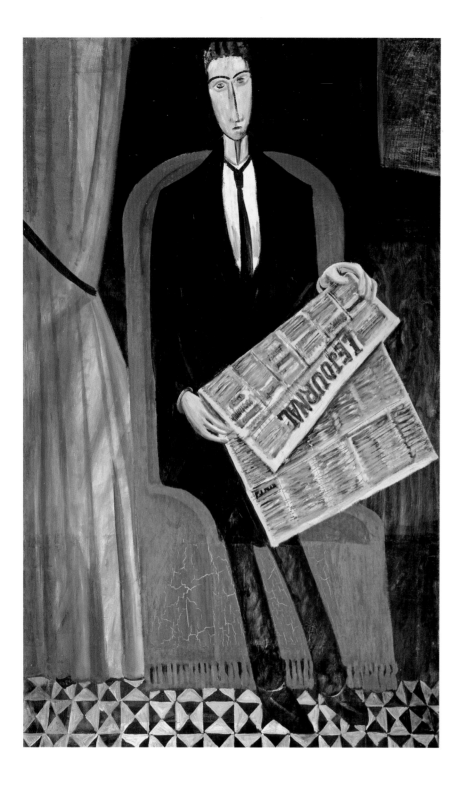

André DERAIN

Portrait of an Unknown Man
Reading a Newspaper
(Chevalier X)

1911–1914
Portrait d'un homme inconnu au journal
Oil on canvas. 162.5 x 97.5
Signed on the reverse side: *a derain*
Herm.
Provenance: 1948, GMNZI. Earlier:
Galerie Kahnweiler from 1914; collection
of S. I. Shchukin from 1914; MNZZh-1
from 1918; GMNZI from 1923

In the *Portrait of an Unknown Man*, or, as Guillaume Apollinaire christened it, "Chevalier X", Derain goes farther in the deformation of realistic form than anywhere else in his œuvre. The picture is a synthesis of heterogeneous elements. Parody of official portraiture combines with allusions to late medieval French miniatures with their chequerboard backgrounds, Van Eyck's *Arnolfini and His Wife* (National Gallery, London), and the young Cézanne's painting of his father with a newspaper. In a photograph of Derain's studio taken in 1914, one can see next to the *Portrait of an Unknown Man* a sculpture of the Virgin and Child in Romanesque style, which is characterised by analogous methods of deformation and simplification. According to Kahnweiler and Salmon, the newspaper was originally a real one pasted to the canvas (photographs of the painting in that state still exist). In this the influence of Braque and Picasso is clearly evident; they made collages with the very same newspaper, *Le Journal*. The painting achieved its first incarnation in 1911 and underwent revamping in early 1914. One might consider the ink drawing *Head of a Roman Emperor* (circa 1910–1911, Museum of Modern Art, Troyes) to be a study for the *Portrait of an Unknown Man*; that drawing was once given by the artist to André Breton, who devotedly kept a reproduction of the *Portrait*, though he never saw the original. (A. K.)

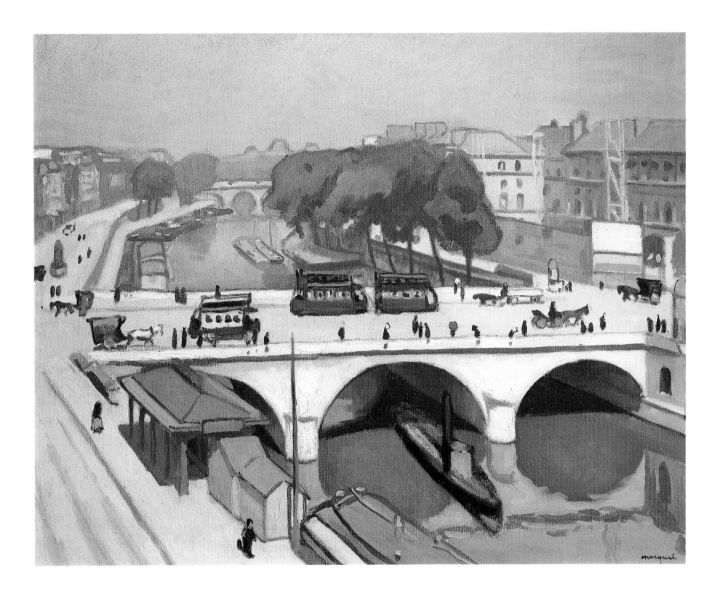

Albert MARQUET

Saint-Michel Bridge, Paris

1908
Pont St. Michel
Oil on canvas. 65 x 81
Push. Mus.
Provenance: 1948. Earlier: 1908,
purchased by Galerie Druet, Paris;
1910 (?), purchased at Galerie Druet,
Paris, by S. I. Shchukin; until 1918,
collection of S. I. Shchukin, Moscow;
MNZZh-1; from 1923, GMNZI

In 1908, Marquet moved into a studio on the Quai Saint-Michel which Matisse had just vacated. The Bridge of Saint-Michel soon became one of the artist's favourite subjects; its presence on dozens of pictures, shown in different seasons and times of day, recalls the serial painting experiments of the Impressionists. Here the bridge is seen from the window of the artist's studio, high above the Left Embankment of the Seine. In the foreground are the arch-es of the bridge with varicoloured spots of pedestrians and carriages in the bright summer day. The pavement continues into the depths, to the next bridge, Pont-Neuf. The horizon is enclosed by the silver silhouette of the Louvre's high roof. This painting is one of the best from Marquet's "Paris Suite" series, which the artist worked on over the whole course of his life. It entered Sergei Shchukin's collection at the beginning of the 20th century. (A. P.)

Maurice de VLAMINCK

Stream

1912–1913
Le rivière
Oil on canvas. 83 x 102
Push. Mus.
Provenance: 1948. Earlier: purchased
from the artist, Paris, by Vollard; 1913,
delivered to I. A. Morozov free of charge
as a supplement to a purchase of
a group of paintings; until 1919,
collection of I. A. Morozov, Moscow;
MNZZh-2; from 1923, GMNZI

In 1906, Vlaminck moved to the little village of La Jonchère, situated in the woods near the town of Bougival. *Stream* was probably painted in those woods. With its large, sweeping brushstrokes, the painting recalls the artist's still lifes with flowers executed in late 1912 — early 1913. Judging by the agitated state of the depicted nature, it was probably painted in 1912, at the very end of Vlaminck's "Cézanne" period, when precisely structured composition and a calm organisation of mass gave way to dynamic and bristly forms which seem to "sweep away" the landscape's stage set-like structure. Ivan Morozov acquired the picture for his Fauvist gallery from Parisian art dealer Ambroise Vollard. (A. P.)

**Sonia DELAUNAY-TERK,
Blaise CENDRARS**

Prose of the Trans-Siberian
and Little Jehanne of France

1913
La prose de transsibérien et
de la petite Jehanne de France
Stencilled water colour on paper.
198 x 36.5 (in all); 190 x 18 (left part,
all drawing, without text). Des Hommes
Nouveaux Publishers, Paris, Deluxe
Edition No. 47
Dedicatory inscriptions of both authors on
the title page: *à mon vieil cher ami simul-
tané Sacha Sonia Delaunay-Terk*; to the
left in black ink: *Blaise Cendrars à
Smirnov le premier qui sur les ailes simul-
tanées apporta le disque synchrone en
Russie 1 janv. 1914*
Herm.
Provenance: 1966. Earlier: collection
of A. A. Smirnov, Leningrad

The events of the poem, created by Cendrars under the impression of his travels to Russia between 1903 and 1907, take place during the Russo-Japanese War of 1904–1905 and the Revolution of 1905–1907. Cendrars and Sonia Delaunay intended in their collaboration to create a "simultaneous book", where the text and the pictorial accompaniment would coexist on the same level. It is thought that the composition's extended form was inspired by the Eiffel Tower, which was one of Robert Delaunay's obsessions. The first "simultaneous book" appeared in 1913, creating a loud resonance in Parisian art circles. Articles and letters both attacking and defending the book appeared in *Paris-Journal*, *Gil Blas* and *Les Soirées de Paris*. Originally, a printing of 150 copies was planned, but significantly fewer actually came out. According to Robert Delaunay's conception, the total length of all the copies — each one was two meters in length when unfolded — was to equal the height of the Eiffel Tower.

The first owner of the Hermitage copy was A. A. Smirnov (1883–1962), a literary critic and friend of Cendrars and Robert and Sonia Delaunay. Before and during the First World War, he was an assistant professor at Petersburg University. At the same time, he read lectures (in the cellar of the literary/artistic cabaret "The Stray Dog", in particular) which he accompanied with demonstrations of the poem and the "synchronous disc" mentioned in the dedicatory inscription. The disc, like the poem, was intended to present an "abstract display of light in motion". (A. K.)

BRIEF BIOGRAPHIES
OF FRENCH ARTISTS

Besnard, Paul-Albert
1849, Paris — 1934, Paris
Painter, graphic artist. From a tender age, moved in artistic circles connected with his father, a pupil of Ingres. Began studying at Cabanel's atelier at age 17; made his debut at the 1868 Paris Salon at age 19. Won the Prix de Rome in 1874. Acquired his own artistic style only in the 1880s, when under the influence of the Impressionists he began using a light, bright palette. Executed a number of major decorative ensembles. Showered with medals and honours, he took up the post of director of the École des Beaux-Arts in 1922 and was elected to the Académie Française in 1924.

Bonnard, Pierre
1867, Fontenay-aux-Roses — 1947, Cannes
Painter, graphic artist. Studied law, then gave up a barrister's career to devote himself to art. Exhibited for the first time at the Salon des Indépendants in 1891 after meeting Toulouse-Lautrec. First one-man exhibition in 1896, at the Galerie Durand-Ruel. Part of the Nabi group from 1890 to 1900. Lived and worked in the south of France from 1910 onwards. His 1938 Chicago exhibition was the largest showing of his works in his lifetime.

Braque, Georges
1882, Argenteuil-sur-Seine — 1963, Paris
Grew up in Le Havre, where he first began to paint. Mastered the profession of decorator in Paris, and began to paint at the easel as well. Moved away from Impressionism in 1905 in the direction of Fauvism, becoming close with Dufy and Friesz. Exhibited for the first time at the Salon des Indépendants in 1907. Turned to geometric experiments in the 1908–1913 period. Considered the co-founder of Cubism, along with Picasso. Fought in the First World War; wounded in battle. Returned to art, but painting in a new, more emotional manner, re-interpreting classical canons in his own way.

Carolus-Duran (real name: Charles Émile Auguste Durand)
1837, Lille — 1917, Paris
Studied in Lille and, beginning in 1859, at the Académie Suisse in Paris. His early works were influenced by Spanish painting and Courbet. One of the founders of the Société Nationale des Beaux-Arts, whose honorary president he was from 1904 to 1913. Member of the Institut Français from 1904; from 1905, director of the Académie de France in Rome. Painted landscapes and historical, religious and mythological pictures, but achieved his greatest fame as a portraitist.

Cendrars, Blaise (real name: Frédéric Louis Sauser)
1887, La Chaux-de-Fonds, Switzerland — 1961, Paris
French writer. Son of a Swiss businessman. Ran away from home at age 15, travelled throughout the world and tried his hand at many professions. Met and became friends with Apollinaire in 1910. Was linked to the Cubists. Often turned to Russian themes. A master of blank verse, he also wrote novels and essays.

Cézanne, Paul
1839, Aix-en-Provence — 1906, Aix-en-Provence
Studied at the Collège Bourbon in Aix, where he became friends with Émile Zola (their friendship was interrupted after the publication of Zola's novel *L'Œuvre*, whose central figure, Claude Lantier, bore many of Cézanne's traits). Entered the drawing school at the Museum of Aix in 1856. Set up a studio in 1859 at his father's estate, Jas de Bouffan. Left for Paris in 1861; studied at the Académie Suisse, where he met Pissarro and Guillaumin. Also met Monet, Sisley, Bazille and Renoir. His early, "romantic" period is marked by the influence of Delacroix and Courbet. Collaboration with Pissarro in Pontoise and Auvers (1872–1873) marked the start of the Impressionist phase of Cézanne's œuvre. Participated in the first and third Impressionist exhibitions (1874, 1877). Worked in L'Estaque with Renoir in 1882. Was accepted into the Salon that year for the only time in his life. Participated in the 1889 and 1900 World's Fairs in Paris. In 1895, Ambroise Vollard organised his first one-man exhibition. From 1888 to 1900, worked alternately in Aix and Paris; in his later years, in Aix. Painted landscapes, still lifes, figure compositions and portraits.

Corot, Jean-Baptiste Camille
1796, Paris — 1875, Ville-d'Avray
Painter, graphic artist. Began working in the family business, a clothing shop, while studying painting at the Académie Suisse beginning in 1817. Obtaining with difficulty an annual stipend from his parents, continued studies in 1822, first with Achille Michallon and then with Jean-Victor Bertin. Much of his life was spent travelling: he visited Italy three times and spent time in Switzerland, Holland, London, Fontainebleau, Normandy, Brittany and Auvers. From 1827, he became a regular participant in the annual Salons.

Dagnan-Bouveret, Pascal-Adolphe-Jean
1852, Paris — 1924, Quincey, Haute-Saône Dept.
Painter, graphic artist, illustrator. Studied at the École des Beaux-Arts with Gérôme, as well as with Corot. Won the second Prix de Rome in 1876, making his Salon debut with a mythological scene. Became influenced by Bastien-Lepage and was famed for his ethnologically exact and finely painted scenes from the life of the French provinces, especially Brittany. As a portraitist, created a large gallery of images of France's intellectual and political elite.

Daubigny, Charles-François
1817, Paris — 1878, Paris
Landscape painter. Studied with his father, a landscape painter; with François-Marius Granet (1836); and with Paul Delaroche (1840). Copied Dutch Master paintings in the Louvre. Did engravings in his youth. Began exhibiting at the Salon in 1838. Worked for many years in Barbizon and the Morvan district from 1843 onwards. His acquaintanceship with Corot in 1852 spurred both artists to work together on the same subjects. Travelled widely in France and abroad (Italy, England, Spain and Holland). One of the most important forerunners of Impressionism.

Delaunay, Sonia (née Terk)
1885, Grazhist, Ukraine — 1980, Paris
Childhood years passed in St Petersburg. Studied painting in Karlsruhe from 1903 to 1905. Settled in Paris in 1906, where she studied at the Académie de la Palette. Married well-known art critic Wilhelm Uhde. Second marriage in 1910, this time to Robert Delaunay, whose creative ideas she would henceforth espouse. Created fabric sketches, monumental-decorative paintings and costumes for Diaghilev's ballet troupe.

Denis, Maurice
1870, Granville, Normandy — 1943, Paris
Studied at the Lycée Condorcet (1881–1887), together with Sérusier, Vuillard and Roussel. In 1888, got to know Bonnard at the Académie Julian and began studying at the École des Beaux-Arts, first with Lefebvre, then with Doucet. In 1889, helped found the Nabi group, together with Sérusier, Bonnard, Vuillard and Roussel. Influenced by Puvis de Chavannes and Gauguin. Exhibited at the Salon for the first time in 1890. Worked mainly in Saint-Germain-en-Laye. Spent time in Italy, Palestine and Russia. Was an active art critic and theoretician. In 1919, organised the Ateliers d'Art Sacré, together with Georges Desvallières. Became a member of the Institut Français in 1932. Painted portraits, landscapes and mythological and allegorical compositions. Decorated a number of churches in France and Switzerland.

Derain, André
1880, Chatou, near Paris — 1954, Garches, near Paris
Attended the Académie Carrière, where he met Matisse and Puy. Met Vlaminck in 1900. The two artists turned an abandoned restaurant in the suburb of Chatou into a studio. Began studying at the Académie Julian in 1904. Worked with Matisse in Collioure in 1905. Participated in the Autumn Salon of 1905, becoming one of the founders of Fauvism. Met Picasso and the other "Bateau-Lavoir" artists in the autumn of 1906. Broke with Fauvism in 1907, under the influence of Cézanne, Picasso and Braque. Fought in the First World War (1914–1918), after which he turned to Neoclassicism. Did less and less easel painting in his mature and later years, executing decorations and costumes for theatrical productions and working on book illustrations and sculptures.

Gauguin, Paul
1848, Paris — 1903, Atuona, Marquesas Islands
Childhood (1849–1855) in Lima, Peru. Worked as a sailor in the South Seas (1865–1871). Settled in Paris in 1871, working for an exchange broker and dedicating his spare time to art. One of his landscapes was shown at the Salon in 1876. Became a regular at the Nouvelle Athenes Café, where he got to know Manet, Degas, Renoir and Pissarro. Quit his job at the stock exchange in 1883 to devote himself completely to art. Showed his works in five Impressionist exhibitions (1879, 1880, 1881, 1882 and 1886). In 1886, divided his time between Pont-Aven and Paris, where he met Van Gogh. In Brittany, a group of Symbolist-oriented artists formed around him (the Pont-Aven School). Abandoned Impressionism at

this time and developed a "synthetic" style. Worked together with Van Gogh in Arles in the autumn of 1888. Left for Oceania in 1891 (first Tahitian period — 1891–1893). Wrote the book *Noa Noa*. Returned to France for a year and a half in 1893. Lived in Tahiti from 1895 onwards. Along with painting, did ceramics, woodcuts and wood relief carving.

Guérin, Charles-François-Prosper
1875, Sens, Yonne Dept. — 1939, Paris
Painter, illustrator. Studied with Gustave Moreau. Made his debut in 1897 at the Salon de la Société Nationale des Beaux-Arts. Though acquainted with the art of the avant-garde and in particular the work of Cézanne, Guérin did not share their views and developed his own individual style which he remained true to until the end of his life.

Manet, Édouard
1832, Paris — 1883, Paris
Painter, graphic artist, illustrator. Came from a well-to-do family. Was drawn to art at an early age. After a voyage to Brazil on a merchant ship, began studying at the studio of Thomas Couture, studying Old Masters at the Louvre. Acquired his own atelier in 1856. Recognition and success alternated with scandals: in 1859, his pictures were rejected for the first time by the official Salon, and in 1863 his famous *Le Déjeuner sur l'Herbe* became one of the main exhibits at the Salon des Refusés. A contemporary of and participant in the most celebrated artistic events of his time, he was one of the first to begin painting subjects from modern life, balancing between tradition and innovation.

Marquet, Pierre-Albert
1875, Bordeaux — 1947, Paris
Painter, graphic artist, illustrator. Began studying painting in his hometown of Bordeaux. Moved to Paris in 1890 and entered the School of Decorative Arts, where he became close with Henri Matisse. Also studied at the École des Beaux-Arts in the atelier of Gustave Moreau, and at the Académie Ranson. Began exhibiting at the Salon des Indépendants in 1901 and the Autumn Salon in 1909. In 1905, participated in the scandalous Fauvist exhibit at the Autumn Salon. Worked mainly in Paris until the 1920s, making trips to Le Havre, Naples, Honfleur and Tangiers. Renewed his tireless travels in the 20s and 30s, changing his focus to North Africa and Algeria, where he lived for a long time.

Matisse, Henri
1869, Le Cateau-Cambrésis — 1954, Nice
Studied at the Académie Julian (1891), then at the École des Beaux-Arts, where he attended the class of Gustave Moreau along with Rouault, Marquet, Manguin and Camouin (1892–1898). Met Pissarro in 1897. Made a successful debut at the Salon of the Académie des Beaux-Arts in 1896. Began exhibiting at the Salon des Indépendants in 1901 and the Autumn Salon in 1903. Vollard organised his first one-man exhibition in 1904. Spent the summer of 1904 in Saint-Tropez together with Signac and Cross and the sum-

mer of 1905 in Collioure with Derain. Led the Fauvists' showing at the 1905 Autumn Salon. The following year, met Sergei Shchukin, who became his patron. Published "Notes of a Painter" in 1908. Made trips to Italy (1907), Germany (1908), Spain (1910–1913), Russia (1911) and Morocco (1912, 1912–1913). Settled in Nice in 1917. Awarded the Carnegie Prize in 1927. In 1930, made a trip to Tahiti and two trips to the US. Awarded the Grand Prix at the Venice Biennale in 1950. Matisse's last significant creation was the Chapel of the Rosary in Vence, where everything (architecture, frescos, stained glass, furniture and priests' vestments) was designed by him. Along with painting, worked in graphic arts, sculpture, book illustrations, theatrical decorations and monumental frescos.

Monet, Claude
1840, Paris — 1926, Giverny, Eure Dept.
His childhood and youth passed in Le Havre, where he began his artistic activities as a caricaturist. In 1858, met Boudain, who introduced him to the principles of *plein air* landscape. In 1862, began studying at the Paris studio of Charles Gleyre, where he became close with Renoir, Sisley and Bazille. Made his Salon debut in 1865 with two seascapes. Created the foundations of Impressionist painting in the latter half of the 1860s. At the beginning of the Franco-Prussian War in 1870, left for London, where he discovered the paintings of Turner and the English landscapists. Made a trip to Holland in the summer of 1871, after which he settled in Argenteuil-en-Seine, where he was visited by Manet, Renoir, Sisley and Caillebotte. Moved to Vétheuil in 1878, then to Giverny in 1883. Participated in five Impressionist exhibitions (1874, 1876, 1877, 1879 and 1882). Made three trips to London between 1899 and 1901 to work on his images of the Thames. Travelled to Venice twice, in 1908 and 1909. Began work in 1914 on the panorama *Water Lilies* (put on display in the Orangerie soon after the artist's death).

Picasso, Pablo
1881, Málaga, Spain — 1973, Mougins, Alpes-Maritimes Dept.
Received his first art lessons from his father, José Ruiz y Blasco, an art school teacher in Málaga. Studied in the Barcelona Art School from 1895 to 1897, and at the Academia de San Fernando in Madrid in 1897. Returning to Barcelona, met the avant-garde artists who frequented the Four Cats (Els Quatre Gats) Cafe (1898–1900). Made his first trip to Paris in 1900, where one of his pictures was displayed at the World's Fair. Vollard arranged his first one-man exhibition in 1901. Settled permanently in Paris in 1904, living in the "Bateau-Lavoir" and becoming friends with poets André Salmon, Max Jacob and Guillaume Apollinaire. In 1907, became close with Braque, with whom he moved from one stage of Cubism to another. Acquaintance with Diaghilev (1916) resulted in the creation of decorations and costumes for the latter's productions. The first half of the 1920s is marked by Neoclassical tendencies, after which varied stylistic principles began to coexist in his work. The Civil War in Spain moved Picasso to paint the mural *Guernica* (1937). Remained in Paris during the German occupation. After the war, lived in the South of France. In addition to painting, worked in sculpture, engraving and ceramics.

146

Pissarro, Jacob-Abraham-Camille
1830, Charlotte Amalie, St. Thomas, Antilles —
1903, Paris
Painter, graphic artist. Spent his early years on the island of St. Thomas, where he began to draw. Left for Paris in 1855, where he studied at the École des Beaux-Arts, the Académie Suisse, and with Corot and Courbet. Became one of the founders of Impressionist art in the early 1870s and remained one of its most brilliant proponents, inculcating the Impressionist style in artists of the younger generation. From 1885 to 1890, began experiments in the spirit of Neo-Impressionism and pointillism, considering the latter to be "scientific Impressionism".

Renoir, Pierre-Auguste
1841, Limoges — 1919, Cagnes-sur-Mer,
Alpes-Côte d'Azur Province
Worked in his youth as an apprentice to a porcelain artist (1854–1858). Studied at Gleyre's studio (1861), where he became close with Monet, Sisley and Bazille, and at the École des Beaux-Arts (1862-1863). Exhibited at the Salon in 1864. Courbet's influence is visible in the pictures of the 1866–1868 period. Worked with Sisley in the Fontainebleau Forest (1866) and with Bazille and Monet in Paris (1867). Took part in four Impressionist exhibitions (1874, 1876, 1877 and 1882). In the 1870s, worked mainly in Paris. His trips to Algeria (1881) and Italy (1881, 1882) led to the use of lighter and brighter paints. From 1884 to 1887, developed his "bitter style" (*manière aigre*), signalling a dissatisfaction with Impressionism. His next period (1888–1898) is marked by Neo-Baroque tendencies. Moved to Cannes in 1898, rarely leaving the south from then on. Painted portraits, landscapes, still lifes and figure compositions. Worked in sculpture in addition to painting.

Rousseau, Henri Julien Félix
1844, Laval, Loire Valley — 1910, Paris
Studied law in his yonth, then served in the army. Moved to Paris and entered the government service in 1868; promoted to position of tax inspector in 1871. A self-taught painter, he never received an artistic education and claimed to have "no teacher other than nature". Exhibited regularly at the Salon des Indépendants beginning in 1886, attracting the interest of artists and critics. After retiring in 1893, dedicated himself completely to painting. In the last half of the first decade of the 20th century, the leaders of the Paris avant-garde (Picasso, Delaunay and Apollinaire) rediscovered Rousseau, creating an atmosphere of reverence around the old artist.

Rousseau, Théodore
1812, Paris — 1867, Barbizon
Studied at the École des Beaux-Arts under Rémond (1827–1828) and with Lethière (1828–1829). Was influenced by Claude Lorrain, the 17th-century Dutch landscapists, Constable and Bonington. Began exhibiting at the Salon in 1831, but from 1835 to 1848 the jury rejected his pictures. From 1836 onwards, worked mainly in the village of Barbizon, settling there permanently in 1847. Made a number of trips to France, sometimes with other landscape painters with whom he enjoyed friendly relations (Normandy in 1831 with Paul Huet, Landes in 1844 with Jules Dupré, and Franche-Comté in 1861 with Jean-François Millet). Achieved real recognition at the 1855 World's Fair.

Tissot, James
1836, Nantes — 1902, Château de Buillon,
Doubs Dept.
Entered the École des Beaux-Arts in Paris in 1857, studying with Lamothe and Flandrin. Maintained friendships with Degas, Whistler and Alphonse Daudet. Began exhibiting at the Salon in 1858 and at the Royal Academy of Arts in London in 1864. Fled to London in 1871, fearing persecution for his participation in the Paris Commune. He remained there and worked, returning in 1882. Made a trip to Venice with Manet in 1875. Awarded a Gold Medal at the 1889 World's Fair in Paris. Made the first of three trips to Palestine in 1886. Turning to compositions on Biblical themes, he created an extensive cycle of works on subjects from the New Testament, including illustrations for *The Life of Jesus Christ*, published in 1896.

Vallotton, Félix
1867, Lausanne — 1925, Paris
Lived in Paris from 1882 onwards, where he studied at the Académie Julian (1882–1885). Began exhibiting at the Salon in 1885. Made etching reproductions to earn a living. Became friends with Toulouse-Lautrec, Cotte and Vuillard in 1889. Wrote critical articles in the *Gazette de Lausanne* (1891–1893). Turned to the woodcut in 1891. Began collaborating with *La Revue blanche* at that time, along with other art periodicals. Joined the Nabis in 1892. Vollard organised an exhibition of his works in 1897. In 1898, Julius Meier-Graefe's book about him published in Germany and France. Received French citizenship in 1900. Began exhibiting at the Autumn Salon from the moment of its founding (1903). Wrote prose and plays. Made a trip to St Petersburg and Moscow in 1913, then went to Italy. From the beginning of First World War, worked on symbolic anti-war compositions.

Van Dongen, Kees
(Cornelis Theodorus Maria van Dongen)
1877, Delfshaven, near Rotterdam —
1968, Monte Carlo
Studied at the Royal Academy of Fine Arts in Rotterdam (1892-1897) with Jan Striening and Johannes Heyberg. First went to Paris in 1897 (settled there in 1900). Achieved some renown for his early humorous drawings. Joined the Salon des Indépendants in 1904, becoming friends with Derain and Vlaminck. Exhibited in the Autumn Salon in 1905, along with Matisse, Derain, Manguin and other Fauvists. Acquaintance in 1906 with the young artists and writers living in the "Bateau-Lavoir": Picasso, Salmon and others. Remained loyal to Fauvism until 1913. Made trips to Spain, Tunisia, Morocco (1910), Egypt (1913) and Venice (1921). Lived in Monaco from 1957 onwards. From 1920 to 1960, specialised in portraits of celebrities, performing artists, writers and political figures.

Van Gogh, Vincent Willem

1853, Zundert, The Netherlands —
1890, Auvers-sur-Oise, France
Painter, graphic artist. Childhood passed in Brabant. Made his first acquaintance with art at age 17, at the gallery of Goupil & Cie in the Hague; left soon to work as the gallery's representative in London and Paris. Turned to religion in the 1876-1879 period, studied theology and preached in the mining region of Borinage. Studied with Anton Mauve in Holland in 1882 and at the Academy in Antwerp in 1885. In 1886, moved in with his brother Theo in Paris where he became acquainted with innovative French art. Left for Arles in February 1888, where Gauguin later joined him. A conflict between the artists drove Van Gogh first to the hospital in Arles in 1889, then to a mental asylum in Saint-Rémy-de-Provence. In 1890, went to live with his brother in Auvers, where he soon committed suicide.

Vlaminck, Maurice de

1876, Paris — 1958, Rueil-la-Gadelière
Painter, graphic artist, illustrator. Born into a family of musicians; studied the violin in his youth. Serious illness interrupted a promising career as a bicycle racer. Entered military service, where he met André Derain, who kindled his interest in art. An active participant in the Fauvist circle, his work was inspired by the Post-Impressionists — Van Gogh and Cézanne.

Vuillard, Jean-Édouard

1868, Cuiseaux, Saône-et-Loire —
1940, La Baule-Escoublac, Loire-Atlantique
Painter, graphic artist, illustrator, decorator. After his family's move to Paris, studied at the Lycée Condorcet, where he met Roussel and Denis, future Les Nabis members. Rejecting a military career, entered the École des Beaux-Arts, where he met Bonnard. An active member of the Nabi group from the moment of its creation at the end of the 1880s. Began exhibiting at the Salon des Indépendants in 1901 and at the Autumn Salon in 1903. Worked in both small-scale genres and large decorative works, the first of which he executed at the end of the 19th century and the last just before his death.

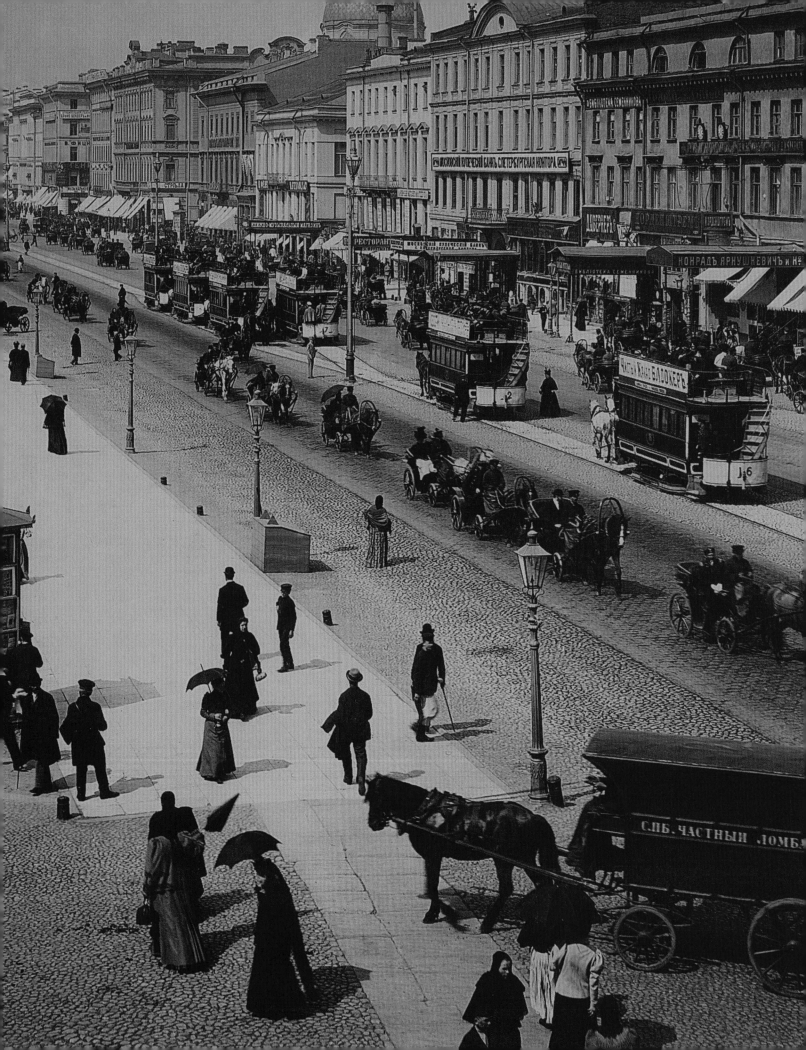

RUSSIA

RUSSIAN ART
ON THE PATH FROM REALISM
TO IMPRESSIONISM
AND SYMBOLISM

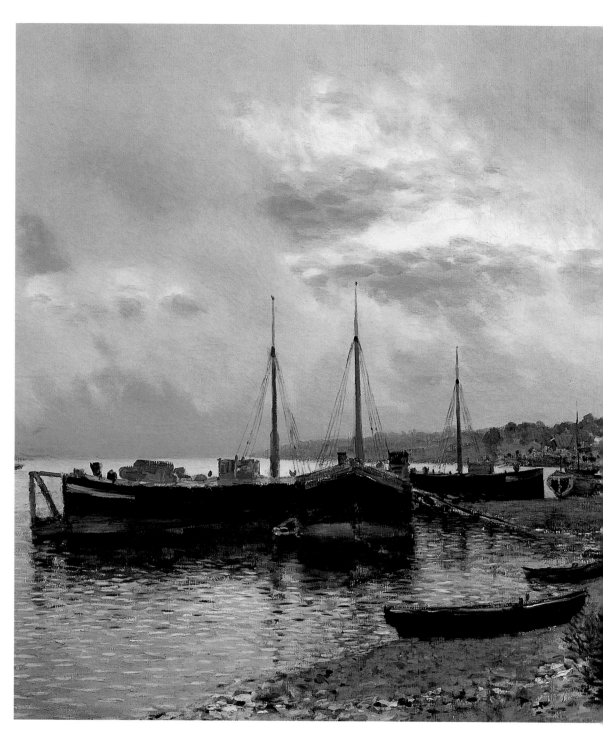

In the second half of the 19th century Russian art dwelt under the sign of Realism — critical, democratic and social. This phenomenon has been described in various ways, but in essence what happened is this: a striving adequately and truthfully to represent the life of the people, nature and history in their indispensably social aspect, with sympathy for the "insulted and injured" (in the words of Dostoyevsky), penetrated all forms and genres of Russian art — not only painting, but also literature, poetry and music. Notions of the new and progressive in art became connected with the movement of Realism. What is more, Realism became a sort of "style" in an epoch which was otherwise, strictly speaking, eclectic and devoid of style, though easily recognisable by its artefacts.

Russian Realism from the 1850s to the 1880s was definitely a movement of the youth. The new art first made its presence known when, in 1863, fourteen young graduates from the Imperial Academy of Fine Arts in Petersburg refused to paint their diploma works and entries in the gold medal competition on a required subject from Scandinavian mythology. They demanded permission to choose subjects themselves, in accordance with their own tastes. This event became known as the "Revolt of the Fourteen".[1] The young rebels' tastes were clearly leading them away from traditional academic art in the direction of realism and modernity. The appeals of the new philosopher and future social revolutionary Nikolai Chernyshevsky, "Life is beautiful", and "Everything which shows us or reminds us of life is beautiful",[2] excited young minds, summoning them to the artistic "barricades". We must not forget that serfdom — slavery, in other words, albeit softened by Russian society's traditional patriarchal way of life — continued to exist until 1861. Until the mid-19th century, the life of the majority of the Russian population, the peasantry, was utterly dependent on the will and whims of the aristocratic minority. Naturally, for a 19th-century European country this was a complete anachronism, a fact not lost on Russian society. "My attitude toward the serfs is beginning to trouble me greatly,"— the twenty-seven-year-old count and writer Leo Tolstoy would write in his diary in April 1856.[3] As a result of Russian society's steadily rising concern for the fate of the peasantry, and along with it concern for the fate of Russia herself, the folkish/peasant theme would become the main focus in all of Russian art for many years to come. "The peasant is now our judge," wrote the young Ilya Repin in 1872, eleven years after the abolition of serfdom, "so therefore we need to reflect his interests."[4]

The creation in 1870 of the Society of Travelling Exhibitions, uniting artists of the Realist movement from both the "older" (1860s) and "younger" (1870s) generations, and the triumphant "procession" of the Society's exhibitions through the Russian capitals and provinces, irreversibly established Realism (critical and social) as the leading movement in Russian art. The influence of the "Wanderers" (as the Society's members began to refer to themselves) on Russian society, the formation of its aesthetic tastes, its views on art and even politics was enormous, lasting almost three decades. The Society reached its peak between 1870 and 1881. Those were the years when the Wanderers created their most significant works, those which now grace the exhibition halls of the Tretyakov Gallery in Moscow and the Russian Museum in Petersburg. Among these epic pictures, these "pictorial novels" and "encyclopedias" of Russian folk life, are Ilya Repin's *Barge Haulers on the Volga* (1873, Russian Museum) and *Religious Procession in the Kursk Province* (1874, Tretyakov Gallery), Konstantin Savitsky's *Repairing the Railroad* (1874, Tretyakov Gallery) and many others. This was the era of grandiose compositions which, like the operas of Borodin and Mussorgsky, re-created the most dramatic moments from the pages of Russian history, like Vasily Surikov's *Morning of the Execution of the Streltsy* (1881, Tretyakov Gallery), *The Boyarynia Morozova* (1887, Tretyakov

[1] The "Revolt of the Fourteen" took place in the autumn of 1863. The young artists' demands were not satisfied. The heads of the Academy saw in the graduates' demands a "revolt" against the Academy's age-old traditions. Undaunted, the rebels organised Russia's first independent artists' alliance, "The Petersburg Artists' Guild" (in existence until the early 1870s).

[2] Cited from the dissertation "The Aesthetic Relation of Art to Reality", written by well-known publicist Nikolai Chernyshevsky (1828–1889) in 1855 and published in the journal *Sovremennik* as a self-recommendation. The dissertation's aesthetic arguments strongly influenced more than one generation of Russian artists and writers.

[3] L. N. Tolstoy. *Sobranie sochineniy. V 22 tomakh. V. 2. Povesti i rasskazy. 1852–1856.* Moscow, 1972, p. 401.

[4] From Ilya Repin's letter to Vladimir Stasov of 3 June 1872. *I. E. Repin, V. V. Stasov. Perepiska.* Moscow–Leningrad, "Iskusstvo", 1948–1950, V. 1, p. 37.

Gallery) and others. These are staggering works in their penetrating psychological insight into Russian people from various classes, together with their majestic and monumental but at the same time touchingly lyrical expression of Russian nature.

Stylistically, the realism of the Wanderers has acquired greater force and confidence, compared with the art of their forebears, the Realist artists of the 1860s: the pictures are significantly larger in size, compositions have become more complex, and space has expanded to contain teeming crowds and realistic landscapes receding into distant horizons. A striving towards naturalistic *plein air* illumination and atmospheric effects has replaced chiaroscuro. Russian artists began to talk of colouration and to take an interest in the works of the French Impressionists. "We need to move towards the light, colours and air," agreed Kramskoi with Repin, when they were talking about the Impressionists. "But", added the artist raised in the Russian Realist tradition, "how can we do so without losing the artist's most precious quality — the heart?" [5]

In search of new artistic impressions and creative principles, Russian artists were drawn to Paris; by the end of the 1860s they had practically stopped travelling to the artistic mecca of the first half of the 19th century, Italy. A whole Russian colony arose in Paris in the 1870s, the Society of Russian Artists, headed by landscapist Alexei Bogoliubov (1824–1896). At first, the Russians were attracted mainly to the French *plein air* painters and masters of the Barbizon School. Their artistic methods — work in nature, and an interest in atmospheric effects and the national landscape — could not have been more perfectly suited for Russian Realism, and considerably enriched it.

By the end of the 1870s, however, the Russians were already turning their attention to Impressionism. For a long time, the art of the Impressionists had seemed to them to be too unfinished and lacking in content (this is what prompted Kramskoi's remark: "But how can we do so without losing the most precious quality of the artist along the way — the heart?"). However, the Wanderers' contact with French painting left its mark on them and on all Russian art which followed. In the work of the 1880s generation — Ilya Repin, Vasily Surikov, Victor Vasnetsov, Vasily Polenov and others — one can observe much more "light, colour and air" than with their predecessors. This comes, however, without detriment to "the heart" — meaningful content, in other words, understood as art's obligation to reflect the whole spectrum of the life of the people, in both its social and poetic aspects.

The new spirit of the age was manifested even more strongly in the art of those who began their independent creative lives at the end of the 1880s and beginning of the 1890s: Isaac Levitan, Valentin Serov, Konstantin Korovin, Abram Arkhipov, Sergei Ivanov, Philipp Malyavin and others. While maintaining loyalty to the main tenet of Realism — art's connection with real life — artists of the 1890s generation did not always share the near-exclusive interest of their teachers in the purely social aspects of that reality. The young artists were more inspired by the poetic and aesthetic components of the life situations they depicted. At this point, the painting methods of the Impressionists became much more attractive than they had been before. There arose something like a school, a large group of Russian Impressionists: Konstantin Korovin, Igor Grabar, Abram Arkhipov and, to a degree, Isaac Levitan, Philipp Malyavin and others. Impressionism was especially dear to the hearts of representatives of the Moscow school, with the interest in working outdoors, *en plein air*, which they had acquired from Alexei Savrasov (1830–1897). Impressionism became one of the features of the Moscow painting school which survived in one way or another right up until the end of the 20th century, weathering even the persecutions of the period of socialist realism.

[5] From Ivan Kramskoi's letter to Ilya Repin of 23 February 1874. *I. N. Kramskoi. Pis'ma, stat'yi. V dvukh tomakh*. Moscow, "Iskusstvo", 1965, V. 1, p. 233.

156

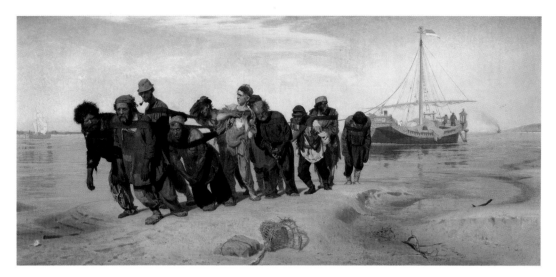

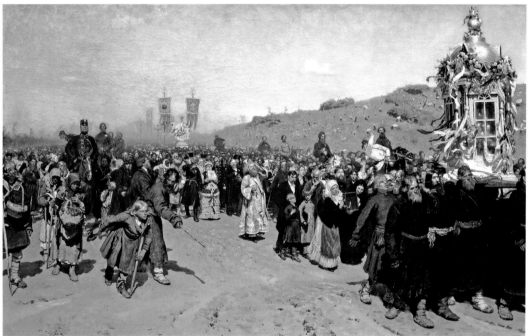

Ilya Repin. Barge Haulers on the Volga
1870–1873. Russ. Mus.

Ilya Repin. Religious Procession in the
Kursk Province. 1883. Tret. Gal.

Konstantin Savitsky. Repairing
the Railroad. 1874. Tret. Gal.

157

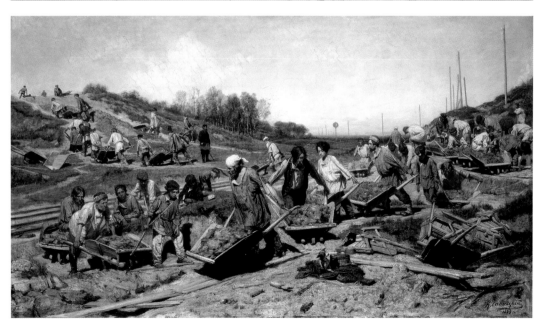

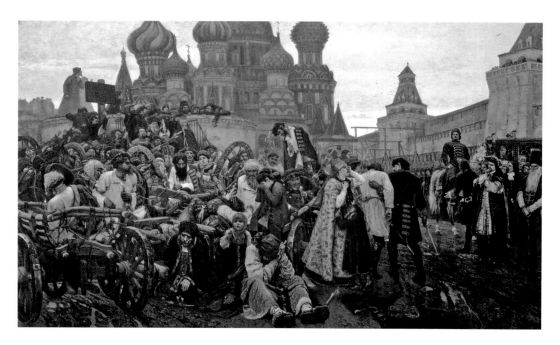

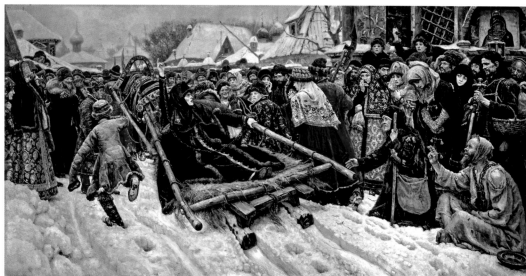

Vasily Surikov. Morning of the Execution of the Streltsy. 1881. Tret. Gal.

Vasily Surikov. The Boyarynia Morozova. 1887. Tret. Gal.

In those same 1890s, the first distinct signs of Symbolism began to appear in Russian art. First they boldly announced their presence in poetry (Konstantin Balmont, Alexander Blok, Andrei Bely, Valery Briusov among others). After poetry, it was the turn of painting. The first conscious, principled Symbolist among painters was Mikhail Vrubel. Earlier than anyone else, during the years of Realism's seemingly undivided triumph, he adopted the fundamental imperatives of Symbolism as his credo: the purpose of art is the affirmation of Beauty and Truth of the Spirit, and the artist's path is a never-ending struggle between good and evil, God and the devil, the human and the demonic. In Symbolism, every idea is an Absolute, taken to an all-demanding extreme and categorically abstracted from everyday life. However, like many other in-

novative artistic movements which came to Russia from the West, Symbolism was rather quickly "Russified", taking on visible national traits, both in the character of the subjects chosen and in the style itself, which reflected the Russian artist's traditional adherence to lifelikeness. Vrubel's proud *Demons* embody less Absolute Evil than a boundless sorrow for the world they have lost, a world which has rejected them.

Vrubel's younger contemporary Victor Borisov-Musatov (1870–1905) might be considered another representative of the "first wave" of Russian Symbolism. At the same time, it is hard to imagine two artists more dissimilar: while Vrubel's image/symbols are seething with passion and powerful temperament and his painting manner tends towards the mosaic-like, Borisov-Musatov's soft, hazy pictures, coloured in a combination of blue, green and lilac pastel shades, are the very embodiment of harmony and musicality. Despite their dissimilarity, however, both men strongly influenced the following generation of Russian artists and aided the formation of a new artistic style which was to encompass all areas of Russian culture by the turn of the 20th century — from architecture, painting, theatre, the decorative and applied arts and book printing to the new lifestyle and tastes of prewar and pre-revolutionary Russian society. This style, named "Russian Moderne", was a variation of French Art Nouveau — albeit with its own unavoidable and very significant national traits.

The large group of Petersburg artists who fell under Vrubel's spell united around the journal *World of Art* (1898–1903), created on the initiative of Sergei Diaghilev (1872–1929). Borisov-Musatov became the "standard bearer" for the Muscovites who participated in the 1904 "Crimson Rose" exhibition and the 1907 "Blue Rose" exhibition, as well as the exhibitions running from 1908 to 1910 organised by the editor and publisher of the journal *Golden Fleece*, Nikolai Ryabushinsky (1876–1951). Neither of these artistic alliances were as long-lived as the Wanderers Society (1870–1923) had been, but it was they who would define the character of Russian artistic life in the pre-avant-garde period.

PERSONAL RELIGIOUSNESS AND RELIGIOUS CONSCIOUSNESS AMONG RUSSIAN ARTISTS AT THE TURN OF THE 20TH CENTURY

In the 19th and 20th centuries, Russian society still regarded art as either a church or a pulpit from which sermons significant for all members of society were preached. Even today, actors, artists and literary people often say: "I serve art". For them, the theatre, fine arts and all other forms of creativity are not just work, but service. This sacralisation of art is something peculiar perhaps to the Russian mentality.

This feature of Russians' approach to art came markedly to the fore in the mid-19th century. At that time, society, the public and critics began to demand more than just "art for art's sake" from literature and painting. The Russian *intelligentsia* was hungering for answers to the most fundamental questions of life and the spirit, the so-called "accursed questions".

This situation was probably a result of the lack of political freedom and the reign of the censorial yoke in 19th- and 20th-century Russia. There were no channels for open discussion of the country's burning social issues. Therefore, culture — literature, theatre, fine arts, and later cinema — took upon itself the role of church pulpit or orator's platform, from which passionate declamations on the questions of the day could be delivered. These were received by the public as prophecies, as prayers, and as calls to action.

Various spheres of human consciousness became mixed up, each striving for universality and to replace the others. For example, after reading Leo Tolstoy's treatise "What Is Art?", Ilya Repin expressed his impressions of it in this fashion in a letter: "A religion has been found — this is the greatest event of our lives".[1] In his essay, Tolstoy posited that art's main and only task is the advocacy of moral virtue, considering art's aesthetic side to be an inferior, or "lower" virtue, inaccessible to the masses of the people, who require simpler methods of moral education. One might be tempted to say that Tolstoy confused truth with beauty and morals with aesthetics; and Repin, morals with religion. However, neither of them confused anything. Tolstoy gave an extremely rigorous, principled and supra-asthetic reinterpretation of art's inherent essence, replacing beauty with virtue and the pleasure-giving function with an educational one. He construed art as simply one means of communicating with an audience, a means which the artist can fill with any content, in accordance with his will. This harsh dictate of pan-moralism espoused by Tolstoy in his later years was shared by many representatives of the Russian *intelligentsia*; behind it lies the basically religious imperative to subordinate all forms of human activity to the guideposts and norms of one's own spiritual experience. This belief in the necessity and possibility of bringing cultural and public life into accordance with one's own understanding of good and evil is fundamental for the "believing" member of the *intelligentsia*, a type which is very widespread in Russia. And he can believe in anything: in the triumph of good and justice, in the means of revolutionary terror justifying its ends, in the "God-bearing people", in the Kingdom of Heaven on Earth or in various social utopias. It is no accident that Vasily Rozanov considered the great Russian writer Leo Tolstoy to be "an enormous religious phenomenon, maybe the greatest phenomenon of Russian religious history".[2] Once again, everything is out of place in this statement, but it reflects the reality of the Russian cultural context rather well. In a country where even atheism was religious — by the heat of its passion and energetic activism — religion knew no bounds and pervaded everything, from the traditional Orthodox Christianity of the simple folk to the raging agnosticism and atheism of part of the educated classes, which replaced organised religion for them.

The last half of the 19th century was a time of glaring political contradictions and the ascendancy of positivist ideas in Russia. The revolt of 14 students at the Academy of Fine Arts against outdated educational methods spilt over into other areas, forcing a reexamination of not only ethical and aesthetic, but social and ideological postulates as well. The art world split in two. Innovators considered mythological and

[1] *I. Repin. Izbrannye pis'ma: V 2 t. 1867–1930*. Moscow, Iskusstvo, 1969, V. 2, p. 138.
[2] V. V. Rozanov. *V temnykh religioznykh luchakh*. Moscow, Respublika, 1995, p. 36.

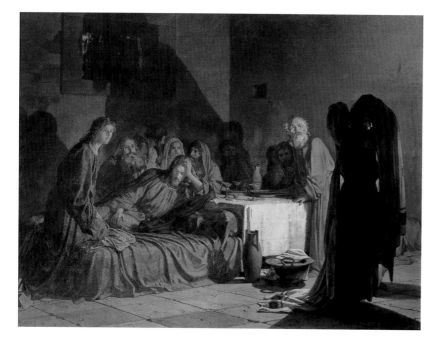

Nikolai Ghe. The Last Supper. 1869
Russ. Mus.

Nikolai Ghe. What Is Truth? Christ and
Pilate. 1890. Tret. Gal.

Biblical subjects too remote from the life of contemporary society, in need of replacement by depictions of "the harsh conflicts of reality". A critical, socially oriented attitude focusing on the lives of the "humble and oppressed" strata of society and odes to Russian nature — these were the main ideas of the artists who came to be known as the "Wanderers" for their active exhibition activities in many Russian cities.

The Wanderers were not some nationalist group obsessed only with things Russian. They travelled abroad much and greatly esteemed the art of various countries. However, their understanding of the artist's role in society differed significantly from the European one. "Though we are always seeing new and fresh things here," writes Ilya Repin from France in February 1874, "most of it is formal. The French are entirely uninterested in the human being: costumes, colours, lighting — that is what attracts them in nature. However, as far as taste, tact, lightness and grace go, they are accomplished masters…" [3]

For himself and for the Russian art which he saw himself as embodying, Repin sees a different path, which he describes in another letter to the same recipient: "You say we need to move towards light and colour. No! Here, too, our goal is content. The character and soul of the person, the drama of life, impressions of nature, her life and meaning, and the spirit of history — this is what concerns us, it seems to me. For us, paint is a weapon: it exists to express our thoughts…" [4] The Russian artist distances himself from the purely aesthetic matters in which the French are immersed. He sees art's purpose in spiritual revelation.

The Wanderers did indeed create marvellous genre paintings, portraits and landscapes whose motifs were drawn from contemporary life. To their credit are many works, which revive the "spirit of history". However, these Realists of the last half of the 19th century, with their fierce opposition to "lifeless" Biblical subjects, not only turned to them often in their works, but expressed more vividly in these works than anywhere else the dramatic problems of contemporary life. In this contradiction lies one of the features peculiar to

[3] Repin. Op. cit. V. 1, p. 113.
[4] Ibid. p. 123.

162

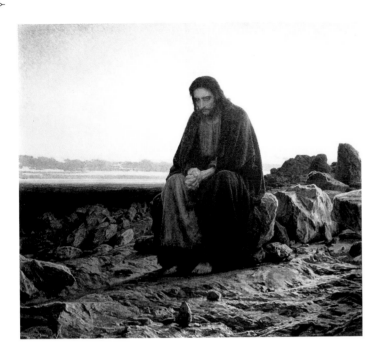

Ivan Kramskoi. Christ in the Desert. 1872. Tret. Gal.

5 N. A. Berdyaev. *Dusha Rossii // Russkaya ideya.* Moscow, 1992, p. 305.
6 *Ivan Nikolayevich Kramskoi. Pis'ma, stat'i: V 2 t.* Moscow, Iskusstvo, 1965, p. 132.

Russian culture, which recurs in various ways throughout the 19th and 20th centuries. "The creations of the Russian spirit always bifurcate, just like Russian historical reality... In other countries one can observe all manner of contradictions, but only in Russia does thesis turn into antithesis." [5] These words, belonging to the well-known philosopher Nikolai Berdyaev, accurately reflect the situation in the 19th- and early 20th-century Russian art world.

In 1863, Nikolai Ghe showed *The Last Supper* (Russian Museum) to the public for the first time. Never before had a painting provoked such passionate debate. Good and evil, loyalty and betrayal — these eternal moral contradictions lie at the base of the artist's conception. Events of the day, a schism between former confederates at the journal *Sovremennik*, served as the emotional impulse for the choice of this subject, a widespread one in Western art.

Ghe chose neither a group portrait nor a genre picture to represent the conflict of ethical opponents, but a Biblical subject instead. This helped the artist to avoid a concrete and private context and rise to a higher level, to the theme of loyalty and betrayal in general.

At a time of positivism's reign and the triumph of the "fact", artists and the Russian *intelligentsia* found themselves strangely drawn to religious questions. Once more, Leo Tolstoy comes to mind, this time with his attempt to reinterpret the Gospels, his thoughts on the subject of religion, the tortured writing of his *Confession* and, finally, his excommunication by the Church and the *intelligentsia's* violent reaction to it.

Like Tolstoy, many artists of the Realist school turned at that time to the figure of Jesus Christ. In their relation to Christ, they expressed their understanding of faith, the role of the individual in history and the mutual relationship of the individual and society.

Ivan Kramskoi, one of the most atheistically minded artists of the mid- to late 19th-century period, wrote while working on his painting *Christ in the Desert* (1872, Tretyakov Gallery): "... for five years now, he [Christ] has been standing before me, and I needed to paint him, to get it over with... During my work on him I thought, prayed and suffered much (I am going to use high-flown language)". [6]

Kramskoi, like many of his contemporaries, has an ambiguous relationship to Christ and religion. On the one hand, Christ is a moral authority for him. However, Kramskoi sees Christ as a figure more legendary than real. Grounded in this conviction, the artist at-

Nikolai Ghe. The Crucifixion. Sketch variant for
The Crucifixion. 1894. Russ. Mus.

tempts to "purge" the image of Christ of his divine hypostasis. More-over, by desacralising Christ, he attempts to locate in him the seeds of atheism — and finds them! At a certain point, Christ stops being God for Kramskoi. "My God, or Christ, is the supreme atheist," writes Kramskoi, "a man who destroyed God in the universe and placed him in the very centre of the human spirit, and goes to his death calmly for that reason."[7] "What is a real atheist?" asks Kramskoi rhetorically, and answers the question: "He is a person who draws strength only from himself."[8]

For Kramskoi, Christ, contemplating in the desert his role in the life of his people, whom he is leading to a new religion, is a metaphor for the conflict of opposing principles within man: strength and weakness, faith and disbelief.

Man's suffering on account of ideas, truth and justice, and the opposition of the individual and the mob: these were critical issues in the last half of the 19th century. They were examined in Nikolai Ghe's *What Is Truth?* (1890, Tretyakov Gallery) and *The Crucifixion* (1892, Musée d'Orsay; 1894, location unknown). If not directly connected with the life of Leo Tolstoy, these canvases were undoubtedly inspired by the conversations the artist had with the great thinker. *What Is Truth?* and *The Crucifixion* express the artist's deep concern for the world's moral imperfections and human suffering, as well as the conflicts between good and evil, truth and falsehood, and the individual and the state. Once again, Realist artist Ghe, like his contemporaries Repin, Kramskoi, Polenov and others, poses and solves problems of a non-religious nature through the use of a religious subject. Along with this, the fierce passions present in these canvases, and the profound suffering of their New Testament personages, which were inspired by actual contemporary issues, transforms these works into reflections of fiery emotions taken to a level of religious zeal. Naturally, neither Church nor state had any use for such pictures. The Church, because they were secular in principle. The state, because they harboured the seeds of criticism and protest against actual social ills.

So it's not surprising that *What Is Truth?* was removed from the XVIII Wanderers Exhibition and forbidden from being shown in other cities. It was even removed from the exhibition catalogue.[9] *The Crucifixion*, painted in 1892, met with more or less the same fate.

"You cannot go anywhere today where you would not find crucifixions," wrote Ghe at the end of 1892, "…neither America, nor France, nor England, nor Germany, nor here in Russia…"[10] It was this condi-

[7] Ibid. p. 226.
[8] Ibid. p. 230.
[9] *Nikolai Nikolayevich Ghe. Pis'ma. Stat'i, Kritika. Vospominaniya sovremennikov.* Moscow, Iskusstvo, 1978, p. 144.
[10] Ibid. p. 165.

164

Ilya Repin. Christ Taken Prisoner. 1886. Russ. Mus.

Ilya Repin. Begone, Satan! 1895 (?) Russ. Mus.

[11] Ibid. p. 190.
[12] Repin. Op. cit. V. 2, p. 115.
[13] I. E. Repin. *Dalekoye blizkoye*. Leningrad, Khudozhnik RSFSR, 1982, p. 401.
[14] Ibid. p. 400.

tion of society in which lack of understanding reigned, and where those sincerely distressed by human suffering were persecuted and condemned for telling the truth, which found its reflection in *The Crucifixion*. While examining the picture, Tsar Nicholas II remarked: "Why, that is just butchery!"[11] That was enough to have the picture forbidden by the censors. As a result, Ghe showed it in Paris, where it remained.

Around artworks effectively forbidden at the end of the 19th century by the Church and the government, as was wont to happen in Russia, heated debates arose exposing rifts in society's attitudes not only to art, but to the Church, religion, ethics, aesthetics and other questions of public life and existence in general.

Many Realist artists devoted themselves to expressing their world-view through religious subjects. One of them was Ilya Repin, the author of *Barge Haulers on the Volga* (1870–1873). This creator of genre and historical compositions, as well as remarkable portraits of his contemporaries, always sought "something higher than mere mastery and virtuosity" in art. In a letter to his pupil Marianna Verevkina in 1894, Repin sees art's purpose in the "expression of the spirit" which reigns everywhere, to which he adds: "It can be comprehended only by the inspired and depicted only by the chosen…"[12]

Already a celebrated artist by that time, Repin sought new content more fitting of contemporary life. Several times he turns to the figure of Christ. His *Christ Taken Prisoner* (1886, Russian Museum) and *Begone, Satan!* (1895 [?], Russian Museum) are executed as superb sketches which were never realised as paintings. Finally, he creates one of his masterpieces, *Leo Tolstoy Barefoot* (1901, Russian Museum), depicting a perfectly concrete and well-known personage. The artist painted Tolstoy from life, "full size", barefoot, during prayers[13] — the way he saw him at Yasnaya Polyana, where he was a frequent guest, visiting with and observing the writer. Not really a portrait in the traditional sense, *Leo Tolstoy Barefoot* depicts its subject as a wanderer or apostle. "How much life and passion there is in that wanderer,"[14] wrote Repin of Tolstoy, revealing just what inspired him to create this image.

Man's spiritual life, his yearnings and sufferings and his departure from this sinful world — these themes conveyed in Repin's portrayal of Tolstoy captured the imagination of a significant part of Russian society. A different side of the writer was revealed by Mikhail Nesterov, one Russia's subtlest Symbolist artists.

Mikhail Nesterov. Hermit. 1888. Russ. Mus.

Nesterov devotes many of his paintings to people of the Church, remote from worldly vanity, immersed in the mysterious and rich world of spiritual quest (*On the Eve of the Annunciation*, 1895; *Hermit*, 1888 — both Russian Museum). As a rule, the personages in Nesterov's canvases are not portrait-like, having no concrete prototypes. They are symbols of the existence of a way of life, which rejects vanity and worldliness.

St Dmitry the Murdered Tsarevich (1899, Russian Museum) does represent a real-life historical personage: the son of Ivan IV (the "Terrible") and his last wife, Maria Nagaya. After his father's death, the regent Boris Godunov exiled Dmitry, together with his mother, to Uglich Monastery, where he was murdered. According to folk legend, the souls of the departed remain on earth for nine days among their nearest and dearest. Using this religious belief, Nesterov paints a picture depicting a real historical figure, but in an unearthly, otherworldly state. Humility, a tranquil soul and all-forgivingness form the meaning of this complex canvas, which has a splendidly painted landscape background, as do the majority of Nesterov's pictures.

The works of Mikhail Vrubel, one of Nesterov's contemporaries, exhibit a completely different kind of religiosity, rebellious in character, in keeping with the spirit of the Symbolist age. The thinking being tormented by good and evil, pride and sorrow, condemnation and revolt, strength of will and resignation to fate (*Seated Demon*, 1890, Tretyakov Gallery; *Flying Demon*, 1899, Russian Museum): this is the main theme of the mature Vrubel. Later, exhausted and wracked by disease, the suffering artist would turn to the image of the Prophet (*Six-Winged Seraph*, 1904, Russian Museum; *The Prophet*, 1905, Pushkin Museum; *The Vision of the Prophet Ezekiel*, 1906, Russian Museum). In his later years, Vrubel embodied his obsession with the idea of repentance in another masterpiece on a religious theme, *Six-Winged Seraph*. The irreversibility of fate and the retribution which the Seraph is about to inflict, with his raised sword and blazing fire, are fully captured in this vehement image.

Unlike the late 19th-century artists who preceded them, the Symbolists addressed issues far removed from the social realm. The individual, with his private spiritual world and suffering, is what concerns them. They feel themselves co-creators with God. They visualise divine prophecy.

The religiosity of the next generation of Russian artists was of another type altogether. It would seem that the avant-garde, with its declaration of war on everything accustomed and traditional,

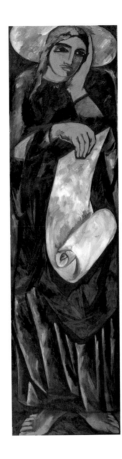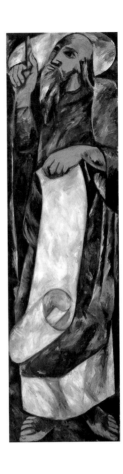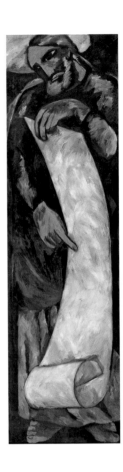

Natalia Goncharova. Evangelists
Tetraptych. 1911. Russ. Mus.

Evangelist (in Blue)
Evangelist (in Red)
Evangelist (in Grey)
Evangelist (in Green)

ought to have destroyed the old forms not only in art, but in philosophy and religion as well, replacing them with something entirely different. In fact, everything turned out to be much more complex. The beginning of the 20th century, when innovative, avant-garde tendencies had just arisen and were beginning to develop in Russia, was also a time of the rebirth of the spiritual foundations of Christianity, as paradoxical as that may seem.

Goncharova, Malevich, Kandinsky and Filonov repeatedly turned to religious subjects in their art, and not only to pay tribute to icon painting traditions or the symbolic or neo-primitivist style. For all of them, religion remained a reference point to which they returned at various stages of their creative lives.

Attention to religion is always heightened in Russian art during times of cataclysm.

The First World War gave birth to Kuzma Petrov-Vodkin's *Virgin of Tender Mercy* (1914, Russian Museum) and other works containing the image of the Virgin. Natalia Goncharova created a series of lithographs entitled "Mystical Images of War" (1914, Russian Museum) and Pavel Filonov painted his *The German War* (1914, Russian Museum), in which the downward-falling figures refer back to a Christian prototype, the icon *The Descent into Hell*.

As a rule, Russian avant-garde artists no longer imbued their works on religious subjects with social and collective pathos. Instead, their connection with Scripture was inspired by the painterly and visual language of icon painting, woodcuts and folk art (*lubok*), and a return to the archetypal roots of religiosity in general. There were true believers among Russian avant-garde artists, like Natalia Goncharova and Olga Rozanova. Others began life, like many Russians, observing religious rites but later rejected God out of a general nihilism towards tradition or due to their own pride, like Pavel Filonov. Often, a grotesque attitude

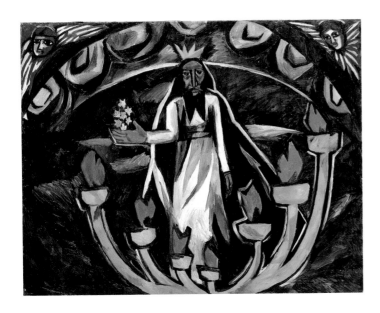

Natalia Goncharova. The Elder with Seven Stars
(Apocalypse). 1910. Tret. Gal.

[15] E. F. Kovtun. *Pis'ma K. S. Malevicha
M. V. Matyushinu // Ezhegodnik ruko-
pisnogo otdela Pushkinskogo doma na
1974*. Leningrad, 1976, pp. 177–195.
[16] *Kazimir Malevich. Sobr. soch.: V 5 t.*
Moscow, Gileya, 1995, V. 1, p. 246.

to religion at some point in their lives gave way to a genuine quest
for Christian spiritual values, as with Kazimir Malevich.

In one way or another, Russian avant-garde artists were tied to
religion through their sense of the world as a whole, and in their striv-
ing to uncover and convey the fundamental bases of existence.
Conscious of themselves as innovators and creators of a new aes-
thetic world, they sometimes identified themselves with God,
whether seriously or in jest (David Burliuk's *Portrait of Vasily Ka-
mensky*, 1917, Russian Museum; Svyatoslav Voinov's self-portrait
in *Head of an Apostle*, 1919, Russian Museum).

Artists of the Russian avant-garde were often drawn to religion
through their interest in and love for folk history, legends, symbols
and myth-making. In creating their new art they imitated no one, ex-
cept possibly God Himself! For example, Kazimir Malevich wrote in
a letter to Mikhail Matyushin in 1916: "Christ opened up heaven on
the earth, created a limit to space… Space is greater than heaven,
stronger and mightier, and our new book [the theory of Suprema-
tism] is a study of space in emptiness."[15]

In 1916, Malevich uses a comparison with Christ to explain his
new concept of space as cosmos. At the end of the 1910s, his
thoughts about art in general lead him to write the tract "God Is
Not Cast Down. Art. The Church. The Factory". The essay's title and
phraseology are suffused with religious pathos. In it, the artist con-
centrates on the topic of mutual relations between religion and so-
ciety after the revolution of 1917, when religion and the Church were
already factually prohibited. The conclusions which Malevich ar-
rives at reveal his egocentric, cosmic-scale brand of religiosity and
help us understand the artist's work both before 1917 and later, up
to his death in 1935.

Invoking the Bible, Malevich interprets God's creation of the
world thus: "God decided to create the world in order to free him-
self of it forever, to become free, to retreat into complete nothing-
ness and eternal rest as a thinking being, for perfection lies in the
complete cessation of thought. He desired to do the same for man
on earth also. Man could not endure the system, however, violated
it [original sin], escaped from bondage, and the whole system col-
lapsed, its weight falling on him. In other words, God, feeling weight
in himself, dispersed it into the system and weight became light,
making him weightless and leaving man in a weightless system."[16]
This "weightless system", in the words of Malevich, is the World, the
Universe in which man lives. Suprematism is an artistic expression

Kazimir Malevich. Head of a Peasant. 1928–1929. Russ. Mus.

Kazimir Malevich. Peasants. Circa 1930. Russ. Mus.

[17] *Pis'mo K. S. Malevicha M. O. Gershenzo-nu ot 20 marta 1920 // Cherny kvadrat / Sost. A. Shatskikh.* Petersburg, Azbuka, 2001, pp. 438–439.

of man's existence in the Universe. Weight, expressed by colour and form, is distributed throughout the weightless Universe (across the canvas, painted in one colour), forming a composition of Suprematist nature.

The Suprematist compositions *Black Square* (an icon of the new time, as the artist himself called it), *Black Cross* and *Black Circle* all have white backgrounds. These images are all semantically connected with Christian symbolism, as researchers have long noted. However, Malevich's repeated return to the same forms (*Black Square*) at various times in his life remains an enigma. What was it? Elementary replication of his masterpiece? Or did the act of repetition itself contain some special idea for the artist?

From Malevich's own writings it follows that by 1920 he sees his *Black Square*, first appearing in 1913 on the curtain of the opera *Victory over the Sun*, in a completely different light. "It is the shape of some kind of new live organism… It is not a painting but something else entirely", writes the artist, and goes on to explain his thoughts: "It occurred to me that if humanity drew the image of the Godhead in its own likeness, then maybe the Black Square is an image of God as a perfect being on the new path of today's beginnings." [17]

From this statement we can assume that Malevich's reason for repeating *Black Square* several times was that at different stages of his creative life that shape and colour ideally expressed his understanding of the image of God in his relationship to the universe and mankind. In effect, Malevich created a new type of icon. Unlike those who painted icons for the Orthodox Church based on Scriptural texts, howev-

er, Malevich banishes all subjects from his art. He minimises his images, reducing them to pure forms and formulae.

The square, circle and cross used by ancient Russian icon painters to ornament the clothing of saints are monumentalised by Malevich, made into self-sufficient, polysemantic symbols denoting something more than just the escape of contemporary art from traditional representation into "nothingness". The icon, a traditional Russian religious art form, returns through Malevich's œuvre in a different, modernised form. Judging from the tract "God Is Not Cast Down", Malevich sought a universal artistic language in order to embody a new religion. In his black, red and white squares, Malevich considered himself to be re-creating the universe in new forms of art. These new art forms, he thought, would enable the creation of a new "architecture" or structure of relationships of Man and the World, which meant a new religion.

Malevich's public position and his ambitious project for the creation of a new religion did not pass unnoticed. Reviewing his book "God Is Not Cast Down", one of the ideologues of Constructivism wrote: "I have shown repeatedly that Suprematism is the most rabid sort of reaction under the flag of revolution, in other words, doubly harmful reaction. Left-wing art, represented by its authentically revolutionary movement (Constructivism), must mercilessly sever the ties binding it to Suprematism. After Malevich's open attack, even the doubters and the nearsighted will now be able to see the black face of the old art lurking under the mask of the red square." [18]

The critic was right. For Malevich in the 1920s, Suprematism became an instrument for the creation of an artistic environment for a New Ideology, which he called a Religion; atheistically minded Constructivists associated this with the old traditions, including religious ones. "For many years," wrote Malevich at the end of the 1910s, "I was busy with my painting movement and left the religion of the spirit by the wayside; twenty-five years passed, and now I have returned to or re-entered the World of Religion. I do not know why this has happened. I visit churches, look at the saints and the whole active spiritual world, and I see in myself, and maybe in the world as a whole, that the moment for a change of religion has arrived." [19]

Reflecting on religion, the artist comes to the conclusion that the Church and the Factory, which he understands to be the structure of socialist society with its cultural centres and clubs, are very similar. "The walls of both are decorated with faces or portraits, organised similarly by worthiness or rank; both have their martyrs and heroes, whose names are entered into books of saints. There's no difference at all, therefore; everything's the same from all points of view, for the question is the same, the goal is the same, and the meaning lies in the search for God." [20]

Malevich wrote this in 1920, after which he practically stopped painting, resuming again only at the decade's end.

The personages created by him in the late 1920s and early 1930s are solemn and magnificent, intentionally impersonal, made for inclusion in some sort of iconostasis of new heroes and martyrs, like the saints on icons.

His *Head of a Peasant* (1928–1932, Russian Museum), with its crosses in the background, is unquestionably an embodiment of the accustomed and well-known image of Christ, but in the guise of a peasant.

Thus the theme of the new religion and the new people, led by God into a new life, appears in the peasant series of works, in which Suprematism, discovered in the mid-1910s, is transformed into a different hypostasis, as Malevich saw it.

[18] B. Arvatov. *Malevich. Bog ne skinut (Iskusstvo. Tserkov'. Fabrika). Izdatel'stvo „Unovis". Vitebsk 1922 // Pechat' i revolyutsiya*. Moscow, 1922, No. 7, pp. 343–344.
[19] *Pis'mo K. S. Malevicha M. O. Gershenzonu ot 11 aprelya 1920 // Cherny kvadrat / Sost. A. Shatskih*. p. 441.
[20] *Kazimir Malevich. Sobr. soch.* V. 1, p. 248.

170

The quest of one of the 20th century's most innovative creators for new themes and a new artistic language had its source in the realm of his religious notions. In this sense, Malevich is a brilliant successor of the Russian artistic tradition.

The creative maximalism of Malevich and many other 19th- and 20th-century artists was connected to a large degree with their religious consciousness, which, though taking various forms, always permeated their world-view.

"A GENERATION CRYING OUT FOR BEAUTY"

The World of Art:
Between the World and Art

The concept of the "World of Art" (Mir iskusstva) embraces more than just the society created by Sergei Diaghilev and Alexander Benois (in existence from 1900 to 1924), the exhibitions that they curated and the periodical of the same name (which ran from 1898 to 1904). The World of Art also stands for one of the most important and illustrious chapters in the history of Russian culture, inspiring a whole new philosophy of creativity.

The appearance of the "World of Art" as an exhibition society requires no special explanation. There were many young artists who, in the words of Alexander Benois, "had nowhere to go … who were either totally rejected by the exhibitions or were only accepted after the complete elimination of all that, for them, represented the clearest expression of their artistic quests." [1] These "outcasts" decided to unite under the common banner of a rejection of "all that is stagnant, established and dead," appealing directly to the viewer.

The founders of the "World of Art" — Alexander Benois and Sergei Diaghilev — understood the true common cultural meaning of this ambitious undertaking. Their aim was "to cultivate Russian painting, clean it up and, most importantly, offer it to the West, exalt it in the West … to create a new word in European art." Alexander Benois led the battle cry: "Talents of all movements, unite!" Diaghilev was more concrete: "I am planning a journal in which I propose to bring together the whole of Russian art life, i. e. illustrations of real works of painting and articles speaking openly about what I really think. Then, in the name of the magazine, a series of annual exhibitions, ultimately linked up to the new branch of industrial art currently developing in Moscow and Finland. In short, I see the future through a magnifying glass." [2]

The first issue of the *World of Art* magazine came out in November 1898, almost immediately after the publication of Leo Tolstoy's treatise *What Is Art?* The great moralist's text read like a direct challenge to the whole of modern culture, which was accused of betraying what was, in the venerable writer's opinion, the only possible task of art — to "bring about fraternal unity". Tolstoy claimed that "art has become not the great deed it was intended to be, but a vacant pastime of idle people." Art had degenerated into a licentious whore: "Always painted, always up for grabs and always alluringly pernicious." [3]

The challenge was accepted. In an article entitled "Complex Questions" in the first issue of the *World of Art* magazine, Diaghilev countered Tolstoy's thesis that "the more we give ourselves up to beauty, the further we move away from good." [4] He claimed that "a creator must love only beauty; only with beauty can he converse as he softly and enigmatically brings out his divine nature." On behalf of "a generation crying out for beauty," Diaghilev declared: "The great power of art is that it is self-valuable, self-effective and, most importantly, free." [5]

The spirit of freedom filling the air at the *World of Art* exhibitions could pervade any space: the realistic portraits of Valentin Serov or the Impressionist landscapes of Sergei Vinogradov; the cosmological fantasies of Mikhail Vrubel or the retrospective daydreams of Konstantin Somov and Victor Borisov-Musatov; the National Romanticism of Mikhail Nesterov, Nikolai Roerich and Filipp Malyavin or the Europeanism of Nathan Altman and Kuzma Petrov-Vodkin; the poetic genre scenes of Boris Kustodiev or the theatrical element of Léon Bakst, Alexander Benois and Alexander Golovin.

This freedom intoxicated some and repelled others. Vladimir Stasov, the champion of Critical Realism, called the exhibitions "an orgy of debauchery and madness," and the contributors to the *World of Art* magazine "beggarly in spirit" and an "inn of lepers". The "intoxicated" were those for whom creativity was a unique cultural gesture or "art for art's sake." As Diaghilev himself later wrote: "A work of art is important only as the expression of the creator's personality." [6]

[1] A. Benois. Vystavka "Sovremennoi russkoi zhivopisi". *Rech'*, 2 December 1916.

[2] *Sergei Dyagilev i russkoe iskusstvo: V 2 t.* Moscow, 1982, Vol. 1, p. 56, Vol. 2, pp. 26, 28.

[3] L. N. Tolstoy. *Chto takoe iskusstvo?, Sobranie sochinenii: V 22 t.* Moscow, 1983, Vol. 15, pp. 94, 194, 211.

[4] *L. N. Tolstoi i V. V. Stasov. Perepiska. 1878–1906.* Leningrad, 1929, p. 218.

[5] S. Diaghilev. *Slozhnye voprosy, Mir iskusstva.* 1898, Vol. 1, pp. 13, 15, 60 et al.

[6] Ibid. p. 50.

Referring to Isaac Levitan as a Realist, Alexander Benois elaborated: "Such words as Realism are even somewhat insulting. This ingenious and vital poet was far removed from any preconceived theory or assignment to any camp."[7] The "World of Art" shied away from genre and stylistic definitions, lumping together all that was "authentic" (Benois' favourite word), be it a painting, an ex libris, an easel illustration or a porcelain knick-knack. They attempted to break free of the clutches of time — past or present.

In Anton Chekhov's play *The Seagull* (1896), Treplev says that "new forms are needed" to replace "those high priests of art" who "show us people in the act of eating, drinking, loving, walking and wearing their coats, attempting to extract a moral from their insipid talk."[8] For the "World of Art", this was a whole, new, integrated view of art; a link between the past and the future; a single age of authentic temporal values. The senior and junior members of the "World of Art", founders and fellow-travellers alike, came to this world of culture and temple of art, still unaware what name history would give to them, yet sensing the pulse of a common creative will and elements of artistic eternity.

Konstantin Somov's enchanting visions evoke a special state of mind, described by Alexander Blok as "when the familiar meets down the centuries, and the mystical is born."[9] This sickly-sensitive fugitive from Repin's studio was not just inspired by the preceding century. Somov's sources were much deeper and more repressed, stretching beyond the bounds of the recent past back to Botticelli, Watteau and Hoffmann.

Fyodor Sologub might have been looking at Somov's *Lady in Blue* (1897–1900) when he wrote in the preface to *The Petty Demon* (1907): "This novel is a skilfully made mirror. I spent a long time polishing and zealously working on it. The surface of my mirror is even and its composition is pure." Working equally zealously, Somov looks beyond the looking glass, seeking an image — a frozen reflection of eternal femininity. More than his teacher, Ilya Repin, he was a contemporary of the Symbolists — Mikhail Vrubel, Alexander Scriabin, Alexander Blok, Andrei Bely, Vyacheslav Ivanov and Vladimir Solovyov.

Remaining aloof from direct "symbolical Symbolism", which appealed to what the Romantics called the "inexpressible," the "World of Art" was even further removed from the callous, crude and inert Realism of Vladimir Stasov. Closer to their hearts was the "transparent Realism unwittingly fastening onto Symbolism" or the Neo-Realists — those who "seek beauty in everyday life and seek its invisible mystical element in the visible world."[10]

Although Mikhail Nesterov's *St Dmitry the Murdered Tsarevich* (1899) is undoubtedly Symbolist — Andrei Tarkovsky employed the artist's images in such award-winning films as *Solaris* (1972) and *Mirror* (1975) — his poetry of the supernatural is hidden in the enchanting melancholy of a kindred landscape motif, familiar to us from childhood. The Realism-Symbolism of Isaac Levitan — the most precious of the Neo-Realists, who was able, in the words of Benois, to "delight with the brush and paint" — was of an even more painterly origin. Vladimir Nabokov's heroes possibly saw Levitan's *Golden Autumn* (1895) in their eternal dreams of returning to their homeland.

Originally perceived as the heir to Ilya Repin, taking traditional portraiture into the next century, Valentin Serov soon became a symbol of the new age. From the magnificent Impressionist Realism of *Girl with Peaches* (1887), he moved towards refined stylism in the spirit of Art Nouveau and then onto Symbolism. In *Portrait of Felix Yusupov* (1903), the painterly energy gives way to elegant plastic reflections. The sharp psychological characteristics are expressed in the magnificent orchestration of the grand form — something that also captured the imagination of the "World of Art" in the oeuvres of the old masters.

[7] A. Benois. *Istoriya russkoi zhivopisi v XIX veke.* St Petersburg, 1902, p. 231.

[8] Anton Chekhov. *The Seagull*, translated by Oliver F. Murphy. Branden Publishing Co, Wellesley, Massachusetts, 1980.

[9] *Aleksandr Blok. Sobranie sochinenii v shesti tomakh.* Vol. 5, Leningrad, 1982, p. 79.

[10] *Andrei Belyi. Arabeski.* Moscow, 1911, p. 399; A. Benois. *Istoriya russkoi zhivopisi v XIX veke.* St Petersburg, 1902, p. 344.

174

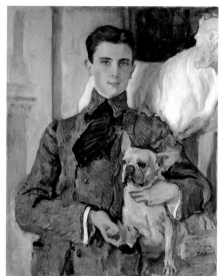

Isaac Levitan. Golden Autumn. Slobodka. 1887. Russ. Mus.

Valentin Serov. Portrait of Count Felix Sumarokov-Elston, Later Prince Yusupov. 1903. Russ. Mus.

[11] A. Benois. *Moi vospominaniya.* Moscow, 1980, Vol. 2, p. 342.

In *Portrait of Ida Rubinstein* (1910), the incorporeal flatness, the contour enclosing the figure in splendid isolation, the decorative details and the bitterness of the general intonation create an oxymoronic effect, similar to what Anna Akhmatova wrote about the Tsarskoye Selo statue: "Look, how this elegant nude enjoys her sorrow." Just as the colour symbolism in Chekhov's *Three Sisters* (1900) or the "distant sound heard as if from the sky, the sound of a breaking string, dying away sadly" in *The Cherry Orchard* (1903) have moral-psychological motivations, Serov's associative layer is transparent, bringing out a dramatic meaning.

Both Alexander Benois and Sergei Diaghilev could say with equal right, in imitation of Louis XIV: "The 'World of Art'? I am the 'World of Art'!" But what was for the "republican" Benois the end — an artistic personality harmonising the real world — was the means for the "monarchist" Diaghilev, a dictator who arranged artists in line with his own Nietzschean ideas of their "usefulness to the general construction." Diaghilev's ends were sublime, ambitious and avant-garde — to conquer the Imperial Theatres Company, St Petersburg, Moscow and Paris. A balletomane, music lover and impresario, he sensed that the theatre, with its unique synthesis of different forms of art, could realise his plans and dreams.

Diaghilev summed up his *World of Art* period in *L'Exposition de l'Art russe* at the Autumn Salon in Paris in 1906, bringing together Old Russian icons, eighteenth-century portraits and such contemporary painters as Mikhail Larionov. This signalled Diaghilev's movement from the general *Saisons Russes* to the more specific *Ballets Russes*, heading "a transplanted branch" of Russian culture, as Andrei Bitov described Vladimir Nabokov.

Such outstanding ballets as *Schéhérazade* (1910), *Pétrouchka* (1911) and *Le Sacre du printemps* (1913) were just as much the offspring of Léon Bakst, Alexander Benois and Nikolai Roerich as they were of Nikolai Rimsky-Korsakov, Igor Stravinsky, Mikhail Fokine and Vaslav Nijinsky. Ballet was perceived as a "painting of movements." Bakst's plastic bacchanalia, Benois's refined stylism, Roerich's pantheistic spirit and Golovin's aristocratic majesty set the style of these shows. But if Dmitry Filosofov is correct in saying that, by the early 1910s, the *World of Art* had turned into the "world of theatre," then the question arises — what remained of the *World of Art* back in Russia?

The answer is the rebirth of the "World of Art" in 1910, when the former reformers now looked almost orthodox in the eyes of the new generation of rebels. Attempting to cast his eyes around as differentially and benevolently as possible, Benois sought sincere and genuine art — that which "in paradise links the most heroic zealots to the meekest and purest of souls." [11] He softened his attitude towards contempo-

rary art: "Although the 'Jacks of Diamonds' enrage and the 'Donkey's Tails' confound, one must admit that, among them, there are a mass of highly talented, exciting and powerful people."[12] Kuzma Petrov-Vodkin, Nathan Altman, Boris Grigoriev, Mikhail Larionov, Natalia Goncharova and Ilya Mashkov were invited to contribute to the "World of Art" exhibitions.

The composition of Nathan Altman's *Portrait of Anna Akhmatova* (1914) — "sitting like a porcelain idol in a pose she selected long ago" — echoes a long line of portrait figures. This illustrious gallery of Russian portraiture began with Dmitry Levitsky's *Smolny Girls* in the eighteenth century and ended with Diaghilev and Benois's famous exhibition of historical portraits at the Tauride Palace in St Petersburg in 1905.

The tragic spirit of Boris Grigoriev's *Portrait of Vsevolod Meyerhold* (1916) is immediately revealed, without analysis, in the nervously interrupted rhythms, grotesque fractures, mournful tones, convulsive gesture and the slightly terrifying and absurd outline of the main figure. This is clearly more than just the representation of an actor in a role, as in most theatrical portraits. This is the self-recognition of an artist, balancing on the threshold of a dual existence and anticipating a catastrophe.

In Kuzma Petrov-Vodkin's *Boys* (1911), a blond "superman" clenches a stone, looking inexorably at his sacral offering. Desperately hoping, he tears himself away, covering his face in a doomed expression with a hand raised to heaven. This is, as Boris Pasternak wrote, "destruction for real." This is Cain and Abel — the first murder on earth.

The faces in Vasily Shukhayev and Alexander Yakovlev's *Self-Portraits (Harlequin and Pierrot)* (1914) finally succumb to masks as theatrically sinister and expressive as those worn by showcase dummies and waxwork figures. The eternally "stray" (Mikhail Bakhtin) subject of standing before a mirror returns us to the self-portrait. The self-portrait mimics the portrait, while the portrait mimics a picture.

The summons made to talents of all movements to unite now seemed naïve and absurd, following the appearance of Wassily Kandinsky's abstract compositions and Kazimir Malevich's Suprematism. With whom were they now to unite? With those who proclaimed that "a museum of Russian street signs would be a hundred times more interesting than the Hermitage"?[13] Or with the "barbarians," whose onslaught had been predicted by Diaghilev ("We are doomed to die so that a new culture might arise again. We who raised it will be destroyed by it")?[14]

Two truths — the Apollonian and the Dionysian — clashed, only no longer on the pages of a magazine, but in real life. As an art historian, Benois understood that the barbarians who had destroyed antiquity had, at the same time, paved the "road to the church" and the building of Notre-Dame. As a follower of the humanist tradition, however, he regarded art as an enlightening and logical element, taming the frenzied waves of paganism with the help of beauty and measure. Losing the artistic perspective, he could not help declaring war on the intoxicating myth-creativity of the modern barbarians — the avant-garde — and the irrational complexes threatening to destroy the fragrant world of culture.

Attempting to maintain a balance between the wild and the human, the "World of Art" united around itself talented people, those who upheld artistic memory and the plastic pedigree of culture. It cast off all others, for whom its aesthetics were too hermetic — hampering development and separating the art of technical mastery and glass bead games from creativity, composition and surges into the unknown.

Many years later, hoping that time had softened the discords of the past, Wassily Kandinsky sought out Alexander Benois. He wanted to hear the opinion of the spiritual father of the "World of Art" on his

[12] A. Benois. *Trudno li? Rech'*, 12 April 1915.

[13] D. Burliuk. *Galdyaschie "benua" i novoe russkoe natsional'noe iskusstvo.* St Petersburg, 1913, p. 3.

[14] S. Diaghilev. *V chas itogov. Vesy*, 1905, No. 4, p. 46.

[15] B. Asvarisch. *V. V. Kandinskii i A. N. Benua v Parizhe. 1936 god. Voprosy iskusstvoznaniya, VIII/I, 96*, Moscow, 1996, p. 613.

Alexander Benois
Sketch of the costume designs
for Igor Stravinsky's ballet
Pétrouchka. 1917. Russ. Mus.

Pétrouchka
Street Dancer
Kitchen Boy
Street Dancer

painting. Benois admitted that Kandinsky's painting was "real art" and "pure music", undoubtedly awaiting a "great future." He could not even bring himself to give a negative rating, so deeply unsettling was this future for him. [15]

The dialogue did not work out. The dream of unity deceived and the crude knout of real life overwhelmed the large-hearted humanism of the "World of Art"… The "World of Art" had arisen at the junction of two ages, in the carefree and short-lived period when Critical Realism had overlapped with the Silver Age. When the search for justice, beauty, ethics and aesthetics converged; when intractable Realists came into contact with pensive, light-hearted dreamers and the two smiled at one another. There was no future for the "World of Art" following the artistic and political revolutions, when all the leading representatives of painting, literature, music and philosophy emigrated and Russia was abandoned by both the world and art.

There is a tragic and bitter irony that the Society of Travelling Exhibitions and the "World of Art" both ended their existences at the same time — in 1923 and 1924 respectively — while the avant-garde fell victim to the same revolutionary ideology that it ostensibly supported. The "World of Art" retained its historical-artistic significance and postmodernist contemporary meaning, however, as the grandiose action-project of a synthetic "imaginary museum".

"Imaginary", for it was impossible to enclose within the walls of a museum not only the painting, drawing, sculpture and applied art of all times and nations, but also crumbling Neoclassical architecture, theatrical productions and writings on art. A "museum" because the museum, constantly falling behind and passing over things, remains the only place in the world where the laws and proportions are dictated by art itself. The only place where Tolstoy and Diaghilev, Benois and Kandinsky, Realism and the avant-garde — "beauty in truth" and "truth in beauty" — can finally live together in concord.

„...SHE HEARS THE CLOCK'S GALLOPING HORSE INSIDE HERSELF"*

FROM RUSSIA

I proceed from the following question: Are there gender-specific features in the art of the Russian/Soviet avant-garde? By features I mean those differences, in the art-historical sense, which manifest themselves in artworks, which are noticeable and recognisable.

While analysing the pictures, I will try to answer that question in a theoretically grounded way, formulating my theses as hypotheses in need of further discussion.

1.

When examining the time period under discussion, the matter of gender-dependent differences in art acquires special acuteness for the following reasons:

Firstly, never before in the history of art had so many female artists stood alongside their male colleagues among the first ranks of innovators.

Secondly, it is well known that representational, figurative art was developing in that period via Cubo-Futurism towards geometric abstraction; furthermore, this form of materialised abstraction stubbornly resists all attempts to identify expressive means as male or female. In fact, such attempts might seem absurd to many, making no more sense than, say, the sciences of male and female geometry.

We must note, however, that in the case of Constructivism we are dealing not with mathematical or geometric illustrations but with art; therefore, such distinctions are not so far-fetched as they might first seem.

Few female artists of the Russian/Soviet avant-garde were single. They were either officially married to artists or living in common-law marriages. Examples of such couples were Liubov Popova and Alexander Vesnin, Varvara Stepanova and Alexander Rodchenko, Nadezhda Udaltsova and Alexander Drevin, Olga Rozanova and the poet Alexei Kruchenykh, Sonia Delaunay-Terk and Robert Delaunay, Valentina Kulagina and Gustav Klutsis, and Natalia Goncharova and Mikhail Larionov.

* Quotations from Marina Tsvetaeva's essays are cited here and elsewhere from the publication: *Zwetajewa Marina. Gedichte — Prosa russisch und deutsch / Hrsg. Fritz Mierau*. Leipzig, Reclam-Verlag, 1987, p. 305, p. 303, p. 303 ff, p. 309, p. 311.

2.

It is worth noting that the women involved in such relationships often painted still lifes with household objects, especially from the kitchen. In the men's pictures, on the other hand, we are hard-pressed to find anything of the kind.

In her painting *Laundress* (1912, Tretyakov Gallery), Natalia Goncharova points out the inequitable nature of her marital household duties with a subtle irony. On the left side of the picture, starched cuffs and collars are heaped up on two carefully-ironed shirt-fronts; furthermore, the repeated doubling of contours, seeming to be part of the Futurist style at first glance, might also be the desire of the drawing ironing-woman or ironing female artist to give visual expression to the constant repetition of her everyday

Giacomo Balla. Speed of a Car + Light
1913. Moderna Museet, Stockholm

services to her husband. The repeated circles and arcs, together with the stripes of the pleated shirt-front, introduce rhythmic order into the painting, which continues with the patterned structure of women's lace on the right side of the work.

Two word fragments placed in a row, formed of the letters ПРАЧЕ/чная ("laundry") and БОТ, which might be continued as БОТ/ва ("greens"), БОТ/винья (a Russian cold vegetable soup) or БОТ/инок ("boot"), complete the picture, setting the still life in motion. However, the objects here, unlike the ones found in Italian Futurism, do not seem to be rushing to escape the picture's rectangle and fly away. On the contrary, the back and forth motion between the left, "male", and right, "female", parts of the picture seems to lock them into a kind of endless cycle.

The back and forth of the iron with its contours repeated in all directions lends rhythm and motion to the picture. This working instrument of the artist, which exists in her domestic world side by side with her creative life, is emphasised through both composition and colour and labelled with her initials, *N. G.*; correspondingly, we see her husband's monogram, *M. L.*, on the shirt-front lying opposite. Thus Goncharova draws our attention, subtly but clearly, to the division of labour in her married life.

Three years later, Olga Rozanova would paint *A Buffet with Dishes* (1915, Tretyakov Gallery). Here we see an even more insistent tendency to lock the picture into a circular motion. In the centre there is a cut-off disc of ordered, concentric rings: white, light blue, golden yellow and grey. Seemingly abstract forms turn out upon closer examination to be a sugar bowl and the ringed contour of a plate; two cups with saucers also enter our field of view. Around this cone of light snatched away from the dark background other utensils circle about — tea things and the boards from a kitchen shelf — like the hub and spokes of a wheel revolving around a central axle.

Rectangular organising structures located parallel to the picture's edge create with their accurate but interrupted lines a system of coordinates with a symmetrical axis on the painting's surface. The stasis of

Nadezhda Udaltsova. Seamstress 1912–1913. Tret. Gal.

Olga Rozanova. A Buffet with Dishes 1915. Tret. Gal.

Natalia Goncharova. Loom + Woman 1913. National Museum and Gallery of Wales, Cardiff

[1] F. T. Marinetti. *Manifesto of Italian Futurism.* Moscow, 1914. Cited from: Christa Baumgarth. *Geschichte des Futurismus. Rowohlts Deutsche Enzyklopädie.* Reinbek bei Hamburg, 1966, p. 169.

this division of planes is destroyed, however, by the diagonally situated forms on the surface (wooden boards) and objects (knives, spoons, and a cup and saucer). The objects and the shelves rotate around the picture's round centre. Thus the old order of things, oriented around a centre of gravity and a horizontal/vertical framework, is set into circular motion.

The dynamic order of circular motion supersedes the rectangular, static system of coordinates.

In Nadezhda Udaltsova's painting *The Seamstress* (1912–1913, Tretyakov Gallery), we discover a similar compositional technique. The sewing machine's flywheel, shifted a bit right of centre in the picture, sets the parallel lines of the rectangular cells into rotating motion. In this way, the picture's horizontal/vertical raster is overlapped by a pentagon, four corners of which are occupied by sphere-like hinges formed by the seamstres head, shoulders and elbow, together with the sewing machine's flywheel. Contours oriented in all five directions amplify the impression of rhythmic motion emerging from the picture's centre and propagating towards its edges. The centrifugal lines leading beyond the rectangular boundaries of the canvas are still dominated by the general circular motion, however.

Unlike the works of Italian Futurists (Giacomo Balla's *The Speed of a Car + Light*, 1913, Moderna Museet, Stockholm), Udaltsova's picture is an internally moving whole, closed from the outside world.

In 1912, Marinetti declared in his "Technical Manifesto of Futurist Literature" the symbiotic unity of man and machine.

"We want to show in literature the life of the motor, this new beast ruled by instinct, whose main instinct we understand … with the help of intuition we … will conquer the enmity which separates our human flesh from the metal of the motor. After the kingdom of living things the kingdom of the machine will dawn." [1]

Compared to such vivification of the machine, likening it to a beast, and the accompanying objectification of man into a machine-like being, all served up from a triumphant male viewpoint, Udaltsova's

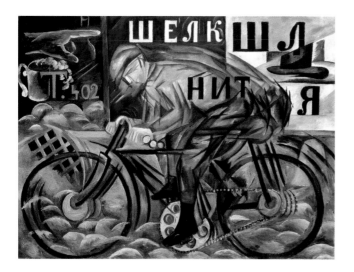

Natalia Goncharova. Cyclist. 1913. Russ. Mus.

Seamstress and Goncharova's *Loom + Woman* (1913) exhibit a much more sceptical and ambiguous mood. Instead of creating a futuristic picture of men of steel marching boldly into the technological age equipped with their modern gadgets, both female Russian Cubo-Futurists present an extremely contradictory picture of woman's encounter with the machine. We see no glorification of technology-equipped human supermen here, nor are the machines depicted in their pictures a means of moving forward, cutting through space in an arrow-straight path. Even where a bicycle is depicted, as in Goncharova's *Cyclist* (1913, Russian Museum), the rider seems to be treading in place rather than moving forward, notwithstanding the image's jagged contours and futuristic style. Here too, as in the previously discussed works, an impression of circular stasis reigns, in spite of the implied forward movement.

My theory states that this circular motion devoid of forward progress can be seen as a metaphor for all forms of motion connected with the repetitive and reproductive activities of domestic labour.

Inasmuch as this cyclical motion is visible even in the static "domestic" still lifes, or household items like sewing machines, metaphoric and symbolic mutual interconnectedness is concretised, made metonymic. The rotating composition becomes a synecdoche for all forms of activity related to the depicted objects and household tools. Activities relating to objects, like doing laundry, cleaning one's house and ironing, for instance, as well as activities connected with people, like buying and preparing food or handiwork, are all repetitive, serving only to obtain, prepare or save already-made products without creating new ones: they neither create nor develop. Daily repetition of these activities leads to a feeling of monotony and endlessness, in which nothing is produced. Things either return to their original condition or, as in the case of food preparation, are consumed as soon as they are produced, and so on, *ad infinitum*. This repetition gives rise to a sense of "objectification", as if repetition were dictated not by the household or family but by the objects themselves.

In both still lifes, we find an expression of this "objectification", inevitability of repetition and seeming independent motion of objects themselves. By rotating around their own axis, they imply the repetition of one and the same thing over and over. In the case of *Seamstress* and *Loom*, the machines' circular motion is shared by the general shape of the pictures, so that the women operating the machines are entirely subordinated to their mechanical repetition.

3.

Natalia Goncharova. Peacock in the Bright Sunlight (in the Egyptian Style). 1911. Tret. Gal.

Male artists of the Russian/Soviet avant-garde were largely remote from the experience of the working world, since they came into contact with material production only in the sphere of consumption, or possibly distribution. Such an abstract and contemplative relation to the economic side of life would most likely have led to a joyful, positive vision of new technological methods of production contrasting with the everyday experience of the female artists. For the latter, both the repetitiveness of household labour and creative activity continued to be an everyday reality. In the repetitive, cyclical motion of their Cubo-Futurist works, this everyday reality is reflected metonymically and physically, undergoing an emotional working-through in the process of painting, in the course of which it is surmounted. Since domestic labour in its "objectified" form is defined both inwardly and from without, it is always perceived ambivalently, as both realisation (positive) and alienation (negative). On the one hand, the pictures express a new, dynamic and life-affirming circular motion, which breaks down the old order of horizontals and verticals; on the other, a monotonous and never-ending repetition.

4.

The truest metonymic symbol for the repetition of domestic labour is the face of a clock. Its round shape and moving hands graphically represent the process of household work with its circularly structured activities. Therefore, clocks with round faces recur frequently in the Cubo-Futurist works of Russian female artists. As the cubist faceted mandolin with its rounded, feminine forms was for Picasso or Braque, the circle of the clock face becomes for Russian women artists a visual synecdoche for their everyday experience as women.

In depiction of clocks Goncharova once again led the way, with her work *Clock* (1910, National Gallery, Berlin). Her example was followed by Liubov Popova (*Clock*, 1914), Olga Rozanova (*Metronome*, 1915, Tretyakov Gallery) and Nadezhda Udaltsova (*Musical Instruments*, 1915), among others. The degree to which the clock's mechanical tick-tock had become the metronome of life for contemporary man was remarked upon by Russian neo-primitivist artist Alexander Shevchenko, who was in close creative collaboration with Goncharova. In 1913, the time when the female artists were creating their clock images, he wrote:

"The world has turned into a unique, monstrous, and fantastic machine in eternal uninterrupted motion, into the only non-organic automatic organism in existence… As ideally-made people, we are used to getting up, going to bed and working in agreement with the clock; the sense of rhythm and mechanical harmony which permeates our whole lives must be reflected in our thinking also, in our spiritual life, in art." [2]

[2] Alexander Shevchenko. *Neoprimitivism.* Moscow, 1913. Cited from: John Bowlt. *Russian Art of the Avant-Garde: Theory and Criticism 1902–1934.* New York, 1976, p. 45.

This quotation explains the degree to which the clock can be perceived as determining the rhythm of modern life, as the true heart beating inside the organism called the world. Thus the clock occupies the centre of the female artists' compositions, transmitting the rhythm of its repetitive ticking to the whole picture by means of gradated visual elements.

Not long before the First World War and the Russian Revolution, Shevchenko eloquently expressed the Russian avant-garde's wavering between enchantment and despondency in its attitude to the industrial age, where the clock is master. In the 1920s, especially towards the end of the decade, when enthusiasm for time's acceleration and euphoria from technological progress begins more and more to dominate the minds of Soviet Constructivists, Russian poetess Marina Tsvetaeva, in her significant essay about Goncharova, draws our attention to the latter's hostility towards technology's intrusion into life and the mechanisation of time. In 1921, as the push for industrialisation is in full swing in the Soviet Union, Tsvetaeva writes from Paris (where Goncharova is also): "I do not oppose the machine to Goncharova because it is dead, but because a murderer. You disagree? Then ask the worker who has lost his fingers. Ask any worker. And do not forget the peasant, whose children have "left for the city". Ask Russian artisans. The machine is the murderer of all human enterprise, from the hand that creates to the creations of hands. The murderer of everything "handmade", of all creativity, of all Goncharova. For Goncharova, the machine is superfluous, but not merely superfluous: it is an encumbrance, an unneeded, external thing, which becomes internal against our will, forcing its way into our inner world through the eyes and ears. Goncharova hears the clock's galloping horse inside herself. First galloping at the edge of the earth, then inside the body, right in the heart. And the physical heart answers in kind, with full hatred and enmity. In her works, Goncharova conquers the clock with her own heart."

On the basis of Goncharova's works, Marina Tsvetaeva formulates an antithesis which could not be more radical. At the same time, she perceives the artist she is writing about not only as a woman, but in her role as the main figure and driving force of the Russian avant-garde over the course of a whole decade. In her life and art, Goncharova foresaw much which others, like Malevich and Tatlin, would later continue.

"Goncharova was the first to introduce the machine into painting", writes Tsvetaeva, and here we should clarify: "into Russian painting". However, she did so not to glorify the machine as an embodiment of futuristic life, but in order to "conquer the machine with her own heart". Tsvetaeva's antithesis applies more or less to the next generation of Russian women artists, too: Exter, Popova, Rozanova, Udaltsova, Stepanova and Sofronova.

"Goncharova is the village, Goncharova is ancient, Goncharova is the village tree, ancient, wooden and woody, Goncharova, with heartwood in place of a heart, and pulp instead of flesh — earthy, middle-earthly, red-and-black earthy. Goncharova is the soil, the tree bark and the burrow which fears clocks." Goncharova "attends the lift", because there she "falls in the lift, with her own heart". She is a "dusty vacuum cleaner" who has "broken her leg in two while going out into a tumbling staircase".

The machines with which the artist enters into confrontation and conquers by her own means do not come from the world of mechanised mass-production, which was much less developed in Russia, after all, than in Western Europe during the early avant-garde period up to the 1920s (and remains so to this day, properly speaking). No, she encounters machines in her more and more mechanised everyday life as an artist and homemaker.

Liubov Popova. Suprematism. 1916. Tret. Gal.

Natalia Goncharova. Electric Lamp. 1913. Musée d'Art Moderne, Pompidou Center, Paris

5.

Goncharova's machines, painted mostly in 1912 and 1913, appear during the transition period from her so-called neo-primitivist phase to abstract Rayonism.

For lack of a better example, I will demonstrate for you Malevich's picture *Peasant Woman with Buckets* (1912, Museum of Modern Art, New York), which appeared under Goncharova's direct spiritual and stylistic influence. This water-bearing peasant woman's close bond with the earth is conveyed not only by her compositional and colouristic connection with the field and the stockiness and mass of her body, but by her overly large bare feet, which stand out most noticeably. What is more, the rough hands point to the hard manual labour she engages in. Goncharova demonstrates how the life and labour of the rural population is still connected with the rhythms of growth and ripening in nature, and not only in her pre-1912 "harvest" works. The cycle of nature, with its eternal succession of day and night, growth and decay, and life and death, manifests itself in other images of her neo-primitivist period, too. It appears in the rhythmic divisions of her still lifes with flowers, as well as in the spreading peacock's tail in *Peacock in the Bright Sunlight (in the Egyptian Style)* (1911, Tretyakov Gallery). When we compare the latter work with the depiction of a clock with similar colour and composition which appeared a year later, we begin to understand what Tsvetaeva had in mind when she spoke of Goncharova's love-hate relationship with the clock as an embodiment of the machine: "Goncharova drives out the machine inside her, like bad blood. When I see what I fear with my eyes, I stop fearing it. So in order to see it, she needs to make it appear. Goncharova is a child of nature; her affair with the machine (alien, repellent, attractive, frightening) is one of both love and enmity." "If Goncharova is an enemy of the machine as instrument of enslavement (of nature by man, of man by himself), she is an ally of the machine enslaved by nature… Here is what Goncharova herself says: 'The principle of motion is the same for both nature and the machine, and, you see, the whole joy of my work lies in revealing the equilibrium of motion.'"

With the transition to abstraction, the painful and tragically perceived conflict between nature and the machine is resolved by pure motion, the thing that both the spreading peacock's tail and the clockwork have in common.

Rhythmically structured cyclical motion becomes the only theme in the abstract work *Rayonist Composition* (1913–1914, Thyssen-Bornemisza Collection). The lines of force, penetrating, but also subordinated to the circular motion, graphically demonstrate the "equilibrium of motion" which Goncharova sees to an equal degree in every machine and every living thing. In this equilibrium, the linear time of the mechanical clock and the machine are brought into harmony with the circular time of nature's cycles. Goncharova senses in this compositional resolution of the contradiction between straight lines of force cutting through the picture's space and the general circular motion the reconciliation of two

Liubov Popova. Space-Force Construction 1921–1922. Tret. Gal.

Liubov Popova. Space-Force Construction 1921. Tret. Gal.

forms of time and life, the rhythm of nature and the ticking of the machine; this was to become a leitmotif in the work of more and more female Russian avant-garde artists in the 1920s (Liubov Popova, *Space-Force Construction*, 1921–1922, Tretyakov Gallery).

The intersection and interpenetration of a rotating, circular composition with a dynamically open framework of diagonal, horizontal and vertical lines is the dominant theme for all female Russian avant-garde artists. In this they differ from both Western Constructivists and their male Russian partners, who preferred figures of development and symbols of progress — diagonals, spirals and hyperbolas — to a conflict-provoking interpenetration of linear and circular elements (Liubov Popova, *Space-Force Construction*, 1921, Tretyakov Gallery; Olga Rozanova, *Suprematism*, 1916; Alexandra Exter, *Non-Objective Composition*, 1916, Tretyakov Gallery; Varvara Stepanova, *Card Players*, 1920, Rodchenko collection; Sofia Dymshitz-Tolstaya, *Compass*, 1920; Nadezhda Udaltsova, *Composition*, 1916; and Antonina Sofronova, the series of "Constructivist Compositions", 1922).

The domination of dynamically opposed figures and the interest in this compositional form which characterised female Russian artists is, in my opinion, mainly connected with the increased sensitivity they acquired through their unique domestic labour experience, which found expression above all in their still life and sewing machine imagery. The ambiguous nature of household work as reproductive activity and its inter-subjective relationships lead to an ambivalent assessment of its repetitive activity structure. Within this structure, female reproductive

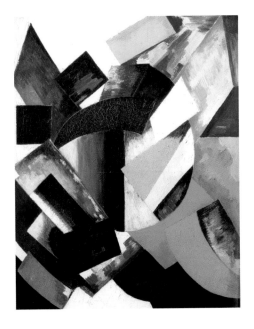

activity is still an integral part of the natural cycle, conditioned by the natural rhythms of day and night, work and sleep, and summer and winter to a much greater degree than typical male activities in the industrial age.

The shape of machine motion and the shape of living motion — that is, peasant reproduction in nature and female reproduction in the household — are perceived by female artists as structurally related, as a cyclical, repetitive circle, as we see with Goncharova. But while the material and monotonous side of that motion was sensed as negative, the side connected with personal relationships was seen as positive; therefore, female artists were unwilling to abandon their metaphoric-metonymic expression of cyclical motion for the sake of linear progress. While male Constructivists attempted, with their diagonals, spirals and hyperbolas, to overcome or even destroy the circle as a symbol of the old, static, self-contained world, the women tried to construct a type of picture-organism where linear forms of development and rotating circular forms would coexist in dynamic unity.

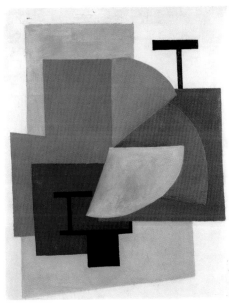

Alexandra Exter. Non-Objective Composition
Circa 1918–1919. Russ. Mus.

Olga Rozanova. Non-Objective Composition
1916. Kostroma Art Museum

"PURE PAINTING":
Abstraction in Russia

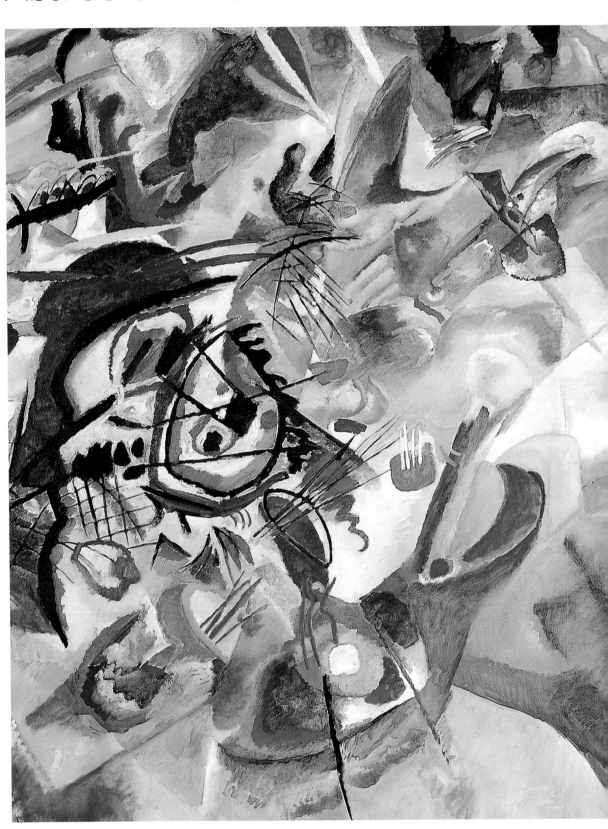

In 1913, the painter Natalia Goncharova wrote "Contemporary Russian art has reached such heights, that, at the present time, it plays a major role in world art. Contemporary Western ideas can be of no further use to us."[1] Although Goncharova's statement may have been slightly premature, it was true that the Russian avant-garde had become one of the most vital forces in modern art, both responsive to, and independent of, creative developments elsewhere. For the next couple of years, Russian artists continued to be inspired by the new pictorial concepts and techniques developed by Cubism and Futurism, but by the end of 1915, Goncharova's declaration had become fact. That year, the painter Kazimir Malevich produced his celebrated *Black Square* and Vladimir Tatlin produced *Corner Counter-reliefs*, abstract constructions of real materials, suspended in space. In pioneering abstraction, Russian artists came to the forefront of aesthetic developments; from following (albeit creatively) inventions emanating from Paris, they became leaders of the European avant-garde.

Even before the important innovations of 1915, the Russian artist Wassily Kandinsky, living and working in Germany from 1896 onwards, had developed a theory and practice for abstract art. According to a letter of 1935, he apparently produced his first abstract painting, *Picture with a Circle*, in 1911.[2] His inspiration came from a wide range of visual and philosophical sources, including the Fauves' expressive use of colour and the ideas of the French and Russian Symbolists. In his treatise *On the Spiritual in Art*, read in St Petersburg at the Second Congress of Russian Artists in December 1911 and published the following year in an extended version in Germany, Kandinsky argued that the artist should obey his intuition or 'inner necessity' in order to create works embodying spiritual values that would counteract the materialism of contemporary society.[3] In pursuit of this aim, he attempted to correlate different colours with particular psychological and emotional effects and also with specific forms and even musical sounds. Since the late nineteenth century, artists and critics in France, Russia and Germany had talked about the synthesis of the arts and of a visual art aspiring to the condition of music, with its autonomy of form and expressive directness. Such ideas were particularly valued by the French *Les Tendances Nouvelles* group, with which Kandinsky was closely associated during his brief stay in France between 22 May 1906 and 9 June 1907.[4]

In 1910, anxious to make a non-figurative art that would not be simply decorative, but possess meaning and create a communication of a spiritual rather than a material truth, Kandinsky started using images of the Apocalypse, derived from medieval painting and Russian lubki (popular prints), which he then disguised by generalising the forms and adding accentuating marks, lines and patches of colour.[5] *Composition 6* represents a later stage in this use of "veiled" religious imagery. It has been dated to 1912, following *Compositions 1–5*, which had been executed between January 1910 and November 1911.[6] In 1913, Kandinsky explained the genesis of the work:

"I carried this picture around in my mind for a year and a half, and often thought that I would not be able to finish it. My starting point was the Deluge. My point of departure was a glass-painting that I had made more for my own satisfaction. Here are to be found various objective forms, which are in part amusing (I enjoyed mingling serious forms with amusing external expressions): nudes, the ark, animals, palm trees, lighting, rain, etc. When the glass painting was finished there arose in me the desire to treat this theme as the subject of a Composition."[7]

During the gestation of *Composition 6*, Kandinsky made numerous sketches, but he dismissed them as either too "corporeal" or too "abstract", while he found himself to be excessively "obedient to the ex-

[1] Natal'ia Goncharova, untitled ms, [spring 1913], State Russian Archive of Literature and Art, Moscow (RGALI), fond 740, opus. 1, list 4; cited in Jane Sharp, *Russian Modernism between East and West: Natal'ia Goncharova and the Russian Avant-Garde* (Cambridge: Cambridge University Press, 2006), 276.

[2] Jelena Hahl-Koch, *Kandinsky* (New York: Rizzoli, 1993), 181. Kandinsky's *Picture with a Circle* (1911, oil on canvas, 54 x 43 inches, State Museum of Art, Tbilisi, Republic of Georgia) is reproduced on p. 185.

[3] Wassily Kandinsky, *Über das Geistige in der Kunst* (Munich, 1912); English translation in Kenneth Lindsay and Peter Vergo, eds., *Kandinsky: Complete Writings on Art* (London: Faber and Faber, 1982), I: 114–219.

[4] Yule F. Heibel, "'They danced on Volcanos': Kandinsky's Breakthrough to Abstraction. The German Avant-Garde and the Eve of the First World War", *Art History*, 12, no. 3 (1989): 342–361.

[5] See Rose-Carol Washton Long "Kandinsky and Abstraction: The Role of the Hidden Image", *Artforum* (New York) 10, no. 10 (June 1972): 42–49.

[6] Ibid.

[7] See Wassily Kandinsky, "Komposition 6", in *Kandinsky 1901–1913* (Berlin: Der Sturm, 1913); English translation in Lindsay and Vergo, *Kandinsky: Complete Writings*, I: 385.

pression of the Deluge, instead of heeding the expression of the word 'Deluge'. I was ruled not by the inner sound, but by the external impression".[8] The final monumental canvas fuses the corporeal and the abstract. Lines and swirls of colour overlay a few remaining allusions to the original imagery, including a boat with oars in the bottom left, an angel blowing a trumpet above it, and the heaving crests of waves rising up from the lower border. In a statement of 1913, that strongly evokes *Composition 6*, Kandinsky described the general nature of the creative procedures that produced it:

"Painting is like a thundering collision of different worlds that are destined, in and through conflict, to create that new world called the work. Technically, every work of art comes into being in the same way as the cosmos — by means of catastrophes, which ultimately create out of the cacophony of the various instruments that symphony we call the music of the spheres. The creation of the work of art is the creation of the world."[9]

Kandinsky arrived at his vision of abstract art without reference to Cubism. Yet, in 1911, at the same time as he was developing abstraction, Pablo Picasso and Georges Braque were producing paintings in which the subject matter was no longer identifiable (despite titles like *Accordianist* or *Man with a Guitar*), and the objects had disintegrated into a mass of lines and planes.[10] Picasso and Braque did not take the final step into abstraction, but chose to reassert the relationship between painting and reality, by introducing visual clues, lettering, and pieces of everyday material, like oil cloth, newspapers and wall paper. Nevertheless, in 1913 other artists in Paris pursued the implications of the 1911 paintings, and took Cubism to what they and others saw as its logical conclusion.

Robert Delaunay and Fernand Léger for a short time produced works that appeared to be totally abstract: as in their "Circular Forms" and "Contrast of Form" series respectively. For Robert Delaunay, whose wife Sonia was Russian, Kandinsky's approach may actually have been one of the factors that encouraged him to adopt an abstract vocabulary. Delaunay shared an interest in the relationship between colour and music, was in correspondence with Kandinsky, contributed to the *Blaue Reiter* almanac, saw the three *Improvisations* that Kandinsky exhibited at the Salon des Indépendants in May 1912, and even read *On the Spiritual in Art* in translation. One of the most abstract of his works, *Disc* of 1913, consists simply of seven concentric rings of various colours, divided into four segments.[11] For critics, like Guillaume Apollinaire, such works represented "the beginning of pure art" — "the art of painting new compositions with elements not taken from reality as it is seen, but entirely created by the artist".[12] He described them as Orphic Cubism, from Orpheus whose music enchanted the gods and spoke directly to the soul.[13]

All these developments were well known in Russia through exhibitions, journals and personal contact. Artists like Liubov Popova, Sofia Dymshits-Tolstaya, and Nadezhda Udaltsova, had all studied in France, while Alexandra Exter, who was a close friend of Sonia Delaunay's, had been constantly travelling back and forth between Paris and Moscow since 1907, bringing valuable first-hand information about the very latest innovations, as well as actual "paintings by Picasso, Léger, and Braque" which she displayed on the walls of her Moscow apartment.[14] Such works complemented the collections of French art from Post-Impressionism onwards that graced the walls of the residences of Sergei Shchukin and Ivan Morozov.

Mikhail Larionov and Goncharova described their new style of Rayism as a synthesis of "Cubism, Futurism and Orphism".[15] The Cubist planes and Futurist lines of force, which had endowed works like Goncharova's *The Cyclist* with sensations of motion, were now used to depict "the spatial forms arising from the intersection of the reflected rays of various objects."[16] Larionov asserted that the forms were "cho-

[8] Ibid. For an illuminating discussion of the studies for *Composition 6* and the final painting, see Dabrowski, *Kandinsky: Compositions*, 37–40.

[9] Wassily Kandinsky, "Rückblicke", in *Kandinsky 1901–1913* (Berlin: Der Sturm, 1913); English translation in Lindsay and Vergo, *Kandinsky: Complete Writings*, I: 373.

[10] See Robert Rosenblum, *Cubism and Twentieth-Century Art* (New York: Abrams, 1976), 47–8, plates 32 and 33.

[11] See Neil Cox, *Cubism* (London: Phaidon, 2000), 22–4. Delaunay's *Disc (The First Disc)* (1913, oil on canvas, diameter 13.4 cm, Private Collection) is reproduced on p. 222.

[12] Guillaume Apollinaire, *Les Peintres Cubistes* (Paris, 1913); cited from Guillaume Apollinaire, *The Cubist Painters*, trans. Peter Read (Forest Row: Artists Bookworks, 2002), 28.

[13] Ibid.

[14] Some of the correspondence between Sonia Delaunay and Alexandra Exter is to be found in the Bibliotheque Nationale, Paris. For the description of Exter's apartment, see A. Koonen, *Stranitsy zhizni* (Moscow: Iskusstvo, 1975), 225–226; cited from G. F. Kovalenko, *Aleksandra Ekster: Put' khudozhnika. Khudozhnik i vremia* (Moscow: Galart, 1993), 193.

[15] Mikhail Larionov and Natal'ia Goncharova, "Luchisty i budushchniki. Manifest" in *Oslinyi khvost i mishen* (Moscow, 1913); English translation in John. E. Bowlt, ed. and trans. *Russian Art of the Avant-Garde: Theory and Criticism, 1902–1934* (London: Thames and Hudson, 1988), 90.

[16] Ibid.

190

sen by the artist's will" and that the paintings were to be self-sufficient, "free from concrete forms, existing and developing according to painterly laws". [17] He seems to have developed the style during 1912, but only presented it as a fully fledged movement at *The Target* exhibition in spring 1913. [18] He later described his early Rayist works as "Realistic Rayism" because they were still based on legible images. In *Rayist Landscape* (1912), for instance, the boat and trees are easily identified. Such references disappeared completely in "Pneumo-Rayism", where the pictorial elements became completely autonomous and the image was composed entirely of coloured lines, applied with a certain degree of gestural freedom. In such works there was a quality that Larionov identified as the fourth dimension. He wrote "The painting appears slippery, it imparts a sensation of the extra temporal and the spatial — in it arises the sensation of what could be called the fourth dimension, since the length, breadth and density of the paint-layer are the only signs of our surrounding world." [19] Appropriately, perhaps, the style received its greatest accolade from Apollinaire who praised the Rayist works he saw in Paris in 1914 for bringing "a new refinement not only to Russian painting, but to European painting as a whole". [20]

A year later, in late spring 1915, while Russia was cut off from Europe by the First World War, Malevich invented geometrical abstraction with his first Suprematist paintings, comprising flatly painted planes of colour on white grounds. That December, he publicly launched the new style at *The Last Futurist Exhibition 0.10 (Zero Ten)* in Petrograd. The display was dominated by *The Quadrilateral*, better known as *Black Square*, in which subject matter was reduced to a mere quadrilateral and colour was limited to black and white. It is one of the most extreme statements of abstraction in painting. Malevich later illustrated the essential vocabulary of Suprematism with the basic three shapes of the *Black Circle*, *Black Cross*, and *Black Square*, all of 1923. He also devised more complex compositions from shapes varied in colour, scale and geometric regularity, which were richly suggestive of space and movement, before embarking on his white on white paintings of 1918.

Malevich called Suprematism "the new pictorial realism" and presented it as such in his seminal text of 1915, *From Cubism to Suprematism: The New Pictorial Realism*. [21] With a rhetoric that matched Kandinsky's, Malevich announced: "I have transformed myself into the zero of form and emerged from nothing to creation, that is to Suprematism to the new realism in painting — to non-objective creation." [22] He characterised his new style as 'the pure art of painting', in which pictorial elements have their own reality, in contrast to the 'old realism' of imitation. Yet this did not mean that Malevich was only interested in formal effects for their own sake. He asserted, for example, that the new artistic language encapsulated the essential spirit of the contemporary world of speed and machinery. While he acknowledged that the Italian Futurists had inspired his affirmation of the modern world, he considered that their actual art works had been limited by its descriptive approach, "in pursuing the form of aeroplanes or automobiles, we shall always be anticipating the new cast off forms of technical life…" For Malevich, it was essential to create a more abstract equivalent:

"The artist can be a creator only when the forms in his pictures have nothing in common with nature. For art is the ability to construct, not on the interrelation of form and colour, and not on an aesthetic basis of beauty in composition, but on the basis of weight, speed and the direction of movement." [23]

Malevich stressed the fact that his work presented a new perception of reality by hanging *The Quadrilateral*, better known today as *The Black Square*, across the corners of a room in the position normally occupied by an icon in a Russian Orthodox home. In this way, he suggested that his work embodied a new

[17] Ibid.

[18] Mak [Pavel Ivanov], "Luchizm", *Golos Moskvy* (14 October 1912) is the first published mention of the new style. For a detailed discussion of Rayism, see Anthony Parton, *Mikhail Larionov and the Russian Avant-Garde* (Princeton: Princeton University Press, 1993), especially chapters 7 and 8.

[19] Mikhail Larionov, *Luchizm* (Moscow, 1913), 20; cited from Parton, *Mikhail Larionov*, 133.

[20] Apollinaire's review appeared in *Soirées de Paris*, July 1914. See Guillaume Apollinaire, *Apollinaire on Art: Essays and Reviews 1902–1918*, ed. Leroy C. Breunig, trans. Susan Suleiman (London, Thames and Hudson, 1972), 413.

[21] Kazimir Malevich, *Ot kubizma i futurizma do suprematizma. Novyi zhivopisnyi realizm* (Moscow, 1916); English translation in *K. S. Malevich: Essays on Art 1915–1928*, ed. Troels Andersen, trans. Xenia Glowacki-Prus and Arnold McMillin, 1 (Copenhagen: Borgen, 1968), 19–41.

[22] Ibid., 37.

[23] Ibid., 24.

24 Aleksandr Benua, "Poslednaia futuris-ticheskaia vystavka", *Rech'* (9 January 1916).

25 Kazimir Malevich, letter to A. N. Benua, May 1916; reprinted in *Malevich o sebe. Sovremenniki o Maleviche. Pis'ma. Dokumenty. Vospominaniia. Kritika*, ed. I. A. Vakar, and T. I. Mikhienko (Moscow: RA, 2004), I: 85.

26 V. V. Kandinskii, "O dukhovnom v iskus-stve" in *Trudy Vserossiiskago s'ezda khu-dozhnikov v Petrograde, dekabr 1911 — yanvar 1922 gg.* (Petrograd, 1914), I. Malevich might also have been encour-aged by English discussions about ab-straction, see Susan Compton, "Kazimir Malevich: A Study of His Paintings, 1910–1935" (Ph.D. diss., Courtauld Institute, University of London, 1983), 309 and 312.

27 See A. Belyi "Budushchee iskusstvo" (1907) in *Simvolizm* (Moscow, 1910), 452. Cited in John E. Bowlt , "Vasilii Kandin-sky: The Russian Connection", in *The Life of Vasilii Kandinsky in Russian Art; A Study of On the Spiritual in Art*, ed. John E. Bowlt and Rose-Carol Washton Long, trans. John E. Bowlt (Newtonville, Mass.: Oriental Research Partners, 1980), 8.

28 *Poslednaia futuristicheskaia vystavka kartin 0,10 (nol'-desiat). Katalog* (Petro-grad, 1915), nos. 40–41, and 43–46.

29 For a highly accessible discussion of French Cubism and the fourth dimension, see Neil Cox, *Cubism* (London: Phaidon, 2000), 188–91.

30 See Mikhail Matyushin, "O knige Metzan-zhe-Gleza 'Du Cubisme'", *Soyuz molode-zhi*, 3 (1913): 25–34; English transla-tion in Linda Dalrymple Henderson, *The Fourth Dimension and Non-Euclidean Geo-metry in Modern Art* (Princeton: Princeton University Press, 1983) 368–375. Profes-sor Henderson's discussion of the sub-ject is highly detailed and fascinating.

31 A study for this painting shows that the black and white stripped strip refers to a piano keyboard (Chaga-Khardzhiev Foun-dation, Stedelijk Museum, Amsterdam).

32 E. F. Kovtun, "K. S. Malevich. Pis'ma k M. V. Matyushinu", in *Ezhegodnik rukopis-nogo otdela Pushkinskogo Doma na 1974 god* (Leningrad: Nauka, 1976), 177–195.

192

transcendental truth. The allusion was not lost on his contemporaries. The painter and critic Alexander Benois fumed against such sacrilege. [24] In his riposte, Malevich proudly called the *Black Square* "the icon of my time". [25] By introducing this spiritual nuance, Malevich was very much in line with Kandinsky's think-ing, and it is possible that Malevich may have actually been encouraged to make his final move into ab-straction when he saw the Russian version of Kandinsky's text *Concerning the Spiritual in Art*, published in late 1914, which contained a colour illustration of a yellow triangle, a blue circle and a red square. [26] Prior to this, Malevich had been producing works like *Composition with Giaconda*, in which large rectan-gles of colour were combined with collaged elements and lettering arranged loosely in the language of Cubism. Kandinsky's illustration may have prompted Malevich to liberate his rectangles from such Cu-bist practice and give them full pictorial autonomy. This is perhaps not the only connection between the artists. Like Kandinsky, Malevich's ideas and even his terminology also possess affinities with Symbol-ism. Malevich called his art "non-objective" or "objectless" (*bezpredmetnyi*), a term that seems to have been first used by the Russian Symbolist writer Andrei Bely in 1907. [27]

At the same time, six of Malevich's thirty-nine exhibits actually contained titles that referred to the fourth dimension, such as *Painterly Realism of a Boy with Knapsack — Colour Masses in the Fourth Di-mension*. [28] This abstruse idea was in tune with current scientific terminology, suggesting that the universe was more spatially and temporally complicated than our naïve sensory awareness would seem to indi-cate. Certain French Cubists and critics had talked about the fourth dimension, and in spring 1913, be-fore Larionov mentioned the term in relation to Rayism, the Russian musician and artist Mikhail Matyushin had linked it with Cubism. [29] His article combined long quotes from the Russian translation of Albert Gleizes and Jean Metzinger's book *Du "Cubisme"*, with extensive citations from Peter Ouspensky's writ-ings, especially *Tertium Organum*, which stressed the spiritual qualities of the fourth dimension as a high-er state of consciousness. [30] Malevich was clearly aware of this article through his close friendship with Matyushin. Matyushin also brought Malevich into direct contact with the related poetic theory of *zaum*, which may also have been a factor in the emergence of Suprematism. *Zaum* (the transrational or be-yonsense) which rejected conventional logic, and liberated words, syllables, letters and sounds from their accepted meanings, so that they could acquire new meanings that transcended reason. The autonomy of the sounds and syllables in a *zaum* poem is similar to the autonomy of the painted elements in a Supre-matist painting.

Ideas of the fourth dimension and *zaum* came together in the opera *Victory over the Sun*, for which Alexei Kruchenykh wrote the libretto, Matyushin composed the music, and Malevich designed the sets and costumes. The *zaum* script intensified the incomprehensibility of the opera's plot, which was a bizarre mixture of allusions to space, time travel, and other dimensions, while Malevich's sets and costumes com-plemented such ideas by destroying any sense of visual or spatial coherence on the stage. It was around this time that Malevich painted his *Portrait of Matyushin*, in which the piano keys are prominent and the face is almost entirely absent. [31] Not surprisingly perhaps, it was two years later, while studying his de-signs in preparation for an edition of the opera, that Malevich developed one of his designs for a back-cloth into the first Suprematist painting. [32]

The invention of Suprematism brought Malevich to immediate prominence among the Russian avant-garde. [33] The new style acted as a starting point for a wide spectrum of experimentation among artists who had previously been exploring Cubism and Futurism such as Popova, Exter and Udaltsova. Yet few

See also A. Shatskikh, "Malevich, Curator of Malevich", in *The Russian Avant-Garde: Representation and Interpretation*, ed. Yevgeniia Petrova (St Petersburg: Palace Editions, 2001), 149–156.

[33] Tatiana Goriatcheva, "Le suprématisme et le constructivisme Deux parallèles qui se croisent", in *La Russie et les avant-gardes* (Saint-Paul: Fondation Maeght, 2003), 124.

[34] Charlotte Douglas "The Art of Pure Design: The Move to Abstraction in Russian and English Art and Textiles: A Meditation", in *Russian Art and The West: A Century of Dialogue in Painting, Architecture and the Decorative Arts*, ed. Rosalind P. Blakesley and Susan E. Reid, (DeKalb, Ill.: Northern Illinois University Press, 2007), 99–101. Quote, ibid, 100.

[35] Ol'ga Rozanova, letter to Aleksei Kruchenykh, 2–4 January 1916; cited by Douglas "The Art of Pure Design", 100.

[36] Magdalena Dabrowski "Aleksandr Rodchenko: Innovation and Experiment" in Magdalena Dabrowski, Leah Dickerman, and Peter Galassi, *Aleksandr Rodchenko* (New York: Museum of Modern Art, 1998), 29.

[37] Varvara Stepanova, *Chelovek ne mozhet zhit' bez chuda. Pis'ma. Poeticheskie opyty. Zapiski khudozhnitsy* (Moscow: Sfera, 1994), 60–63.

[38] *Personal'aia vystavka sintezo-statichnykh kompozitsii (Pervaia vystavka zhivopisnykh rel'efov)*, 10–14 May, 1914, Studio No. 3, 37 Ostozhenka, Moscow. "Verzeichnis der Austellungen", in *Anatolij Strigalev and Jürgen Harten, eds., Vladimir Tatlin: Retrospektive* (Köln: DuMont Verlag, 1993), 400.

[39] Anatolii Strigalev, "O poezdka Tatlina v Berlin i Parizh", *Iskusstvo*, 2 (1989): 39–43.

[40] *Vladimir Evgrafovich Tatlin* (Petrograd, 1915), 3. Reproduced in Larissa Zhadova, ed., *Tatlin* (London: Thames and Hudson, 1988), plate 125; translation, ibid, 331. The text was apparently written by Nadezhda Udal'tsova, see Vasilii Rakitin, "Nadezhda Udaltsova" *Amazons of the Avant-Garde* (London: Royal Academy of Arts, 1999), 273.

painters merely copied Suprematism, and many quickly developed alternative approaches. Popova produced compositions of layered, intersecting planes of colour before moving onto rigorous investigations into the structural possibilities of the line in works like *Spatial Force Construction* (1921). In this painting, concerns with pictorial construction and texture are paramount; she employed only three colours and applied pigment with a palette knife. Matyushin himself produced the extraordinary *Movement in Space* (before 1920), in which a lines of colour move across the canvas, producing a sense of spatial and dynamic continuity and evoking that higher state of consciousness about which the artist had written in his 1913 article.

Exceptionally, Olga Rozanova had been making abstract collages of coloured paper as early as the summer of 1915. Produced independently of Malevich, these "must be counted as one of the "earliest appearances of abstraction in Russia".[34] When she saw the exhibits at *Zero-Ten*, she felt that Malevich had stolen her ideas. Rozanova immediately wrote to Kruchenykh, "The whole of Suprematism is completely my *paste-ups … Did you show my paste ups to Malevich*?"[35] Despite this, Malevich's objectless paintings clearly encouraged her to move from paper to canvas, and expand the scale of her explorations. Rozanova's abstract works, like *Non-Figurative Composition* 1916, are far removed from Suprematist in terms of the range of colours and shapes, the tautness of the composition, and the handling of space.

Malevich's emphasis on the autonomy of pictorial elements led Alexander Rodchenko to produce a series of paintings that demonstrate how line, form and colour can yield compositions of radical simplicity. *Red and Yellow* and *White Circle* (both of 1918) deal with simple primary shapes, but are characterised by a pronounced interest in the texture of the painted surface and in the use of tonal modelling to create sensations of light. This emphasis on the materiality of the pigment and painting as a material artefact took Rodchenko away from mainstream Suprematism. To emphasise his independence he even created a series of black on black canvases, which he exhibited in 1919 as a direct challenge to Malevich's white on white paintings of 1918.[36] By this time, as Varvara Stepanova tartly observed, "the dominant atmosphere is not to submit to the influence of Malevich".[37]

By 1919, ideas of construction and work with real materials in space were coming to the fore, inspired by the work of Vladimir Tatlin. Five years earlier, between 10 and 14 May 1914 Tatlin had presented his "synthetic-static compositions" and "pictorial reliefs" to the Moscow public for the first time.[38] In creating such works, Tatlin had clearly been inspired by his experience of Cubist experiments in collage, *papier collé* and construction, which he had seen that spring in Picasso's Paris studio.[39] Bringing together in a new way the worlds of painting and sculpture, these compositions were built up from, "wood, metals, glass, plaster, cardboard, gesso, tar, etc.," while "the surfaces of these materials were treated with putty, gloss paints, steam, sprinkled with dust, and other means".[40] These materials, their textures (*faktura* in Russian) and the way they interacted became the subject matter of these abstract works, while the configurations (initially constructed outwards from a base plane) established increasingly active relationships with their spatial environments.

In late 1914 Tatlin took the dramatic step of liberating his structures completely from the wall and produced a series of corner counter-reliefs that consisted simply of intersecting planes of metal in space, suspended on wires or ropes across the corners of a room. Their placement, like Malevich's *Black Square*, recalled the position of the icon in the Russian Orthodox home, possessing metaphysical connotations.

Corner Counter Relief (remade by Tatlin himself in 1925 after an original version of 1915) is the only surviving example of this type of construction. The splayed rope supports recall the fact that Tatlin had been a sailor, while the dramatically intersecting metal sheets create a strongly dynamic configuration, reminiscent of a ship's sails, in which suggestions of movement and time are evocative of a fourth dimension. Tatlin tends to be regarded as a staunch materialist, but this may have been overstated because of his rivalry with Malevich and later career as a designer. His paintings such as *The Nude* of 1913 had been based on the pictorial technique and composition of icon painting, while in his reliefs he sometimes used old icon boards and methods associated with icon painting. He also used "found" materials, which bore the imprint of their experiences over time in the form of dents, scratches, etc. Indeed, the emerging concept of *faktura* (texture) in Russian art was closely associated with metaphysical notions. Vladimir Markov pointed out: "Through the resonance of the [icon's] colours, the sound of the materials, the assemblage of textures (faktura), we call the people to beauty, to religion, to God". [41] Tatlin even confessed to Berthold Lubetkin that "if it was not for the icons… I should have remained preoccupied with water-drips, sponges, rags and aquarelles." [42]

Tatlin inspired a whole range of experiments with constructed sculpture by a wide range of artists from Rodchenko to Popova. Sofia Dymshits-Tolstaya, for instance, started working with materials like wood, sand, plaster, and rope, but also with glass. [43] Her first glass constructions, exhibited at *The Store* of 1916, created a variety of spatial effects by painting on both sides of the material. After the Revolution she used the same techniques in a series of "Propaganda Glass", including *Workers of All Countries Unite*, 1921, in which she incorporated revolutionary slogans into her multi-layered constructions.

The Russian Revolution of October 1917 presented new challenges. The avant-garde identified their artistic innovations with the revolution and responded by running artistic affairs, decorating the cities for the revolutionary festivals, designing posters, etc. Tatlin declared that 'what happened from the social aspect in 1917 was realised in our work as pictorial artists in 1914, when 'materials, volume and construction" were accepted as our foundation. [44] Tatlin's commitment is manifest in his extraordinary *Model for a Monument to the Third International*, first exhibited in November 1920. Envisaged as a building a third higher than the Eiffel tower, it was intended to house the headquarters of the Comintern, the international communist organisation dedicated to fomenting world revolution. The external framework (to be made of iron) spiralled upwards on a diagonal axis, creating a powerful image of dynamism and progress. Within it were to be suspended three enormous glazed volumes (rotating at various speeds). The Tower combined the geometric clarity of the new abstract art with technology, synthesising 'the principles of architecture, sculpture and painting", and "uniting purely artistic forms with utilitarian intentions". [45] The emphasis on practical application and on a "machine" aesthetic appropriate to a workers' state, made the Tower a paradigm of new possibilities.

Inspired by Tatlin's call for artists to 'take control over the forms encountered in everyday life," [46] Rodchenko, Stepanova and others began in March 1921 to describe themselves as Constructivists. The group, which pledged its allegiance to Marxist materialism, rejected art as a bourgeois commodity, replacing it with what they called "intellectual production", which would harness artistic skills and design everyday items for industrial manufacture, and so help in the creation of a new socialist environment. [47] They envisaged a completely new kind of creative activity that would establish a new relationship between art and reality and between art and society.

[41] Vladimir Markov, *Printsipy tvorchestva v plasticheskikh iskusstvakh. Faktura* (St Petersburg, 1914), 56.

[42] Bethold Lubetkin, "The Origins of Constructivism", 1 May 1969, tape recording; cited in Christina Lodder, *Russian Constructivism* (New Haven and London: Yale University Press, 1983), 12.

[43] See A. D. Sarab'ianov, *Neizvestnyi Russkii avangard v muzeiakh I chastnykh sobraniiakh* (Moscow: Sovetskii khudozhnik, 1992), 86.

[44] Vladimir Tatlin, Tevel Shapiro, I. Meerzon and P. Vinogradov, "Predstoiashaia rabota", *VIII s'ezd sovetov. Ezhednevnyi byulleten' s'ezda VTsIK*, 13 (1 January 1921), 11. English translation in Stephen Bann, ed., *The Tradition of Constructivism*, (London: Thames and Hudson, 1974), 12–14.

[45] Ibid.

[46] Ibid.

[47] "Programme of the Working Group of Constructivists" in Selim O. Khan-Magomedov, *Rodchenko: The Complete Work* (London: Thames and Hudson, 1986), 289–290.

When *The First Russian Art Exhibition* opened at the Van Diemen Gallery in Berlin in October 1922, it included Suprematist paintings as well as constructions by Tatlin, Rodchenko and others. Such innovations were identified with the progressive ideology of post-revolutionary Russia and with "the art of the material culture of the technical age".[48] The works fuelled the movement in the West known as International Constructivism. Progressive artists now looked to Russia as a political and artistic beacon.

[48] Alfréd Kemény, "Die abstrakte Gestaltung vom Suprematismus bis Heute", *Das Kunstblatt*, 8 (1924): 248.

RUSSIA

Vasily POLENOV
Moscow Courtyard

1878
Oil on canvas. 64.5 x 80.1
Signed bottom left: *В Полѣновъ*
(letters *В* and *П* joined)
Tret. Gal.
Provenance: Purchased in 1878 from
the artist by P. M. Tretyakov

Moscow Courtyard is one of Vasily Po-
lenov's best and most well-known
paintings. The shifting waves of sum-
mer air seem to dissolve and lend a vi-
tal tremulousness to the outlines of
the slender bell tower, the little peo-
ple's figures and the humble struc-
tures occupying the courtyard. Every
object and every detail merges organ-
ically into the surrounding space, filling
this Moscow landscape with a glowing
enchantment and imbuing the every-
day scene with the poetry of Russian
life, with its unhurried rhythms, archi-
tectural beauty, silence and tranquilli-
ty. The view actually existed in real life.
The artist painted it from the window
of a house on an alley off central Mos-
cow's Arbat Street, by the Church of
the Saviour on the Sands which is still
there to this day. (G. Ch.)

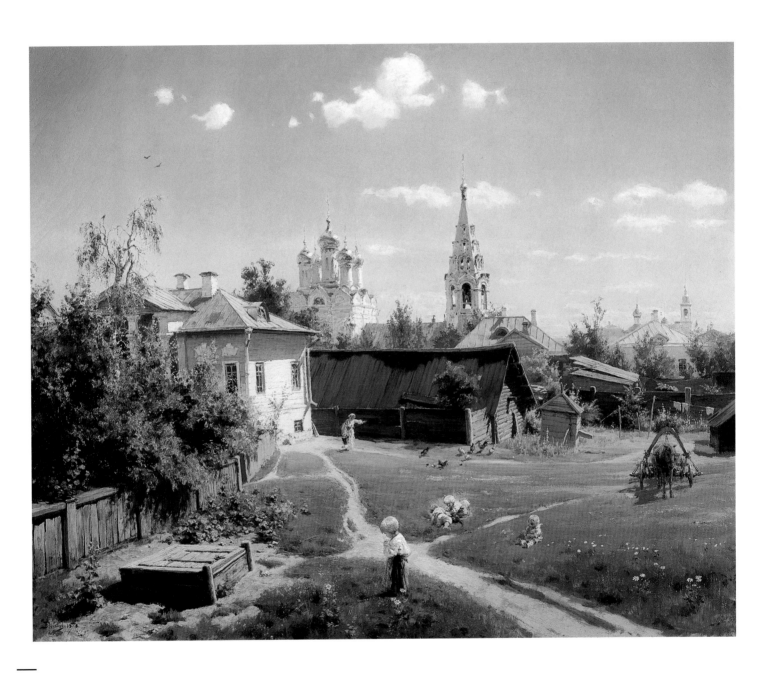

Isaac LEVITAN

After the Rain. Plyos

1889
Oil on canvas. 80 x 125
Signed and dated bottom left:
И. Левитанъ 89 г.
Tret. Gal.
Provenance: Purchased in 1890 from
the artist by P. M. Tretyakov

This picture was painted in the summer of 1889, when Levitan was living in the small town of Plyos on the Volga River. The artist first visited the area in 1887. The enormous river captivated him with its mighty currents, distant horizons and the beauty of the charming old towns scattered along its banks. The picture is full of poetic charm. The rain has passed, filling the air with moisture and lending freshness and depth to the colours of nature. Levitan's painterly mastery is expressed to its fullest degree in this work. The artist saw the landscape painter's principal task in conveying an organic sense of nature and expressing on canvas a feeling for its changing moods and resonance with man's inner world. The sky blue of the church cupolas, echoed by the bright patches in the sky, which deepens to shades of lilac as it approaches the earth, defines a unified tonality for the image and creates the sensation of moist air after a downpour. The work combines the arsenal of *plein air* painting with Impressionist elements, evidence of Levitan's interest in this important school of European painting. (G. Ch.)

200

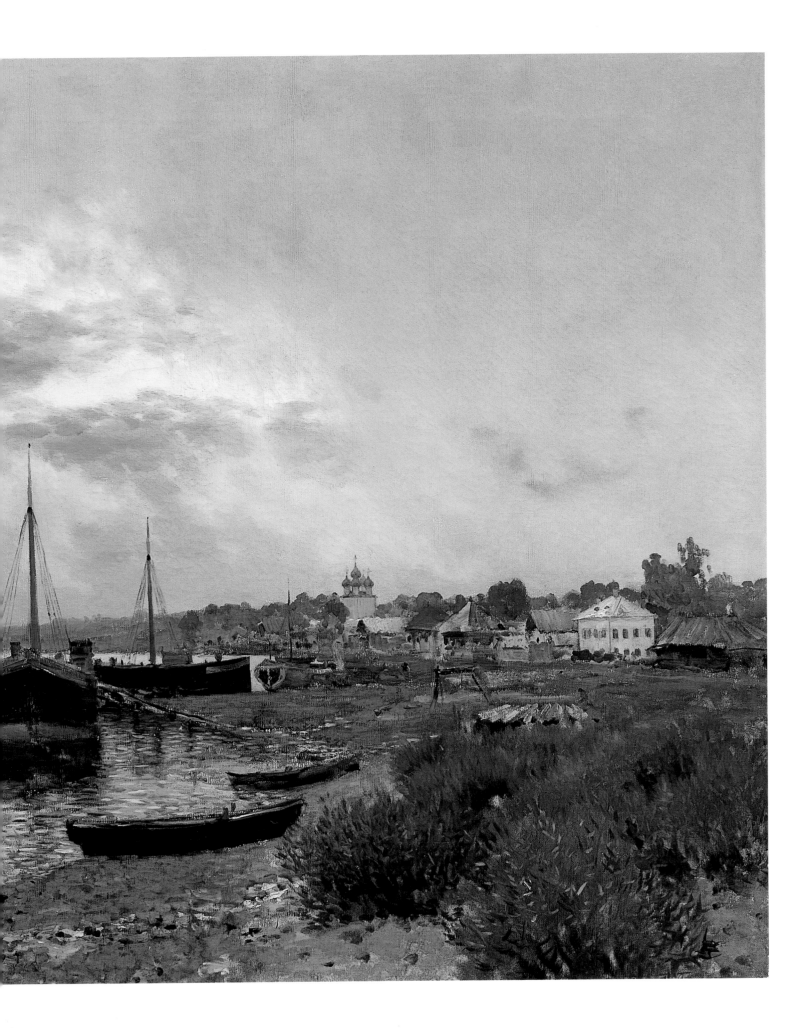

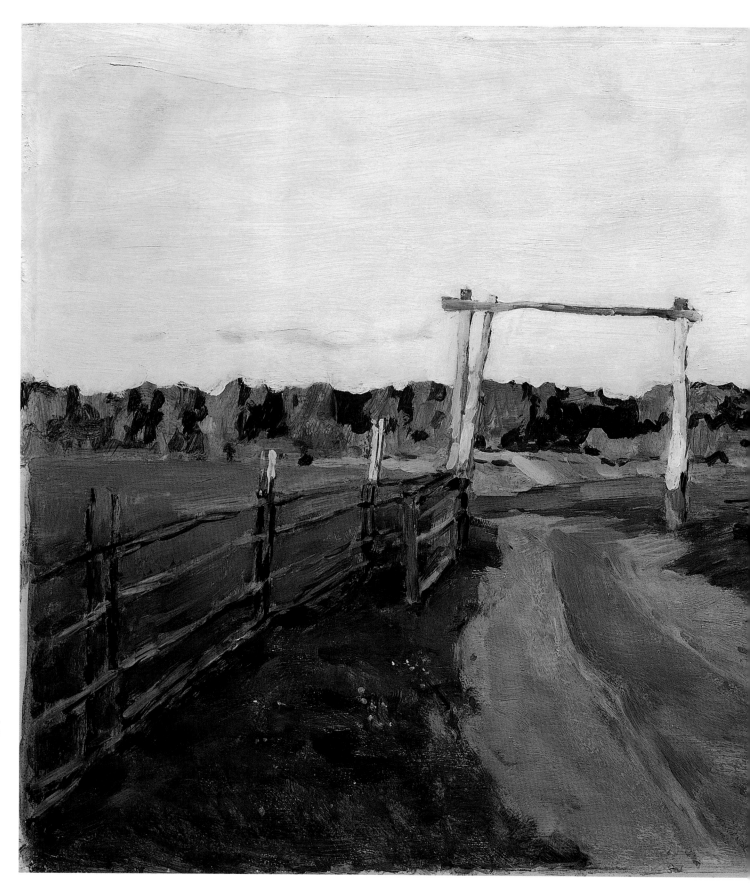

FROM RUSSIA

Isaac LEVITAN
Summer Evening

1900
Oil on pasteboard. 49 x 73
Signed bottom right: *И. Левитанъ*
Tret. Gal.
Provenance: Acquired by the Board
of the Tretyakov Gallery in 1900

The clear and simple composition and
the twilight rays of the sun gilding the
fields and forest on the horizon instill
the everyday rural landscape with a
solemn beauty. (G. Ch.)

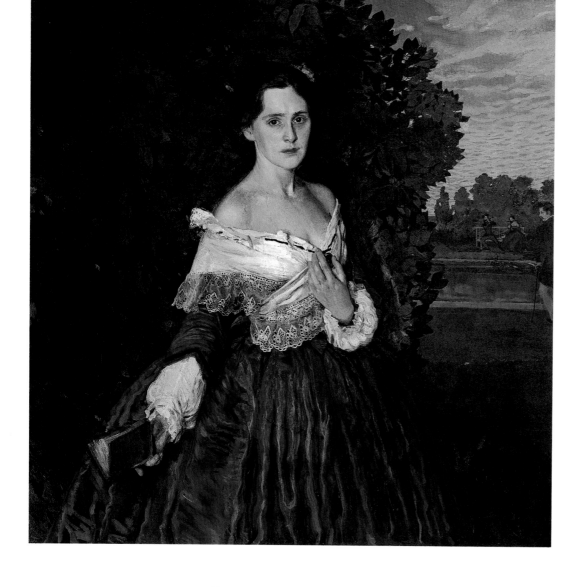

Konstantin SOMOV
Lady in Blue. Portrait
of Elizaveta Martynova

1897–1900
Oil on canvas. 103 x 103
Signed bottom left: *К. Сомовъ 1897*;
inscribed by the artist on the reverse
side: *пис. 1897. оконч. 1900.* [painted
1897. finished 1900.]
Tret. Gal.
Provenance: Purchased in 1903
from the artist by the Board of
the Tretyakov Gallery

Depicted on the painting is Somov's friend and fellow student at the Academy of Fine Arts, Elizaveta Mikhailovna Martynova (1869–1904). Somov clothes Martynova in an old-fashioned dress and creates a stylised, decorative background, placing his contemporary in a time long past, a world half real. The result is a poetic and poignantly stirring image of a woman tragically isolated from the world. Upon seeing the picture at the "World of Art" exhibition, one of Martynova's friends, M. Yamshchikova, said: "I saw Liza in front of me, but not the one I once knew from drawing school … What did the artist do with that face, with those once-bright eyes? How was he able to bring out that hidden pain and melancholy, that bitterness of dissatisfaction? How was he able to convey that tender yet morbid expression of the lips and eyes?" Elizaveta Martynova dreamt of a grand future, wanted to realise herself in high art, and held the vanity of the world in contempt. However, she died in her early 30s of tuberculosis, having achieved little of what she set out to do. (L. B.)

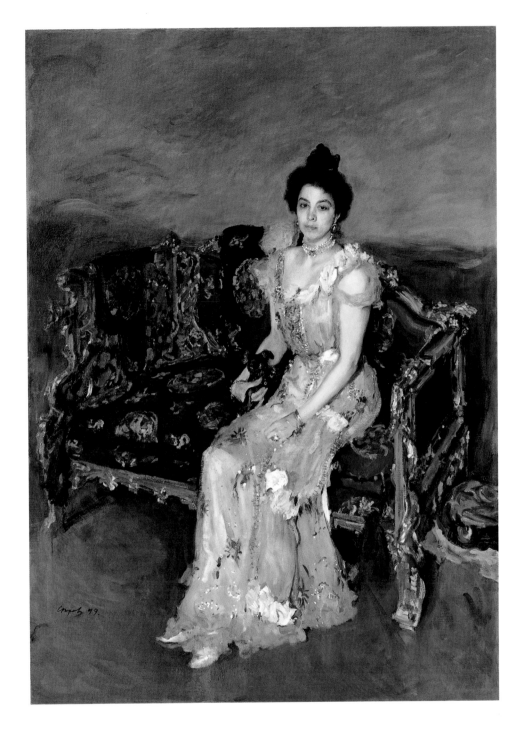

Valentin SEROV
Portrait of Sophia Botkina

1899
Oil on canvas. 189 x 139.5
Signed and dated bottom left:
Сѣровъ 99
Russ. Mus.
Provenance: 1934, S. M. Luzina

This work is one of the most celebrated formal portraits to emerge from the easel of Serov, who began working in this genre in the 1890s. Continuing the tradition of the Russian formal portrait begun in the late 18th and early 19th centuries, the artist has created a picture harmonising with the mood of the fin-de-siècle epoch. The asymmetrical composition and wrenchingly melancholic and resonant combination of pearly yellows and deep, saturated blues, heightened by black and rose hues, together with the play of sharply defined silhouettes, adorn the image with notes of sorrow and loneliness, revealing the reflective nature of the model. The portrait is distinguished by a superb mastery of execution. Along with several other pictures, it was awarded the Grand Prix at the 1900 World's Fair in Paris. Sophia Mikhailovna Botkina (née Maliutina), was the wife of Moscow merchant and well-known collector Pyotr Dmitrievich Botkin. (V. K.)

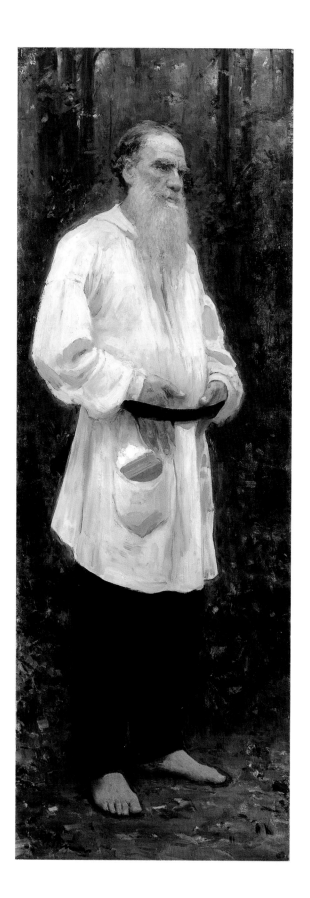

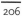

Ilya REPIN

Leo Tolstoy Barefoot

1901
Oil on canvas. 207 x 73
Signed bottom left: *И. Рѣпинъ*
Russ. Mus.
Provenance: 1901, the artist

Repin enjoyed friendly relations with Leo Tolstoy (1828–1910) for many years. The artist was a frequent guest at his estate in Yasnaya Polyana, and worked much there in the open air, leaving behind a whole gallery of portraits of the famous writer. Tolstoy posed several times in his garden. The character of this portrait reflects to a degree the author's spiritual yearnings: at that time he was striving towards "simplicity", often engaging in hard peasant labour. Greatly impressed by his contact with Tolstoy, Repin wrote to his daughter: "However much that giant might humble himself, whatever rags he might cover his mighty body with, one always sees in him a Zeus, whose one raised eyebrow causes the whole of Olympus to tremble." It took ten years for the artist to finish the portrait, in which he conveyed the author's condition of concentrated inwardness. Along with this, the painter was as always interested in the expressiveness of Tolstoy's outward appearance. His pose is lively, with a characteristic gesture of the hands placed on the waistband. For all its natural simplicity, this image of Tolstoy is filled with the significance the artist was striving for. (I. Sh.)

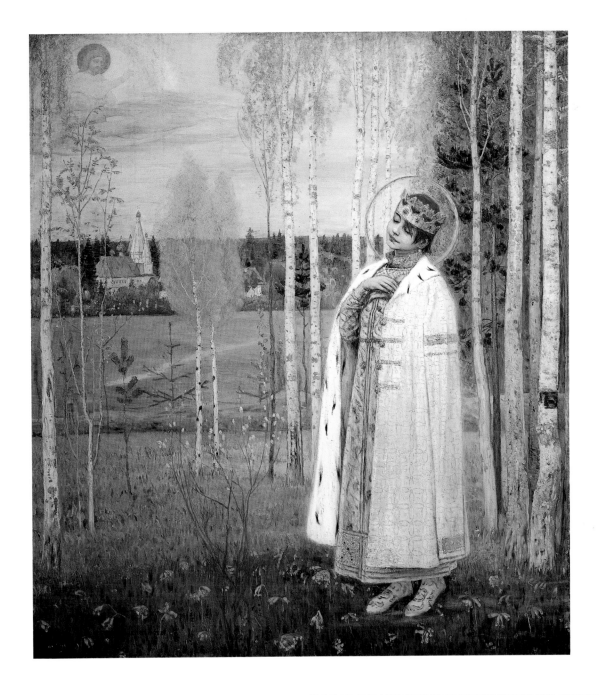

Mikhail NESTEROV

The Murdered
Tsarevich Dmitry

1899
Oil on canvas. 197 x 175
Signed and dated bottom left:
Михаилъ Нестеровъ 1899 г.
Russ. Mus.
Provenance: 1910, the artist

Tsarevich Dmitry (1583–1591), the youngest son of Ivan the Terrible, died in the city of Uglich under mysterious circumstances. The child Tsarevich would likely have inherited the throne upon the death of his older brother, the childless Fyodor Ivanovich. According to the most widely-held belief, Dmitry was murdered on the orders of Boris Godunov, the powerful boyar whose ascent to the Russian throne was thus opened up by the death of his potential rival. Thus, Tsarevich Dmitry entered the consciousness of the Russian people as a symbol of innocent victimhood. (L. Sh.)

Ilya REPIN
October 17, 1905

1907, 1911
Oil on canvas. 184 x 323
Signed and dated bottom left:
Илья Рѣпинъ 1911
Russ. Mus.
Provenance: 1938, Museum of the
Revolution, Leningrad. Earlier: collection
of V. G. Winterfeld, St Petersburg

This picture, painted in 1907, was a response to Tsar Nicholas II's proclamation of 17 October 1905, "For the Improvement of State Order", published during the days of revolutionary unrest in Russia. The proclamation, drafted by then head of the Council of Ministers Sergei Witte, who considered constitutional concessions the only way to preserve the Tsarist regime, promised to give the people "unshakable foundations of civil liberty": rights of the individual, freedom of conscience, speech and assembly, and recognition of the Duma as the country's lawmaking body. Liberal circles in Russian society met the proposed changes with great enthusiasm. Repin wrote: "The painting depicts a procession of Russian progressive society… mainly students of both sexes, professors and workers with red flags, elated and singing revolutionary songs!.. Because of censorship, it was exhibited in Russia only in 1912, at the XLI "Wanderers" Exhibition. (I. Sh.)

Igor GRABAR
Samovar

1905
Oil on canvas. 80 x 80
Signed and dated bottom right:
Игорь Грабарь Октябрь 1905
Tret. Gal.
Provenance: 1936, purchased
from the artist

This picture was painted at the estate of Dugino near Moscow, where Grabar was a guest of the artist Nikolai Me- shcherin. Along with landscapes, still lifes take on a special meaning for the artist at this period. Grabar recalled how he worked on the picture: "…I began painting at the moment when daylight began to fade but twilight hadn't yet set in. During these short minutes, flames don't glow yet but seem to be just spots of colour. I de- picted part of a table covered with a tablecloth, a silver-coloured samovar, several bowls of jam, a glass and a mug; the flame in the samovar's base had already stopped burning but still glowed red. I sat Nikolai Vasilievich's [Meshcherin's] eldest niece Valya at the table with a cup in her hand. I was fascinated above all by the twinkling of crystal in the evening hour, when bluish reflections are at play every- where." (L. B.)

Igor GRABAR
September Snow

1903
Oil on canvas. 79 x 89
Signed and dated bottom right:
Игорь Грабарь 1903 года Сентябрь
Tret. Gal.
Provenance: 1917, collection
of V. O. Girshman, Moscow

September Snow was painted at the estate of Titovo in Tula Guberniya. The painting enjoyed great success with the public and the artist considered it an important milestone in his œuvre: "…the painting *September Snow* was truly a turning point for me … the fluffiness and seeming whiteness of the snow, contrasting with the intense colours, was achieved by the sparing use of pointillism rather than mixing of paints." It was the colour combination of the still-hanging autumn foliage with unexpected snowfall which attracted the artist's attention, but here he has created more than just a striking painting from life; this is a truly poetic work conveying the beauty and "abandonedness" of a Moscow suburban estate, where the simplicity and lyricism of the picture's composition combines with a special mood of silence and tranquillity brought on by winter's unexpected arrival. (L. B.)

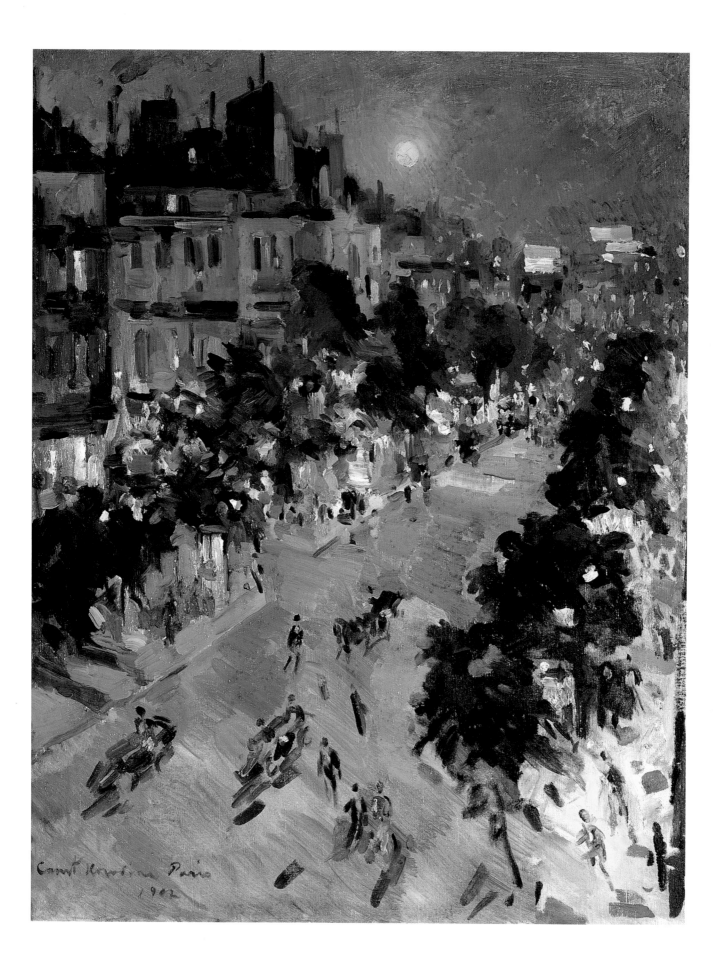

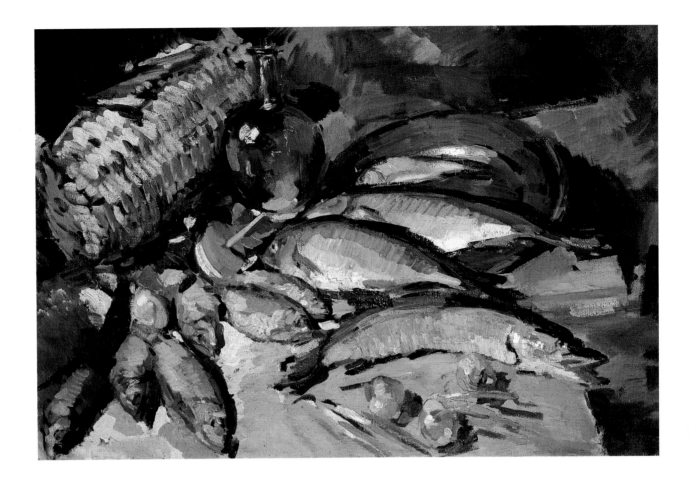

Konstantin KOROVIN

Paris

1912
Oil on canvas. 85 x 70
Signed and dated bottom left:
Const. Korovine Paris 1912
Tret. Gal.
Provenance: 1995, Z. V. Nortsova,
bequeathed by P. M. Nortsov

Korovin loved Paris with a passion and went there often. Feeling the city's beauty intensely, he presented the Russian viewer with its bright, variegated holiday atmosphere, the life of its boulevards and restaurants, its fanciful lights and the mysterious charm of Parisian nights. Struck by the cityscapes shown at the Korovin exhibition of 1932, one French critic was moved to write: "The streets of Paris at night would seem to be a nearly im-

possible task, but behold, through the use of the tiniest, most surprising dabs of paint flung at the canvas with a wonderful lightness or pressed on with the palette-knife, the artist, while seeming to be at play, achieved what he wanted." Korovin's passion for French art unquestionably affected his painting style, but, as collector and subtle art connoisseur Prince Shcherbakov discerningly noted, "The French wine was poured into a Russian vessel." (N. A.)

Konstantin KOROVIN

Fish

1917
Oil on canvas. 85.5 x 125.7
Signed and dated bottom right:
Конст. Коровинъ 1917 г.
Tret. Gal.
Provenance: Purchased from
S. A. Pkhakadze in 1968

The still life was one of Korovin's favourite genres, and he was one of the first Russian artists to begin painting pictures just for beauty, for art's sake alone. Korovin often turned to the "still life with fish" theme popular in European art. Freely and artistically varying this beloved motive, he always retained the freshness of nature's first impression. With quick strokes, he places on the canvas a most traditional fisherman's assortment: a basket for the fish, floats, onions and the recent catch. The artist was himself a skilled and avid fish-

erman; he once recalled how he would head off with a whole waggon train, and a separate cart for canvases and paints, to the river, habitat of "smooth tench", "enormous 36-pound pike", and "golden ides". Once he caught a big carp "of beautiful colour, with light yellow eyes" and "golden scales mixed with silver and pearly plates", and a black perch "with white eyes and blood-red fins". In the rich, colourful wealth of the catch portrayed in this still life we can recognise the fish Korovin so picturesquely described. (N. A.)

Philipp MALYAVIN

Peasant Woman Dancing

Late 1900s
Oil on canvas. 210 x 125
Signed top left: *Ф. Малявинъ*
Russ. Mus.
Provenance: 1920, collection of
Alexander Korovin, Petrograd

A belief in the powerful forces hidden within the Russian people was firmly held by many Russian artists, especially Malyavin, who himself was of peasant background. The artist's quest to define the national character manifested itself in images of rural women in which the typical dominates over the individual. In the highly-expressive *Peasant Woman Dancing*, a fiery torrent of colour floods the canvas. The figure opens up energetically, her bright clothing whirling up and outwards. Here the passion of the dance and the elemental force of the Russian peasantry have found their embodiment on canvas. (G. K.)

Mikhail VRUBEL
Six-Winged Seraph

1904
Oil on canvas. 131 x 155
Russ. Mus.
Provenance: 1918, collection
of E. M. Tereshchenko, Petrograd. Earlier:
collection of Nadezhda Zabela-Vrubel,
the artist's wife, St Petersburg

This picture, evocative of the spirit of
Alexander Pushkin's famous poem
"The Prophet", is among the most sub-
lime manifestations of this Symbolist
master's creative spirit. It is perceived
as an inner vision of the artist, to whom
an angel has appeared to remind him
of his high mission as one of the cho-
sen, calling him to "inflame the hearts
of people through the word", to arouse
their spirits "from the trivia of the
everyday, through sublime imagery".
The astonishing beauty of the canvas'
colouration amplifies its solemnity.
(V. Kn.)

216

Léon BAKST

Portrait of Sergei Diaghilev
with His Nanny

1906
Oil on canvas. 161 x 116
Signed and dated bottom left:
Л. Бакстъ 1906
Russ. Mus.
Provenance: 1923, Expert Commission
of the People's Commissariat of External
Trade, Petrograd

The artist depicted the well-known art world figure and future famous impresario in the interior of his Petersburg apartment. Bakst has created an image of an energetic, intelligent, self-confident and assertive man, the way his contemporaries knew him and the way he would enter the history of world culture. The old woman's small figure at the back wall introduces into the composition a feeling of cosy tranquillity and domesticity contrasting with the stormy temperament of the primary model. Bakst worked a long time on the portrait — on and off for two years. In the spring of 1904, he wrote in a letter: "Today I worked on Seryozha's portrait for the first time (at his house). They are all very satisfied." In a later letter to his wife we find an extremely interesting passage relating to the same work: "…Seryozha's portrait again, and in addition he posed disgustingly today, minced and pestered me so much to make him look more refined and handsome that I nearly attacked him with my brushes!" (G. K.)

Valentin SEROV

The Rape of Europa

1910
Tempera on canvas. 71 x 98
Tret. Gal.
Provenance: Purchased in 1911
by the Board of the Tretyakov Gallery
from O. F. Serova, the artist's widow,
Moscow

The return of late 19th- and early 20th-century artists to the legacy of antiquity was intimately connected with their search for new paths in art. Serov considered his trip to Greece in 1907 as an essential for participation in decorating the walls of the Greek Hall at the Museum of Fine Arts in Moscow (the plan was not realised). In creating his own reading of a Greek myth, the artist intended to unite real life with the fantastic world of antiquity. In his depiction of the dark, slender girl with slanted eyes, Serov seems to re-create an archaic *korai*. The sea, covered with dark pattern-like ripples, rears up, swelling like a sail, to occupy practically the whole surface of the canvas. This creates an impression of the might of the elements, which even a bull or a god is powerless to overcome. The sea parts under the god-bull's insistent pressure, boiling with white foam. Dolphins playing in the waves lend the composition a rhythmic structure. There are several sketch versions for *The Rape of Europa* panel; the chief one, dated 1910, is in a private collection (Moscow). (L. B.)

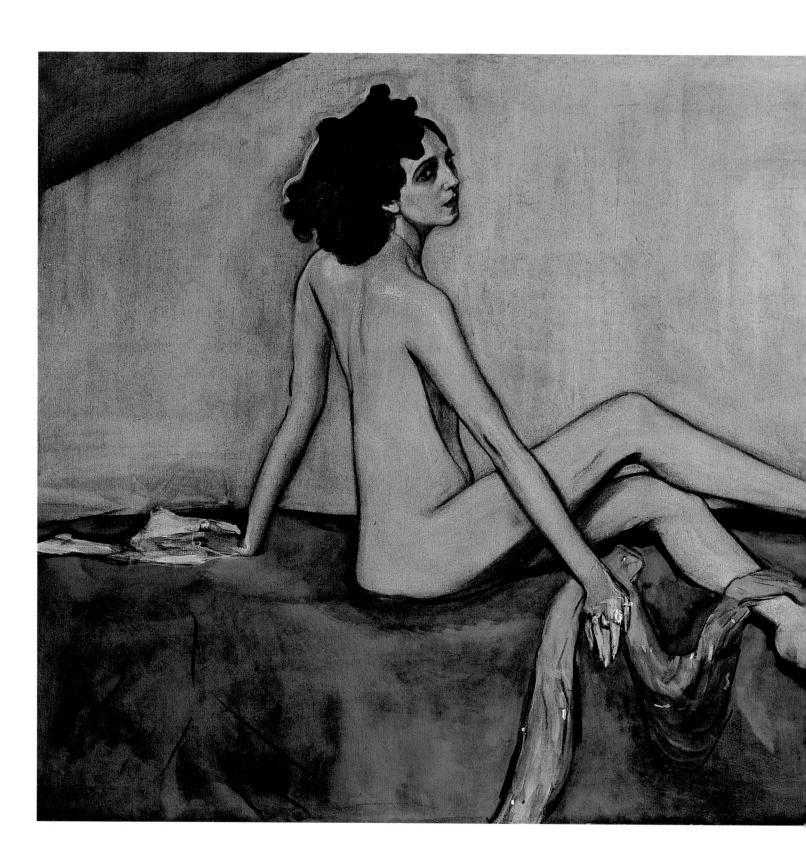

Valentin SEROV

Ida Rubinstein

1910
Tempera and charcoal on canvas
147 x 233
Russ. Mus.
Provenance: 1911, the artist

Created one year before the artist's untimely death, this portrait is one of the outstanding examples of Russian Modernism. Its stylistic language was dictated by the peculiarities of the appearance and character of its model, the well-known *danseuse* Ida Lvovna Rubinstein, celebrated in Paris for her roles of Cleopatra and Scheherazade in the eponymous ballets performed by Sergei Diaghilev's company. In both the actress's appearance and the character of her dancing the authentic Ancient Orient seemed to come to life. An enchanted Serov wrote: "There is monumentality in her every movement — [she is] simply an archaic bas-relief come to life". The picture was painted in Paris in the summer of 1910, with Rubinstein posing for the artist nude, as aristocratic women had once posed for Titian. The master likened his model to an Assyrian relief, flattening the contours of her body, rendering them in a chiselled line, at times flexible, at times broken. The sharp silhouette and refined and spicy colouring heighten the psychological traits of the dancer, who is portrayed with her characteristic tragic facial expression and "mouth of a crystal lioness" (in the words of Serov himself). The relief of the face, shoulders and legs are rendered masterfully, with mere hints. Typical for the Modernism are the play of contrasts between the psychological and the decorative and asceticism combined with acerbic colouration; here they form the the basis for an effective and piercing image. (V. K.)

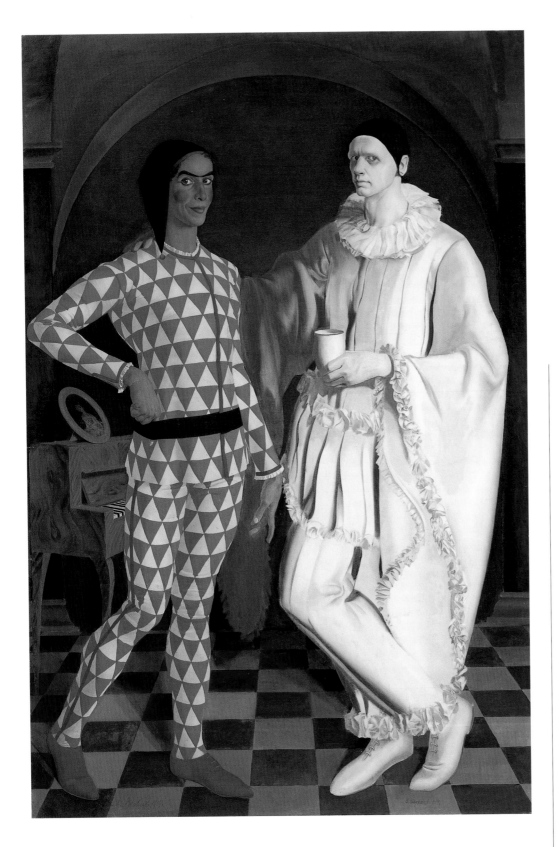

Vasily SHUKHAYEV
Alexander YAKOVLEV
Self-Portraits
(Harlequin and Pierrot)

1914
Oil on canvas. 210 x 142
Signed and dated: *А. Яковлев 1914 г.*
(bottom left); *В. Шухаев 1914*
(bottom right)
Russ. Mus.
Provenance: 1963, Vasily Shukhayev,
Tbilisi

The work is typical for Petersburg cul-
ture of the pre-revolutionary years,
with its peculiar atmosphere of "the-
atrocentrism" and the popularity of
the idea of life as theatre. The picture
was painted in Capri, during the
artists' stipendiary trips. It reflected
their interest in the art of the Old Mas-
ters and reminiscences of Petersburg
and of their enthusiasms at the Dom
Intermedia where they, as students at
the Academy, had once had the good
fortune to debut in Vsevolod Meyer-
hold's production of Arthur Schnitz-
ler's pantomime *Columbine's Scarf*.
Harlequin and Pierrot are symbols of
two personality types and embodi-
ments of eternal human destinies.
The friends portrayed themselves in
costumes created from Nikolai Sa-
punov's drawings. The picture's pe-
culiar combination of reality and con-
ventionality, truth and play, lends the
image wit, a dreamy and ironic tinge
and a sense of the ambivalence of hu-
man existence. (V. K.)

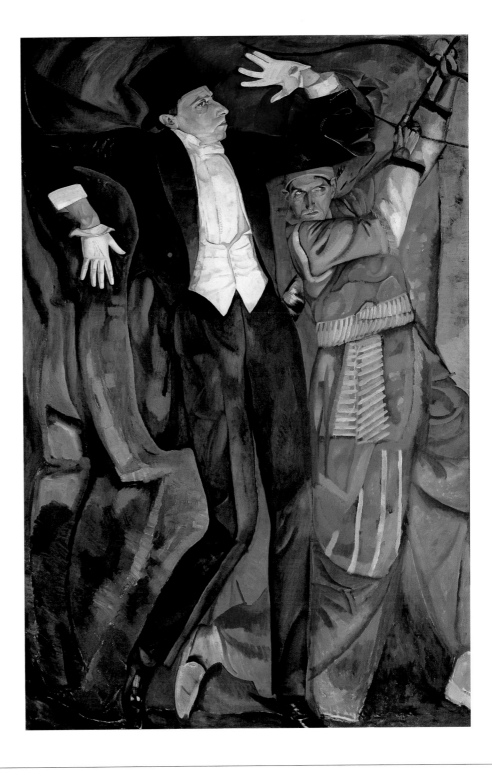

Grigoriev and Meyerhold had much in common: a penchant for the grotesque, a unique and elegant artistry, self-demanding natures, and a seemingly paradoxical combination of radical innovation with reliance on classical tradition. Grigoriev later recalled how "Meyerhold heartily and joyfully accepted my art, not posing, but creating for me…" In the portrait, the artist brings to life one of the most intriguing themes of turn-of-the-century Petersburg art and literature: the theme of the "double". "There is one Meyerhold in a tail coat and another one behind the first in an Oriental costume. Interesting and beautiful…", wrote Konstantin Somov. (A. N.)

Boris GRIGORIEV

Portrait of Theatre
Director Vsevolod Meyerhold
(1874–1940)

1916
Oil on canvas. 247 x 168
Russ. Mus.
Provenance: 1920, collection of
Alexander Korovin, Petrograd

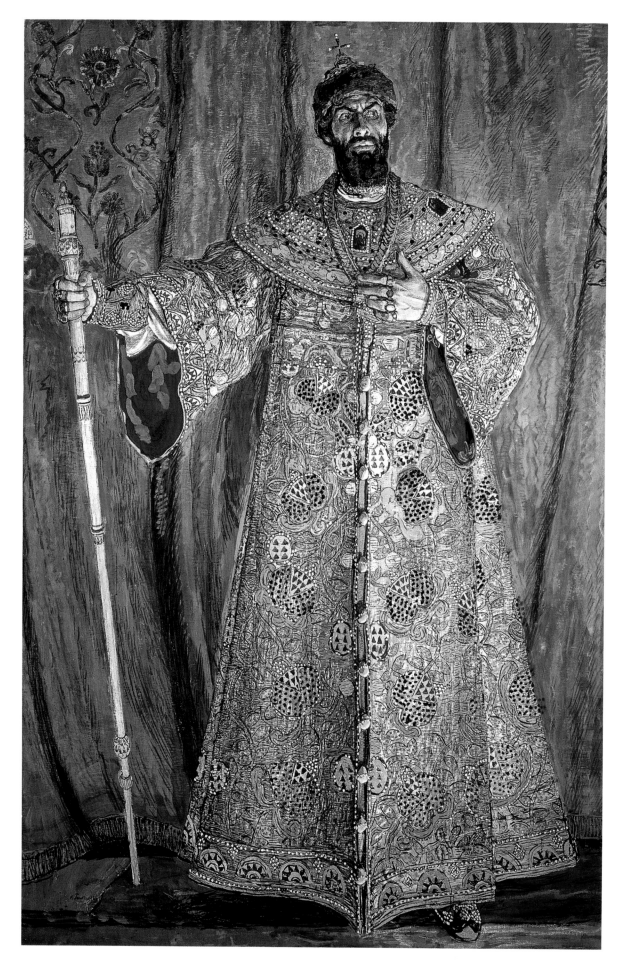

FROM RUSSIA

Alexander GOLOVIN

Portrait of Fyodor Chaliapin
in the Role of Boris Godunov

1912
Size paint, gouache, pastel,
chalk, gold and silver foil on canvas
211.5 x 139.5
Signed bottom left: *А. Головинъ*
Russ. Mus.
Provenance: 1912, the artist

Golovin created a series of portraits of
the famous opera singer in various
roles. In these works, the artist con-
veyed both the singer's character and
that of the roles he created. Theatre-
goers have noted how Golovin's por-
traits vividly convey the dramatic mo-
ment, inviting us to imagine the sound
of the music taking place on stage. The
magnificent and monumental *Portrait
of Fyodor Chaliapin in the Role of Go-
dunov* is a portrait/scene, unfolding
against the background of the theatre
curtain. Chaliapin-Boris' luxurious vest-
ments, embroidered with precious
stones and golden threads, occupy a
large part of the visual space, but with-
out distracting attention from the sub-
ject's face, with its dramatic expres-
sion. This is an intense, psychologi-
cally rich and drama-filled depiction of
Tsar Boris. "I wanted to represent one
of Chaliapin's best theatrical embodi-
ments in this portrait," wrote the artist
in his memoirs. (G. K.)

Alexander GOLOVIN

Pavlovsk

1911
Tempera on canvas. 107 x 107
Signed bottom left: *А. Головинъ*
Tret. Gal.
Provenance: 1927, State Museum
of New Western Art. Earlier: collection
of I. A. Morozov

Alexander Golovin was a versatile artist who achieved his greatest success in the area of scenography. In his easel paintings, he was consistently decorative, lending great significance to expressive motifs and striking effects. *Pavlovsk* is constructed more according to the rules of stage scenery than a painted-from-life landscape, although Golovin knew Pavlovsk well, living in nearby Tsarskoye Selo. The whimsical lacework of lines and patches of colour is characteristic of the European Jugendstil and recalls the works of Gustav Klimt. Therefore it is not surprising that the picture was acquired by Ivan Morozov, an avid collector of contemporary art, both Western European and Russian. (L. B.)

Nikolai SAPUNOV
Still Life with Vases, Artificial
Flowers and Fruits

1912
Tempera on canvas. 147.2 x 115.8
Tret. Gal.
Provenance: 1927, State Museum Fund
Earlier: collection of B. O. Gavronsky

A contemporary wrote of Sapunov: "He has a marvellous colouristic temperament, volcanic but conscious; his colours are like the timbre of a good voice…" In his still lifes, the artist creates a wonderful, harmonious world in which one can forget the worries and tensions of real life. He arranges a composition of artificial roses — not only the traditional white, rose and red ones, but also blue, lilac and sky blue, placed in splendid vases, glittering with gold, standing on the table among fruits, with pretty decorative fabrics draped in the background. In the still life's composition we see the hand of a theatrical artist, but this theatricality serves only as a means of spiritualising the world of objects, transforming it into something ideal and splendid, into an elevated realm of art, where everything is subordinated to the laws of harmony and beauty. (L. B.)

Sergei SUDEIKIN

Giselle

1915
Sketch for the decorations for Act I
of Adolphe Adam's ballet for the 1915
Mariinsky Theatre tour
Oil on pasteboard. 64 x 91.5
Russ. Mus.
Provenance: 1928, State Museum Fund,
Leningrad

231

A participant in the "Blue Rose" group, Sudeikin was also closely affiliated with the "World of Art". As a superb scenographer, he collaborated with Vera Komissarzhevskaya and Vsevolod Meyerhold. As a stylist and decorator, he was involved with the art-cabaret "The Stray Dog" and "The Comedians' Haven" in St Petersburg. An enthusiasm for the ballet is visible in all of Sudeikin's work. Theatrical life and make-believe always held an unusual attraction for the artist. The conventions of the stage allowed the master broad possibilities for transformation. In Sudeikin's sketches for sets, elements of the classical ballet are intertwined with the naive simplicity of primitive folk art in the most inconceivable ways. The romantic charm of an old-time stage performance and festive combinations of vibrant patches of colour are enriched with a good portion of the irony which was always a part of this artist's sarcastic muse. (G. K.)

Nikolai ROERICH
Kissing the Earth

1912
Study for the decorations for Act I
of Igor Stravinsky's ballet *The Rite of
Spring* for Diaghilev's *Saisons Russes*,
Paris, 1913
Tempera on pasteboard. 62 x 94
Russ. Mus.
Provenance: 1920, collection
of Zh. L. Rumanova, Petrograd

This work is connected with the theme of the early history of the Russian land. Roerich was a co-author of Stravinsky's libretto. Immersed in his notions about the synthesis of the arts, an idea which excited the whole "World of Art" group, he worked out the "score" of the ballet action on stage as the music was being composed, using his colossal knowledge of the lifestyle, rituals, dances and dress of the ancient Slavs. Though the critics rated his decorations highly, Roerich was distressed by the public's failure to appreciate Nijinsky's innovative choreography. During performances, the hall roared and whistled, drowning out the orchestra. (V. Kn.)

Alexander GOLOVIN

The Grave of the Commander

1917
Sketch for the scenery for the 1917
Mariinsky Theatre production of Alexander
Dargomyzhsky's opera *The Stone Guest*
Tempera on veneer. 79 x 115
Signed bottom left: *А. Головинъ*
Russ. Mus.
Provenance: 1919, collection
of P. P. Suvchinsky

Famous theatrical decorator Alexander Golovin decorated seven theatrical productions on Spanish themes. In Georges Bizet's *Carmen*, his most well-known production, he presented "the real Spain, without embellishment", with its narrow streets, dusty squares, signs and sickly foliage, using this everyday provincial background to give the dramatic events more impact. Ten years later, in his decorations for Vsevolod Meyerhold's production of *The Stone Guest*, the artist remains true to Pushkin's conception (on whose work the opera was based) by presenting a romantic image of an exotic country. (G. K.)

Ilya MASHKOV

Self-Portrait with
Pyotr Konchalovsky

1910
Oil on canvas. 208 x 270
Russ. Mus.
Provenance: 1986, S. A. Schuster,
Leningrad

234

This picture belongs to the early period of the Russian avant-garde. It was first shown at the Moscow exhibition with the surprising name "Jack of Diamonds" organised in the winter of 1910–1911 by a group of young innovators headed by Mikhail Larionov. Mashkov was one of the rebels who, for the sake of "rejuvenation" of art, turned to phenomena formerly banished from the realm of high art: signs, ornamental trays, carved wood and clay toys with their naive originality and bright colours, and the aesthetic of the bazaar and street theatre. His unusual picture, with its huge proportions and darkly outlined, hypertrophied forms of naked music-making "Herculi" surrounded by barbells, dumbbells and books — the Bible and monographs on Giotto, Cézanne (the young artists' idol) and the antiquities of Egypt, Greece and Italy — was seen as a manifesto of a new movement aspiring towards a seemingly crude but at the same time strong and masterful painting style, with the hypnotic gazes of the personages, taunting in their youthful brashness, prompting examination, reflection and understanding. (V. K.)

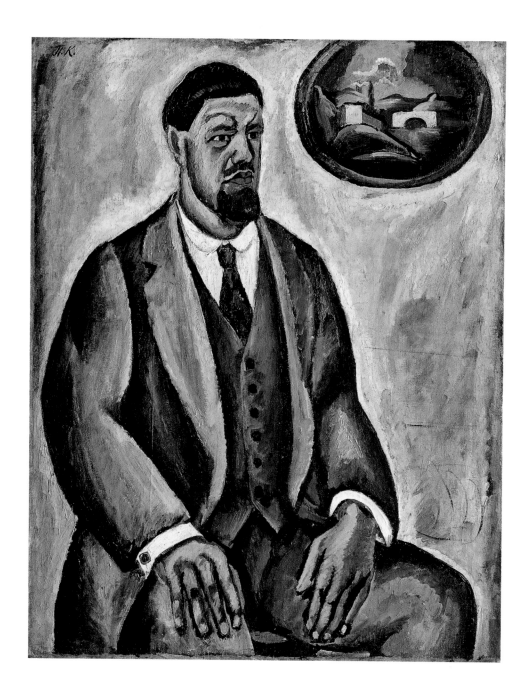

Pyotr KONCHALOVSKY
Self-Portrait in Grey

1911
Oil on canvas. 141.5 x 112.5
Signed top left: *П. К.*
Tret. Gal.
Provenance: 1928, Museum of Artistic
Culture. Earlier: collection of I. S. Isad-
zhanov; from 1918, A. V. Lunacharsky
Proletarian Museum No. 7, Bauman
District, Moscow

Konchalovsky painted *Self-Portrait in
Grey* at Abramtsevo in the summer of
1911. By that time it had become
clear to the artist that mere imitation
of primitive art and the use of city folk-
lore motifs (in this case, the composi-
tional clichés of provincial fair pho-
tography) were insufficient to satisfy
the artist's creative yearnings. Thanks
to the dab-by-dab application of paint,
the surface acquires its own indepen-
dent existence in which there are no
"main" and "secondary" areas, where
everything is in a sense equally im-
portant: the face of the subject, his
clothing and the background. This
work can be considered a transitional
one from primitivism to the Cézanne-
influenced period of Konchalovsky's
development. (L. B.)

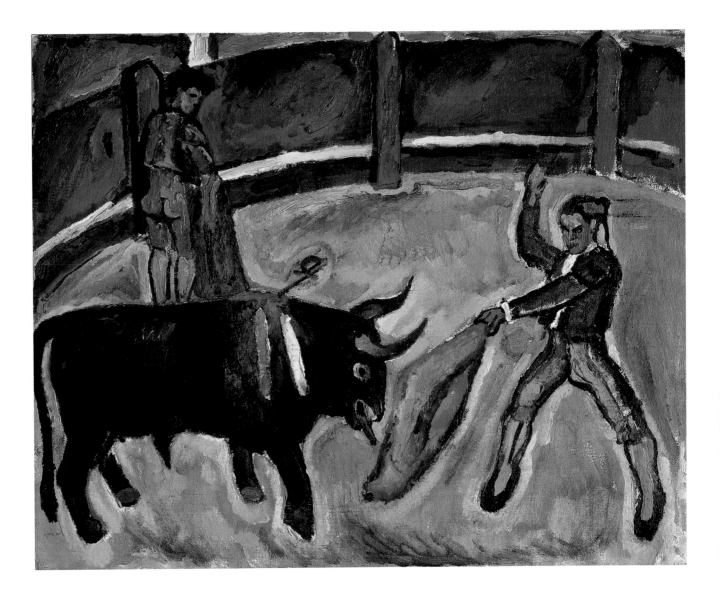

Pyotr KONCHALOVSKY
The Bullfight

1910
Oil on canvas. 59.5 x 73.3
Tret. Gal.
Provenance: 1927, State Museum
Fund. Earlier: collection of I. S. Isad-
zhanov; from 1918, A.V. Lunacharsky
Proletarian Museum No. 7, Bauman
District, Moscow

237

In 1910, Konchalovsky travelled to Spain (Barcelona — Madrid — Toledo — Seville) together with his father-in-law, one of the most famous Russian painters of the late 19th century, Vasily Surikov. Captivated by the bullfights he saw there, he created many images of the *corrida* and portraits of toreadors and enthusiasts. In addi-tion, the artist was swept away by new colouristic discoveries: "…in Spain, colours are extremely simplified; black and white dominate over everything else, as if all other colours have been sprinkled with ashes… The whole time I was living in Spain I was beset by the idea of mastering the art of sim-plified, synthetic colour." (L. B.)

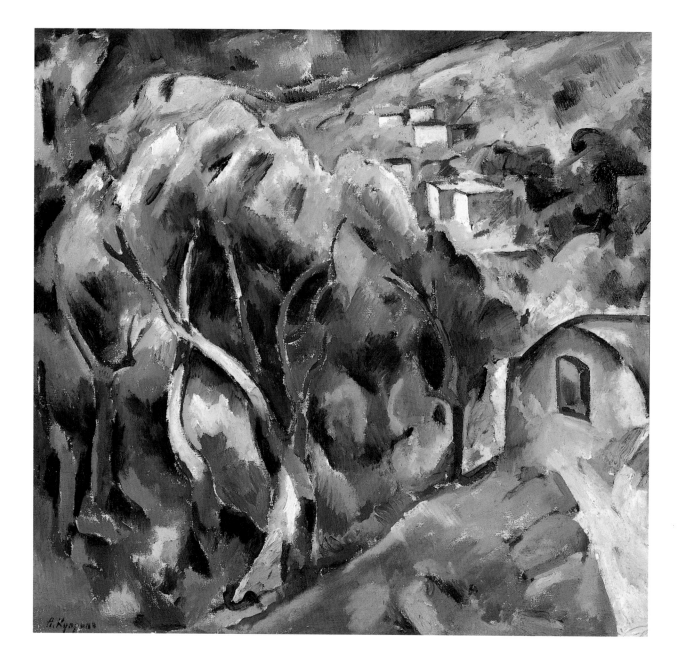

Alexander KUPRIN

Olive Trees. Menton

1914
Oil on canvas. 85.2 x 91.7
Signed bottom left: *А. Купринъ 1914*

Tret. Gal.

Provenance: 1927, Museum of Painting
Culture

In 1913 and 1914 Kuprin studied painting abroad, living in Paris and then in the south of France, returning home through northern Italy. It was there that he painted *Olive Trees. Menton*, which was shown at the "Jack of Diamonds" exhibition in 1914. At that time, the "Jacks of Diamonds" were moving away from primitivism and turning to Cézanne's painting tradition. Here Kuprin depicts the eternal motif of olive trees growing in the sun-parched earth; dab-by-dab with his brush, he creates distinct, architectonic natural forms on the canvas, using a muted, silver-grey-green-blue colour range. The picture is imbued with a feeling of eternity, infinitude and nature's unchangingness. (L. B.)

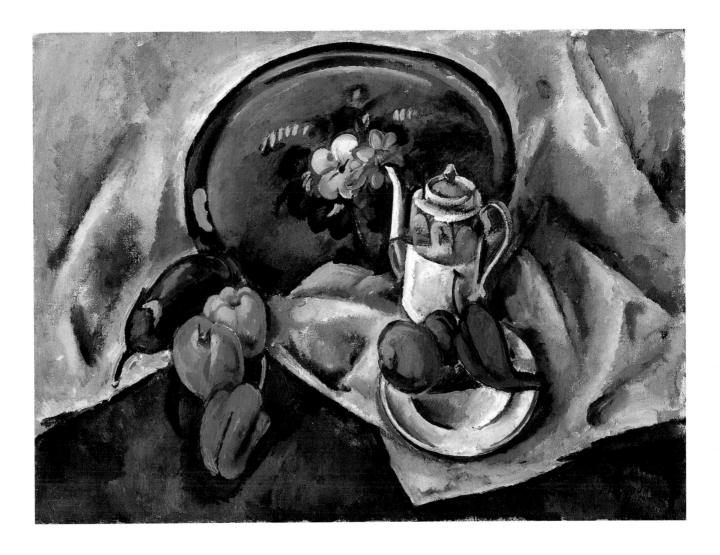

Alexander KUPRIN

Still Life with a Blue Tray

1914
Oil on canvas. 71 x 102
Signed and dated bottom right:
A. Купринъ 1914
Tret. Gal.
Provenance: 1927, State Museum
Fund. Earlier: collection of I. A. Morozov;
GMNZI (1918–1925)

Ivan Abramovich Morozov bought *Still Life with a Blue Tray* from the artist for his famous collection, placing it alongside his outstanding works of contemporary French art. The "Jack of Diamonds" group achieved its peak in the still life genre in the mid-1910s, and Alexander Kuprin's *Still Life with a Blue Tray* offers fine evidence of that.

The tray's soft but intense colour is juxtaposed with the "hot" red and green of the peppers, with the white drapery and white porcelain of the coffee pot and plates accentuating the principal colours. The composition's subject turns out to be not a thing itself but its depiction — flowers on a Zhostovo tray. (L. B.)

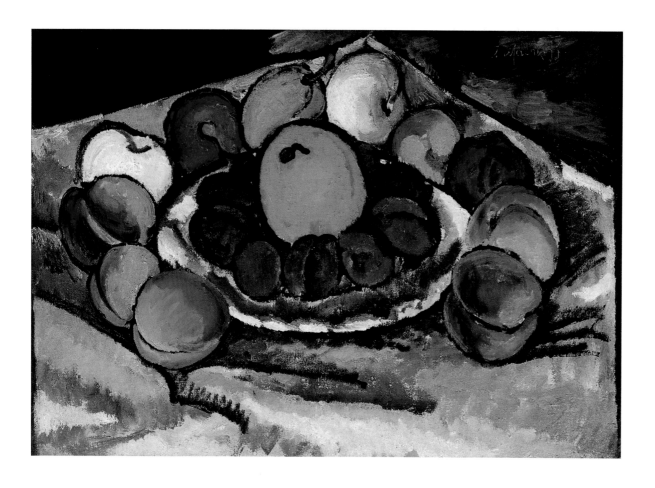

Ilya MASHKOV

Still Life with Fruit on a Plate ("Blue Plums")

1910
Oil on canvas. 80.7 x 116.2
Scratched-on signature top right:
I Machkoff
Tret. Gal.
Provenance: 1927, GMNZI. Earlier: collection of I. A. Morozov

The still life was the favourite genre of the "Jack of Diamonds" artists, and the works of Ilya Mashkov are considered by scholars to be among the highest achievements in this genre, and an absolute peak among contemporary works. Colour attains an especially intense vibrancy in *Blue Plums*. The neutral dark background and white tablecloth contrast with the intense colours, which are further intensified by the thick black contours outlining the fruits. The painting's composition and colouring cannot help but remind us of expressive and colourful decorative trays and *lubok* pictures. Here painterly texture and the beauty of the painting itself come to the forefront: real natural colours, which depend on the light source or the time of day when the picture is painted, are less important here than the primary colours on the surface of the canvas. Though Mashkov's teacher Valentin Serov regarded his student's manner of painting with disapproval, he could not help but admit that painting of such temperament deserved respect. After seeing *Blue Plums* at the 1910 Autumn Salon in Paris, Serov wrote to Mikhail Morozov: "Our Muscovite Matisse, Mashkov, was not bad at all, seriously. His fruits are painted with great verve and resonance..." Thanks to this favourable opinion, which the collector took as a recommendation, Morozov bought *Blue Plums*; after his death in 1903 the picture was transferred to the Tretyakov Gallery in accordance with his will. (L. B.)

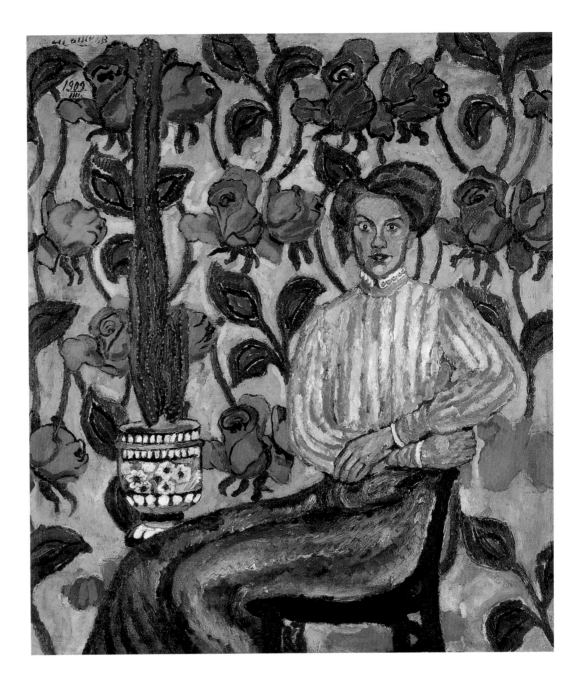

Ilya MASHKOV

Portrait of Varvara Petrovna
Vinogradova

1909
Oil on canvas. 144 x 128
Signed and dated top left:
Илья Машков 1909
Tret. Gal.
Provenance: 1929, Museum
of Painting Culture

Ilya Mashkov's *Portrait of Varvara Petrovna Vinogradova* could serve as a typical example of the "Jack of Diamonds" group's approach to the portrait genre. The artist does not hide his affinity with the Fauvists, especially Matisse and Van Dongen. In the portrait, the model poses strikingly against a background of patterned wallpaper and a huge exotic cactus. *The Portrait of Vinogradova* challenges commonly-accepted norms and traditions of the Russian psychological portrait, with its traditional aim of revealing the inner spiritual life of the subject. Here Mashkov completely subordinates the model to his painterly objectives, resulting in an ornamental composition rather than a psychological characterisation. It is no accident that the picture received the informal subtitle "Woman Against a Background of Wallpaper". (L. B.)

Natalia GONCHAROVA

Peasants

1911
From a nine-part polyptych
The Grape Harvest
Oil on canvas. 131 x 100.5
Russ. Mus.
Provenance: 1926, Museum of Artistic
Culture, Leningrad

In 1911, Goncharova painted two monumental, nine-part compositions: *The Grape Harvest* and *Harvest*. Of the first, only four fragments remain: *Dancing Peasants* (private collection, Paris), *Celebrating Peasants*, *Peasants Carrying Grapes* (both Tretyakov Gallery) and the *Peasants* from the Russian Museum collection. All four surviving canvases are marked by monumentality and a powerful emotional richness which underscore the sacred, epic conception of the whole composition, which was based on the Gospels. (V. K.)

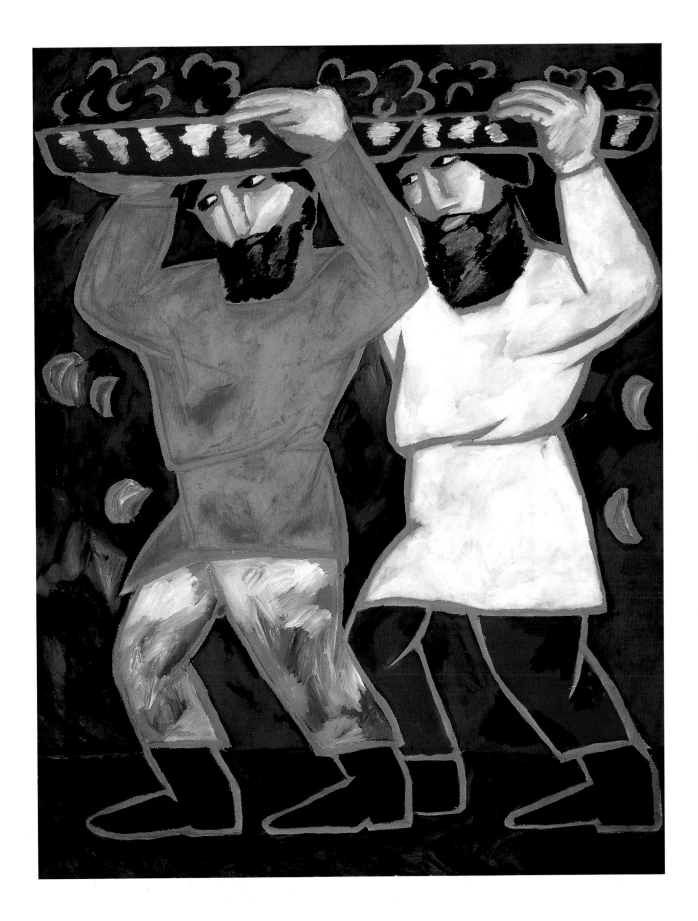

Natalia GONCHAROVA
Pillars of Salt

Circa 1910
Oil on canvas. 80.5 x 95.5
Inscribed on the reverse side: *№ 441*;
Larionow; and labels from the Moscow
Archive of Contemporary Artworks
Tret. Gal.
Provenance: 1988, bequeathed
by A. K. Larionova-Tomilina

Around the beginning of the 1910s, Natalia Goncharova began to address Biblical themes, which she brought to life on canvas in the language of contemporary art. The story of Lot's wife served as the basis for the subject of *Pillars of Salt*. The artist departs somewhat from the Biblical version, however; in her picture not only Lot's wife but all the story's participants are turned to salt pillars, against a background of smouldering ruins. Goncharova renders them using the principles of Cubist faceting, as she had done earlier in her depictions of Scythian stone women, which Goncharova considered to be the first Cubist sculptures. (L. B.)

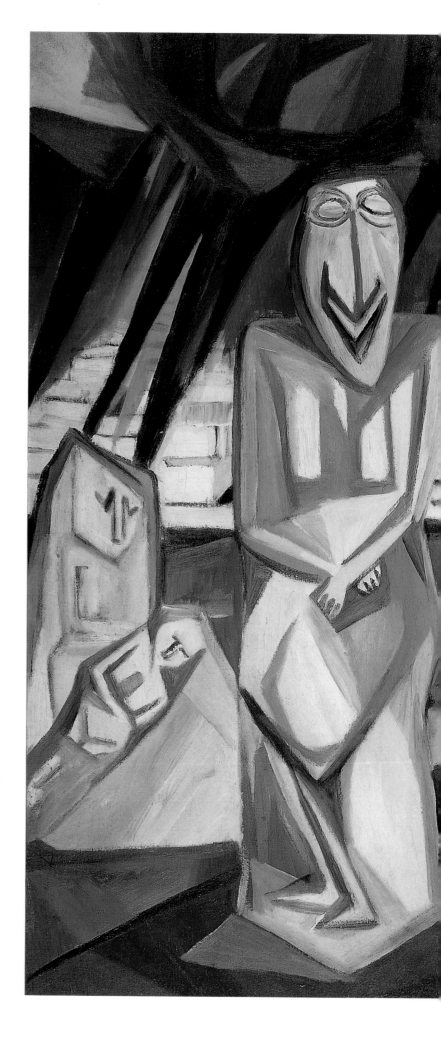

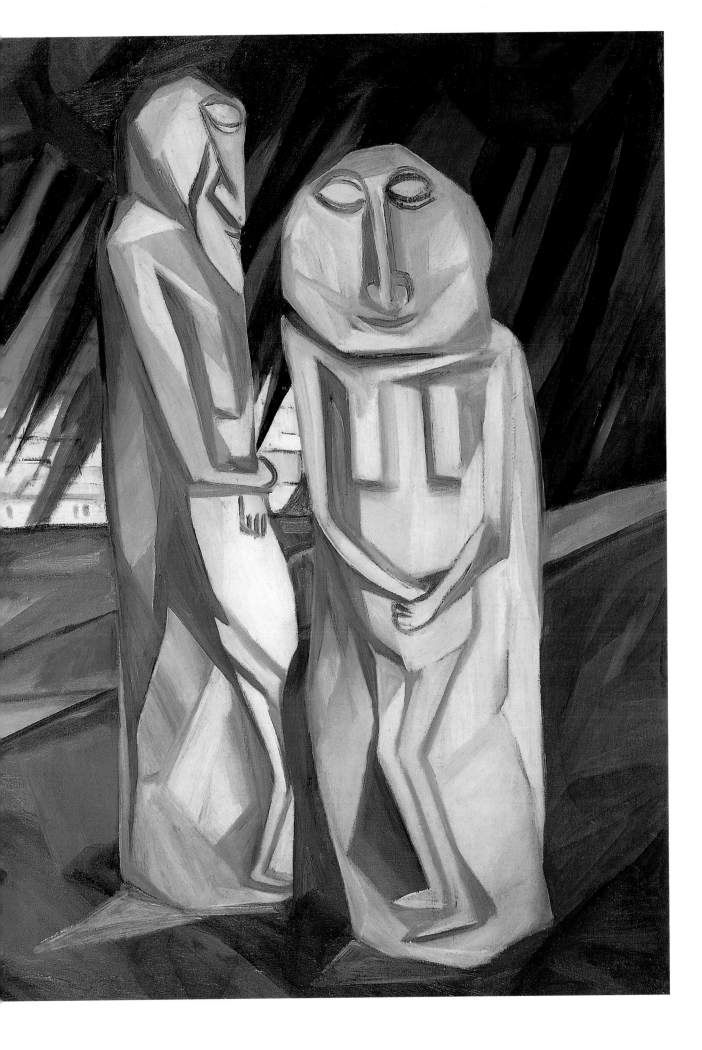

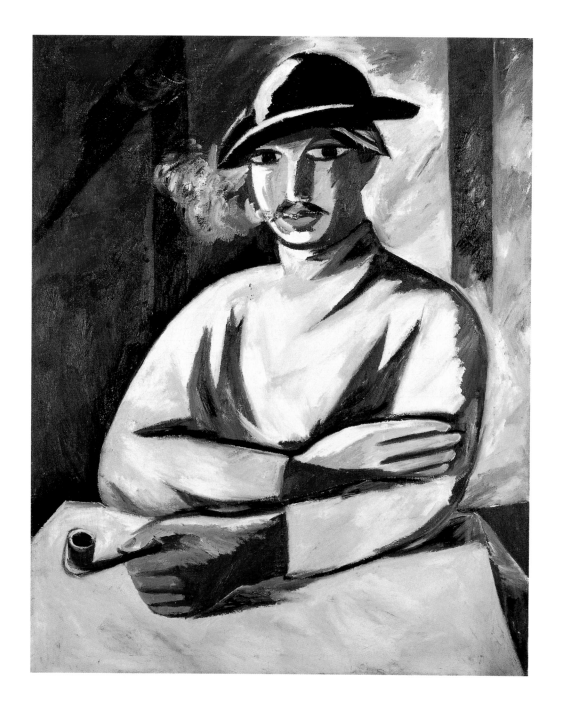

Natalia GONCHAROVA
A Smoking Man

1911
Oil on canvas. 100 x 81
Inscribed on the reverse side: *№ 577*
Ц. 600 p; and labels from the Moscow
Archive of Contemporary Artworks
Tret. Gal.
Provenance: 1988, bequeathed
by A. K. Larionova-Tomilina

A Smoking Man was shown for the first time at the "Donkey's Tail" exhibition which opened on 4 January 1912. The artist defined the work's style in the exhibition catalogue as "decorative-tray". At that time, primitivism dominated in the work of left-oriented artists, and many of them turned to the painted ornamental trays and street signs of folk art for inspiration. They were especially fascinated by children's toys, *lubok* and other forms of naive folk art which had a rich tradition in Russia. Goncharova and Larionov often found as much inspiration in other people's art as in reality itself. Here Goncharova reinterprets one of Cézanne's favourite themes in the language of neo-primitivism. Her interest in the "smoker" motif may have been connected with the appearance in 1910 of a Cézanne painting by that name in Ivan Morozov's collection. (L. B.)

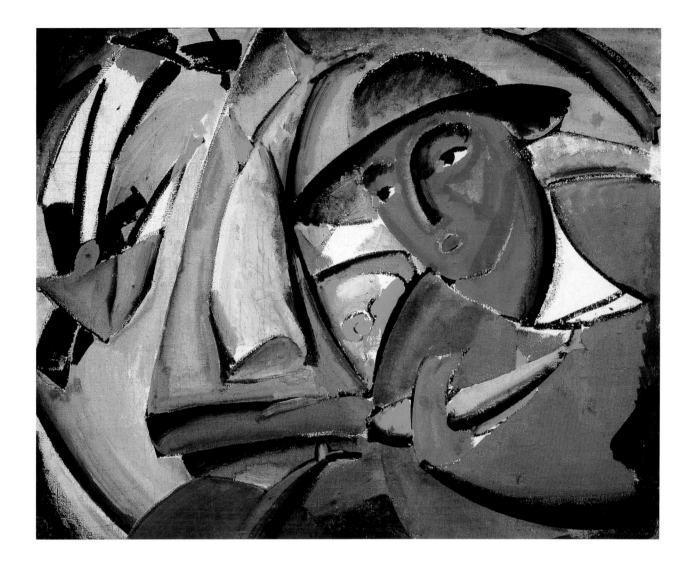

Vladimir TATLIN

The Fish Seller

1911
Glue paint on canvas. 77 x 99
Inscribed on the reverse side: *Татлинъ*
„Продавецъ рыбъ" 911 г
Tret. Gal.
Provenance: 1929, Museum
of Painting Culture

The Fish Seller is rightly considered a milestone in Tatlin's creative evolution, marking the appearance of the artist's own unique style which would propel him into the forefront of the Russian avant-garde. The picture's composition is organised so that the table on which the gutted fish lie is tilted to form a background for the image of the subject. The contours of the figures and objects are all rounded, including the edges of the rectangular table, and these dark-coloured arcs are repeated throughout the canvas, seeming to lock the composition into a circle. Rhythmic unity is accompanied by a unity of colour, with the picture's brown and grey tones existing in a precisely calibrated correlation with the whites and reds, with each colour achieving maximum expressiveness. (L. B.)

Mikhail LARIONOV

Winter

1912
From "The Seasons" series
Oil on canvas. 100 x 122
Tret. Gal.
Provenance: 1929, Museum
of Painting Culture

Winter is one of two paintings in the Tretyakov Gallery collection from Larionov's famous series "The Seasons"; they were first exhibited at the "Mishen'" exhibition in Moscow in the spring of 1913. *Winter*, like other works from the "Seasons" series, was described by the artist as "new primitive". The canvas reminds us of a children's drawing in the conventionality of its forms and in the division of the picture's surface into rectangles, each containing a different image: the figure of Winter with a scarf in outspread hands, a cat under a tree, little houses with fir trees between them, and the inscription in a childish hand reading: "Winter cold snowy snowstorm wrapped frozen in ice". (L. B.)

Mikhail LARIONOV
Soldier Smoking

1910–11
Oil on canvas 100 x 72.5
Signed and inscribed on the reverse
side: *М. Ф. Ларіоновъ Солдатъ Этюдъ*
[M. F. Larionov Soldier Study]; and label
of the Moscow Archive of Contemporary
Artworks: *№ 27 Larionov „Le Soldat"*
99 x 72
Tret. Gal.
Provenance: 1988, bequeathed
by A. K. Larionova-Tomilina

From October 1910 to the spring of
1911, Larionov was doing his military
service in Moscow; the summer of
1911 was spent in an army camp near
Petersburg. The regulations for army
volunteers were rather liberal; the
artist was not only able to help organ-
ise the first "Jack of Diamonds" exhi-
bition, a milestone in the history of
20th-century Russian art, but also to
create his famous "Soldier" series of
paintings. *Soldier Smoking* could serve
as a classic example of expressive
primitivist imagery: it corresponds per-
fectly to the folk ideal of the soldier —
a carefree fellow with a waxed mous-
tache, hand-rolled cigarette in his
mouth, cocked service-cap, red cuffs
and piping, and shiny, "gold" buttons
and belt buckle. For all this, the paint-
ing's surface retains a harmonious
balance: the green-, brown- and rose-
coloured patches on the yellow back-
ground are repeated in the glints of
colour on the soldier's coat and uni-
form. (L. B.)

Robert FALK

Steamboat Landing. Grey Day

1911
Oil on canvas. 87.2 x 106.5
Signed bottom left: *ФАЛЬКЪ*
signed by the artist on the reverse side,
lower left: *Фаль...* On the frame, top left:
№ 489, and further to the right: *1911 г*
Tret. Gal.
Provenance: Purchased in 1975
from A. V. Shchekina-Krotova, the
artist's widow

At the beginning of the 1910s, Falk, like his artist friends and fellow "Jack of Diamonds" members, was caught up in the general enthusiasm for primitivism. He achieved no small success in this area, creating a number of landscapes which were shown at the first "Jack of Diamonds" exhibitions. *Steamboat Landing. Grey Day* was painted in Finland, where the colour of the dim northern sky sets the tone for all the other colours in the picture. Falk invented the expression "orchestration of colour". The artist wrote: "In pure colour perception there is no near, no far, no space at all as far as the eye's concerned. They are just an idea, not a visual reality. All objects must be fixed by the artist's eye in one plane, and only different colours can indicate the position of objects in space ... One must look at a landscape as if it were imprinted on the flatness of a window pane. A landscape, like any picture which we see and draw, is built entirely on a single plane, however many fields might be included in it... Only colour relations and changes in proportions tell us something about foreground or background." (L. B.)

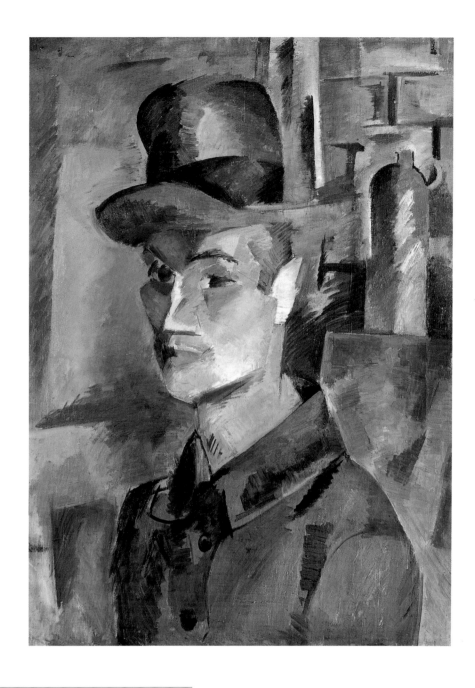

Robert FALK
Self-Portrait

1917
Oil on canvas. 100 x 77
Tret. Gal.
Provenance: 1929, Museum
of Painting Culture

In the last half of the 1910s, Falk achieves such mastery in organising form on the canvas that we can assert that the world of painting he created transcends the bounds of any concrete representation. Man pondering his place in the surrounding world, an eternal theme of artists of all times and nations, is the central theme of Falk's 1917 *Self-Portrait*. The subject's concentration and immersion in his inner world is evidenced by the artist's slow, painstaking, and intense work on the picture, which he did not hide, and the complex "colour painting" created by meticulous brush strokes. (L. B.)

Vladimir TATLIN
Female Model

1913
Oil on canvas. 104.5 x 130.5
Russ. Mus.
Provenance: 1920, the artist

By the beginning of the 1910s, Tatlin had developed an absolutely original artistic style, distinguished by laconicism and at the same time heightened expressiveness and emotionality. These qualities are especially present in *Female Model*, one of the artist's best works from this period. The figure's outline and her motions are conveyed in an extremely synthetic manner, and each stroke is so precise that one cannot help but thinking about the inevitability of the artist's future evolution: towards greater and greater constructivism and logical precision in formulating tasks and their solutions. Along with this, the picture reveals not only the influence of Picasso and Matisse, but that of ancient Russian art, which Tatlin held in very high esteem and studied carefully. (O. M.)

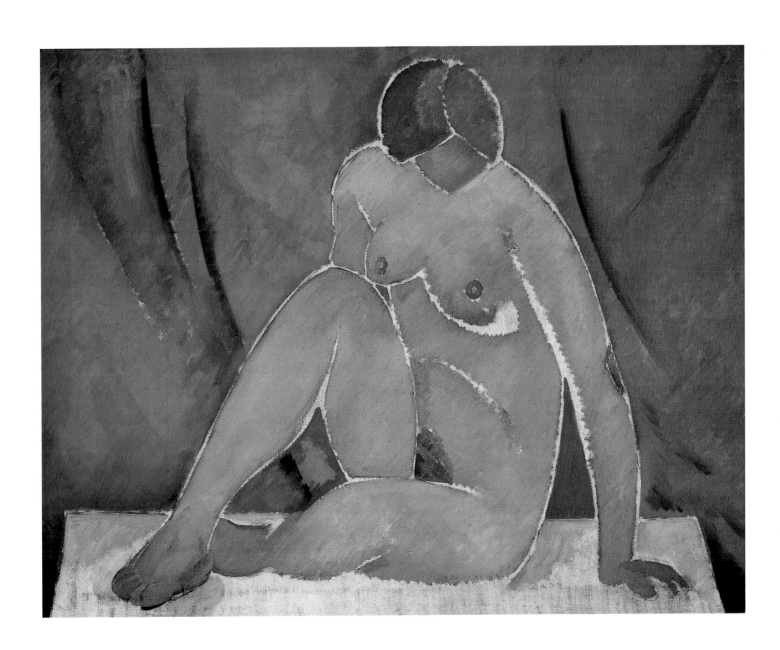

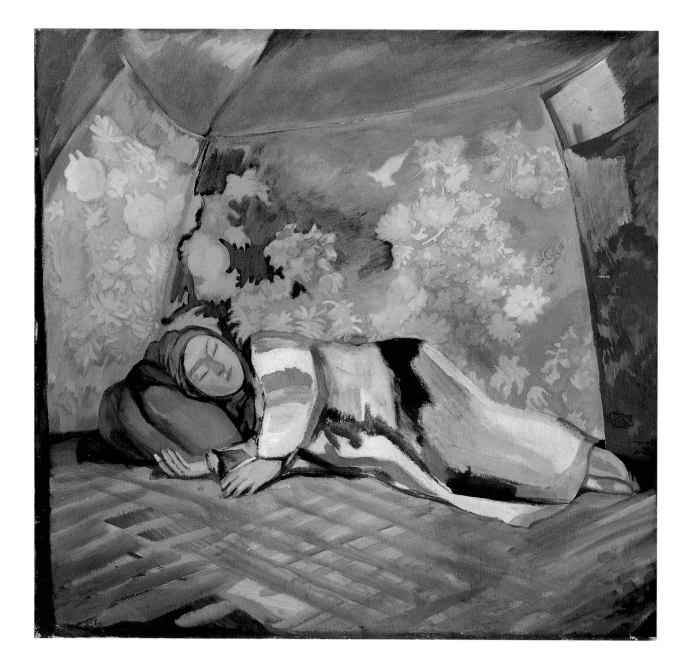

Pavel KUZNETSOV

Woman Sleeping
in a Sheepcote

1911
Tempera on canvas. 67 x 71.5
Tret. Gal.
Provenance: 1921, State Museum Fund.
Earlier: collection of S. A. Shcherbatov

254

Gauguin, the first artist to comprehend the beauty of primitive civilisations, paved the way to the Orient for many other artists. The Tahitian dream world on display at the grandiose Gauguin display at the 1906 Autumn Salon in Paris made a great impression on Pavel Kuznetsov. The artist set out in search of his own primordial civilisation, finding it on the steppes of the Volga, and in Kirghizia, Bukhara and Samarkand. Kuznetsov spent much time in the settlements of nomadic sheepherders, absorbing the calm, measured rhythm of their uncomplicated lifestyle. Here the artist found his source of inspiration, an oriental fairy tale world on the endless expanse of the steppes populated by contemplative women and lethargic animals. The harmoniousness of this natural lifestyle, simple and yet many-faceted, like the surrounding landscape, was the main theme in Kuznetsov's works of the early 1910s. *Woman Sleeping in a Sheepcote* is one of the best-known paintings from Kuznetsov's "Kirghiz Suite". (L. B.)

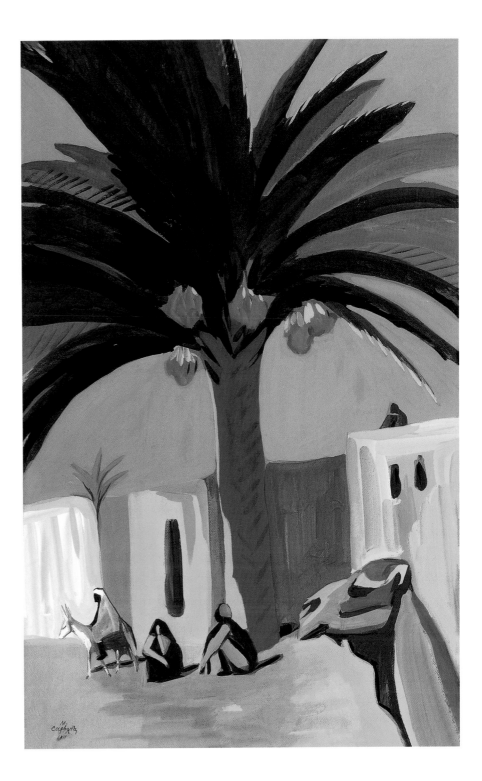

Martiros SARYAN
Date Palm. Egypt

1911
Tempera on pasteboard. 106.2 x 70.6
Signed bottom left: *М. Сарьянъ 1911*
Tret. Gal.
Provenance: 1927, State Museum Fund.
Earlier: collection of B. O. Gavronsky

Martiros Saryan, like the other members of the "Blue Rose" group, sought themes for his paintings in the imagery of the Orient. In the late 19th and early 20th centuries, many Russian and European artists made pilgrimages to the East. In a conscious attempt to free themselves from the classical artistic tradition established in European painting since the Renaissance, they sought other foundations for their art. This led them to an interest in things folkish, primitive and ancient. Saryan travelled to Constantinople, Egypt and Persia to find sources of inspiration not just in museums (though he did not neglect to study their collections), but above all in nature herself. *Date Palm. Egypt* is one of the most expressive works of his Egyptian series. This is not genre painting with an "ethnographic" slant, but a contemplative, poetic perception of another world. The artist immerses the viewer in the atmosphere of Oriental fairy tales populated by unhurried people and slow-moving animals, quiescent under the rays of the scorching sun. (L. B.)

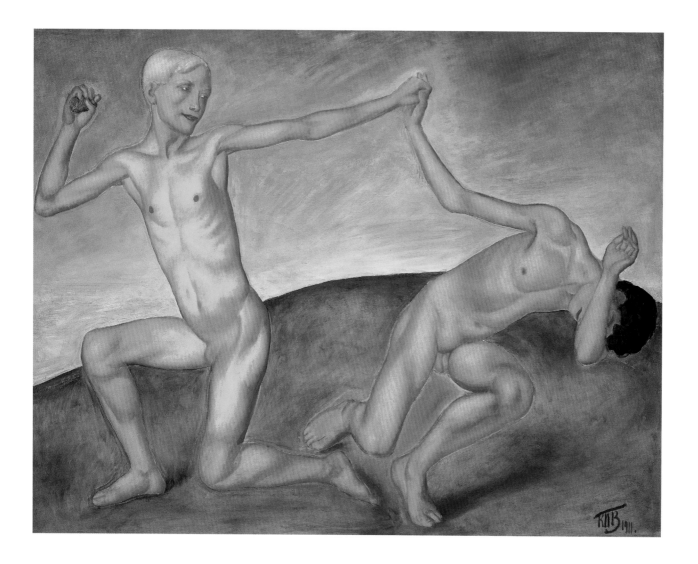

Kuzma PETROV-VODKIN

Boys Playing

1911
Oil on canvas. 123 x 157
Initialled and dated bottom right:
КПВ 1911
Russ. Mus.
Provenance: 1920, collection of
Alexander Korovin, Petrograd

This canvas occupies an important place in the artist's creative evolution. The abstract subject, defying simple interpretation, served as a vehicle for the artist to solve a problem concerning him: the expression of rhythm and motion. The canvas is marked by true monumentality and the concentrated power of its emotional impact. In it, the Neoclassical aspiration towards ideal harmony characteristic of the 1910s combines with an interest in the legacy of 17th-century Russian painting, when artists were solving the problem of depiction of volume on a flat surface. For the first time, the artist has clearly formulated his new "three colour" principle: the contrasting and combining of the three main colours of the earth — yellowish red, green and blue. Opposing the drab everydayness of modern life with an eternally young world of irrational dreams, Petrov-Vodkin introduces into the observed scene traits of a peculiar ritual pantomime. The difference in characters and temperaments of the two subjects is revealed in the painterly expression of the bodies and the rhythm of the lines — at times elastic and energetic, at times circular, soft and falling downward, and amplified by sharp colour contrasts. (V. K.)

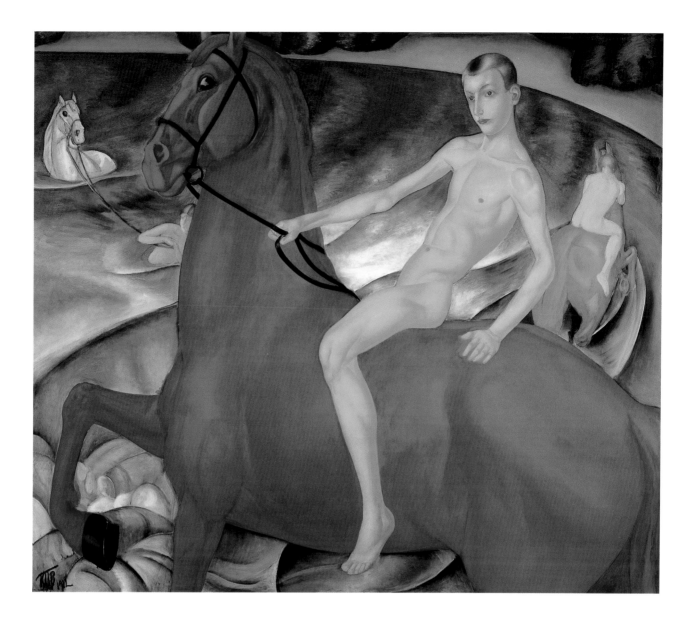

Kuzma PETROV-VODKIN

Bathing the Red Horse

1912
Oil on canvas. 160 x 186
Signed (monogram) and dated
bottom left: *КПВ 1912*
Tret. Gal.
Provenance: 1961, donated by
K. K. Basevich. Earlier: until 1953,
collection of Petrov-Vodkin's widow

257

Work on this picture was begun in the early spring of 1912 at the farm of Mishkina Pristan' in Saratov Guberniya. Originally it was to be a perfectly realistic scene of boys and horses bathing in the Volga, with the artist's cousin Alexander Trofimov serving as the model for the picture's central figure. Bit by bit, the trivial genre scene was transformed into a picture whose main focus became the image of a magnificent "horse of fire" embodying motives from Russian folklore, whose "progenitors" were the horses on the icons of St George and *Archangel Michael's Miracle with Florus and Laurus*. It was the red colour on the icons of the Moscow and Novgorod Schools, just come to light after their recent cleaning and restoration, which inspired the artist to turn the chestnut colour of his sorrel horse into a symbolic red. The painting was received by contemporaries as a metaphoric expression for their time, as a kind of unique premonition of the events which the 20th century would soon bring. (L. B.)

David BURLIUK

Portrait of Vasily Kamensky

1917
Oil on canvas. 104 x 104
Russ. Mus.
Provenance: 1975–1980, Vasily
Kamensky, Moscow

David Burliuk's acquaintanceship with
Vasily Kamensky, which took place in
1908 at the opening of the "Modern
Tendencies in Art" exhibition, marked
the beginning of an important stage in
the history of Russian Futurism. It was
Kamensky who took Burliuk to the
home of the artist and composer
Mikhail Matyushin and his wife Elena
Guro, a poetess and artist; this meet-
ing marked the beginning of the first
alliance of Russian Futurists, or "Bu-
detlyane" (a Russian neologism mean-
ing "people of the future", literally
"futurites"). Kamensky's poetry and
pictorial experiments harmonised with
the quest for new forms in art espo-
used by Burliuk. *Portrait of Vasily Ka-
mensky* became a sort of creative
manifesto for the painter, in which the
image of poet/innovator is trans-
formed into an "icon", with an inscrip-
tion running along its "halo" reading:
"king of poets and song-warrior futur-
ist Vasily Vasilievich Kamensky year
1917 republic Russia". Vasily Vasilie-
vich Kamensky (1884–1961) was a
poet, writer, playwright, artist and avi-
ator; he was one of Russia's first pro-
fessional pilots. (V. K.)

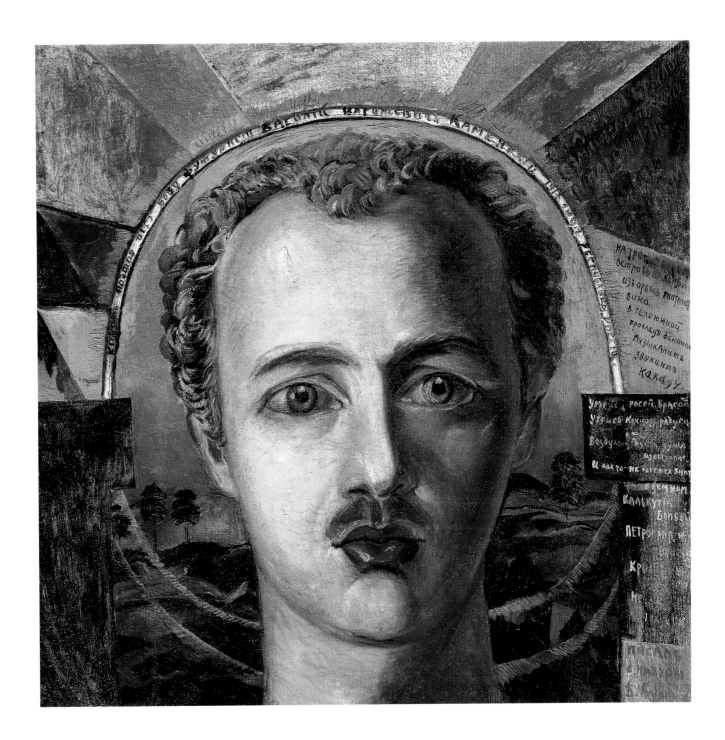

Kuzma PETROV-VODKIN

Virgin of Tender Mercy

1914–1915
Oil on canvas on wood. 100.2 x 110
Monogram bottom right: *КПВ*
Russ. Mus.
Provenance: 1985, collection of
B. N. Okunyov, Leningrad

Since these were the years of the First World War, the picture *Virgin of Tender Mercy to Evil Hearts* (the artist's title; in Orthodox iconography the image is known as the "Virgin Softening Evil Hearts") acquires a special significance, as the artist's heartfelt response to the tragic events taking place at the time. Though not physically large, the canvas is perceived as a major, monumental work, permeated with an energy of great spiritual force. In the potency of its impact, this tender and sublime image of the Virgin created by Petrov-Vodkin is one of the most powerful works in his œuvre. (G. K.)

260

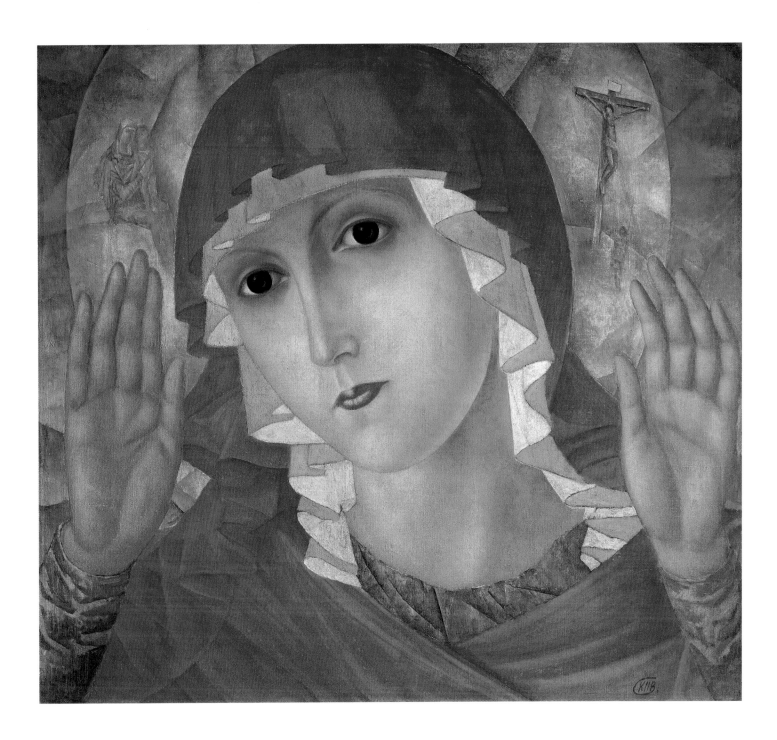

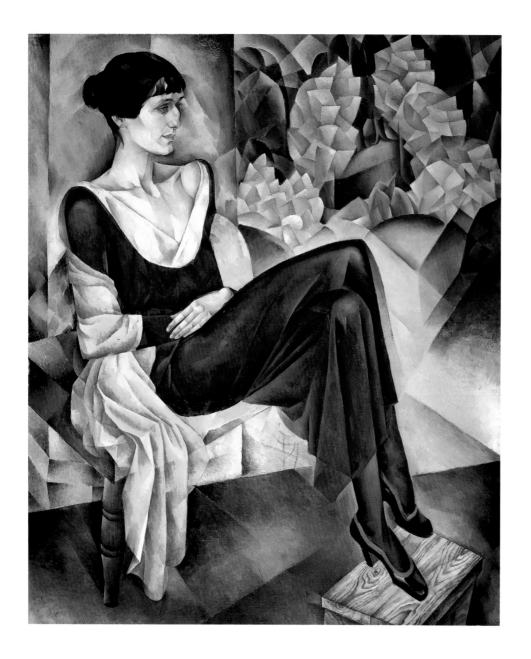

Nathan ALTMAN

Portrait of Anna Akhmatova

1915
Oil on canvas. 123.5 x 103.2
Russ. Mus.
Provenance: 1920, collection
of Zh. L. Rumanova

This portrait, one of the best in Altman's œuvre, is of the poetess Anna Andreyevna Akhmatova (whose real surname was Gorenko). It was created under the influence of Akhmatova's poetry (she had already written the book of verse *Evening* by then), as well as the artist's acquaintanceship with her, which began in Paris in 1911 and continued with their meetings at the Petersburg cabaret "The Stray Dog". Akhmatova is captured here just as many of her contemporaries knew her: a melancholy young woman, tall and thin, with a chiselled profile, her hair worn in bangs and wrapped up in a big scarf. Working on the portrait in his studio on the Tuchkov Embankment, Altman rejected any concretisation of the background. The poetess is depicted against an invented landscape of glittering crystals, perceived as a world of abstract and sublime dreams. (V. Kn.)

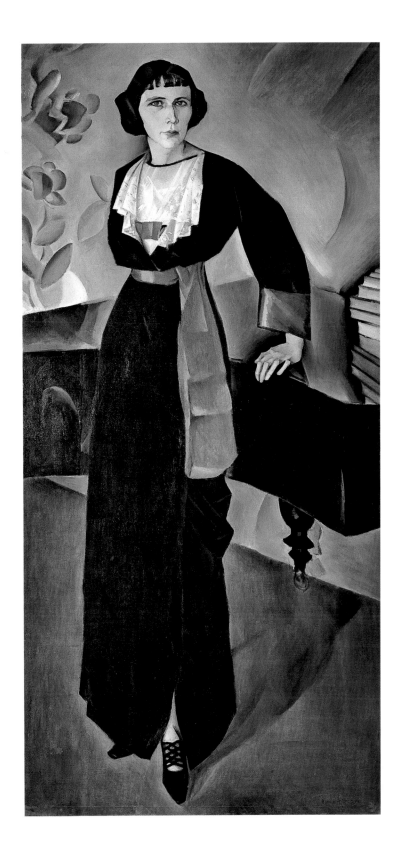

Nathan ALTMAN

Lady at the Piano

1913
Oil on canvas. 176 x 87
Signed and dated bottom right:
Натан Альтман 1913
Tret. Gal.
Provenance: 1929, Russian Museum

Nathan Altman worked for a time at the famous *La Ruche* (the "Beehive") in Montparnasse, alongside Legér, Modigliani, Chagall and other artists of the Paris School. He was also attracted to Cubism, but used its methods rather sparingly, with a cold detachment, never allowing Cubist fragmentation to degrade the strict and distinct draughtsmanship which always lay at the basis of his paintings. This "classic" draughtsman's quality distinguishes Altman's œuvre.
The subject depicted in *Lady at the Piano* is Ekaterina Emilyevna Vlasyeva, née Gerbek. (L. B.)

Marc CHAGALL

The Red Jew

Between 1914 and 1915
Oil on pasteboard. 100 x 80.5
Signed bottom right: *Chagall*;
signed and dated reverse side:
Chagall 915
Russ. Mus.
Provenance: 1926, Museum of Artistic
Culture, Leningrad

The heavy suffering, loneliness and despair characteriseing every personage in this series epitomise the fate of the Jewish people. The figure seated against the background of a conventional yet concretely depicted house is perceived as a symbol, a generalisation. The differenthy coloured hands and the beard, red like a tongue of flame, emphasise the symbolic, archetypal nature of the image. The inkwell with pen standing on one of the roofs reminds us that the rabbi is a keeper of the law, which we see written in Hebrew letters in the picture's background. The crude but powerful figure of the seated Jew in red is a mighty expression of the spirit of prophecy and holiness existing in this ancient people. (V. K.)

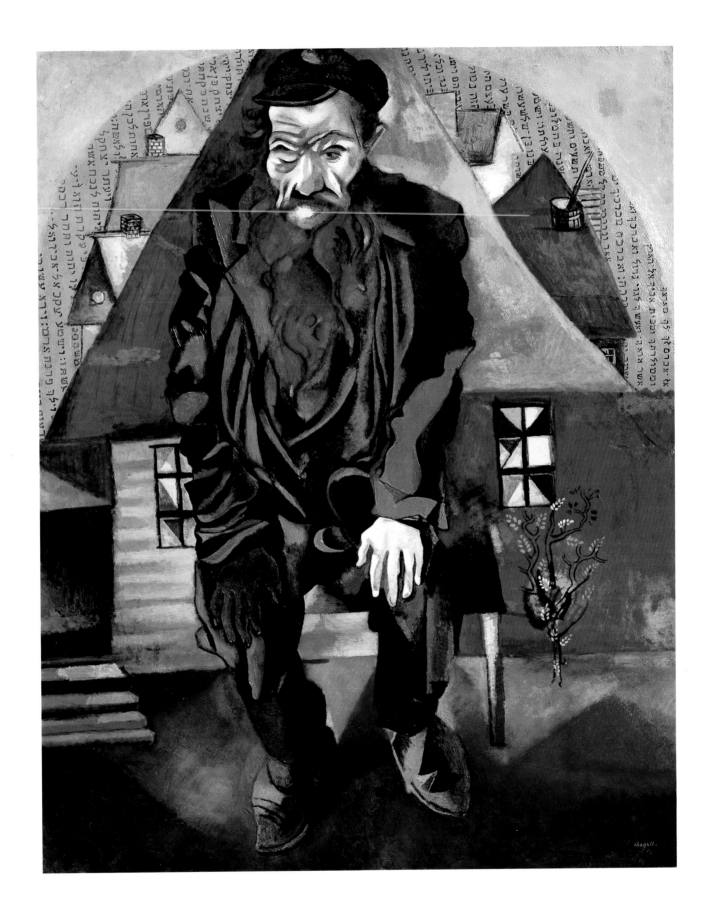

Marc CHAGALL
The Promenade

1917–1918
Oil on canvas. 170 x 163.5
Signed and dated bottom right:
Шагал 1917
Russ. Mus.
Provenance: 1924, State
Museum Fund

From his very first meeting with Bella Rosenfeld in 1909, Chagall referred to her as his bride. Upon his return from Paris in the mid-1910s, the artist married her and began to address the theme of love with enviable regularity. The feeling of bliss which always overcame the artist when he was with Bella remained with him for many years. The artist depicted his "ideal girl" by turns as angel or muse; she was often present in his painterly compositions, and many portraits of her exist. This deep feeling of love always lived in Bella's heart, too, she would later write in her memoirs of her husband: "...he is like a wandering star, uncatchable. Either shining with a cold, piercing light or hidden from view". *The Promenade* reveals much about the master's approach to art's strategic objectives. He considered symbolism unavoidable in true works of art. Therefore, if a bird in a youth's hand is a symbol of real happiness, then a bird-girl in the sky whom he holds by the hand stands for a "fairytale dream caught", as the Russian phrase goes. The joy of that acquisition and the subtle and tender world of his young wife's heart aroused the delight and heartfelt elation which is visible in the artist's paintings. (A. N.)

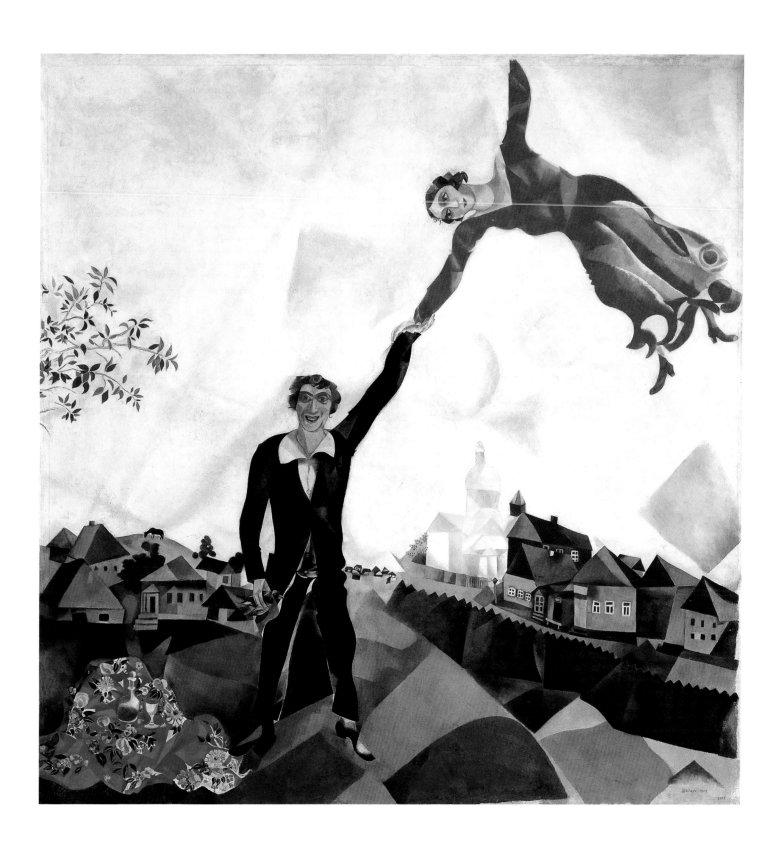

Boris KUSTODIEV
Beauty

1915
Oil on canvas. 141 x 185.
Signed and dated bottom right:
Б. Кустодіевъ 1915
Tret. Gal.
Provenance: 1938, Leningrad State
Buying Commission

At the end of 1914, Kustodiev was living in Moscow and working on the sets for Saltykov-Shchedrin's play *The Death of Pazhukhin*. In that production, the role of Nastasya Ivanovna Furnacheva, a thoughtless, lazy and eternally-bored Old Believer merchant's daughter and "a very fat lady", was being played by Faina Shevchenko, an actress at the Moscow Art Theatre. It was she who posed for the artist for his pencil sketch for the painting *Beauty*, depicting the type of imposing Russian merchant's wife which Kustodiev would become known for: full-figured, with a round face and rosy complexion. From that drawing came one of Kustodiev's most famous pictures, in which he placed his indifferent blue-eyed beauty in a typical merchant's house interior: an open bed on a painted chest with a quilted satin blanket and lace pillowcases. The author exploited this successful image many times in his later work. (L. B.)

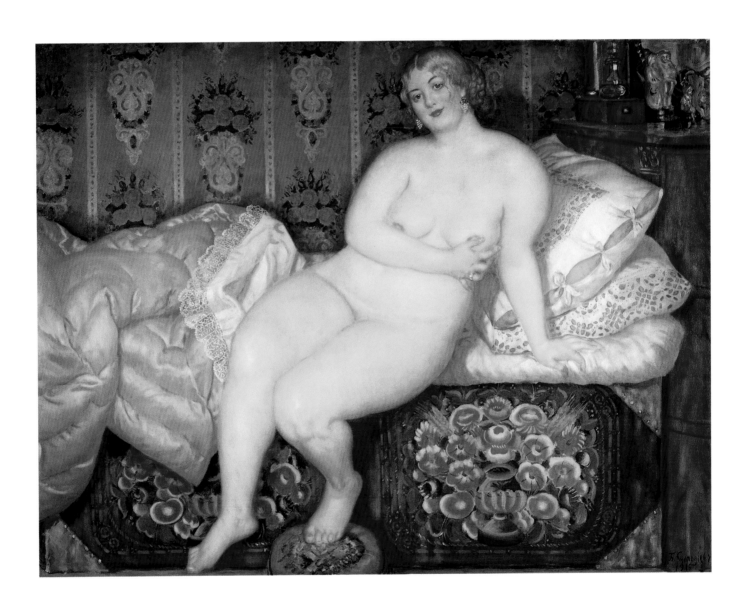

Pyotr MITURICH
Portrait of the Composer
Arthur Lourié

1915
Oil on canvas. 102 x 101.5
Signed and dated bottom left:
15 г П. Митуричъ
Russ. Mus.
Provenance: 1920, S. K. Isakov

Portraying his subject indoors, Mitu-
rich places the main accent on the ex-
pressiveness of the silhouette, and on
a small but precise selection of ac-
cessories, which can say much about
a person's character and his way of
life. Despite a seeming lightness and
a certain ornateness of execution, the
portrait renders its subject with sur-
prising veracity and conveys the rela-
tionship of the artist to his model. The
expressive line dominates over colour.
A certain freedom of execution under-
scores the artistic nature of the sub-
ject. Arthur Vincent Lourié (Artur Serge-
yevich [Naum Israilevich] Lurye, 1891–
1966), an avant-garde composer and
music critic, was the author of the
opera *The Moor of Peter the Great* and
the opera/ballet *Feast during the
Plague*, as well as chamber and sym-
phonic works. (A. L.)

270

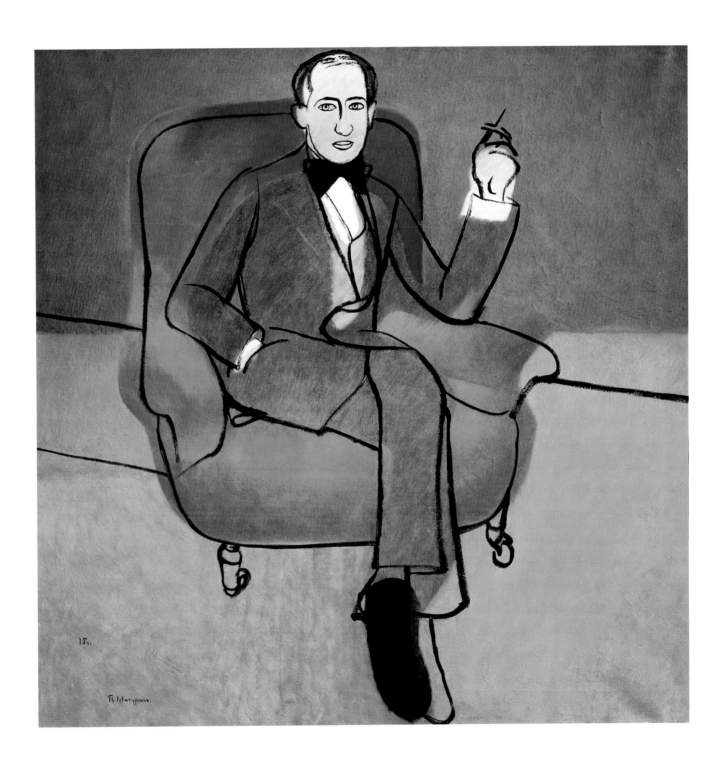

15..

П. Мтурич.

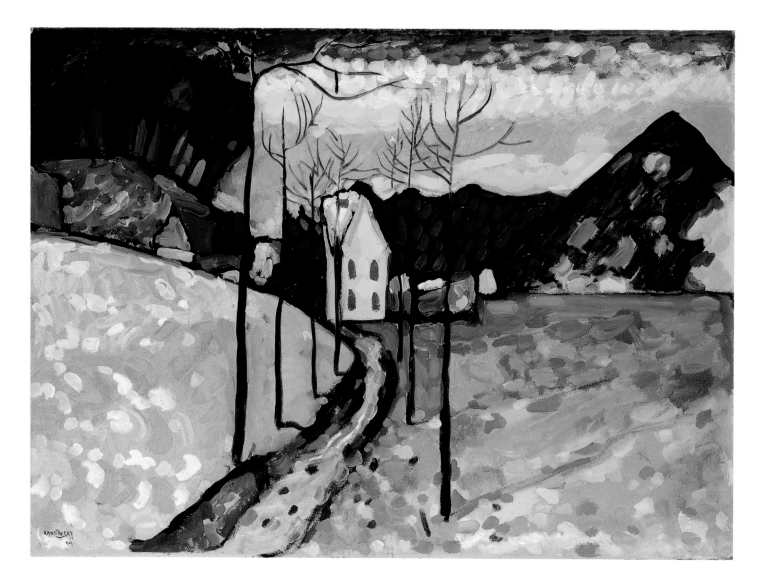

Wassily KANDINSKY
Winter

1909
Oil on pasteboard. 70 x 97
Signed and dated bottom left:
Kandinsky 909

Herm.
Provenance: 1948, GMNZI. Earlier:
1921, left by Kandinsky for safekeeping
at GMNZI before his departure for
Germany; 1929, nationalised after the
artist received German citizenship

Winter, like the majority of Kandinsky's landscapes dating from around 1910, was probably painted at Murnau. The artist was to use the motif of thin black tree trunks repeatedly in his later work. This painting is among those in which the artist's individual qualities are manifested to the fullest degree. The colour scheme, dominated by rose, yellow, blue and black, is built on a direct visual impression —

Kandinsky is striving to convey the effect of snow illuminated by the setting sun, and the depth of the landscape is emphasised compositionally. However, the broad patches of colour and the prominence of the flat, decorative element are evidence of the pioneer of abstract painting's decisive break with representation and the ever-greater role of pure colour in his work. (B. A.)

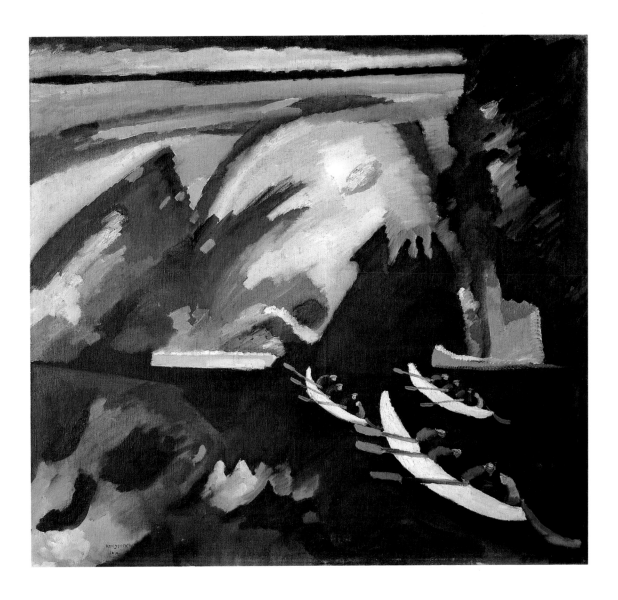

Wassily KANDINSKY

Lake

1910
Oil on canvas. 98 x 103
Signed and dated bottom left:
Kandinsky 1910
Tret. Gal.
Provenance: 1922, Narkompros Chief
Directorate of Research, Museum
and Art Works

Lake belongs to a number of Kandinsky's works which might be called "half-abstract", in which the representative and non-representative (non-objective) principles coexist harmoniously. The viewer sees boats, with their red oars and rowers, and a castle on the shore of the lake. The remainder of the picture, however, can be interpreted in any number of ways. A bright patch of light in the centre charges the whole canvas with energy. Illuminated by this light, the white boats with their oarsmen move diagonally across the surface of a bottomless black lake with no shore — it is impossible to tell where the water ends and where the land or sky begins. The light yellow strip in the picture's centre can be seen by the viewer as he wishes; he might not even associate it with any concrete object. Thus the picture's colour composition acquires a self-sufficient value. (L. B.)

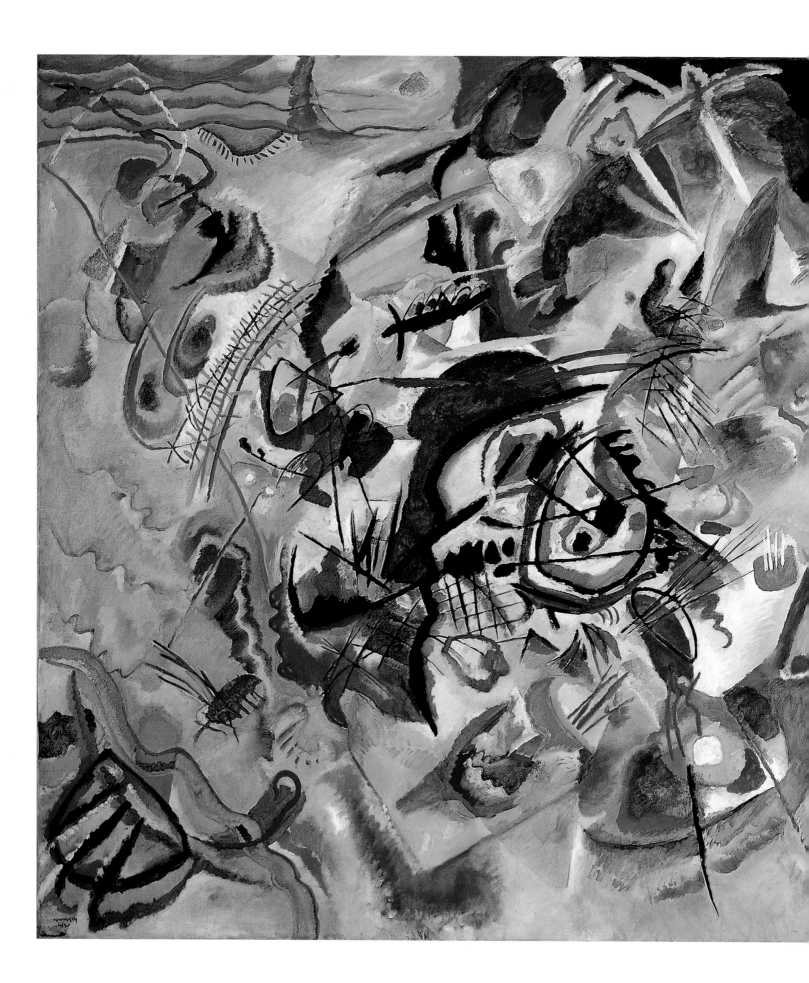

Wassily KANDINSKY
Composition VII

1913
Oil on canvas. 200 x 300
Signed and dated bottom left:
Kandinsky 1913
Tret. Gal.
Provenance: 1929, GMNZI. Earlier:
collection of the artist's family

Composition VII, one of the central works of the 1910s, signals Kandinsky's arrival at creative maturity. For Kandinsky, the word "composition" meant the highest and most complex form which creative activity can produce. "From the very beginning, the word 'composition' sounded to me like a prayer", wrote the artist. In *Composition VII*, the artist neither invents nor constructs forms, but merely directs and corrects what arises in his imagination under the influence of first impressions. There exist more than thirty sketch studies and sketches for *Composition VII*, from pen and ink drawings and watercolours to canvases over a metre in size. These preliminary works show that the artist arrived at his final version methodically, knowing where he wanted to go from the very beginning. The theme of the Last Judgement is considered to have inspired the work; only here it is presented in a completely abstract, nonobjective way. (L. B.)

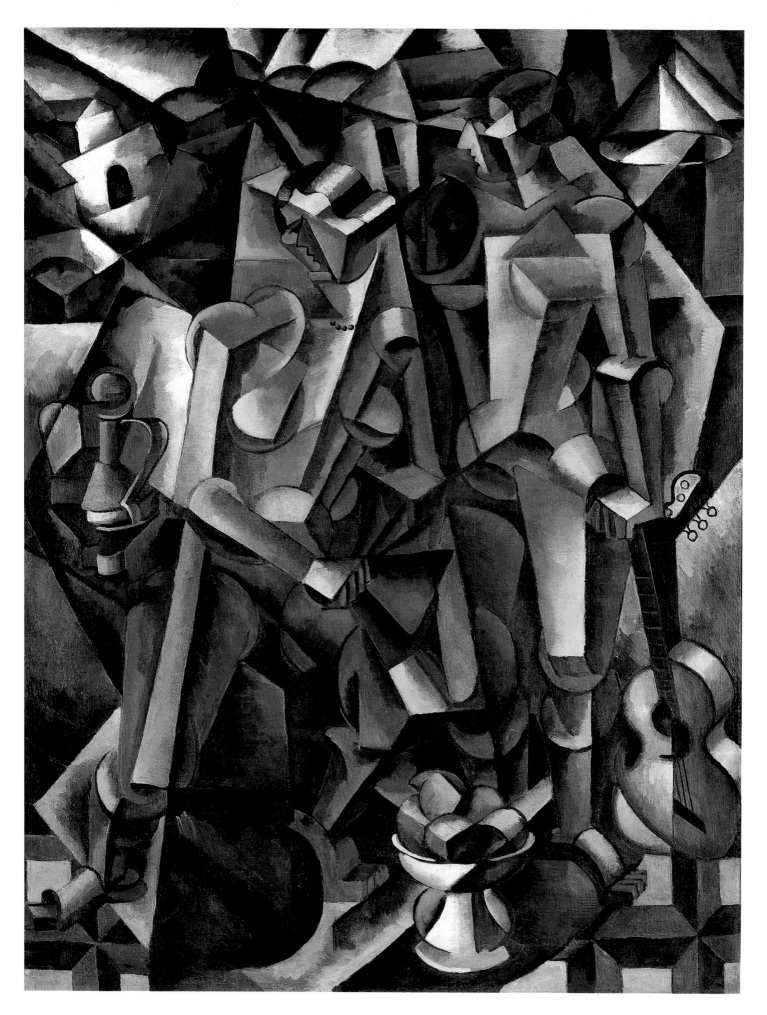

Liubov **POPOVA**
Composition with Figures
(Two Figures)

1913
Oil on canvas. 161 x 124
Tret. Gal.
Provenance: 1977, donated by George
Costakis. Earlier: collection of the artist's
brother, P. S. Popov

Liubov Popova's works from the early 1910s clearly reveal her familiarity with contemporary French art, a familiarity which was commonplace in Moscow thanks to the famous collections of Ivan Morozov and Sergei Shchukin. However, we see the artist searching for her own visual language here, as she did in the "pre-Parisian" studies of nude male and female models (in which the direct influence of Cézanne can be seen) and her Cubist compositions executed while she was studying at "La Palette". The 1913 *Composition with Figures* demonstrates a new quality in Popova's painting, in which Tatlin's Constructivist ideas seem to be superimposed on top of the system of her Parisian teachers. Dominant in the picture is the idea of the organisation and the balance of forms. Objects are included in the composition to signify depth of field: a vase with fruits in the foreground, a blue fan in the female figure's hand, a pitcher, a guitar, and fragments of a landscape in the background. A unique balance is created between the illusion of volume and the flatness of the canvas. (L. B.)

Aristarkh LENTULOV

Moscow

1913
Oil and coloured foil on canvas
179 x 189
Tret. Gal.
Provenance: Purchased in 1979
from M. A. Lentulova, the artist's
daughter

The painting *Moscow* "made a hit", as Lentulov himself put it, during the 1913–1914 Moscow art season. It was the first in his series of well-known mural paintings, which might be called architectural landscapes. The artist himself called this landscape synthetic. The image of the ancient capital is associated by Lentulov with Muscovites' love of bright colours and decorative richness in architecture. The bright motley of the Moscow buildings captured on canvas resembles the splintered, refracted image seen in a kaleidoscope; what is more, the bits of paper and coloured foil added to the surface of the canvas serve to intensify the main colours. The energy with which the artist organises the composition creates a feeling of movement and unending change of perspective. We hear the ringing, humming and crashing noises of a modern city and see a fantastical, gigantic heap of multi-coloured structures from different time periods, with the famed "forty forties" of churches mixing with multi-storeyed apartment houses from the early 20th century. (L. B.)

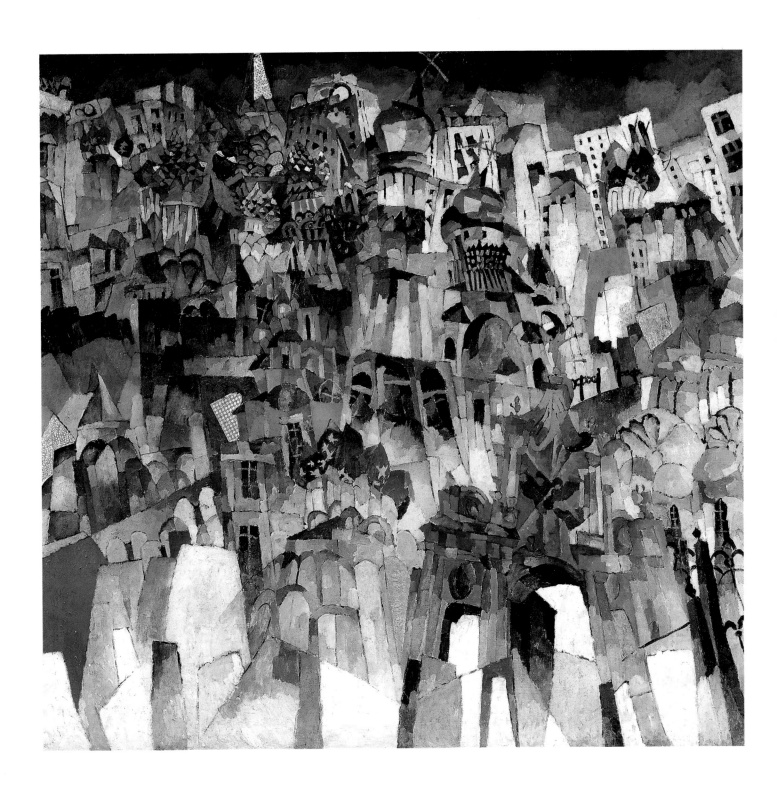

Pavel FILONOV

The German War

1914–1915
Oil on canvas. 171.5 x 156;
175 x 161 (canvas)
Russ. Mus.
Provenance: 1926, Museum of Artistic
Culture, Leningrad

The German War was painted during the war years. Stylistically, it is related to the Cubo-Futurist works of Malevich, Popova and Udaltsova. The picture is painted in a restrained grey-brown colour range. More than any other work of this period, it displays the features that would become typical of Filonov's later work. Thus forms break up into "shards" only to reunite in crystals, which in turn create new formations. (O. M.)

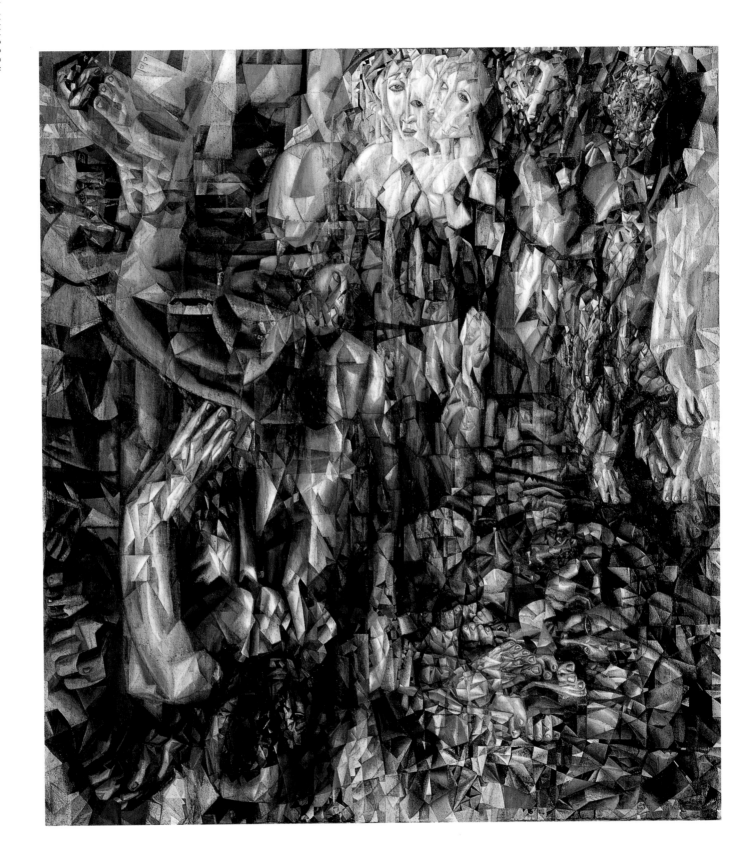

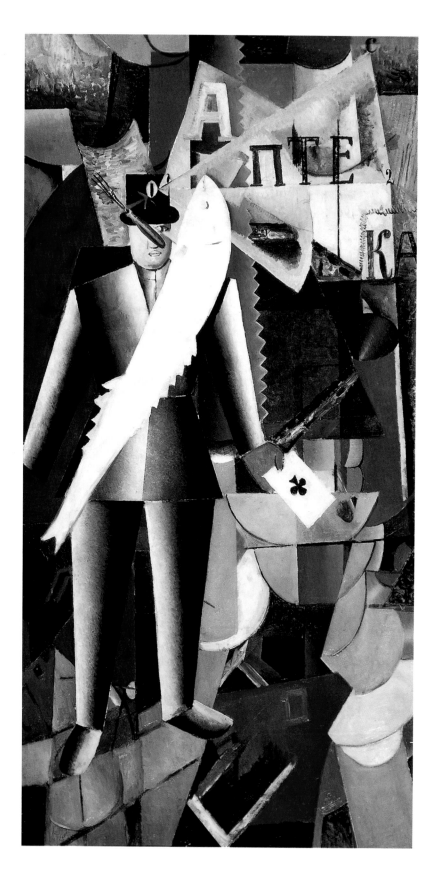

Kazimir MALEVICH
Aviator

1914
Oil on canvas. 125 x 65
Signed, dated and inscribed reverse side:
К. Малевичъ 1914 г awiator; artist's in-
scription smeared with paint (reverse
side): *(не символизмъ) карта рыба
означаютъ только себя* [(not symbolism)
map and fish represent only themselves].
Inscribed on frame: *Авиатор N 82*
Russ. Mus.
Provenance: 1920, IZO Department
of Narkompros

Malevich's Cubo-Futurism, amplified
in his work by elements of illogicality,
allowed him for perhaps the first time
to achieve that special state of do-
minion over form which he would lat-
er characterise as "emancipation of
the artist from an imitative subordina-
tion to objects into direct, unmediated
creativity." In *Aviator*, the artist creates
his own not so much visible as calcu-
lated and invented world, existing ac-
cording to its own laws and unfettered
by Philistine "common sense". In ad-
dition, he eagerly indulges in the use of
what could be described as the "visu-
al pun". Thus, the white silhouette of
the fish intersecting with the figure of
the aviator, who seems to be hovering
in heavy, saturated Cubist space, calls
to mind the word *vozdukhoplavanie* (lit-
erally "swimming in air", the Russian
word for "flight"). (O. M.)

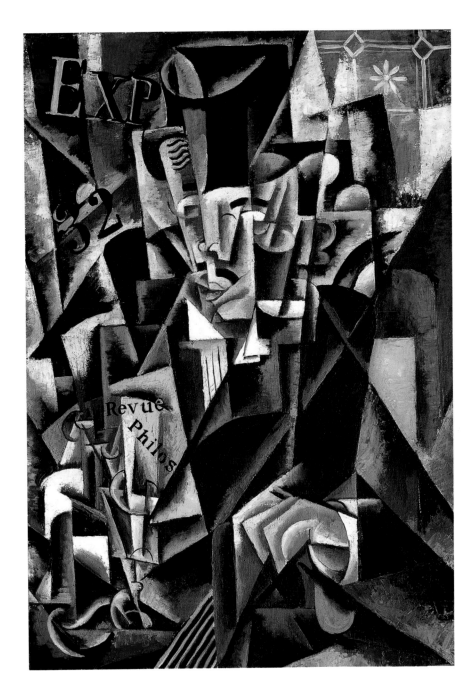

Liubov POPOVA

Portrait of a Philosopher

1915
Oil on canvas. 89 x 63
Inscribed by the artist reverse side:
230 14 x 20; signed on frame: *Попова*
Russ. Mus.
Provenance: 1926, Museum of Artistic
Culture, Leningrad

Popova's Cubo-Futurist period is most expressively embodied in her portraits, and among them the *Portrait of a Philosopher* could be considered the most typical. The spatial disposition of the figure at the table, along with the respectable suit and top hat, lend the image an emphatic significance. However, this "officiousness" is relieved by the picture's expressive execution. The model, the surrounding objects and the background are homogeneous; the artist deprives space of depth and the background stops being a background. The enigmatic unfinished words lead the viewer to seek a key to decode to the picture's visual-expressive meaning. The planes forming the body, head and objects do not differentiate between man, thing and air, which is principally important for Popova, who is beginning her transition into purely abstract, "non-objective" painting. The subject depicted is the artist's brother, Pavel Sergeyevich Popov (1892–1964), a law graduate of Moscow University, who also studied philosophy, psychology and ancient literature. (A. L.)

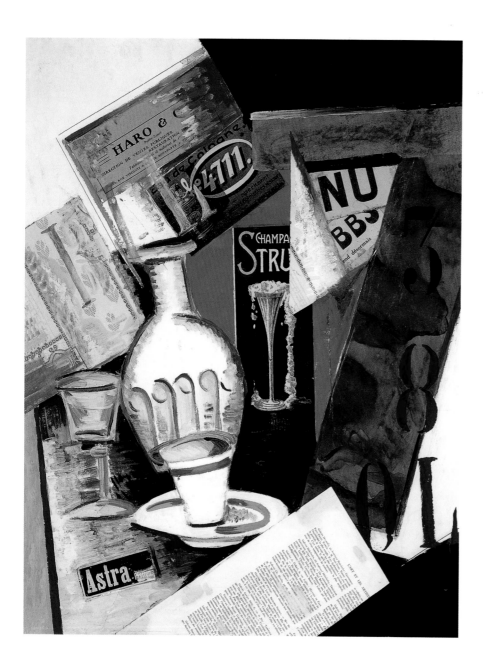

Alexandra EXTER
Still Life

1915
Gouache, tempera, oil and collage
on pasteboard. 68 x 53
Tret. Gal.
Provenance: 1929, Museum of Painting
Culture, Moscow

Alexandra Exter's *Still Life* was first exhibited at the first Futurist "Tramway V" exhibition in Petersburg. By the end of the first decade of the century, Exter was painting in Paris, and she was one of the first Russian female artists to adopt Cubism and Futurism, exhibiting at the Salon des Indépendants and the 1914 Futurist painting and sculpture exhibition in Rome. Elements of collage appear in her still lifes from the 1910s. However, the stickers and labels do not dominate the surface of the painting; instead, they serve as pictorial accents to underline the work's painterly texture and as reference points for its colour scheme. (L. B.)

Alexandra EXTER
The City at Night

1913
Oil on canvas. 88 x 71
Signed in pencil reverse side: *Exter*
Russ. Mus.
Provenance: 1929, Tretyakov Gallery

City at Night is among the early works by Alexandra Exter. Turning to a favourite Futurist motif, the artist does more than merely build on the dynamism of form and lighting effects characteristic of Futurism; she strives to bring out the composition's inner structure, its tension and precisely rendered rhythm. (A. L.)

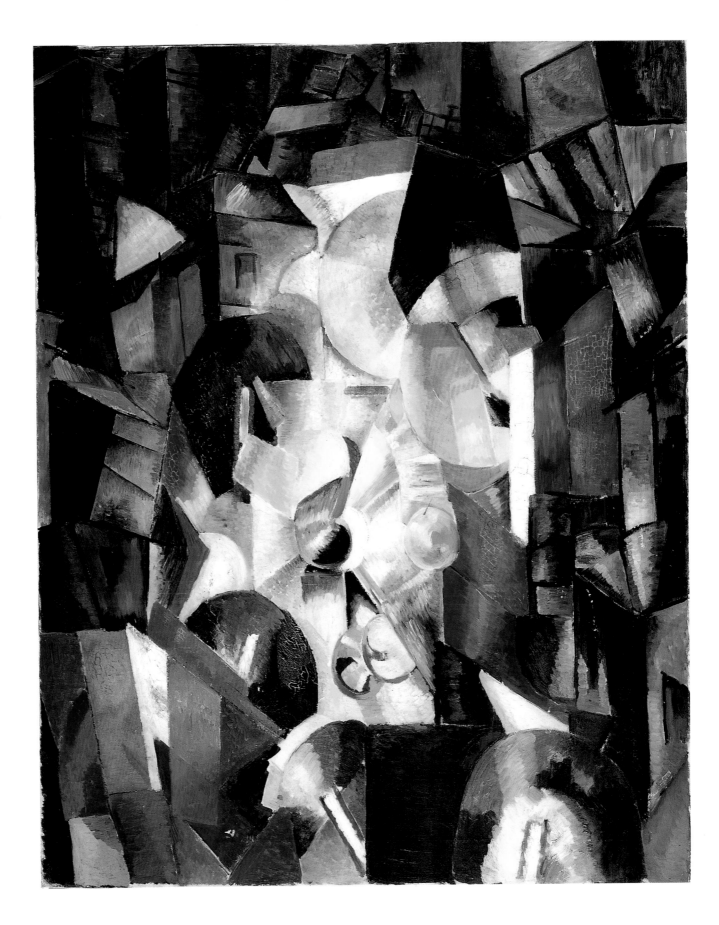

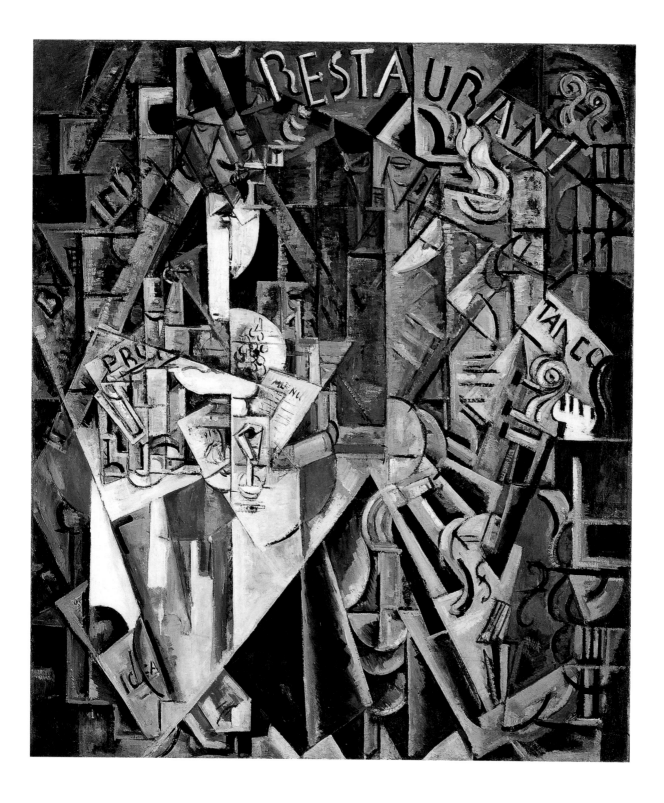

Nadezhda UDALTSOVA

Restaurant

1915
Oil on canvas. 134 x 116
Russ. Mus.
Provenance: 1926, Museum of Artistic
Culture, Leningrad

Among painters of the new genera-tion, Nadezhda Udaltsova was the most open to the influence of French Cubism. Some works from that period, like *Restaurant*, havever, are more of-ten considered typical examples of Russian Cubo-Futurism, with their marked fan-like composition gravitat-ing towards three-dimensional Cubism and the introduction of text fragments intended to arouse in the viewer as-sociations of the big city, with its noise, accelerated rhythms and quickly-changing impressions, for which they are unquestionably indebted to Italian Futurism. (A. L.)

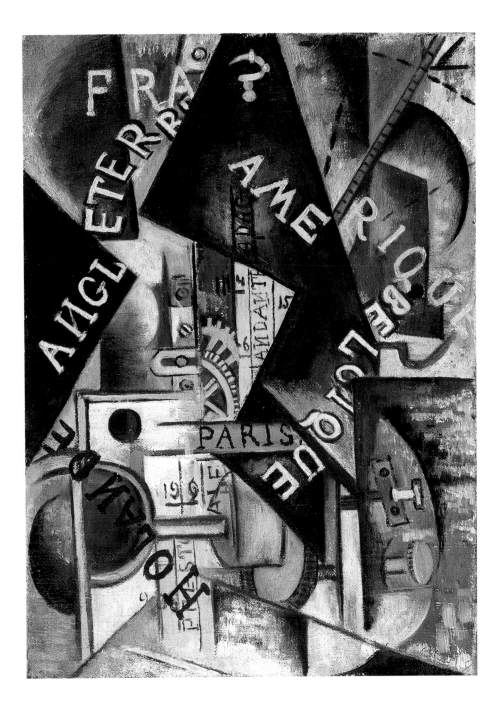

Olga ROZANOVA

The Metronome

1915
Oil on canvas. 46 x 33
On the reverse side, paper label with
a penned inscription: *№ 8 Розанова*
Tret. Gal.
Provenance: 1929, Museum
of Painting Culture

The art of the Futurists subverted un-
dermined 19th-century notions of
space and time. For Russian artists,
Futurism became a school of knowl-
edge of the world and a system for the
transcending of "linear" time. "The Fu-
turist movement can only be regarded
as a movement beyond time", af-
firmed the "Budetlyane" (a Russian
neologism meaning "people of the fu-
ture"). The clockwork in Rozanova's
The Metronome is a sort of archetype
for both the eternal and the momen-
tary, a "perpetual motion machine" of
historical time, a symbol of its infini-
tude. *The Metronome* belongs to the
same group of Cubo-Futurist works as
Popova's *Clock* and Goncharova's *Dy-
namo Machine*. In these pictures we
see an undeniable interest in and a
curiosity about various mechanisms,
springs and pendulums. (L. B.)

Ivan PUNI

Violin

1919
Oil on canvas. 115 x 145
Russ. Mus.
Provenance: 1926, Museum of Artistic
Culture, Leningrad

Violin reveals the influence of Suprematism on Puni. His variant turned out to be something of a compromise. In his works, the principles of the movement are combined with reality, whose existence is confirmed by various objects and details of everyday life. Though marked by Puni's characteristic aestheticism, *Violin* nonetheless demonstrates more than any other work the artist's adherence to the Suprematism of Malevich. (A. N.)

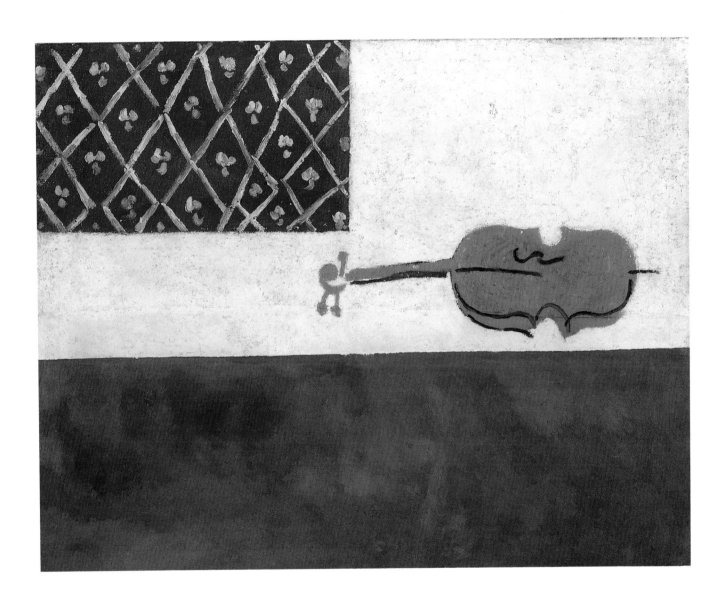

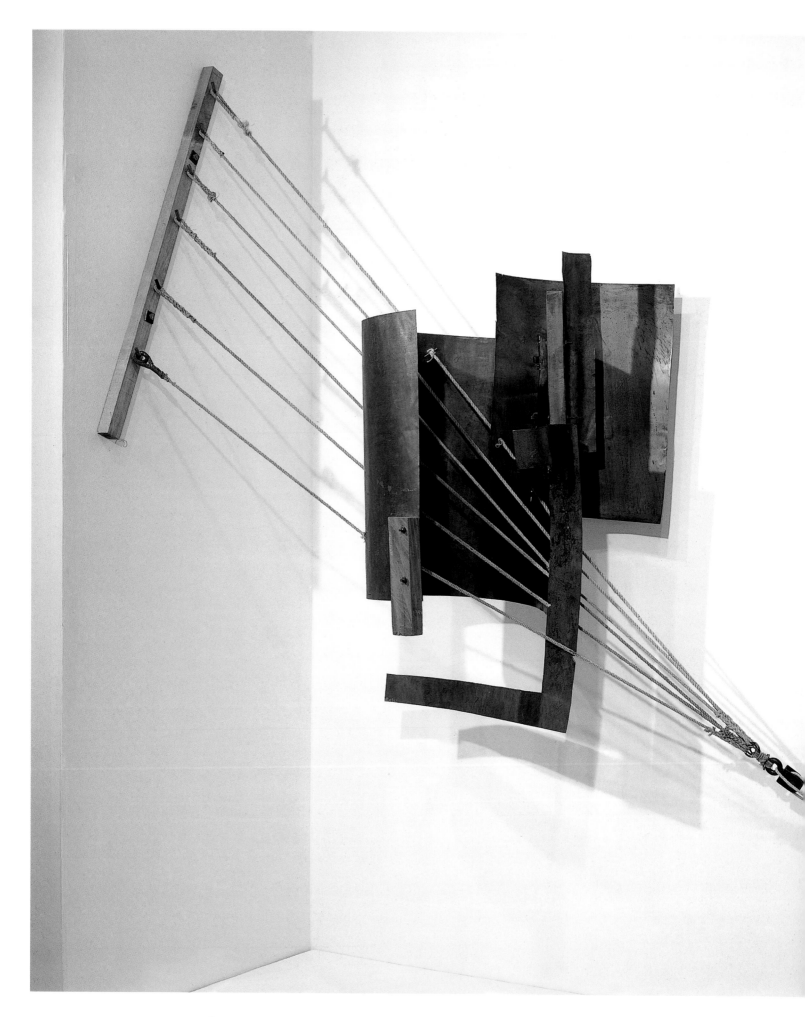

Vladimir TATLIN

Corner Counter-Relief

1914
Iron, copper, wood, cables
71 x 118
Russ. Mus.
Provenance: 1926, the artist

Corner Counter-Relief (with cables) was first shown in 1915 at the "Last Futurist Exhibition '0.10'" in Petrograd. This three-dimensional abstract composition was intended to be viewed as a logical continuation in the development of "objectless", or "non-objective" art, which Tatlin had earlier embodied in his "painterly reliefs", constructed from a combination of materials with contrasting textures (paper, glass, plaster, wood and tin). The novelty of *Corner Relief* was in the artist's desire to abandon traditional "picture-like" flatness and take non-objective constructions into the space formed by two intersecting planes. The latter were necessary not only for "hanging" the composition; they created the necessary abstract background for it, underscoring its three-dimensionality. Another, equally significant element was the desire to highlight the qualities of the materials used, which seem to symbolise opposing but mutually connected ideas: flexibility and stiffness, freedom and tension, motion and rest. (E. K.)

Kazimir MALEVICH

Suprematism

1915
Oil on canvas. 87.5 x 72
Inscribed by the artist on the frame:
H Новгород; and label from the jubilee
1932 exhibition. Reverse side:
464 M.X.K.; and label: *M.X.K. 464*
Russ. Mus.
Provenance: 1926, Museum of Artistic
Culture, Leningrad

As an artistic movement, Malevich's Suprematism strove to attain the "higher" (supremus) supra-personal essence of art. The constructions making up the picture's composition are depicted floating on a white background, which the artist intended to represent the endlessness of the cosmos. In this picture, which has no top or bottom, Malevich is creating a new, different reality, a certain "Ding an sich", whose existence is limited by the boundaries of the canvas. (O. M.)

292

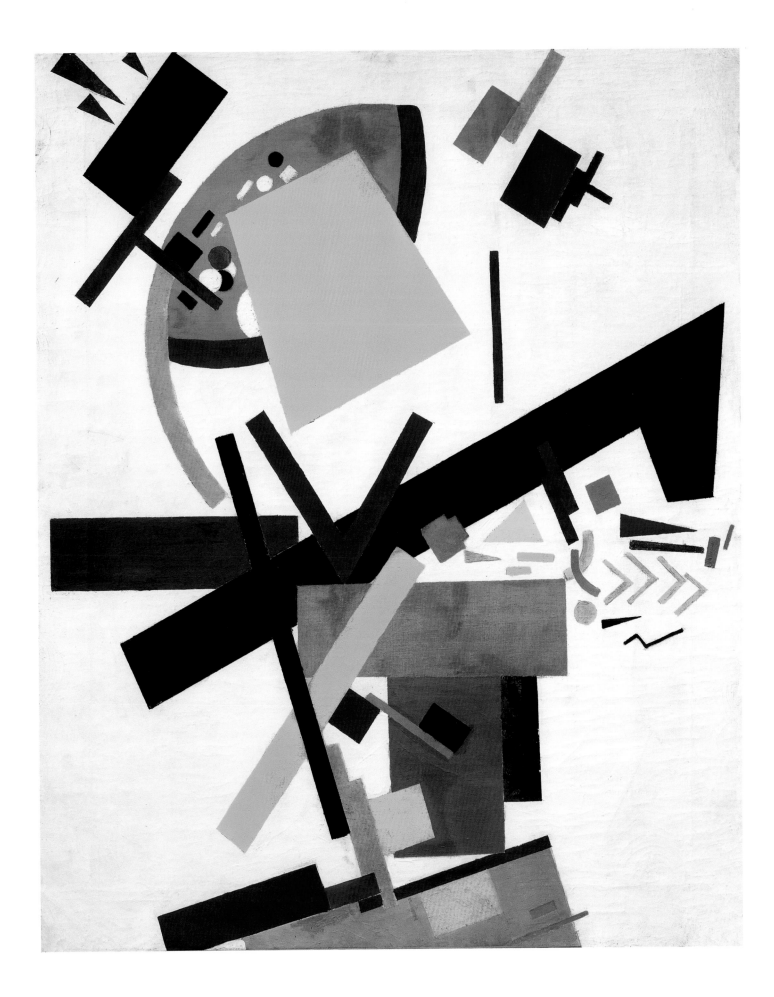

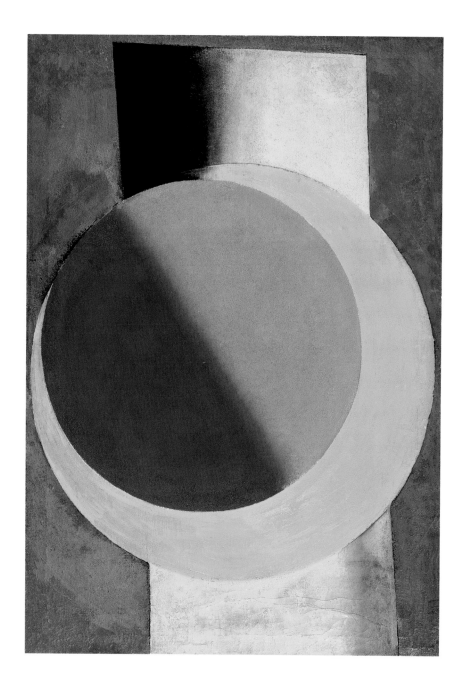

Alexander RODCHENKO
Red and Yellow

1918 (?)
Oil on canvas. 90 x 62
Russ. Mus.
Provenance: 1926, Museum of Artistic
Culture, Leningrad

Red and Yellow is an abstract compo-
sition in which the artist arranges a
new pictorial space, whose optical ef-
fect is amplified by the textural treat-
ment of the surface of the canvas and
heightened by the logic of its colour
combinations. Line, colour and space
are the main components of Alexan-
der Rodchenko's painting style. In
1918, the artist stated in the news-
paper *Anarkhiya* that he was "making
a serious study of projection into
depth, height and width, and opening
infinite possibilities of construction be-
yond the boundaries of time...", calling
his works "compositions of coloured
and designed parts". (O. M.)

Vladimir LEBEDEV
Selection of Materials

1921
Oil, metal, wood (collage). 84.7 x 53.5
Russ. Mus.
Provenance: 1988, A. S. Lazo-Garbenko,
the artist's widow, Leningrad

In *Selection of Materials*, the artist is
interested not only in the relationships
between the textures of iron and var-
ious wood pieces; he also investigates
the colour relations of materials. Each
plane, painted in a certain colour and
interacting with the surrounding
space, intensifies the colour satura-
tion of the collage's other compo-
nents. (A. L.)

294

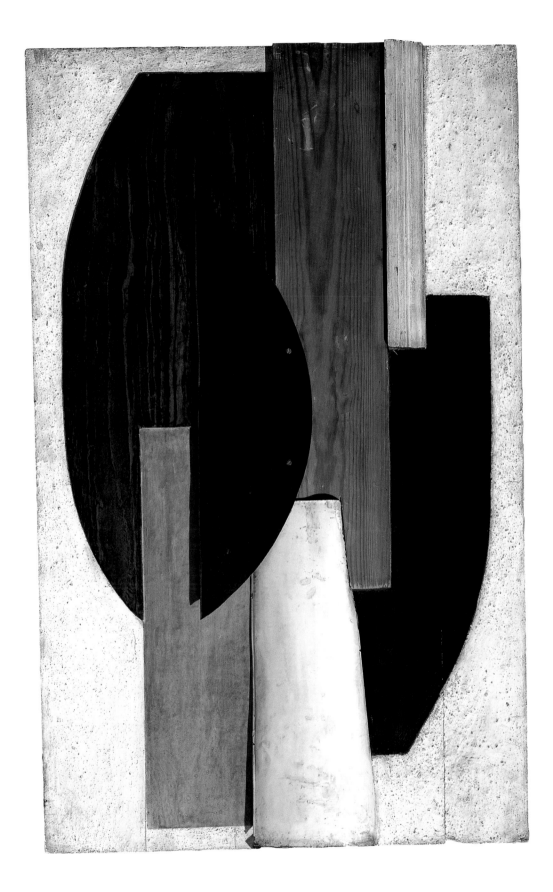

Kazimir MALEVICH

Red Square. Painterly
Realism of a Peasant Woman
in Two Dimensions

1915
Oil on canvas. 53 x 53
Russ. Mus.
Provenance: 1926, GlnKhuK,
Leningrad

Red Square dates from the middle of the 1910s, a period when Malevich was referring to his art as "the last chapter in the development of easel painting". Like *Black Square*, *Red Square* is a kind of summation of the œuvre of the artist, whose main merit is considered to be the creation of a universal artistic system. "Paint a red square in your studios as a sign of the world revolution in art", he wrote in 1920 ("Pamphlet of the Vitebsk Creative Committee — 1"). *Red Square's* subtitle, "Painterly Realism of a Peasant Woman in Two Dimensions", helps us to understand Malevich's conception. The artist's imagination endows "Painterly Realism of a Peasant Woman" with a certain semantics, partly decipherable and partly "cited" from Malevich's theoretical pronouncements, which reveal an acquaintance with the current philosophical views of his age, including P. D. Ouspensky's then-popular work *Tertium Organum. A Key to the Enigmas of the World* (1911). The reality around us, which we perceive as three-dimensional, is transformed on Malevich's canvas into a sign-image interpreted in two dimensions, and by virtue of this fact remote from concrete associations. According to the basics of Malevich's Suprematist theory, red (and black) are interpreted as "the height of pure tension of colour and form", and white as "the height of colour tension, period" (or colourless light, in the artist's words). The saturated red square, thanks to its barely noticeable asymmetry joining dynamically with the white fields of the background, expresses with maximum force the supra-personal essence of art, formulated in Malevich's Suprematism thanks to his serious study of icon painting and its special symbolism, attainable only by the initiated. (O. M.)

Kazimir MALEVICH

Black Cross

Circa 1923
Oil on canvas. 106 x 106
Russ. Mus.
Provenance: 1936, the artist's heirs.
Given by the USSR Ministry of Culture
to the Russian Museum in 1977

Kazimir MALEVICH

Black Square

Circa 1923
Oil on canvas. 106 x 106
Russ. Mus.
Provenance: 1936, the artist's heirs.
Given by the USSR Ministry of Culture
to the Russian Museum in 1977

Kazimir MALEVICH

Black Circle

Circa 1923
Oil on canvas. 105 x 105
Russ. Mus.
Provenance: 1936, the artist's heirs.
Given by the USSR Ministry of Culture
to the Russian Museum in 1977

Black Square, *Black Circle* and *Black Cross* form a sort of triptych of Malevich's most legendary compositions. The artist uses the simplest possible geometrical figures isolated in their "purest" form; like primordial building blocks of some language, they are equivalent to painterly formulae like those of a medieval alchemist, containing sacral meaning in the artist's consciousness. It is no accident that the first version of *Black Square* was shown by Malevich at the "0.10" Exhibition like an icon, hung in the Russian manner in the right, "holy" corner of the exhibition room. Contemporaries also viewed the *Black Square* as an icon and sign of the new times, possibly prompted by Malevich's own declaration: "It is a bare icon without a frame (like a pocket), an icon of my times…" (O. M.)

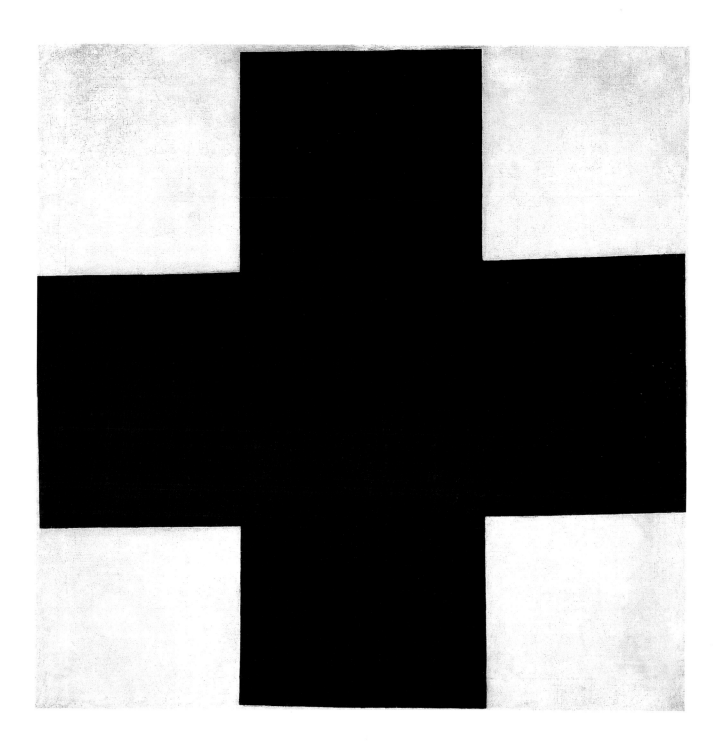

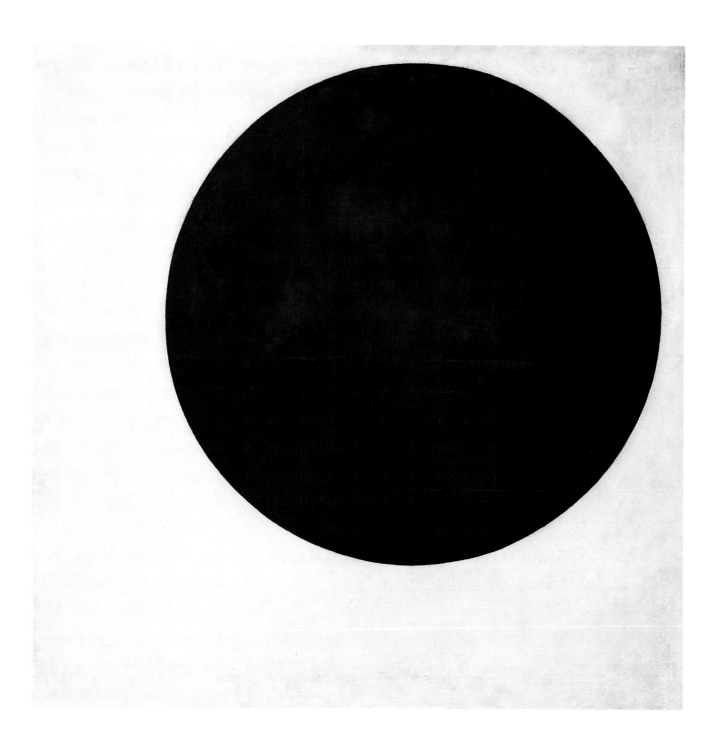

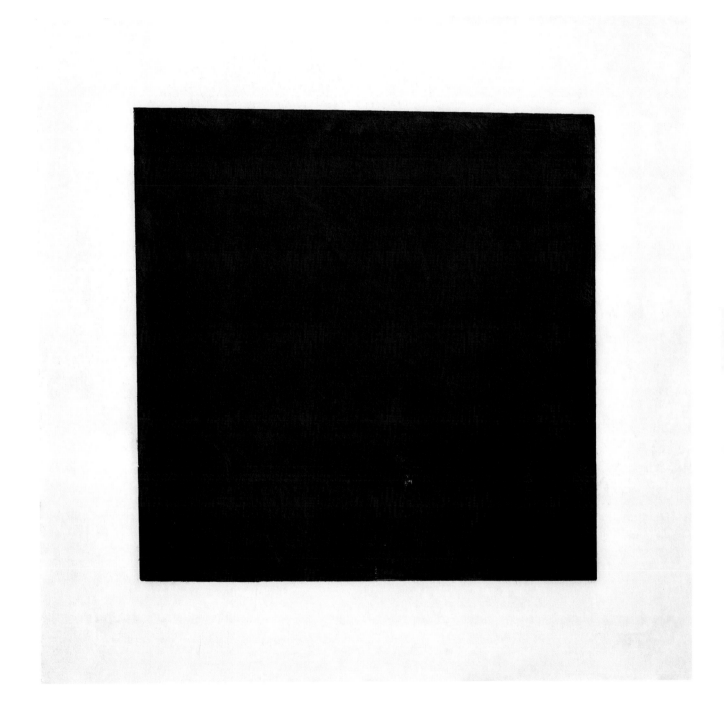

Mikhail MATYUSHIN
Movement in Space

Before 1922
Oil on canvas. 124 x 168
Initialised bottom right: *M. M.*
Russ. Mus.
Provenance: 1926, Museum of Artistic
Culture, Leningrad

Movement in Space is perhaps Matyushin's most important work, an original summation of his entire œuvre. In the painting, the artist explores the interaction of colour and environment using eight colours: red, orange, yellow, yellow-green, light blue, blue and violet. Relying on the fundamental axioms of his theory, the "law of additional colours", Matyushin divides colour into main, active colours and environment-dependent middle colours. He theorised that colour can either be active or dependent: on neighbouring colours, the degree of illumination and the scale of colour fields. The artist's research formed the basis for his *Colour Reference* (1932). (O. M.)

BRIEF BIOGRAPHIES
OF RUSSIAN ARTISTS

Altman, Nathan Isayevich
1889, Vinnitsa — 1970, Leningrad
Painter, graphic artist, sculptor, theatrical artist, illustrator. Studied at the Odessa Art Academy (1901–1907) with K. K. Kostandi and G. A. Ladyzhensky and at the Free Russian Academy of Maria Vasilieva in Paris (1910–1912). Began exhibiting in 1910. Belonged to the following art alliances: "L'Araignée" (Paris, 1925), "Young Europe" (Paris, 1932) and the "Association of Revolutionary Artists" (Paris, 1934–1935). Taught at VKhUTEMAS in Petrograd (1918–1920). Worked in the IZO Department of Narkompros (1918–1921). Awarded title of Honoured Artist of the RSFSR (1968). Beginning in 1913, collaborated with publishers Academia and Gallimard (Paris), Detgiz and Goslitizdat (USSR), and others. Was a prolific children's book illustrator from 1930 to 1940.

Bakst, Léon (Lev Samoilovich Rosenberg)
1866, Grodno — 1924, Paris
Painter, decorator, theatrical artist. Studied at the Imperial Academy of Fine Arts (1883–1887) and in Paris at the studios of Jean-Léon Gérôme, the Académie Julian and with Albert Edelfelt (1893-1896). Taught at the Art School of E. N. Zvantseva (1906-1909) in Petersburg. Member of the following alliances: the Society of Russian Watercolourists (1891–1897), "World of Art" (1899–1903, 1906, 1913 — founding member), and SRKh (1903–1910). A life member of the Paris Autumn Salon (from 1906). Academician (from 1914). Participant in many exhibitions of theatrical and decorative art and one-man exhibitions. Decorated productions of the Mariinsky and Alexandrinsky Theatres in Petersburg, the Opéra de Paris and theatres in London and New York. One of the leading decorators for Sergei Diaghilev (from 1909) and the ballet troupes of Anna Pavlova and Ida Rubinstein. Lived in Paris from 1909 onwards.

Burliuk, David Davidovich
1882, Semirotovshchina Hamlet, Kharkov Guberniya —
1967, New York
Painter, graphic artist, illustrator; poet, author of manifestos and critical articles. Studied at the Kazan (1898–1899) and Odessa (1899–1900, 1910–1911) Art Academies, the Royal Academy of Fine Arts in Munich (1902–1903) under Wilhelm Dietz, and MUZhVZ (1910–1914, expelled). Began exhibiting in 1906. Organised the "Zveno" exhibition in Kiev in 1908. Helped organise the first "Jack of Diamonds" exhibition in 1910. Member of the following alliances: the SRKh (1906–1907), TYuRKh, "Youth Union" (1910–1912), "Blue Horseman" (1912, Munich) and "Jack of Diamonds" (1912–1916). Lived in the Urals (1917–1919), in Japan (1920–1922) and in the US (from 1922 onwards).

Chagall, Marc Zakharovich (Movsha Khatskelevich)
1887, Vitebsk — 1985, Saint-Paul de Vence, France
Painter, graphic artist, theatrical artist, monumental artist; author of philosophical symbolic/metaphorical pictures, portraits and landscapes. Studied under Yehuda Pen (1906) in Vitebsk; at the Drawing School of OPKh (1907–1908), the drawing courses of S. M. Seidenberg (1908) and the Art School of E. N. Zvantseva (1909–1910); under Léon Bakst and Mstislav Dobuzhinsky in Petersburg; and at the Académie de la Grande Chaumière (1910) in Paris. Lived in the "Beehive" on Montparnasse; entered the "Paris School" circle of artists.

Participated in the Salon des Indépendants (1912–1914), Autumn Salon (from 1912), "World of Art" (1912, 1922), "Donkey's Tail" (1912), "Mishen'" (1913), "The Year 1915" and "Jack of Diamonds" (1916, 1917) exhibitions; the International Exhibitions in Berlin (1913) and Amsterdam (1914); the Exhibition of Russian Art in Berlin (1922); and others. From 1918 to 1919, was plenipotentiary for artistic matters in Vitebsk, where he founded a museum and the Free Painting Studios, where he taught. From 1919 to 1920, worked in theatres in Moscow. Lived in Paris from 1923.

Exter, Alexandra Alexandrovna
1882, Bielostok — 1949, Fontenay-aux-Roses, France
Painter, graphic artist, theatrical artist. Graduated from the Kiev Art Academy (1906); studied in the studio of Carlo Delvall at the Académie de la Grande Chaumière in Paris (1908). Participated in the "Zveno" (Kiev, 1908), "Venok-Stefanos" (1909), "Jack of Diamonds" (1910–1916), "Youth Union" (1910, 1913–1914), "First Futurist Picture 'Tramway V'" (1915), "Magazin" (1916) and "5 x 5 = 25" (1921) exhibitions; the International Decorative Arts Exhibition in Paris (1925); and others. Taught at her own studio in Kiev (1918–1920) and VKhUTEMAS in Moscow (1921–1922). Joined the Constructivists in the 1920s. Worked on productions at the Moscow Art Theatre and the Chamber Theatre; designed books, clothing, and patterns for fabrics; worked in the cinema. Lived and worked in Paris from 1924, teaching at Ferdinand Legére's Academy of Contemporary Art and in her own studio.

Falk, Robert Rafailovich
1886, Moscow — 1958, Moscow
Painter, graphic artist, theatrical artist. Studied in Moscow, at the Art School of Konstantin Yuon and Ivan Dudin, the School of Drawing and Painting of Ilya Mashkov (1903–1904), and MUZhVZ (1905–1910) with Valentin Serov and Konstantin Korovin. One of the founders of the "Jack of Diamonds" group. Member of and exhibited with the "Jack of Diamonds" (1910–1927), "World of Art" (1911–1917, 1921–1922), "Moscow Painters" (1925), AKhRR (1925–1928), and OMKh (1925–1928) alliances. Lived and worked in Paris (1928–1937) and then in Moscow.

Filonov, Pavel Nikolayevich
1882/1883, Moscow — 1941, Leningrad
Painter, graphic artist; author of abstract (analytical) and representational compositions, portraits, landscapes and still lifes. Studied at the Painting and Decorating Studios and the Drawing School of OPKh (1893–1901) in Petersburg, L. E. Dmitriev-Kavkazsky's School of Painting and Drawing (1903–1908), and the Higher Art School of the Imperial Academy of Fine Arts (1908–1910, auditor) with Hugo Zaleman, Vasily Savinsky, P. I. Tvorozhnikov, Grigory Myasoyedov and Jan Tsionglinsky. Began exhibiting in 1910. Founding member of the "Youth Union" (from 1910). Organised the "Completed Pictures" painters' studio in 1914. Worked in the general ideology department at MKhK (1923). Helped draft the charter of GInKhuK. Member of the "Community of Artists" (1921–1922) and an organiser of the "Masters of Analytical Art" group (1925–1941). Made trips to Palestine (via Constantinople, 1907), France and Italy (1911–1912), the Volga River and the Caucasus (1905).

Golovin, Alexander Yakovlevich
1863, Moscow — 1930, Detskoye Selo, Leningrad Oblast
Painter, graphic artist, theatrical artist. Studied at MUZhVZ (1881–1889) under Illarion Pryanishnikov and Vasily Polenov, and the Colarossi (1889) and Vitti (1897) Academies in Paris. Academician of Painting (from 1912). Member of the "World of Art" group. Participated in the "Wanderers", MTKh, "World of Art", SRKh and NOKh exhibitions; the World's Fairs in Paris and Brussels; and the International Exhibitions in Venice and Rome. Decorator at the Imperial Theatres (1899–1917). Created decorations and costumes for numerous productions on fairy-tale themes: P. I. Tchaikovsky's *Swan Lake* (1902, Chinese Theatre at Tsarskoye Selo), the ballet *Magic Mirror* by A. N. Koreshchenko (1903, Mariinsky Theatre), Mikhail Glinka's opera *Ruslan and Lyudmila* (1904, Mariinsky Theatre), Wagner's Music Drama *Das Rheingold* (1905, Mariinsky Theatre), Nikolai Rimsky-Korsakov's opera *The Tale of Tsar Saltan* (1907, produced in 1915, Mariinsky Theatre) and others. Participated in the decorations and costumes for Sergei Diaghilev's *Firebird* ballet in Paris, together with Léon Bakst. People's Artist of Russia (1928).

Goncharova, Natalia Sergeyevna
1881, Village of Nagayevo, Tula Guberniya — 1962, Paris
Painter, graphic artist, theatrical artist. Studied at MUZhVZ (1901–1909) under Pavel Trubetskoi, independently attending Konstantin Korovin's studio. Began exhibiting in 1904. Participated in the MTKh (1906, 1907), Leonardo da Vinci Society (1906), Autumn Salon (1907), "Stefanos" (1906–1908), "Zveno" (1908), "Golden Fleece" Salons (1909, 1909/1910), "Salon of V. A. Izdebsky" (1909–1911), "Youth Union" (1910–1912), "Jack of Diamonds" (1910), "Moscow Salon" (1911), "World of Art" (1911–1913, 1915), Sturm Gallery (Berlin, 1912), Second Post-Impressionist (London, 1912), "Donkey's Tail" (1912), "Blue Horseman" (1912, 1914), "Mishen'" (1913), First German Autumn Salon (Berlin, 1913), "No. 4. Futurists, Rayonists, Primitive" (1914) and "The Year 1915" exhibitions; the Exhibitions of Russian Art in Paris (1906, 1921) and Berlin (1906); and the International Exhibition in Venice (1920). From 1912 to 1914, illustrated books for the Futurists. Began working for Diaghilev in 1915. Lived in Switzerland and Italy beginning in 1915 and in France from 1919 onwards.

Grabar, Igor Emmanuilovich
1871, Budapest — 1960, Moscow
Painter, art historian and critic, museum worker. Graduated from the law and history/philology departments of Petersburg University. (1889–1896). Studied at the Higher Art School of the Imperial Academy of Fine Arts (1894–1896) under Ilya Repin, and the Aschbe School in Munich (1896–1898). Academician of Art (1913). Member of the "World of Art" group (1901, 1910) and SRKh (1903); life member of the Paris Autumn Salon (1906). Began exhibiting in 1898. Exhibited at the "World of Art" (1902–1906, 1912–1922), SRKh (1903–1909), "Salon of S. K. Makovsky" (1909), and "Moscow Painters" (1925) exhibitions; the International Exhibitions at Düsseldorf (1904), Venice, (1907, 1924), Rome (1911) and Malmö (1914); the Exhibitions of Russian Art in Paris (1906) and Berlin (1906, 1922); and others. Taught in the joint Aschbe-Grabar School (1898–1901) in Munich. Trustee (1913–1918) and later director (1918–1925) of the Tretyakov Gallery; director of the State Central Art Restoration Studios (1918–1930).

Grigoriev, Boris Dmitrievich

1886, Moscow — 1939, Cagnes-sur-Mer, France
Painter, draughtsman. Studied at the Stroganov College (STsKhPU) under D. A. Shcherbinovksy (1903–1907) and the Academy of Fine Arts in Petersburg under A. A. Kiselyov and N. N. Dubovskoi (1907– 1912). Participated in the "Impressionists" (1909), "Society of the Independents" (1912–1913) and "World of Art" (1913, 1915–1918, member from 1918) exhibitions. Lived in Petersburg, then, beginning in 1919, in Finland, Germany and France.

Kandinsky, Wassily Vasilievich

1866, Moscow — 1944, Neuilly-sur-Seine, near Paris
Painter, graphic artist, pedagogue. Graduated from Moscow University in 1893. Studied at the Aschbe School (1896–1898) and the Royal Academy of Fine Arts in Munich (1900–1901) under Franz von Stuck. Began exhibiting in 1898; participated in the TYuRKh (1898–1910), MTKh (1900–1901), "Phalanx" (Munich, 1901–1904), Berlin Secession (1902–1908), NOKh (1904–1906), Autumn Salon (Paris, 1904–1910), Salon des Indépendants (Paris, 1907–1912), New Art Society (Munich, 1909–1910), "Salon of V. A. Izdebsky" (1909–1911), "Jack of Diamonds" (1910, 1912) and "Blue Horseman" exhibitions; the International Exhibitions in Amsterdam (1913), New York (1913) and Malmö (1914); and others. Organised several art societies in Munich, as well as MZhK (1919) and InKhuK (1920) in Moscow. Member of the collegium of the IZO Department of Narkompros (1918–1919) and InKhuK (1920–1921); director of MZhK (1919–1921), vice president of the Russian Academy of Art Sciences (1921) and professor at SKhUM–VKhUTEMAS (1919–1921) in Moscow. Lived permanently in Germany and France from 1921 onwards. Taught at Bauhaus (1922–1933) in Weimar, Dessau and Berlin.

Konchalovsky, Pyotr Petrovich

1876, Slavyansk, Kharkov Guberniya — 1956, Moscow
Painter, graphic artist, theatrical artist; painted portraits, landscapes and genre compositions. Studied at the Drawing School of M. D. Rayevskaya-Ivanova (1880s) in Kharkov; at the evening courses of STsKhPU (1889–1896) in Moscow; at the Académie Julian in Paris under Jean-Paul Laurens and Jean-Joseph Benjamin-Constant (1896–1898); and at the Higher Art School of the Imperial Academy of Fine Arts (1898–1905) with Vasily Savinsky, P. I. Tvorozhnikov, Hugo Zaleman and P. O. Kovalevsky. Began exhibiting in 1903. Participated in the MTKh (1903, 1905, 1911), Autumn Salon (Paris, 1908), Salon des Indépendants (Paris, 1908), "Golden Fleece" Salons (1909–1910), "Jack of Diamonds" (1910–1914), "World of Art" (1911–1922), "Being" (1926–1927) and AKhRR exhibitions. Taught at GSKhM–VKhUTEMAS–VKhUTEIN (1918–1926). Honoured Artist of the RSFSR (1928), People's Artist of the RSFSR (1946), active member of the USSR Academy of Fine Arts (1947). Awarded the Stalin Prize (1943) for his longstanding achievements in the realm of the visual arts.

Korovin, Konstantin Alexeyevich

1861, Moscow — 1939, Paris
Painter, theatrical artist; landscape painter, portraitist; painted genre pictures and still lifes. Specialist in decorative and applied arts, author of a number of architectural projects. Studied at MUZhVZ (1875–1889) under Vasily Perov, Alexei Savrasov and Vasily Polenov, and the Imperial Academy of Fine Arts (1882). Academician of Painting (from

1905). Taught at MUZhVZ (1901–1918) and GSKhM (1918–1919). Member of the Abramtsevo Circle (from 1885), "World of Art" (from 1899) and SRKh (from 1903). Participated in the "Wanderers" (1889, 1891, 1893–1899), MTKh (1894, 1895, 1897–1902, 1907), Russian and Finnish Artists (1898), "World of Art" (1899–1903, 1906, 1921, 1922), "Contemporary Art" (1903), SRKh (1903–1923) and II, IV and V State (1918–1919) exhibitions; the 1900 World's Fair in Paris (Gold Medal); the International Exhibitions in Munich (1898), Vienna (1902), Venice (1907) and Rome (1922); and the Exhibitions of Russian Art in Paris (1906, 1921), Berlin (1906, 1922) and New York (1924). Worked in theatres in Moscow and Petersburg from 1885 onwards.

Kuprin, Alexander Vasilievich

1880, Borisoglebsk, Tambov Guberniya — 1960, Moscow
Painter, graphic artist, monumental artist; author of landscapes and still lifes. Studied at the Voronezh School of Painting and Drawing (1896); in Petersburg, at L. E. Dmitriev-Kavkazsky's School of Painting and Drawing (1902–1904); and in Moscow, at the Art School of Konstantin Yuon and Ivan Dudin (1905–1906) and MUZhVZ (1906–1910) under Konstantin Korovin, Nikolai Kasatkin, Leonid Pasternak and Abram Arkhipov. Began exhibiting in 1908. Was a member of and exhibited with the MTKh (1908), "Golden Fleece" Salon (1909–1910), "Youth Union" (1911), "Jack of Diamonds" (1910–1916, founding member), "World of Art" (1917, 1921), "Moscow Painters" (1925), "Being" (1926, 1927) and OMKh (1928, 1929). Professor (1924). Associate member of the USSR Academy of Fine Arts from 1954. Honoured Artist of the RSFSR.

Kustodiev, Boris Mikhailovich

1878, Astrakhan — 1927, Leningrad
Painter, graphic artist; portraitist, author of scenes from the life of the Russian provinces. Studied at the Higher Art School of the Imperial Academy of Fine Arts (1896–1903) under Ilya Repin. Stipendiary of the Academy of Fine Arts in France and Spain (1904–1905). Academician of Painting (1909). Began exhibiting in 1896. Participated in the spring Academy of Fine Arts (1900–1905), NOKh (1904–1908, founding member), SRKh (1906–1910, member from 1907), "World of Art" (1910–1924, member from 1910), "First State Free Artworks" (1919), AKhRR (1923, 1925, member from 1923), and "Pictures of Petrograd Artists of All Schools" (1923) exhibitions; the International Exhibitions in Munich (1901 — gold medal, 1909), Venice (1907, 1924), Brussels (1910), Rome (1914), Malmö (1914 — gold medal) and Paris (1925); and the Exhibitions of Russian Art in Paris (1906), Berlin (1906, 1922) and Vienna (1908). Worked at theatres in Moscow from 1911. Taught at the New Art Studio from 1913.

Kuznetsov, Pavel Varfolomeyevich

1878, Saratov — 1968, Moscow
Painter, graphic artist, pedagogue; landscape painter, portraitist, author of still lifes and subject compositions. Studied at the studios of the Saratov Society for Lovers of the Fine Arts (1891–1896) and MUZhVZ (1897–1904) under Valentin Serov and Konstantin Korovin. Member of the "World of Art" (1911) and "Four Arts" (1924, chairman) groups; life member of the Paris Autumn Salon (from 1906). Exhibited in the "World of Art" (1902, 1906, 1911–1921), "Crimson Rose" (1904), SRKh (1906–1910), Paris Autumn Salon (1906, 1910), "Blue

Rose" (1907), "Stefanos" (1907–1908), "Golden Fleece" Salons (1808–1910), "Masters of the Blue Rose" (1925) and "Four Arts" (1925–1929) exhibitions; the International Exhibitions in Venice (1907, 1924, 1928) and Malmö (1914); and the Exhibition of Russian Art in Berlin (1906, 1922). Headed the painting section of the IZO Department of Narkompros (1919–1924). Professor at SKhUM–VKhUTEMAS–VKhUTEIN–MKhI (1918–1937) in Moscow.

Larionov, Mikhail Fyodorovich

1881, Tiraspol, Bessarabia Guberniya —
1964, Fontenay-aux-Roses, France
Painter, graphic artist, theatrical artist, book illustrator. Studied at MUZhVZ (1898–1910, with interruptions). Began exhibiting in 1898. In Paris, became one of the leading artists for Sergei Diaghilev, on whose invitation he left for Switzerland together with Natalia Goncharova, and later for Italy. Lived in Paris permanently from 1919.

Lebedev, Vladimir Vasilievich

1891, St Petersburg — 1967, Leningrad
Painter, graphic artist, book artist, poster artist, theatrical artist. Studied in Petersburg at A. I. Titov's studio (1909); at the battle-painting studio of the Higher Art School of the Imperial Academy of Fine Arts (1910–1911) under Franz Rubo; at the School of Painting, Drawing and Sculpture of M. D. Bernstein and L. V. Sherwood (1912–1914); and as an auditor at the Higher Art School of the Imperial Academy of Fine Arts (1912–1916). Began exhibiting in 1909. Participated in the "Youth Union" (from 1918), "Alliance of New Tendencies in Art" (1921–1922) and "Four Arts" (from 1928) exhibitions. Taught at SKhUM (1918–1921). Collaborated with the journals *Satyricon* and *Argus* in the 1910s. Worked in the poster department of the Petrograd division of "Okna ROSTA" (1920–1922); art editor at Detgiz (1924–1933).

Lentulov, Aristarkh Vasilievich

1882, Penza — 1943, Moscow
Painter; theatrical artist. Studied at the Penza Art Academy (1898–1900, 1905), the Kiev Art Academy (1900–1905) and the studio of D. N. Kardovsky (1906–1910) in Petersburg. Worked independently in Paris at the atelier of Henri Le Fauconnier (1911). Member of and exhibited with the "Jack of Diamonds" (1910), AKhRR (1926–1927) and OMKh (1928–1929) alliances. Began exhibiting in 1907. Participated in the "Venok" (1907), "Zveno" (1908), "Venok-Stefanos" (1909), SRKh (1910) and "World of Art" (1911, 1912) exhibitions. Headed the theatrical decoration studios at the First Free Studios (SVOMAS) (1919) and the theatrical decoration section of the painting department at VKhUTEMAS (1920). Taught at the division of raising theatrical artists' qualifications of the painting department at GIII in Moscow (1932).

Levitan, Isaac Ilyich

1860, Village of Kybartai, Suwałki Guberniya (now Lithuania) —
1900, Moscow
Painter, pedagogue. Studied at MUZhVZ (1873–1885) under Alexei Savrasov and Vasily Polenov. Academician of Painting (from 1898). Member of the "Wanderers" (from 1891) and the Munich Secession (from 1897). Began exhibiting in 1880. Participated in the "Wanderers" (1884–1900), occasional MOLKh (1887–1900), Society of Southern Russian Artists (1892), MTKh (1893), Munich Secession (1896, 1898, 1899), Russian and Finnish Artists (1898), "World of Art" (1899, 1900) and All-Russian in Nizhny Novgorod (1896) exhibitions; the International Exhibition in Munich; the World's Fairs in Chicago (1893) and Paris (1900); and others. Taught at MUZhVZ (1898–1900).

Malevich, Kazimir Severinovich

1878, Kiev — 1935, Leningrad
Painter, graphic artist, theatrical artist; author of portraits, landscapes and abstract compositions. Studied at the Kiev Art Academy (1895–1896), MUZhVZ (1904–1905) and the private studio of F. I. Rerberg (1905–1910). Began exhibiting in 1907. Member of and exhibited with the "Youth Union" (from 1910) and "Jack of Diamonds" (1910, 1916) alliances. Organiser of the "Affirmers of the New Art" group (1920) in Vitebsk. Member of the collegium of the IZO Department of Narkompros (1918–1919). Director of MKhK and later GInKhuK (1923–1926) in Leningrad. Taught at the Kiev Art Institute (1929–1930). Headed the experimental laboratory at the State Russian Museum.

Malyavin, Philipp Andreyevich

1869, Village of Kazanki, Samara Guberniya — 1940, Nice
Painter, draughtsman. Studied at Higher Art School of the Imperial Academy of Fine Arts (1892–1899) under Ilya Repin. Academician of Painting (from 1906). Began exhibiting in 1895. Participated in the "Wanderers" (1895), occasional MOLKh (1895–1896), spring Imperial Academy of Fine Arts (1899), "World of Art" (1899–1906, 1911, 1921, 1922), "Thirty-Six Artists" (1901) and SRKh (1903–1906, 1910–1912, 1916, 1922, 1923) exhibitions; and the 1900 Paris World's Fair (big gold medal). Taught at GSKhM (1919–1920) in Ryazan. Lived abroad from 1922 onwards.

Mashkov, Ilya Ivanovich

1881, Village of Mikhailovskaya, now Volgograd Oblast —
1944, Moscow
Painter; author of still lifes, landscapes, portraits. Studied at MUZhVZ (1900–1909) under Abram Arkhipov, Leonid Pasternak, Konstantin Korovin and Valentin Serov. Lived in Moscow. Taught at his own art studio (1904–1917) in Moscow and GSKhM–VKhUTEIN (1918–1930); headed the central studio of AKhRR (1925–1929). One of the founders of the "Jack of Diamonds" group (1910). Member of and exhibited with the "World of Art" (1911–1917, with an interruption). Member of AKhRR (from 1924) and OMKh (1927–1928, one of its organisers). Honoured Artist of the RSFSR (1928).

Matyushin, Mikhail Vasilievich

1861, Nizhny Novgorod — 1934, Leningrad
Painter, graphic artist; composer; author of a theoretical research work entitled "Laws of Changeability in Colour Relations. Colour Reference". (Moscow, Leningrad, 1932). Studied at the Moscow Conservatory (1876–1881), the Drawing School of OPKh (1894–1898) under Mstislav Dobuzhinsky and Léon Bakst, the studio of Jan Tsionglinsky (1903–1905) and the Art School of E. N. Zvantseva (1906–1908). One of the organisers of the "Youth Union" (1910–1914). Author of the opera *Victory over the Sun* (1913). Creator of the theory of "Expanded Looking" and the ZORVED ("Sight and Knowledge") Group. Taught at PGSKhUM (1918–1926); headed the department of organic culture at GInKhuK in Petrograd (later Leningrad) (1923–1926).

Miturich, Pyotr Vasilievich

1887, St Petersburg — 1956, Moscow

Graphic artist, painter, author of three-dimensional compositions. Studied at the Kiev Art Academy (1906–1909) and the Higher Art School of the Imperial Academy of Fine Arts in Petersburg (1910–1916) with Nikolai Samokish. Exhibited with the "World of Art" (from 1915). Conscripted into the army (1916–1921). When in Petrograd, participated in the city's artistic life; decorated the city for the first anniversary of the October Revolution, participated in the competition to design the Seal of the RSFSR. Appointed emissary of Narkompros to the Northern Communes (1918). Worked on three-dimensional constructions: 3-D painting and 3-D graphics (1918–1920). Became friends with Velimir Khlebnikov (1921). Member of the "Four Artists" group (1925–1929). Taught drawing in the Graphic Arts and Architecture Departments at VKhUTEMAS–VKhUTEIN (Moscow, 1923–1930) and at the Moscow Institute for Raising Artists' Qualifications (1930s). Worked on technical inventions his whole life.

Nesterov, Mikhail Vasilievich

1862, Ufa — 1942, Moscow

Painter; portraitist, landscape painter, genre painter, monumental artist; author of memoirs and essays about figures in the art world. Studied at MUZhVZ (1877–1881, 1884–1886) and the Imperial Academy of Fine Arts (1881–1884). Participated in exhibitions of the "Wanderers" (1889–1901, member from 1896), "World of Art" (1899–1901), "Thirty-Six Artists" (1901–1903) and SRKh (1922, 1923, founding member from 1903). Exhibited at the All-Russian Exhibition in Nizhny Novgorod (1896); the 1900 World's Fair in Paris (1900); the International Exhibitions in Munich (1898, 1909) and Rome (1911); the Exhibitions of Russian Art in Berlin (1922) and New York (1924); and others. Academician (from 1898). Active member of the Imperial Academy of Fine Arts (from 1910). Honoured Artist of the RSFSR (from 1942).

Petrov-Vodkin, Kuzma Sergeyevich

1878, Khvalynsk, Saratov Guberniya — 1939, Leningrad

Painter, graphic artist, theatrical artist; author of genre pictures, portraits, still lifes and landscapes. Studied at the School of Painting and Drawing of Fyodor Burov in Samara (1893–1895); the Baron Stieglitz Central Academy of Technical Drawing in Petersburg; MUZhVZ (1897–1905); the Aschbe School in Munich (1901); and private academies in Paris, including the atelier of Colarossi (1905–1908). Began exhibiting in 1906. First Chairman of the Board of the Leningrad Artists' Union (1932). Deputy of the Leningrad Soviet of Workers, Peasants and the Red Army (1935). Honoured Artist of the RSFSR (1930).

Polenov, Vasily Dmitrievich

1844, St Petersburg — 1927, Borok Estate, Tula Guberniya

Painter; landscape painter, theatrical artist. Took lessons with Pavel Chistyakov in 1859. Studied at the Imperial Academy of Fine Arts (1863–1871) with A. T. Markov, P. V. Basin, P. M. Shamshin, A. E. Beideman and K. V. Venig, simultaneously studying law at Moscow University. Studied under Ivan Kramskoi. Stipendiary of the Imperial Academy of Fine Arts in Germany, Switzerland, Italy and France (1872–1876). Academician (1876). Active member of the Imperial Academy of Fine Arts (1893). Taught at MUZhVZ from 1882 to 1895. Participant in exhibitions of the Imperial Academy of Fine Arts, the "Wanderers"

(1879–1918, with interruptions, member from 1878) and MOLKh. Lived in Petersburg, Moscow (from 1877) and the estate of Borok in Tula Guberniya, where he founded an art museum in 1892. Participated in the Serbo-Montenegrin-Turkish (1876) and Russian-Turkish Wars as artist/correspondent. Travelled in the Near East and Greece several times (1881–1882, 1899, 1909) and in Italy (1883–1884, 1894–1895). Took part in the Abramtsevo Circle. Organised the Polenov Drawing Evenings (1884–1892). Worked as a theatrical artist at the Russian Private Opera and Bolshoi Theatre in Moscow. Organised the People's Theatre in Moscow (1910). People's Artist of the RSFSR (1926).

Popova, Liubov Sergeyevna

1889, Village of Ivanovskoye, Moscow Guberniya — 1924, Moscow

Painter, graphic artist, theatrical artist; worked in decorative and applied arts. Studied at the private studio of Stanislav Zhukovsky (1907) and the Art School of Konstantin Yuon and Ivan Dudin (1908–1909) in Moscow, and the Académie de la Palette under Henri Le Fauconnier and Jean Metzinger in Paris (1912–1913). Attended the "Bashnya" studio in Moscow (1913). Participated in the "Jack of Diamonds" (1914, 1916), "First Futurist Picture 'Tramway V'" (1915–1916), "Magazin" (1916) and "5 x 5 = 25" (1921) exhibitions. Took part in the organisation of the "Supremus" society (1916). Worked at InKhuK in Moscow (1920–1924), participated in the organisation of the Museum of Painting Culture (1921–1922). Member of the "LEF" ("Left Front") group (1922–1924).

Puni, Ivan (Jean) Albertovich

1894, Kuokkala, Finland — 1956, Paris

Painter, graphic artist, theatrical artist, illustrator; author of articles about art. Studied at military school (1900–1908) in Petersburg and at various studios (1909–1910), including the Académie Julian in Paris. Began exhibiting in 1912. Member of and exhibited with the "Youth Union" (1912–1913), Salon des Indépendants (1913–1914), "Jack of Diamonds" (1916–1917), "First Futurist Picture 'Tramway V'" (1928) and "Last Futurist Exhibition '0,10'" (1915–1916) alliances. Professor at PGSKhUM (1918); did pedagogical work at the Vitebsk Art School in 1919 under the leadership of Marc Chagall.

Repin, Ilya Efimovich

1844, Chuguyev, Kharkov Guberniya — 1930, Kuokkala, Finland

Painter, draughtsman, pedagogue. Studied at the School of Military Topographers and under the painter I. M. Bunakov at Chuguyev; the Drawing School of OPKh (1863) under Ivan Kramskoi; and the Imperial Academy of Fine Arts (1864–1871). As stipendiary of the Imperial Academy of Fine Arts in France and Italy, lived mainly in Paris. Academician (from 1876), professor (from 1892), active member of the Imperial Academy of Fine Arts (from 1893). Member of the "Wanderers" (from 1878) and the Viennese Secession (from the 1890s). Began exhibiting in 1865. Participated in the Imperial Academy of Fine Arts (1865, 1868, 1869, 1873, 1878, 1881, 1896), "Wanderers" (1874, 1878–1918), periodical MOLKh (1881, 1904, 1909) and "World of Art" (1899) exhibitions; the All-Russian Exhibition in Moscow (1882); the World's Fairs in Vienna (1873), Paris (1878, 1900) and St. Louis (1904); the International Exhibition at Rome (1911); and many others. Taught at the Higher Art School of the Imperial Academy of Fine

Arts (1893–1907) and the Art School of Princess Maria Tenisheva (1895–1899). Lived at his estate of Penaty near Petersburg (from 1900).

Rodchenko, Alexander Mikhailovich
1891, St Petersburg — 1956, Moscow
Painter, graphic artist, sculptor, author of 3-D constructions, photographer, designer, theatrical artist. Studied at the Kazan Art School (1910–1914) and STsKhPU in Moscow (1914–1917). Began exhibiting in 1913. Participated in the "Magazin" (1916), V, X and XI State (1919), Society of Young Artists (1920, 1921), "5 x 5 = 25" (1921) and "October" alliance (1930) exhibitions. First one-man exhibition in 1918. Member of the art collegium of the IZO Department of Narkompros; director of the Museum Bureau and member of its first buying commission (1918–1921); and founding member of InKhuK in Moscow (1920–1924), where he replaced Wassily Kandinsky in 1921 as chairman of the presidium, becoming an organiser of the Constructivists' working group at the InKhuK. Taught at Moscow Proletkult (1918) and in the woodworking and metalworking departments at VKhUTEMAS (1920–1930); led photography courses at the Moscow Printing Institute (1930s). Collaborated with the journals *LEF*, *Kinofot* and *Ogonyok* and (mainly in the 30s) *USSR at the Building Site*.

Roerich, Nikolai Konstantinovich
1874, St Petersburg — 1947, Kullu Valley, India
Painter, theatrical artist, philosopher, writer, essayist. Studied at the Higher Art School of the Imperial Academy of Fine Arts (1893–1897) under Arkhip Kuindzhi, in the law department at Petersburg University (1893–1898) and at the Académie Cormond (1900–1901) in Paris. Academician of Painting (1909). Member of SRKh (1903) and the Autumn Salon (Paris, 1906); founding member of the "World of Art" group (1910, chairman from 1910 to 1913). Began exhibiting in 1895. Participated in the spring Imperial Academy of Fine Arts (1899–1902), "World of Art" (1902, 1903, 1911-1917), SRKh (1903–1910), Autumn Salon (Paris, 1906, 1907) and "Salon of S. K. Makovsky" (1909) exhibitions; the World's Fairs in Paris (1900) and St. Louis (1904); the International Exhibitions in Munich (1909), Rome (1911, 1914) and Malmö (1914); and the Exhibitions of Russian Art in Paris (1906–1908), Berlin (1906) and Vienna (1908). From 1906 to 1916, was director of the Drawing School of OPKh. From 1907, worked in theatres in St Petersburg and Moscow and for Sergei Diaghilev. Lived abroad from 1918, settling in India's Kullu Valley in 1928.

Rozanova, Olga Vladimirovna
1886, Village of Melenki, Vladimir Guberniya — 1918, Moscow
Painter, graphic artist, book illustrator, poet, art theoretician. Lived in Moscow from 1905 onwards. Studied at the School of Painting and Sculpture of A. P. Bolshakov (1906–1907) and the Art School of Konstantin Yuon (1907–1910), simultaneously auditing courses at STsKhPU. Began exhibiting in 1910. Moved to Petersburg in 1911; studied at the Art School of E. N. Zvantseva. Member of and exhibited with the "Youth Union" (1911–1914) and the "Supremus" society (1917–1918), where she was editor of the journal of the same name. Participated in the creation and reorganisation of art industry training workshops in Ivanovo-Voznesensk, Mstyora, Bogorodsk, Abramtsevo and Sergiev Posad (1918); elected director of the training workshop at the First GSKhM. Died of diphtheria.

Sapunov, Nikolai Nikolayevich
1880, Moscow — 1912, Terioki (now Zelenogorsk), near St Petersburg
Painter, theatrical artist; author of genre pictures, still lifes and portraits. Studied at MUZhVZ (1896–1901) under Isaac Levitan, Valentin Serov and Konstantin Korovin, and the Higher Art School of the Imperial Academy of Fine Arts (1904–1910) under A. A. Kiselyov. Member of SRKh (from 1908). Participated in the "Wanderers" (1900), "World of Art" (1902, 1906, 1911–1913), "Crimson Rose" (1904), MTKh (1905), "Blue Rose" (1907), SRKh (1907–1910), "Stefanos" (1907–1908), "Golden Fleece" Salons (1908) and "Salon of S. K. Makovsky" (1909) exhibitions; the International Exhibition in Malmö (1914); and the Exhibition of Russian Art in Vienna (1908). From 1903, worked in the theatres of Moscow and Petersburg.

Saryan, Martiros Sergeyevich
1880, Nakhichevan (on the Don) — 1972, Yerevan
Painter, draughtsman; author of symbolic compositions, landscapes, portraits and still lifes. Studied at MUZhVZ (1897–1905) under Valentin Serov and Konstantin Korovin. Member of the SRKh (1910), "World of Art" (1910), and "Four Arts" (1925) alliances. Participated in the "Crimson Rose" (1904), MTKh (1905, 1910, 1911), "Blue Rose" (1907), "Venok" (1908), "Golden Fleece" Salons (1908–1910), SRKh (1909–1912), "World of Art" (1911–1916), Second Post-Impressionists (London, 1912), "Leftist Tendencies" (1915), "The Year 1915" (Moscow, 1915) and "Four Arts" (1925–1929) exhibitions; and the International Exhibitions in Rome (1911) and Malmö (1914).

Serov, Valentin Alexandrovich
1865, St Petersburg — 1911, Moscow
Painter, graphic artist, pedagogue. Studied under Ilya Repin (1874–1875 and 1878–1880) in Paris and Moscow, and at the Imperial Academy of Fine Arts under Pavel Chistyakov. Academician of Painting (from 1898), active member of the Imperial Academy of Fine Arts (1903–1905). Member of the Abramtsevo Circle (1878), "Wanderers" (1894), Munich Secession (1899), "World of Art" (1900, founding member from 1910) and SRKh (1903) alliances. Began exhibiting in 1889. Participated in the "Wanderers" (1890–1899), MTKh (1895), Russian and Finnish Artists (1898), "World of Art" (1899–1906, 1911–1912), "Thirty-Six Artists" (1901), Berlin Secession (1903), "Tauride" Russian Portrait (1905), SRKh (1905–1910), "Salon of S. K. Makovsky" (1909) and "Contemporary Russian Women's Portrait" (1910) exhibitions; the World's Fairs in Paris (1900 — Grand Prix); the International Exhibitions in Munich (1896, 1898, 1899, 1909), Vienna (1902), Venice (1907), Brussels (1910) and Rome (1911); and the exhibitions of Russian Art in Paris (1906, 1910), Berlin (1906) and Vienna (1908). Member of the Tretyakov Gallery. Taught at MUZhVZ (1897–1909). From 1886, worked for theatres in Moscow and Petersburg, as well as Sergei Diaghilev's productions.

Shukhayev, Vasily Ivanovich
1887, Moscow — 1973, Tbilisi
Painter, graphic artist, theatrical artist. Studied at STsKhPU (1897–1906) in Moscow, and the Higher Art School of the Imperial Academy of Fine Arts (1906–1912) under D. N. Kardovsky. Stipendiary of the Society for the Encouragement of Young Artists in Rome (1913–1914). Participated in the NOKh (1915, 1917), "World of Art" (1918) and "First

State Free Artworks" (1919) exhibitions; the International Exhibitions in Rome (1924) and Pittsburgh (1925–1927); the Exhibitions of Russian Art in Paris (1921, 1927) and New York (1924); and others. Taught at the New Art Studio (from 1915). Professor at the Higher Art School of the Academy of Fine Arts-SKhUM (1917–1920) in Petrograd. Worked for the theatre from 1918. Lived abroad from 1920 to 1935 (Finland, France). Illustrated books from the 1920s onwards.

Somov, Konstantin Andreyevich
1869, St Petersburg — 1939, Paris

Painter, graphic artist; portraitist, genre painter, landscape painter. Studied at the Imperial Academy of Fine Arts (1888–1897, in the studio of Ilya Repin from 1894) under Vasily Vereshchagin and Pavel Chistyakov, and at the atelier of Colarossi in Paris (1897–1898). Academician (1914). Member of the Munich and Berlin Secessions (1898) and the "World of Art" (1899, founding member), SRKh (1903) and Autumn Salon in Paris (1906) alliances. Participated in the Society of Russian Watercolourists (1894–1895), Russian and Finnish Artists (1898), "World of Art" (1899-1906, 1911, 1918, 1921, 1922), SRKh (1903–1910), New Society of Artists (1907), "Salon of S. K. Makovsky" (1909) and "House of Art" (1920) exhibitions; in the Secessions in Munich (1898, 1899), Berlin (1898, 1901–1903, 1906, 1909) and Vienna (1901, 1904, 1905); in the International Exhibitions in Venice (1907) and Rome, (1909); in the Exhibitions of Russian Art in Paris (1906), Berlin (1906) and New York (1924); and in one-man exhibitions in Petersburg, Berlin and Hamburg (1903), Leipzig (1904) and Vienna (1905). Illustrated the *Golden Fleece* journal and *Art Treasures of Russia*. Lived permanently in Paris from 1925.

Sudeikin, Sergei Yurievich
1882, St Petersburg — 1946, New York

Painter, graphic artist, theatrical artist. Studied at MUZhVZ (1897–1909, with interruptions) under Konstantin Korovin, and the Imperial Academy of Fine Arts (1909–1910) under D. N. Kardovsky. Participated in the MTKh (1905), SRKh (1905, 1907–1909), "Crimson Rose" (1904), "Blue Rose" (1907) and "World of Art" (1911–1917, 1921, member from 1911) exhibitions; and the Exhibitions of Russian Art in Paris (1906, 1910), Berlin (1906), Vienna (1908) and New York and Pittsburgh (1924). Decorated productions for the Theatre Studio on Povarskaya Street and the Chamber Theatre in Moscow; the Vera Komissarzhevskaya Theatre, Maly Theatre, and Dom Intermedia in Petersburg; Sergei Diaghilev's Theatre, the Théâtre du Vieux-Colombier and Theatre of Nikolai Baliev in Paris; and the Metropolitan Opera in New York. Lived in Paris from 1920 and New York from 1922.

Tatlin, Vladimir Evgrafovich
1885, Moscow — 1953, Moscow

Painter, graphic artist, theatrical artist, author of architectural and engineering designs. Studied at the Art School of N. D. Seliverstova in Penza (1904–1910) and MUZhVZ (1902–1903; 1909–1910) under Valentin Serov and Konstantin Korovin. Visited Berlin and Paris (1913). Began exhibiting in 1910. Participated in the "Donkey's Tail" (1912), "Jack of Diamonds" (1913), "World of Art" (1913), "Youth Union" (1911–1914), "First Futurist Picture 'Tramway V'" (1915), "Last Futurist Exhibition '0,10'" (1915–1916) and "Magazin" (1916) exhibitions. Member of the "Alliance of New Trends" (1921–1923). Chairman of the "Left Federation of Artists" in Moscow (1917) and head of

the Moscow collegium of the IZO Department of Narkompros (1918–1919). Helped initiate the creation of the InKhuK (1922). Taught at GSKhM (1918–1919) in Moscow, VKhUTEMAS (1919–1924) in Petrograd, the Art Institute (1925–1927) in Kiev and VKhUTEIN (1927–1930) in Moscow. Honoured Artist of the RSFSR (1931).

Udaltsova, Nadezhda Andreyevna
1886, Oryol — 1961, Moscow

Painter, graphic artist. Studied at the Art School of Konstantin Yuon and Ivan Dudin (1905–1909) and the studio of K. E. Kish in Moscow, and the Académie de la Palette under Henri Le Fauconnier and Jean Metzinger in Paris (1912–1913). Attended Vladimir Tatlin's "Bashnya" studio (1913). A member of the "Supremus" group (1916–1917). Began exhibiting in 1914. Participated in the "Jack of Diamonds" (1914, 1916), "First Futurist Picture 'Tramway V'" (1915), "Last Futurist Exhibition '0,10'" (1915–1916) and "Magazin" (1916) exhibitions, among others. Member of the Moscow collegium of the IZO Department of Narkompros (1918). Taught at the First SKhM (1919) and VKhUTEMAS–VKhUTEIN (1920–1930, professor). Worked at InKhuK (1920–1921). Member of the "Moscow Painters" (1925), and OMKh (1927–1928) organisations.

Vrubel, Mikhail Alexandrovich
1856, Omsk — 1910, St Petersburg

Painter, draughtsman, theatrical artist, sculptor, specialist in decorative and applied arts; portraitist, author of works based on legendary and mythological subjects, monumental artist. Studied in the law department at Petersburg University (1874–1879) and at the Imperial Academy of Fine Arts (1880–1884). Began exhibiting in 1895. Belonged to and exhibited with the Abramtsevo Circle (1870–1890s), MTKh (1895, 1899, 1904, 1908–1909), "World of Art" (1900–1903), "Thirty-Six Artists" (1901–1903), SRKh (1903, founding member) and NOKh (1908, 1910). Academician (from 1905). Went blind in 1906.

Yakovlev, Alexander Yevgenievich
1887, St Petersburg — 1938, Paris

Painter, graphic artist, pedagogue; portraitist, landscape painter, author of genre works and monumental frescos. Studied at the Higher Art School of the Imperial Academy of Fine Arts (1905–1913) under D. N. Kardovsky. Stipendiary of the Imperial Academy of Fine Arts in Italy and Spain (1914–1915), and in Mongolia, Japan and China (1917–1918). Member of the "World of Art" group (from 1915); one of the founders of the St. Luke Workshop (1917) in Petrograd. Participated in the "Salon of S. K. Makovsky" (1909), "Salon of V. A. Izdebsky" (1909–1910), SRKh (1909), "World of Art" (1912–1914, 1916, 1917, 1921), "Contemporary Russian Painting" (1916), and "Russian Landscape" (1918–1919) exhibitions; the International Exhibition in Malmö (1914); the Exhibitions of Russian Art in Paris (1921, 1927) and New York (1924); and one-man exhibitions in Paris (1920, 1922) and London (1920). Taught at the architectural courses of E. F. Bagayeva and the New Art Studio (1916–1917) in Petrograd, and the School of the Museum of Fine Arts in Boston (1934–1937). Lived in Paris from 1920. Cavalier of the French Légion d'Honneur.

EXPLANATION OF ABBREVIATIONS

AKhRR — Association of Artists of Revolutionary Russia (*Assotsiatsiya khudozhnikov revoliutsionnoi Rossii*)

Detgiz — State Children's Literature Publishing House (*Gosudarstvennoye izdatel'stvo detskoi literatury*)

GIII — State Institute of Art History (*Gosudarstvenny institut istorii iskusstva*)

(G)InKhuK — (State) Institute of Artistic Culture (*[Gosudarstvenny] Institut khudozhestvennoi kul'tury*)

GMNZI — State Museum of New Western Art

(G)SKhM — (State) Free Art Studios (*[Gosudarstvennye] Svobodnye khudozhestvennye masterskie*)

Herm.— State Hermitage Museum

IZO Department of Narkompros — Fine Arts Department of the RSFSR People's Commissariat of Enlightenment (*Otdel izobrazitel'nykh iskusstv Narodnogo komissariata prosveshcheniya RSFSR*)

MKhI — Moscow Art Institute (*Moskovsky khudozhestvenny institut*)

MKhK — Museum of Artistic Culture (*Muzei khudozhestvennoi kul'tury*)

MNZZh — Museum of New Western Painting

MOLKh — Moscow Art Lovers' Society (*Moskovskoye obshchestvo liubitelei khudozhestv*)

MTKh — Moscow Artists' Society (*Moskovskoye tovarishchestvo khudozhnikov*)

MUZhVZ — Moscow Academy of Painting, Sculpture and Architecture (*Moskovskoye uchilishche zhivopisi, vayaniya i zodchestva*)

NOKh — New Artists' Society (*Novoye obshchestvo khudozhnikov*)

OMKh — Moscow Artists' Society (*Obshchestvo moskovskikh khudozhnikov*)

OPKh — Society for the Encouragement of the Arts (*Obshchestvo pooshchreniya khudozhestv*)

(PG)SKhUM — (Petrograd State) Free Art Instructional Studios (*[Petrogradskie gosudarstvennye] Svobodnye khudozhestvenno-uchebnye masterskie*)

Proletkult — "Proletarian Culture" cultural and educational organization of the People's Commissariat of Enlightenment (*Kul'turno-prosvetitel'skaya organizatsiya "Proletarskaya kul'tura" pri Narodnom komissariate prosveshcheniya*)

Push. Mus.— Alexander Pushkin Museum of Fine Arts (*Gosudarstvenny muzei izobrazitel'nykh iskusstv imeni A. S. Pushkina*)

ROSTA — Russian Telegraph Agency (*Rossiiskoye telegrafnoye agentstvo*)

RSFSR — Russian Soviet Federative Socialist Republic (*Rossiiskaya Sovietskaya Federativnaya Sotsialisticheskaya Respublika*)

Russ. Mus.— State Russian Museum

SRKh — Union of Russian Artists (*Soyuz russkikh khudozhnikov*)

STsKhPU — Stroganov Central Industrial Art Academy (*Stroganovskoye tsentral'noye khudozhestvenno-promyshlennoye uchilishche*)

SVOMAS — Free Studios (*Svobodnye masterskie*)

Tret. Gal.— State Tretyakov Gallery

TYuRKh — Society of Southern Russian Artists (*Tovarishchestvo yuzhnorusskikh khudozhnikov*)

(V)KhU — (Higher) Art Academy (*[Vysshee] khudozhestvennoye uchilishche*)

VKhUTEIN — Higher Art-Technical Institute (*Vysshiy khudozhestvenno-tekhnichesky institut*)

VKhUTEMAS — Higher Art-Technical Studios (*Vysshie khudozhestvenno-tekhnicheskie masterskie*)

CHRONICLE OF EVENTS
IN THE CULTURAL AND POLITICAL LIFE
OF FRANCE AND RUSSIA

1860	Schopenhauer dies. Chekhov born. Founding of the "New Russian School" of composers (the so-called "Mighty Handful").
1861	Serfdom abolished in Russia. "Land and Will" secret revolutionary organisation founded. Rumiantsev Museum opens in Moscow and moves to Petersburg.
1862	Debussy, Maeterlinck and Hauptmann are born. Flaubert's historical novel *Salammbô*, Hugo's *Les Misérables*, Turgenev's *Fathers and Sons* and Dostoyevsky's *The House of the Dead* are published. Chernyshevsky writes his novel *What is to Be Done?* in prison. Anton Rubinstein founds Russia's first conservatory.
1863	Corporal punishment abolished in Russia. Death of Delacroix and Thackeray. Signac and Munch are born. Vladimir Dahl begins publishing his *Interpretive Dictionary of the Russian Language*. Leo Tolstoy begins *War and Peace*. The Salon des Refusés takes place in Paris. Edouard Manet's *Olympia* and *Le Déjeuner sur l'Herbe*.
1864	Land and education reform in Russia; trial by jury based on the European model introduced. The right to strike introduced in France. Toulouse-Lautrec born.
1865	Valentin Serov born. Claude Monet's *Luncheon on the Grass*.
1869	Matisse born.
1870	Beginning of the Franco-Prussian War. Fall of the Second Empire. Alexandre Dumas, père dies. Ivan Bunin born. Society of Travelling Exhibitions (the "Wanderers") founded.

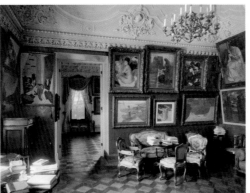

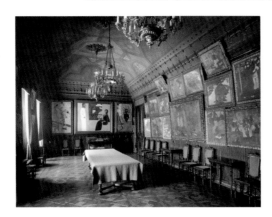

Interior of Sergei Shchukin's mansion in Moscow

1871	Courbet, chairman of the Art Commission of the Paris Commune, participates in the destruction of the Vendôme Column. The Paris Commune is brutally crushed. Proust and Rouault are born. Zola begins his *Les Rougon-Macquart* cycle of novels; Dostoyevsky begins *The Possessed*. Repin's *Barge Haulers on the Volga*.
1872	Nietzsche's *Birth of Tragedy*. Mussorgsky's *Boris Godunov*. Monet's *Impression, Sunrise*, after which the new artistic movement of Impressionism is named.
1874	Birth of the *narodniki* movement. Mussorgsky's *Pictures at an Exhibition*. Bizet's *Carmen*. Millet dies. First Impressionist exhibition.
1875	Opening of the Opéra de Paris at the Palais Garnier. Rilke and Ravel are born.
1876	Tchaikovsky's *Swan Lake* ballet.
1877	Russian-Turkish War. Courbet and Nekrasov die.
1878	World's Fair in Paris. Tchaikovsky's opera *Eugene Onegin*.
1880	Law guaranteeing freedom of speech and assembly passed in France. Spengler, Apollinaire, Alexander Blok, Robert Musil and Franz Marc are born. Flaubert dies. Repin begins work on the painting *Religious Procession in the Kursk Province*.
1881	Assassination of Alexander II by the "People's Will" organisation. Alexander III backs off on reforms begun by his father. Universal secular primary education introduced in France. Dostoyevsky, Mussorgsky and Carlyle die. Picasso born. Rimsky-Korsakov's opera *The Snow Maiden*.

314

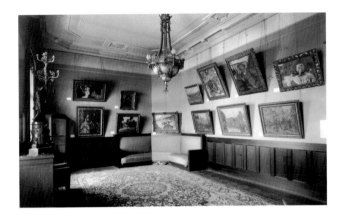

Interior of Ivan Morozov's mansion in Moscow

1883	Karl Marx, Ivan Turgenev, Wagner and Manet die. Maupassant's novel *A Woman's Life*.
1886	Franz Liszt and Alexander Ostrovsky die. Last Impressionist exhibition. Monet's *Haystacks* series.
1887	General Boulanger attempts to take power in France. Chagall born. Borodin, composer of the opera *Prince Igor*, dies. Leo Tolstoy's drama *The Power of Darkness* and short story "The Kreutzer Sonata".
1888	Rimsky-Korsakov's symphonic poem *Scheherazade*. Van Gogh's *The Night Café*.
1889	Social-Democratic International founded in Paris. World's Fair in Paris, with the Eiffel Tower as the main attraction. Saltykov-Shchedrin dies. Akhmatova and Cocteau are born.
1892	Franco-Russian Alliance signed in secret. Witte becomes Finance Minister of Russia, introducing a policy of accelerated economic development. Marina Tsvetaeva born. Franz von Stuck founds the Munich Secession. Tretyakov bequeaths his gallery to the City of Moscow. Pyotr Shchukin starts building his own museum.
1893	Trade war between Germany and Russia. Mayakovsky born. Tchaikovsky's Symphony No. 6, "Pathétique".
1894	Death of Alexander III and Nicholas II's accession to the throne. Assassination of President Carnot and ban on "anarchist agitation" in France. Anton Rubinstein dies.

1900 World's Fair in Paris. Russian Pavilion. Handicrafts section of the Russian Pavilion. Konstantin Korovin and Alexander Golovin exhibit

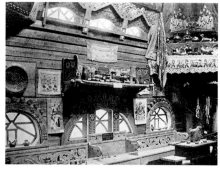

2nd "World of Art" exhibition at the Baron Alexander Stieglitz Museum in St Petersburg. 1900

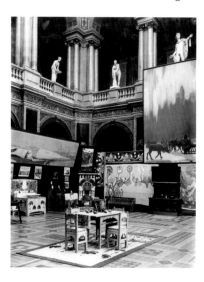

1896 1389 people crushed to death during coronation festivities at Khodynskoe Field in Moscow.
Construction of the Chinese Eastern Railway.
France seizes Madagascar.
Pathé and Gaumont begin producing films in France.
First cinema showings in Russia.

1897 First complete census in Russia.
Witte's money reform and convertible rouble.
Founding of the Viennese Secession.
Leo Tolstoy's tractate "What Is Art?".

1898 Creation of the Russian Social-Democratic Workers' Party.
Alexander III Russian Museum opens in Petersburg.
Stanislavsky and Nemirovich-Danchenko found the Moscow Art Theatre.
World of Art journal founded in Petersburg.
Zola's letter in defence of Dreyfus, "J'accuse!".

1899 Debussy's *Nocturnes*.
Sisley and Johann Strauss die.
Vladimir Nabokov born.

1900 First line of the Paris Métro opens.
World's Fair in Paris.
"World of Art" group founded, led by Diaghilev and Benois.

1901 First Nobel Prize awarded.
Sully Prudhomme wins the prize in literature.
Social-Revolutionary (SR) Party formed in Russia.
Leo Tolstoy anathematised by the Orthodox Holy Synod.
Chekhov's *Three Sisters*.
André Malraux born.
Picasso's blue period begins.
Rachmaninov's *Second Piano Concerto*.
Scriabin's *Symphony No. 1*.

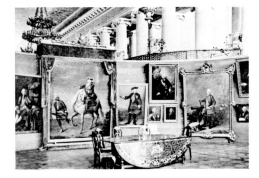

"Historical and Artistic Exhibition of Historical Portraits" at the Tauride Palace in St Petersburg. 1905 Elizaveta Petrovna Hall and Garden, as drawn by Léon Bakst

Interior of Ilya Mashkov's studio 1919–1920

1902
Alexander Blok's *Crossroads*.
André Gide's novel *The Immoralist*.

1903
Gauguin and Pissarro die.
Nikolai Zabolotsky born.

1905
Russo-Japanese War.
First Russian Revolution.
Daniil Kharms, Sholokhov and Sartre are born.
Jules Verne dies.
Debussy's *La Mer*.
Fauvism arises.
Exhibition of Russian portraiture organised by Diaghilev in the Tauride Palace, St Petersburg.

1906
Stolypin replaces Witte as Prime Minister.
First State Duma is formed and then dissolved.
Agrarian reform in Russia.
Cézanne and Ibsen die.
Gorky's plays *Enemies* and *Barbarians*.
Exhibition of Russian art at the Autumn Salon in Paris.

1907
"Triple Entente" between Great Britain, France and Russia arises.
Founding of the "Blue Rose" artistic alliance in Moscow.
Diaghilev organises the "Historical Russian Concerts" in Paris.
Rimsky-Korsakov's opera *The Golden Cockerel*, Scriabin's *Poem of Ecstasy*, Ravel's *Spanish Rhapsody*. Picasso's *Les Demoiselles d'Avignon*. Cubism arises.

1908
Rimsky-Korsakov dies.
Matisse's *Red Room*, commissioned by Shchukin.
Picasso's *Dryad*.
Opening of the "Golden Fleece" Salon, a joint exhibition of the Russian and French avant-garde.
Diaghilev's production of Mussorgsky's *Boris Godunov* premieres in Paris, marking the beginning of what would become "Les Saisons Russes".

Poster by Vladimir Mayakovsky for Alexei Kruchenykh's opera *Victory over the Sun* and the cover the opera booklet. 1913

Members of performance *Victory over the Sun* opera and tragedy *Vladimir Mayakovsky*: Mikhail Matiushin, Alexei Kruchenykh, Pavel Filonov, Josif Schkolnik, Kazimir Malevich. St Petersburg, December 1913

1909	Marinetti publishes the "Manifesto of Futurism" in *Le Figaro*. Marcel Carné born. Opening of Diaghilev's first "Saison Russe" at the Théâtre du Châtelet in Paris.
1910	Tolstoy and Vrubel die. Stravinsky's *Firebird* ballet. Rachmaninov's *Liturgy of John Chrysostom*. Matisse paints *The Dance* and *Music* for Sergei Shchukin. Kandinsky's first abstract water colour. First "Jack of Diamonds" exhibition in Moscow.
1912	"A Hundred Years of French Painting" exhibition, organised by the journal *Apollon* in Petersburg.
1913	Mandelstam's book of poems *Stone*, Proust's *Swan's Way*, Rozanov's *Fallen Leaves*. Stravinsky's *Rite of Spring*. Benjamin Britten born. Blaise Cendrars' *Prose of the Trans-Siberian and Little Jehanne of France* (illustrated by Sonia Delaunay). Kandinsky's *Composition VI*. The opera *Victory over the Sun*, where Malevich's *Black Square* makes its first appearance.
1914	Beginning of World War I. "Last Futurist Exhibition '0,10'", with Suprematist works by Russian artists.
1915	Rachmaninov's *Vespers*. Scriabin dies. Mayakovsky's poems "A Cloud in Trousers" and "The Spine Flute".
1916	The bloody Battle of the Somme. Advance of Russian forces on the Southwest Front (the "Brusilov Offensive"). Murder of Grigory Rasputin.

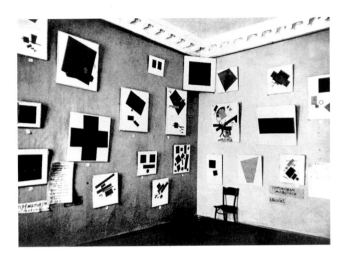

An exhibit at the "Last Futurist Exhibition '0,10'". Petrograd. 1915

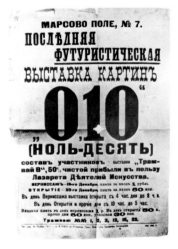

Billboard for the "Last Futurist Exhibition '0,10'". Petrograd. December 1915

1917 February Revolution in Russia.
October Revolution in Petrograd.
Rodin dies.
Rozanov's *Apocalypse of Our Time*.
De Chirico, Carrá and Morandi publish the
"Manifesto of Metaphysical Painting".
The De Stijl (Style) group founded in Leyden.

1918 Russia concludes the Treaty of Brest-Litovsk with
Germany. End of World War I.
Military intervention of the entente powers
in Russia.
Bolsheviks institute the "Red Terror".
Apollinaire dies.
Bolshevik monumental propaganda plan.

1919 Civil war in Russia.
Auguste Renoir dies.
Bauhaus group founded in Weimar.
Tatlin's Monument to the Third International
("Tatlin's Tower") designed.

1920 Defeat of Kolchak's army and his execution.
Wrangel crushed in the Crimea.
Work Obligation Decree declared in Russia.
Defeat of the Red Army at Warsaw.
"First avant-garde" or "cinematic impressionism"
in France.
Velimir Khlebnikov's utopian poem "Ladomir",
Khodasevich's book of verse *The Way of the Grain*.

An exhibit at the Society of Moscow Artists. Moscow. 1921